*Land of Celebration*

# INDIA

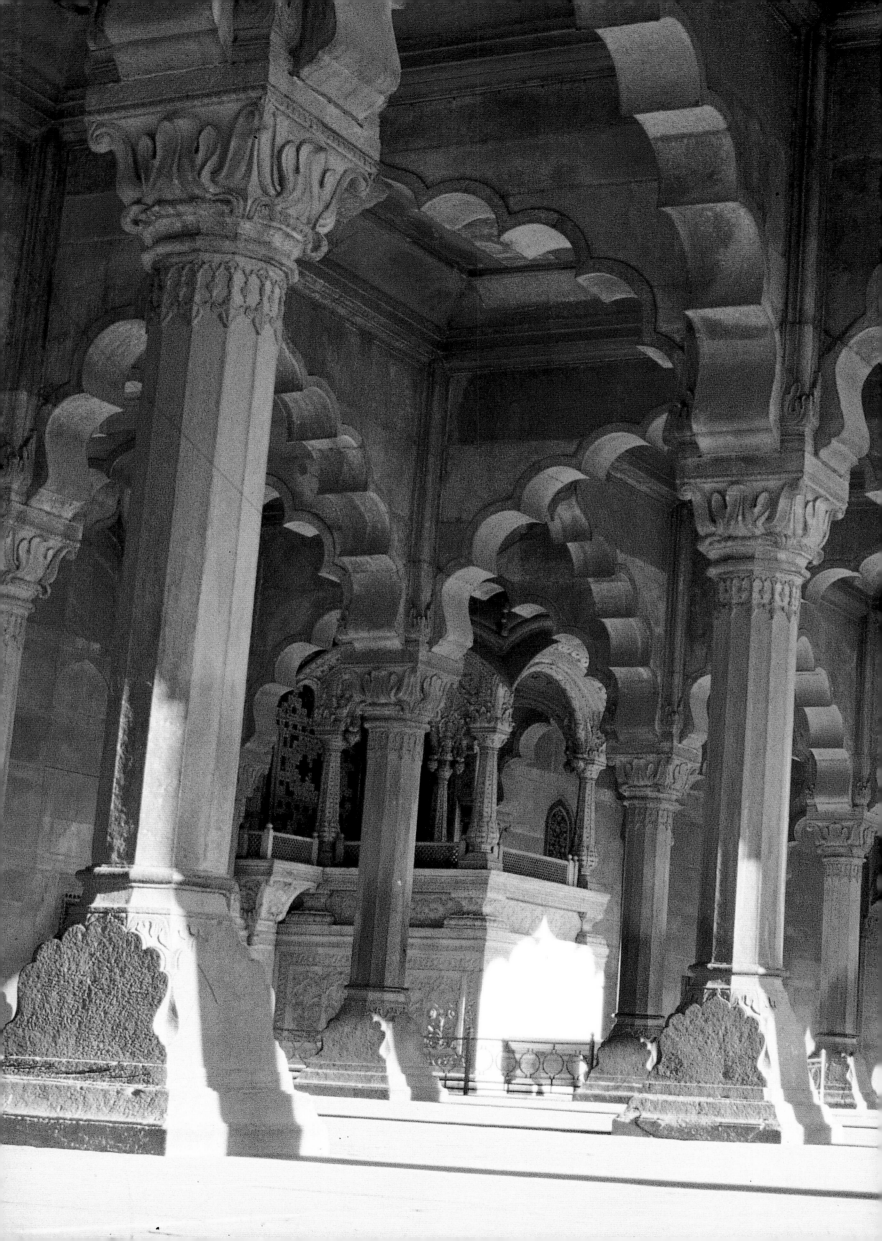

*Land of Celebration*

# INDIA

RUPINDER KHULLAR

MANDALA
PUBLISHING

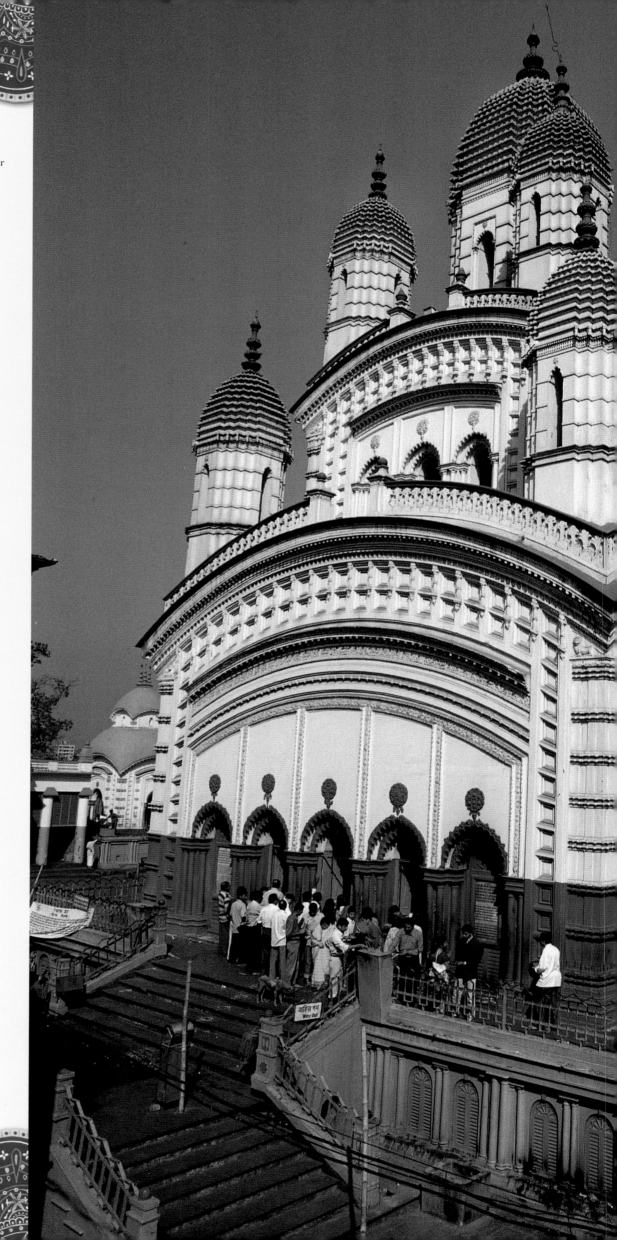

Library of Congress Cataloging-in-Publication
Data available

ISBN 1-932771-28-X
10 9 8 7 6 5 4 3 2 1

**MANDALA**
PUBLISHING

17 Paul Drive
San Rafael, CA 94903
www.mandala.org

Printed and bound in China
by Palace Press International
www.palacepress.com

Published in North America by Mandala Publishing
by arrangement with Om Books International.
All other territories reserved by Om Books.

**OM**

Om Books International
4379/4B, Prakash House
Ansari Road, Darya Ganj
New Delhi - 110 002 (India)
www.ombooks.com

Printed on acid-free paper. Mandala Publishing,
in association with Hamakula Ecology Center,
a not-for-profit organization whose mission
includes reforestation, will facilitate the planting
of two trees for every one tree used in the
manufacturing of this book.

*The author extends his sincere thanks to all the
contributors for making the book so rich.*

*I am also grateful to ITC Hotel Sonar Bangla
Sheraton and Towers, Kolkata, for their kind
hospitality. And my heartfelt thanks to Mr. Sunil
Verma of Radiant Graphics (P) Ltd, for all his
support.*

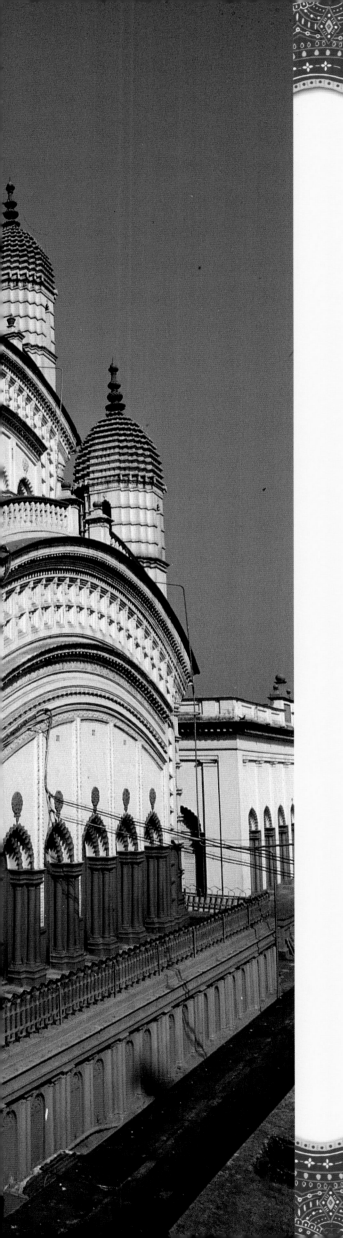

*Oneness is not a concept. It is reality.*
*Difference can only be on the surface.*
*You don't need an effort to bring oneness.*
*All that you need is to wake up and recognize.*
*Every celebration happens when you recognize*
*the abundance that life has provided you.*
*Only when you're grateful can you celebrate.*
*And to be grateful, all that you need is only*
*a simple recognition!*

—His Holiness Sri Sri Ravi Shankar

*Dedicated to H.H. Sri Sri Ravi Shankar,*
*who exemplifies ancient wisdom and unconditional love.*

*…Truly he brings together all the pearls of creation*

*…My Guru, my soul*

*…The Soul of India*

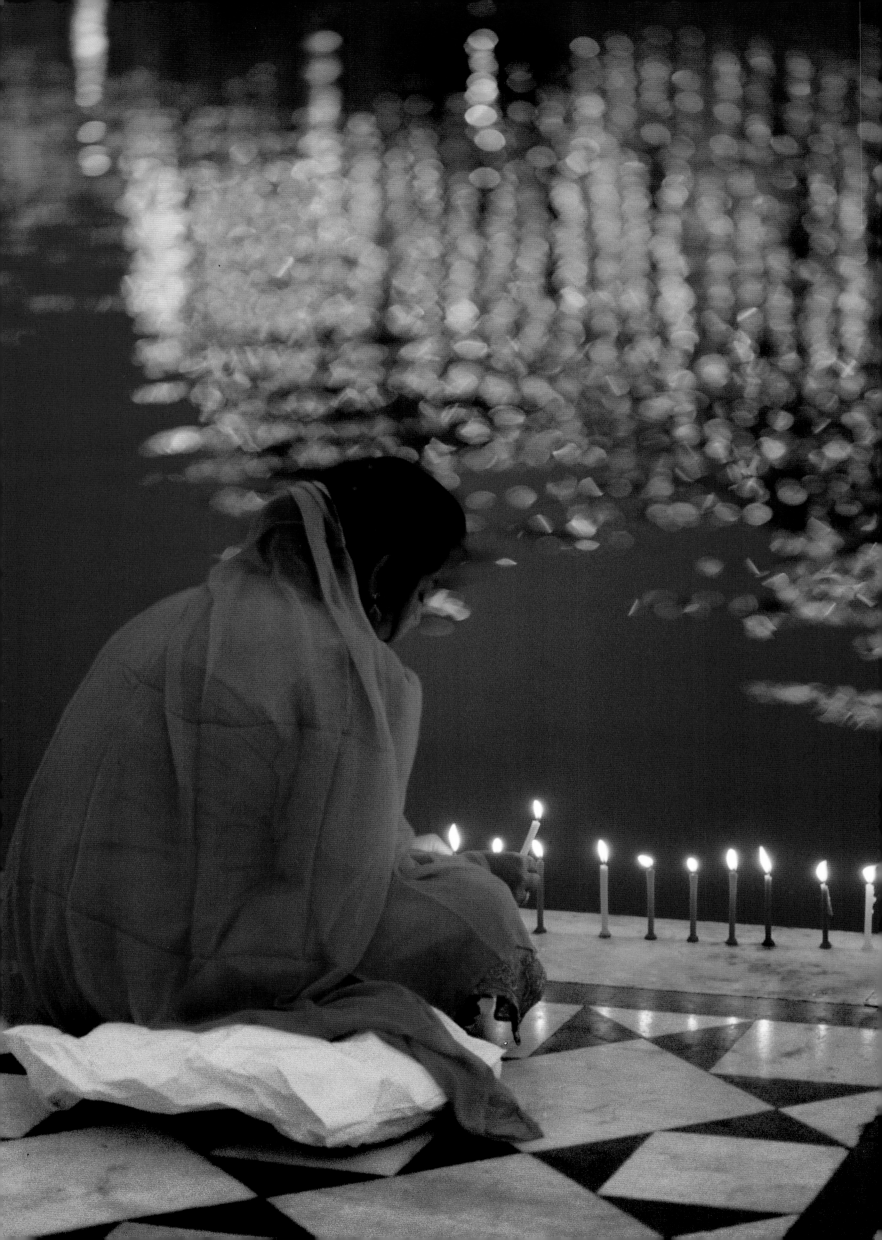

# Foreword

India is a land that reverberates with the noise of modern life, but also, the whispers of antiquity. While much has changed about India's culture since its beginnings, the universal calendar still determines the life of its people in many ways. In India, this relationship between the "micro man" and the macrocosmos—a theme carried forward from ancient times—is still viewed as the raison d'etre for existing here and now.

So, in India there is a great awareness of the big cycle of time in relation to the smaller cycles of time—a few hundred years, a few years, one year or one day. These multiple concentric circles of time affect the individual and also the community. Therefore, the communities celebrate.

In India, every moment is a celebration.

There is a celebration of the life cycle—with everything being joyous, from birth to death, which is viewed as a passing and not a moment of sorrow. Rig Veda says, in the famous funeral hymn, "Let the dead go to the dead, the living return to the living, to the song and the mirth of life." What better statement is there to encapsulate the Indian philosophy of life? Whether it is birth, or stepping into the next ashram, or the celebration of a beautiful Vedic wedding, every moment in India acquires sacredness.

Indians relate to the seasons and the changes they bring and so, they celebrate them all—spring, summer, the monsoon, autumn and winter. They celebrate the presence of the half-moon, the full moon, and even the time of no moon. The dialogue that Indian people have with nature is reflected and structured in all of their community celebrations. Indians are always relating to change and celebrating it.

This celebration also enters into structured religions. Indians view symbolic gods as a projection of life; they have been given a human form, and thus, they can be related to as humans. They have their cycles of sleeping, waking, bathing and eating. It is a one-to-one relationship. Indians decorate the symbolic gods with garlands, jewels, ornamentation—and there is celebration, with music, dance and food.

India celebrates because it is a life-embracing—not life-denying—culture. But the celebration is not about indulgence, profanity or hedonism. It is important to make this distinction because this constant celebration can easily be misunderstood.

Celebration in India is not sense-indulgent. The body is considered sacred, and it must be controlled—even in the moment of intensity. The body is not to be denied, but the body is not to be indulged, either. So, there is a certain sanctity attached to celebration. And this is what makes India, as a land of celebration, unique.

*Dr. Kapila Vatsyayan*

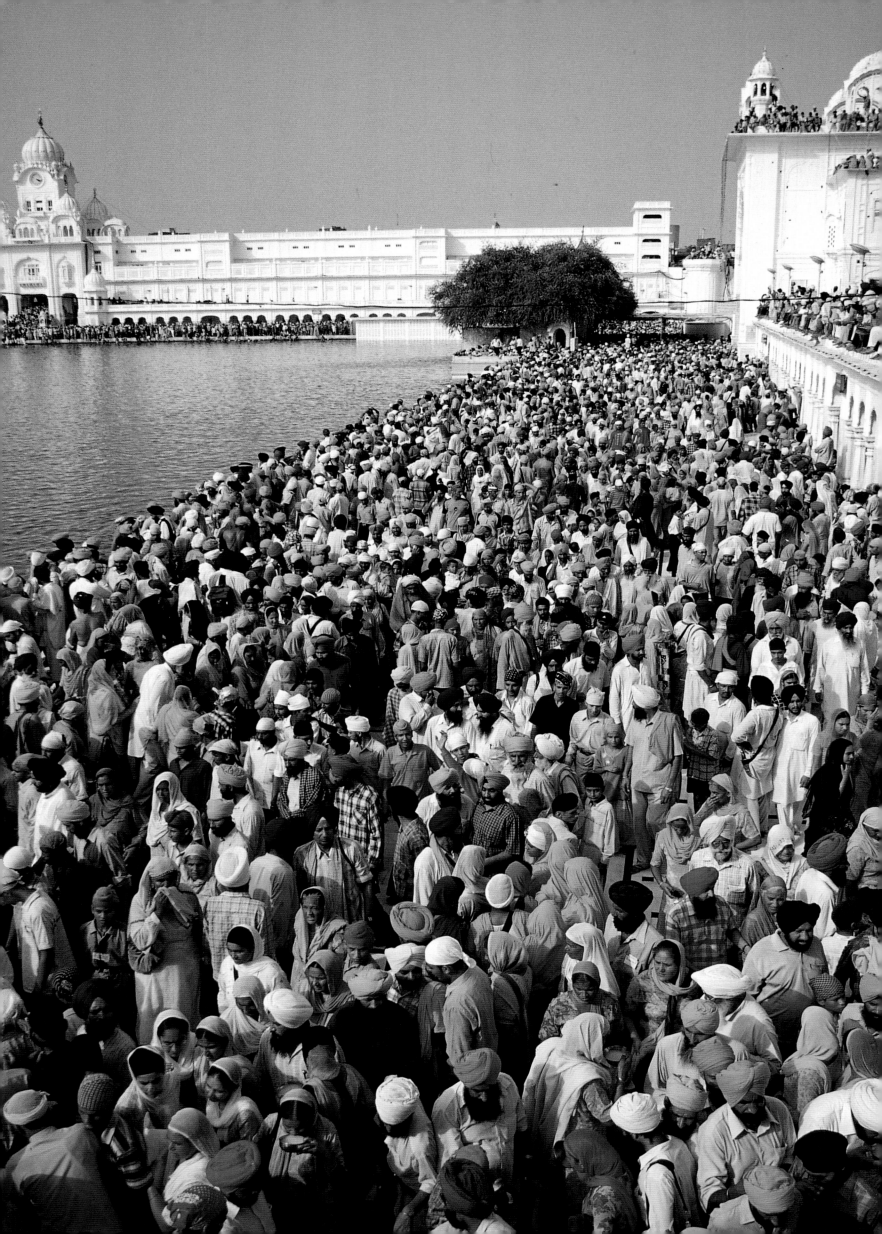

# Publisher's Note

India is the cradle of the human race, the birthplace of human speech, the mother of history, the grandmother of legend, and the great grandmother of tradition.... So far as I am able to judge, nothing has been left undone, either by man or nature, to make India the most extraordinary country that the sun visits on his rounds. Nothing seems to have been forgotten, nothing overlooked.

—*Mark Twain*

*India: Land of Celebration* portrays the essence of India in word and image. With more than 340 vivid full-color photographs and detailed, close-up accounts of journeys taken through every region, this comprehensive volume, complemented by first-rate scholarship and authoritative research, enables the reader to experience the multilayered diversity of the subcontinent.

We are indebted to Ajay Mago, publisher and bookseller extraordinaire, and Rupinder Khullar, principal photographer, as well as all the contributors who travelled vast distances in a relentless pursuit of the true India in order to bring this project to us. We are proud to have published this landmark work.

Discovering India is an ever-changing journey. Here is the eternal mystique of India, a land whose 5,000-year-old layers as well as modern overlays are continually unfolding to reveal a seemingly limitless stream of unexplored facets. India is a destination that will haunt travelers for all time.

—*Raoul Goff, Publisher*

# Contents

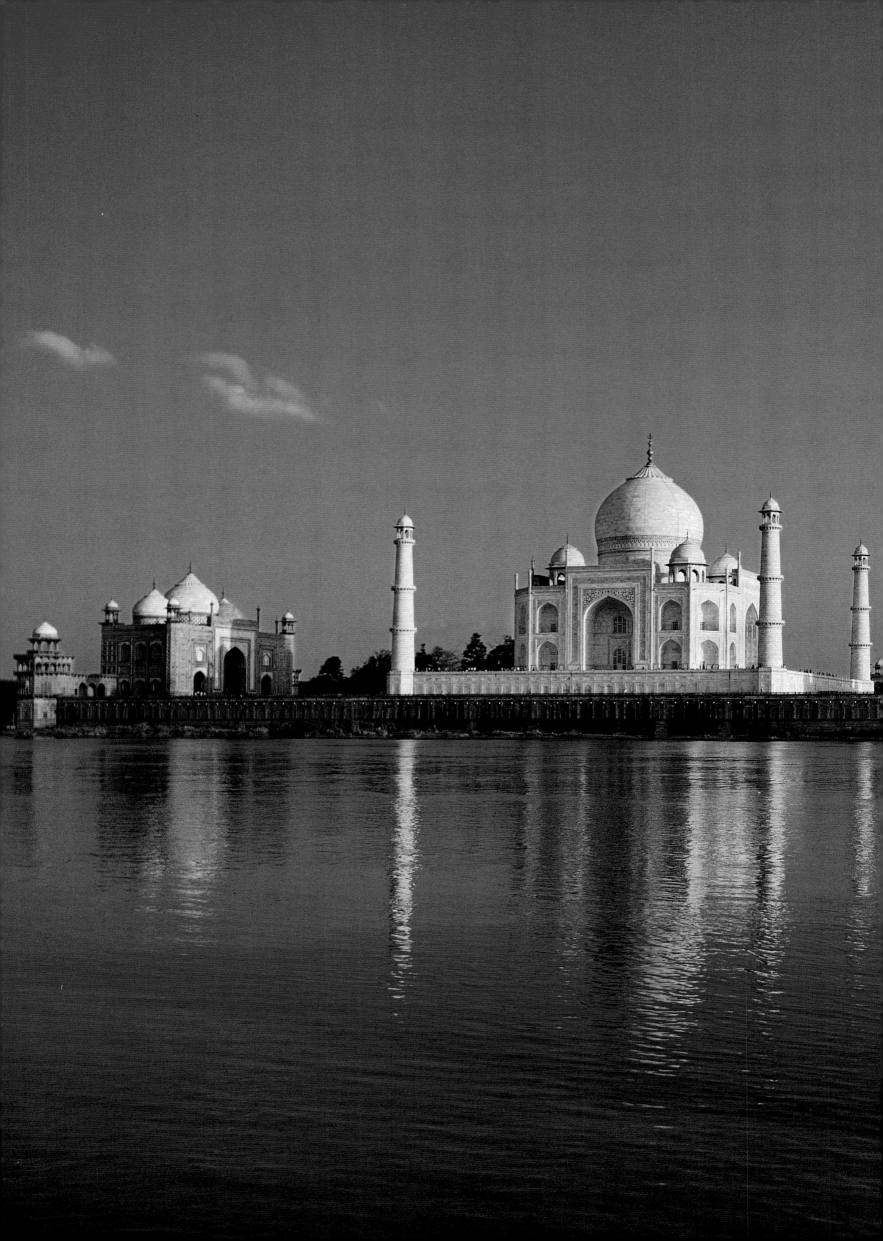

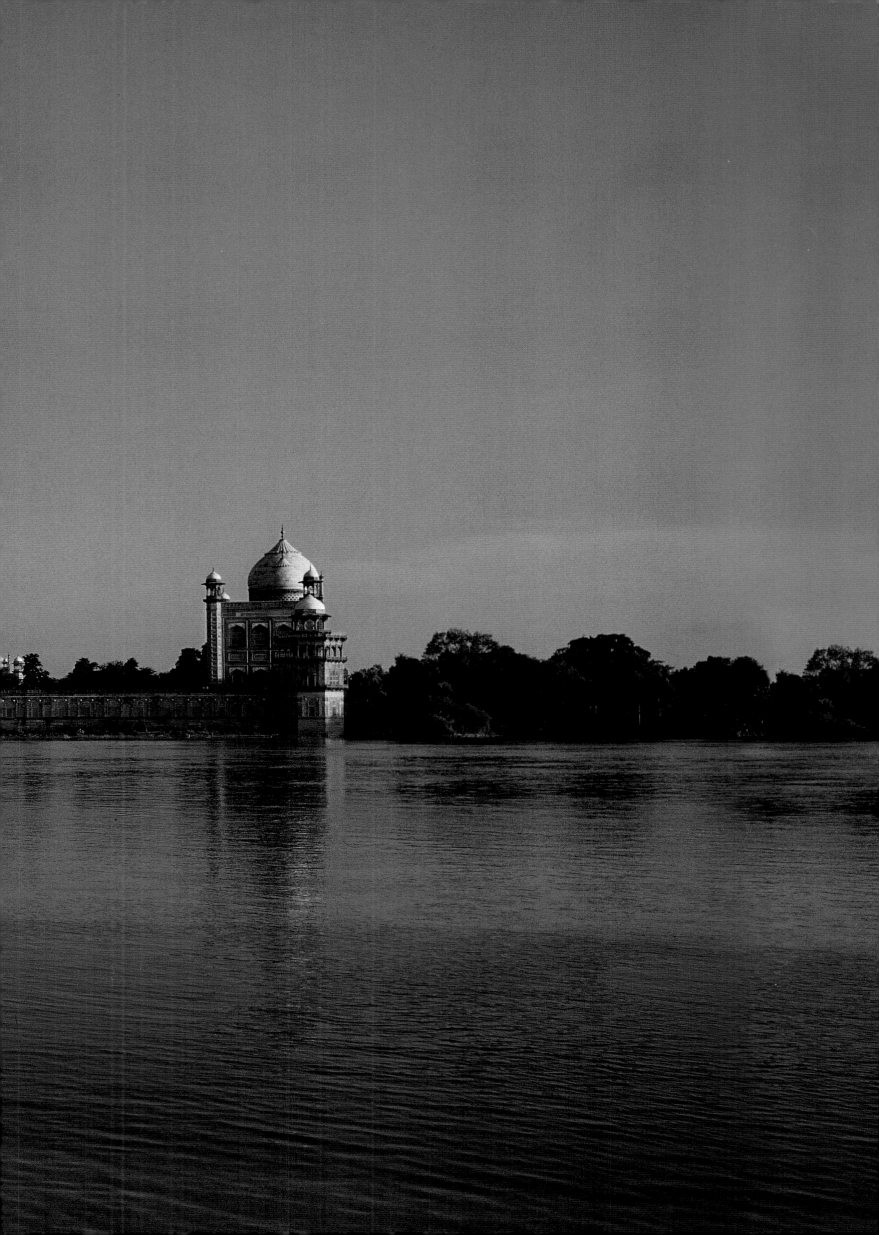

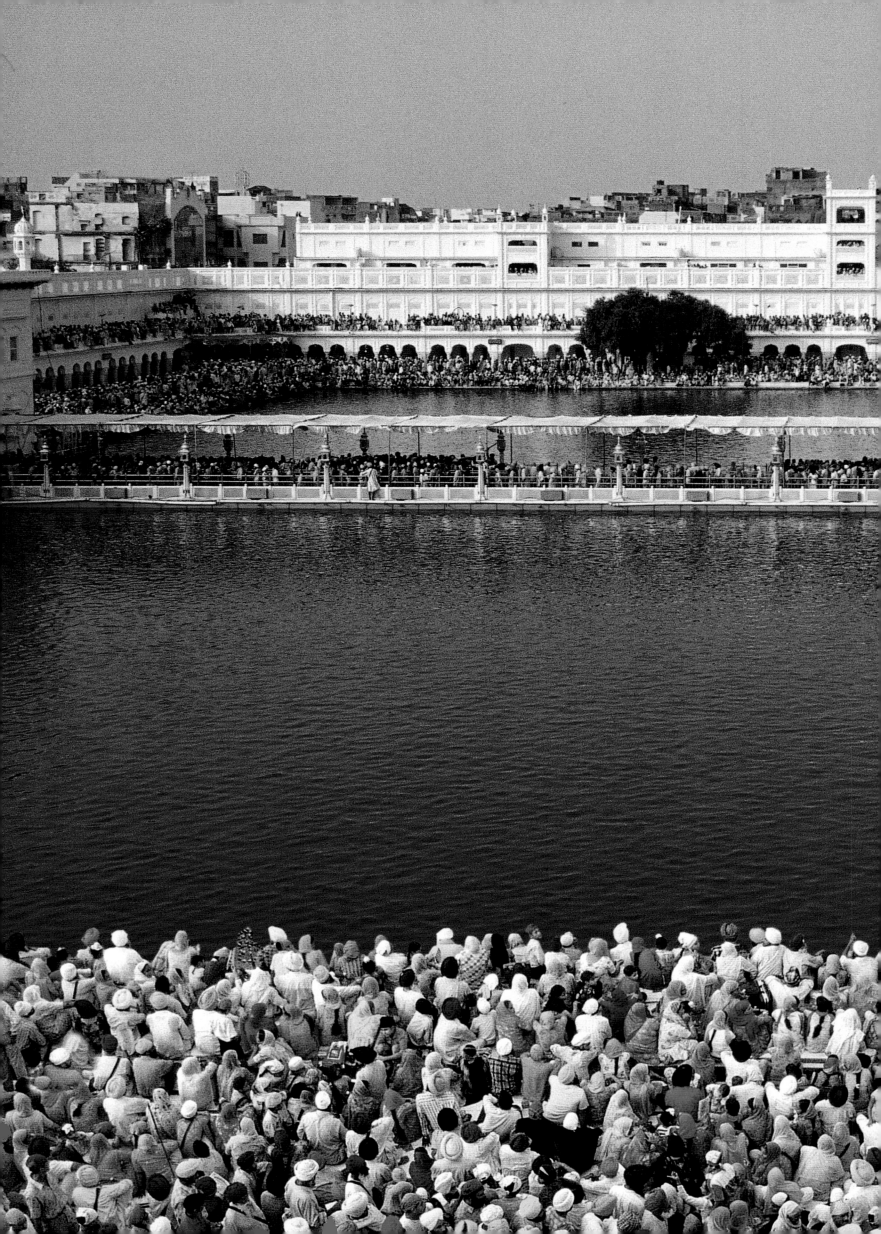

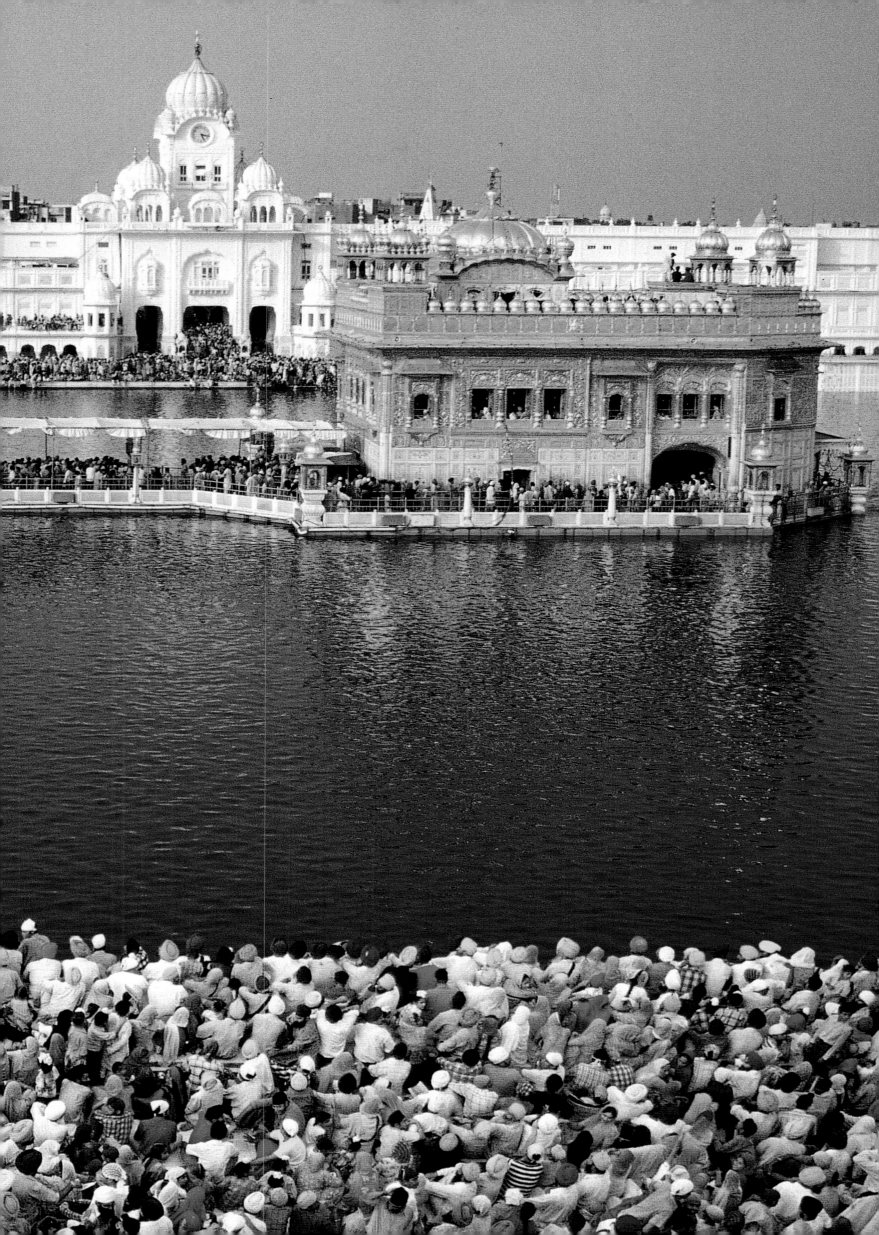

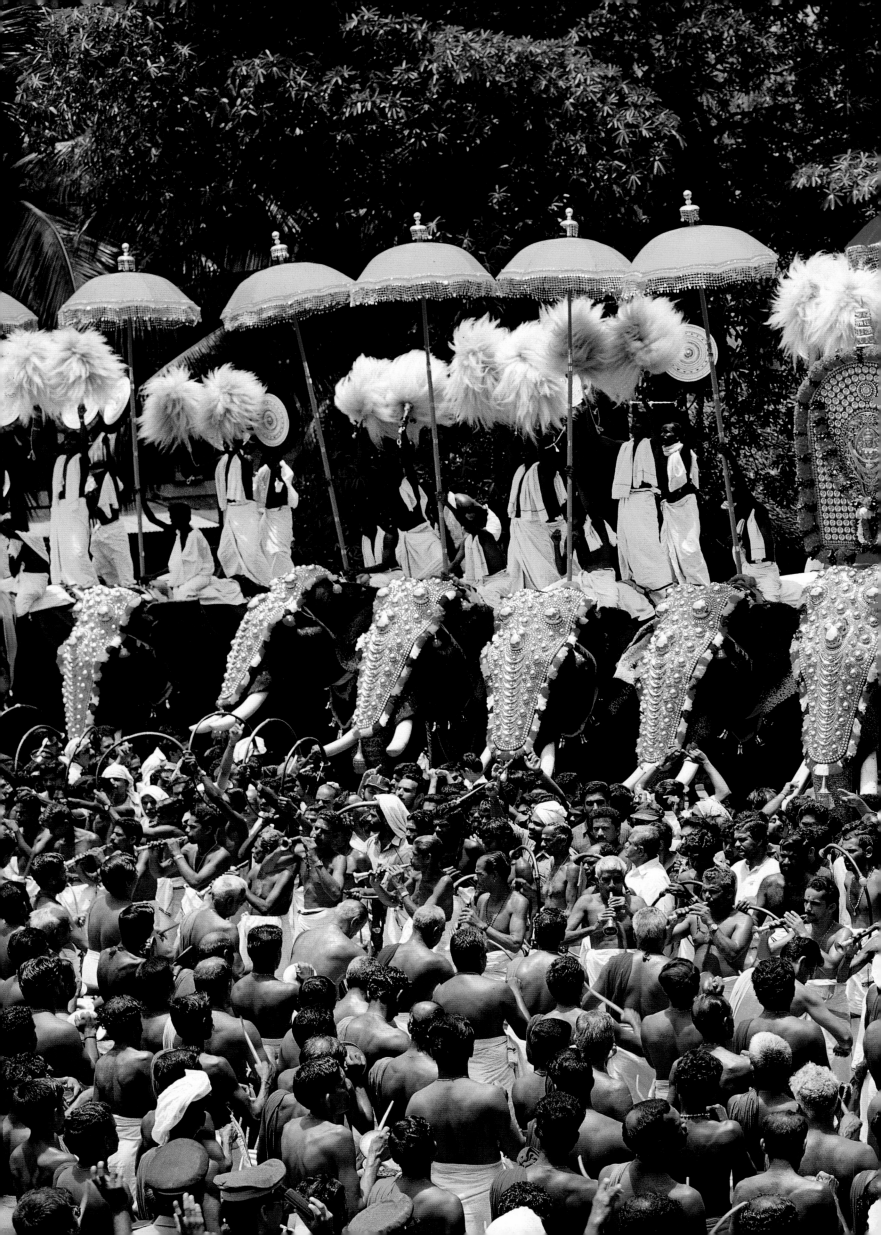

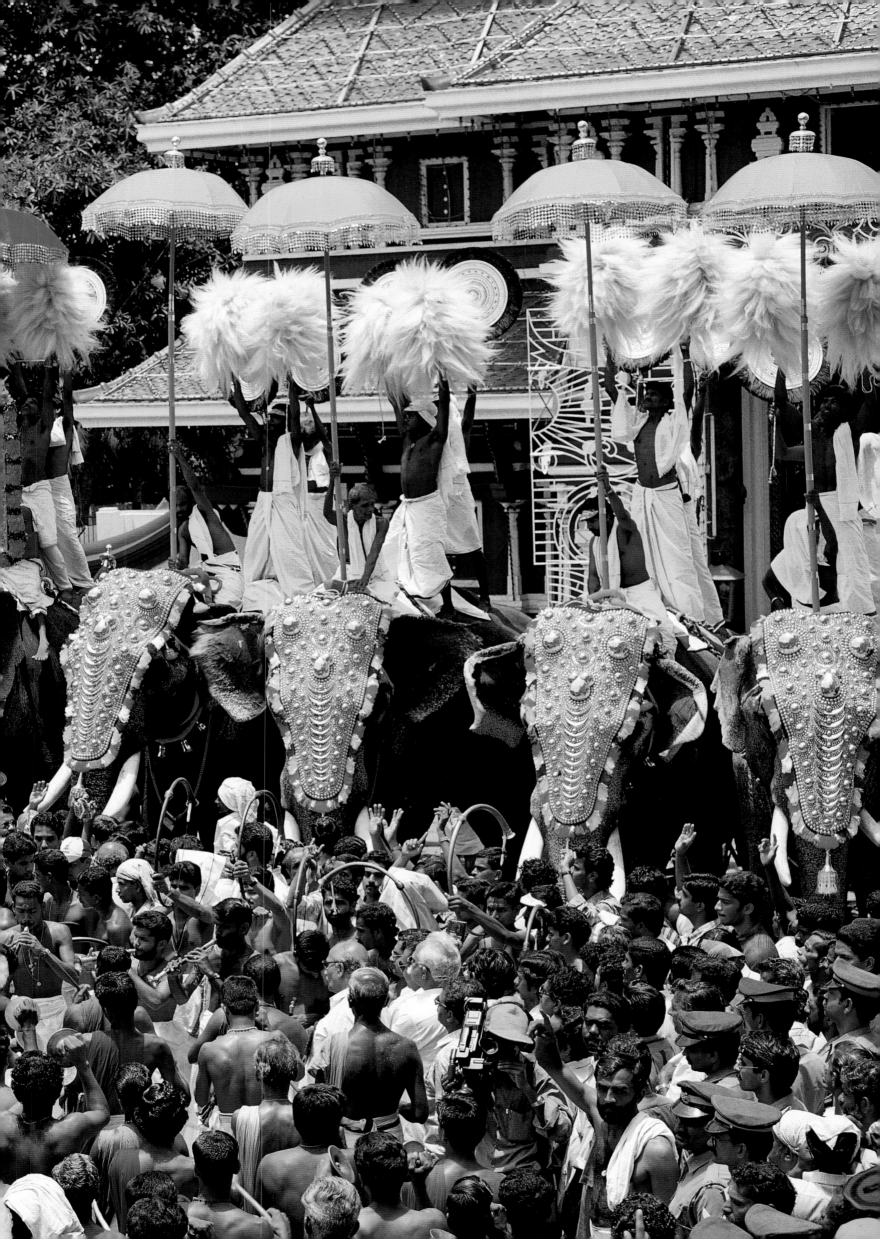

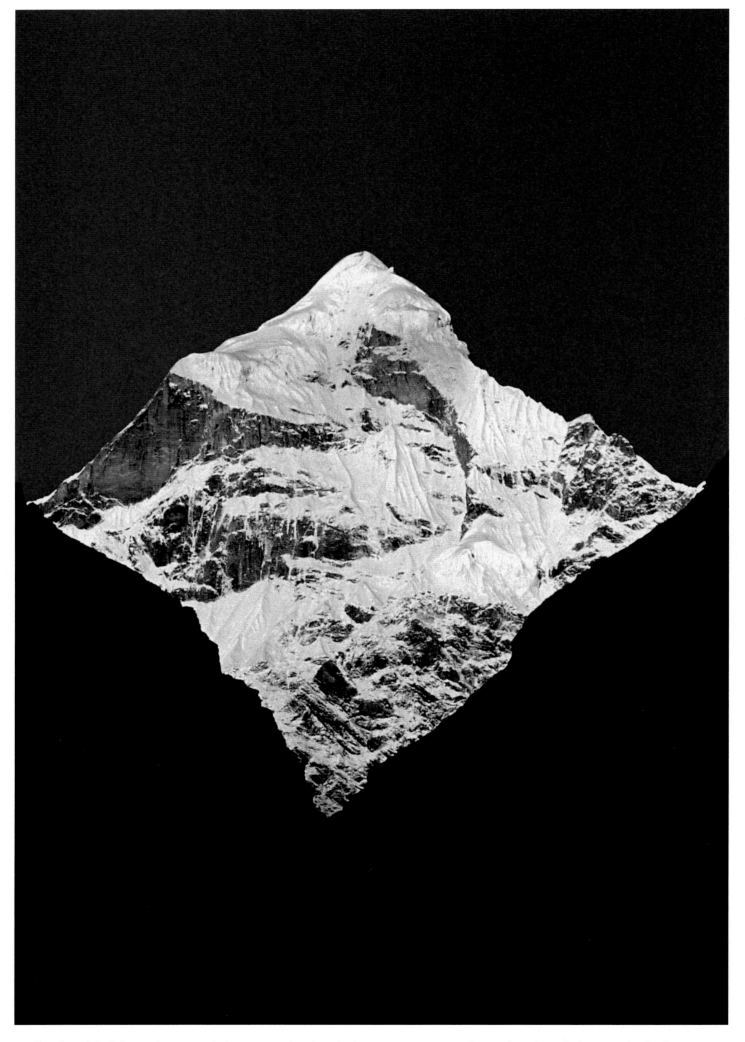

*Neelkanth Peak bathed in early morning light is associated with Lord Shiva. It towers majestically over the Badrinath shrine at a height of 6957 meters.*

# Wonders of Nature
## The Great Himalayas, Flora & Fauna

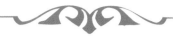

There is a tremendous geography lesson waiting to be learned in India, which is, depending on one's perspective, a country that is blessed or cursed by astounding variations of terrain. It is almost as if the gods themselves once stepped down to earth to outline the incredible natural boundaries of India.

The magnificent Himalayas crown India to the north and create a formidable barrier for anyone aspiring to cross over the highest mountain chain in the world. For centuries, the Himalayas remained virtually impregnable; few have found their way through these high mountain passes, such as the armies of Alexander the Great, who marched through the passes of the Hindukush during their campaign to conquer Central Asia, only to perish later on the plains of Hindustan.

There have been fewer incidents of such ambitious conquests in India's recent history, but that might well be because of technology. Although providing easier methods for mapping ways to navigate through the Himalayas, it has also revealed the difficulties of such missions. Still, modern technology has done much to provide mankind with information and access to the Himalayas' gigantic peaks.

Kashmir is an awesome valley ringed by snow-clad mountains, which are reflected by stunningly beautiful lakes. With its poplar forests and trout-filled streams, it is one of the most beautiful places in the world. Yet, with all of Kashmir's natural beauty, the man-made floating gardens of the Dal Lake, the shikaras used to ferry people across the waterways, and the houseboats of Nagin Lake are some of the more enduring images that visitors treasure for a lifetime.

The Mughal emperors of Hindustan made Kashmir their prized summer retreat. Indian legends and myths tell of the gods coming here to meditate. Even the Pandavas—five princes of the Mahabharata epic, who

*A LAND OF MOUNTAINS CROWNED WITH PEAKS OF SAPPHIRE BLUE, AND OF AMBROSIAL WATER IN ALL ITS BROOKS AND POOLS, A LAND OF LOVELY WOODS AND TREES OF CLUSTERING FRUIT, AND OF GROVES DENSE WITH TREES WITH COOL LUXURIANT LEAF.*

*— SUBRAMANIA BHARATI*

engaged in war with their 100 cousins, the Kauravas—are said to have journeyed to heaven by climbing the Himalayas, where they lived during many years of their exile.

Several northern states of the Indian republic—Himachal Pradesh, Uttaranchal, Uttar Pradesh, and even West Bengal and Sikkim—sport the mantle of Himalayan snows and a continental climate. The British Raj is to thank for creating in these alpine climates some of India's most enduring mountain resorts and retreats. Initially built as sanatoriums, escapes from the summer heat of much of India's plains, they took the shape of European hill-towns in their architecture and sensibility. Today, millions of Indians journey to Shimla and Mussoorie, Nainital and Darjeeling, and to their counterparts Matheran and Lonavala in the west, and Ooty and Kodaikanal in the south, to enjoy the healthful benefits of the invigorating Himalayan air.

The Himalayas are the source for many of India's rivers, and those of its neighboring countries. The Ganges and its tributary, the Yamuna, have their source in Uttaranchal. The Brahmaputra journeys down from Mount Kailash. And the Indus, which originates in Tibet and flows from the Himalayas and through Kashmir, has been instrumental in giving the land of India, and its people, their identity and name.

The Indus Valley Civilization that flourished more than 4,500 years ago is one of the oldest known community habitations in the world. During its time, it evolved to a high degree of sophistication, with planned towns and great baths, and official seals used to imprint trading contracts with ancient Babylon and Sumeria. Excavations have revealed that these settlements spanned a wide swathe of western and northern India, but historians have not been able to unravel many of this ancient society's mysteries, such as its script, or the reason why the Indus Valley Civilization came to an abrupt end.

There is no denying the vital role rivers have played in India's popular culture and folklore—they have been worshipped as goddesses because they bring water to a parched land. The Ganges in particular, is imbued with an other-worldliness; its immortal waters are woven into the very fabric of Indian life. It begins its journey in the Himalayas, raging and tumultuous as it cuts through gorges, and then threading its way through the plains of Uttar Pradash, Bihar and Bengal. The river's sandy banks are lined with temples at pilgrimage spots, and many cities and centers of learning also have sprouted beside it.

The Ganges is particularly revered in Varanasi, a town believed by many in India to be as old as time itself. In Kolkata, formerly called Calcutta, there is the Hooghly, a Ganges distributary, whose broad expanse is now almost as wide as the Brahmaputra that flows through parts of Assam and Bengal, and which merges with the sea when it pours into the Bay of Bengal.

In the west and south of India, the Narmada is what the Ganges is to the north, and the Kaveri is every bit as important as the Brahmaputra; while in Punjab, as many as five rivers irrigate the soil and make the state the world's leading granary. Personified and deified, India's rivers are important ingredients that find reflection in the country's literature, culture, folklore and traditions.

It is ironic that the Himalayas are considered to be the world's youngest chain of mountains, while, in stark contrast, there is geological evidence that points to India's Aravallis as being the oldest mountain range. So, is it any wonder that they formed the cradle of Indian civilization?

Wars and battles have been fought in the folds and valleys of the Aravallis; kingdoms have been established and nurtured in its shadows. Lying across Rajasthan and parts of Gujarat and Madhya Pradesh, and diminishing toward Delhi, in their years the Aravallis have seen the rise and fall of empires and dynasties—and in its scrub jungles, there is a king who still reigns, for it is the chosen habitat of the tiger.

The Aravallis run through the Great Indian Desert, know also as the Thar. A scrub desert for the most part, this area of what is now Rajasthan and Gujarat was once, according to mythology, a sea, until Lord Rama fired an arrow with such fierce incendiary powers that

it swallowed up all the waters, leaving nothing but barren land. There is no evidence to confirm this legend, of course, but fossils of marine life found in the Thar Desert clearly point to its undersea past.

Today, the sun burns bright over the undulating dunes and shifting sands of the Great Indian Desert, but again, as if to contradict the very dreariness of its sameness, village homes in the region are brightly painted, and the inhabitants don vivid colors. In desert towns that were once medieval kingdoms, life is still vibrant, and it is as if the Thar's past and present have melded.

There are other deserts in India, as well—cold deserts. In Lahaul and Spiti, in Himachal Pradesh, and Ladakh in Jammu and Kashmir, the desert freezes in the winter. But here, too, in the barrenness of the high mountain desert are remote outposts, where monks guard the secrets of their religion, and where primarily the edicts of Buddhism (but also Islam and Hinduism) have governed a way of life that is as unchanging and disciplined as the pattern of the seasons.

Sands of another kind mark the coasts of India, forming the triangle that shapes its distinctive land mass. Three great seas—the Bay of Bengal, the Arabian Sea and the Indian Ocean—wash India's feet at Kanyakumari, the point of confluence, where they meet in a medley of colors.

The Arabian Sea off India's west coast is mostly gentle, so strings of resorts have been developed at Goa, Gujarat and Maharashatra. Goa, charming and idyllic, is the most popular of India's holiday spots by the sea. Its red laterite rock and endless golden beaches are enhanced by a relaxed ambience, derived perhaps from the previous Portuguese occupation. Cashews, coconuts and plentiful seafood have blessed this tiny spot on India's map, and it is not surprising that many consider it to be the perfect antidote for big city stress, whether they live in India or elsewhere.

Meanwhile, India's eastern coast has huge shelves for beaches, and the waters tend to be rough, as they can also be at times in Gujarat. Here, inspired primarily by mythology, the Indian people have built temples of abiding beauty and sanctity. At Dwarka, Lord Krishna's kingdom lies drowned. Somnath continues to attract the devout despite being plundered time and again throughout its history. In Tamil Nadu, there is Mahabalipuram's Shore Temple, with rock-cut chariots

hewn out of granite and carved with figures from the Mahabharata and the Ramayana.

Inching up the eastern coast, at Konark, visitors find what ancient seafarers referred to as the Black Pagoda—the Sun Temple built to resemble a chariot pulled by seven horses. Further up the coast is Puri, one of the holiest places of the Hindu pilgrimage, with its carved temples and sumptuous beaches banked by heavy seas.

The riverine estuaries of West Bengal and neighboring Bangladesh are the largest in the world, a swampy inhabitation where the deltas are home to the marsh crocodile and the fish-eating tigers of the Sunderbans, while the salt water lake of Chilika, in Orissa, is the largest known nesting ground for Olive Ridley sea turtles.

At sea are island archipelagos that are also part of India. Lagoons surround the Nicobar Islands, which are mostly uninhabited. The picturesque Andaman Islands, home to some aboriginal tribes, were the outpost of the British Raj, where political prisoners were incarcerated at the dreaded Cellular Jail. Occupied by Japanese forces during World War II, the Andaman Islands are chiefly characterized by their underwater coral gardens and mangrove forests, and for the red wood of the fabulous padouk trees.

The sea also has shaped India in other ways. Backwaters have created a network of natural canals that link remote parts of the lush green state of Kerala. The landscape of Kerala, like its counterparts Karnataka and Maharashtra, is dominated by the Western Ghats, ranges of hills that run along the western coast of India, overlooking the sea on one side, and providing dramatic inland views on the other. Here are secret lakes and high waterfalls, and a plethora of flora and fauna—the road dipping past dense forest one minute, and bare rock the next.

Thousands of years ago, in the caves of the Western Ghats, an order of monks carved great temples, which were sculptured and painted with such virtuosity that they have survived over centuries. The rock-cut temples of Ajanta and Ellora are a tribute to the partnership of nature and man.

India's seasons have long been celebrated in literature, but it is in the north that they are most evident. Here, the

winter is bone chilling; snow dusts the mountain peaks and the plains shiver in near sub-zero temperatures. Spring is beautiful, ablaze with millions of flowers, both indigenous and imported from around the world. The summers are harsh, particularly in the desert where sandstorms occur with great frequency, and are blinding enough to blot out the sun. The rains that follow in the monsoon season are romantic, for what could be more welcome to quench the thirst of a land pining for water, before it must edge toward a short interlude with autumn and then, the frigid winter? But even here, there are no absolutes.

In the south of India, the seasons range from hot to hotter to hottest, barring those parts of the Ghats that are high enough to escape the heat, and are ideal for tree and coffee plantations, and require the wearing of woollens when the temperature falls. India's western coast is either hot or humid or both, while the northern segments of the eastern coast can be quite cool. The northeast is freezing in the winters, even though it does not snow. Cherrapunji, in Meghalaya, has the highest density of rain in the world, while the desert is often bereft of rain for several years at a time. Droughts and floods, therefore, are part of an annual cycle, unchanged over millennia.

From the white-peaked mountains to the seas is a long journey across the riverine plains that characterize much of India. This is the heartland of the country, the fountain of its civilization, where cities arose at different points in its past, some to be lost forever, and others to flourish or even perhaps decay. It was here that the religions of India took root: Hinduism, for the most part, a way of life and therefore, more philosophy than religion, Buddhism, and Jainism. This was also where Islam and Christianity were nurtured, where even Zoroastrianism took root, and where the Jews sought and found sanctuary, flourished, and integrated with mainstream India.

The Saraswati, whether mythical or real, is considered to be one of ancient India's great rivers. Although it no longer exists, it is still worshipped by Hindus. Thousands trek to the outposts of the Himalayas, whether to pray, meditate or simply make the journey. India's rivers, no longer as pristine, thanks to profligate industrial pollution, are still considered holy. The backwaters and beaches and islands are now tourist havens, but there is room for more growth. A blue haze surrounds the Nilgiris in Tamil

Nadu, and the forests of northeast India are still dense and impenetrable.

Together, these places form a unique habitat for India's wildlife. Throughout the subcontinent, there are a huge number of wildlife parks, sanctuaries and reserves. The forests range from tropical to the deciduous, and spread from below sea level to the highest points of the earth, and along the foothills where sal forests cover the entire region of Terai. The higher slopes contain maple, birch, pine, oak, deodar and rhododendron, while elsewhere there is bamboo, fern and other grasses, descending to jungles of chestnut and fruit trees—apple, pear, plum and peach—past flowering meadows and down to the Gangetic Plains, with indigenous leafy trees and thorny scrub.

Amidst these leafy groves flit hundreds of varieties of birds, resident and migratory claiming the forests and sanctuaries as their home. It is a bewildering assortment that is responsible for the vesper birdsongs that enchant much of India. But then, the topography is ideal for the tremendous variety of wildlife that is so intrinsically part of India, where "the wild" means jungles filled with tigers, leopards and lions, roaming herds of elephants, and rivers hosting the dreaded gharial or alligator, and also, the Gangetic dolphin.

There is no greater variety of deer than in India. There are monkeys and langurs, and even a species of gibbon called Hoolock. The Kutch region has colonies of flamingos and wild ass, and in Bharatpur, you'll find painted storks roosting on treetops. Far to the east, hidden in the elephant grass, are sanctuaries for rhinoceros, while the endangered great Indian bustard is free to run in the sands of the Thar Desert. There are bison, bear and wild boar, wolves, foxes and wild dogs, civets and marmots, monitor lizards and reptiles—including python, cobra, krait and numerous harmless snakes—otter and loris, and egret, crane and hornbill, all claiming India as their home.

Even India's cities, to some extent, have evolved from nature's sanctuaries. Throughout time, people in India have built their homes by rivers or lakes, or beside jungles. Urban civilizations here tend to be close to nature, and though cities in India today have become overcrowded and overdeveloped, parts of them still retain their leafy, gardenlike character of the past.

Tree-lined avenues in New Delhi, and the gardens and parks of Bangalore, are reminders of the India of yesterday, before high-rises and other manmade developments started swallowing land and resources. Mumbai was built on seven islands, but who would believe that today, connected now as they are into a seamless whole?

But there is still tranquility to be found in India. Nature is always near by, for large parts of the subcontinent are protected not only by conservationists, but by communities, such as the environmentally conscious Bishnois, who allow neither trees to be felled nor animals to be killed on their lands.

In a country with such extraordinarily diverse geography and wildlife, is it any wonder that nature and the seasons are still the primary forces shaping India?

 *Kishore Singh*

PRECEDING PAGES (12-13): *When Taj Mahal is viewed from across the Yamuna River, the image is a contrast to the formal garden setting in the front.*
(14-15): *Large crowds patiently await their turn to visit the Golden Temple during the celebrations of 400 years of installation of Guru Granth Sahib.*
(16-17): *Richly caparisoned temple elephants are carried out in a spectacular procession during the Puram festival at Trichur in Kerala.*

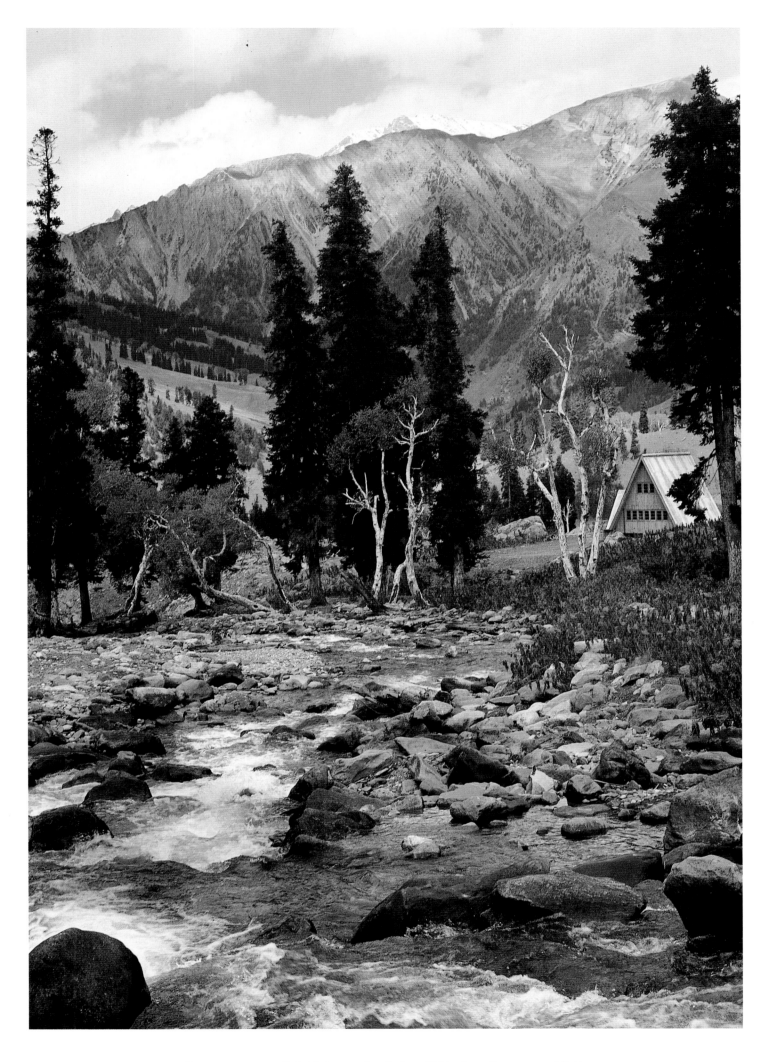

*Sonmarg, on way to Ladakh, is exceptionally beautiful in the mellow autumnal light.*

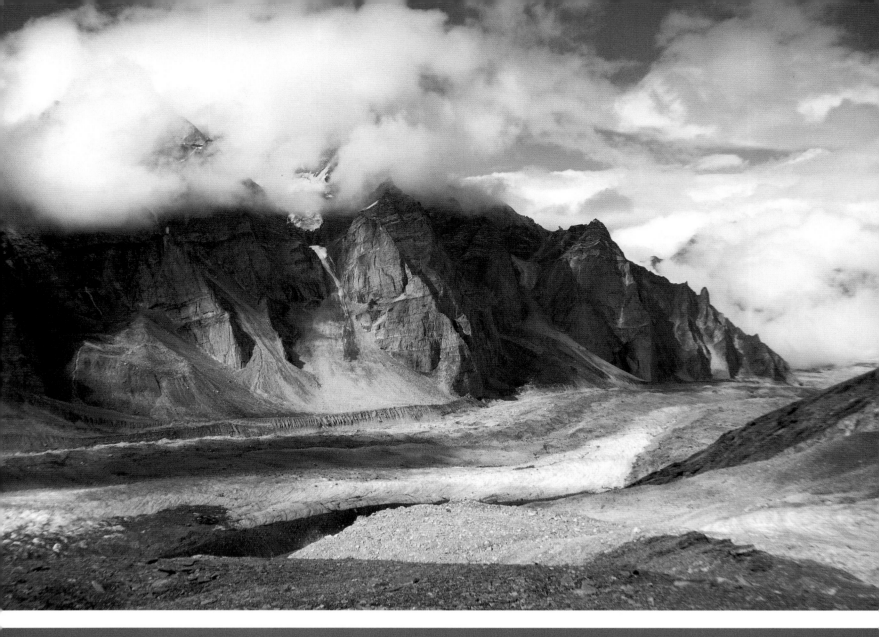
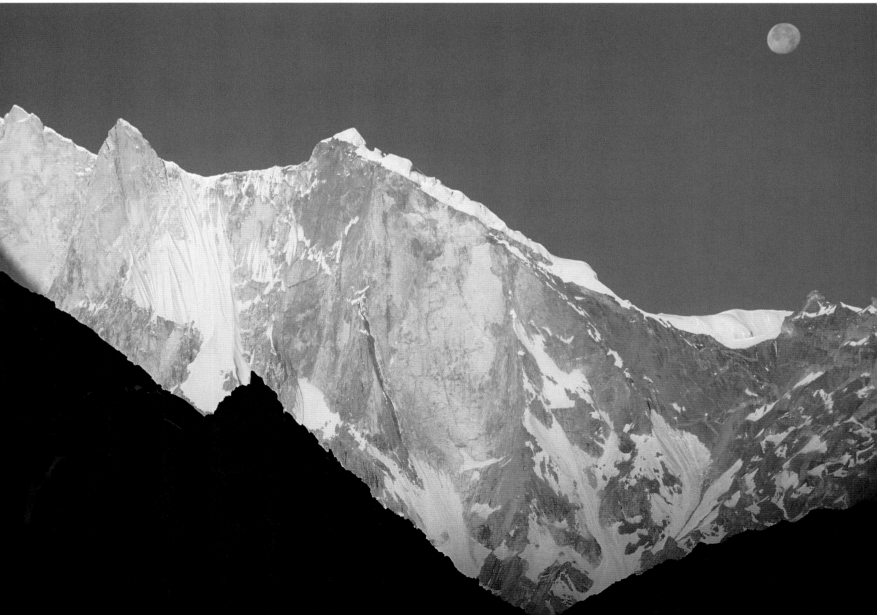

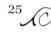

*Himalayas, the highest mountains in the world, consist of range upon range of icy peaks along the top of the Indian subcontinent that seem to reach out to the heavens.*

FOLLOWING PAGES: *Buddhism and the tradition of monastic life spread from Tibet into Ladakh, which lies at the northern tip of India.*

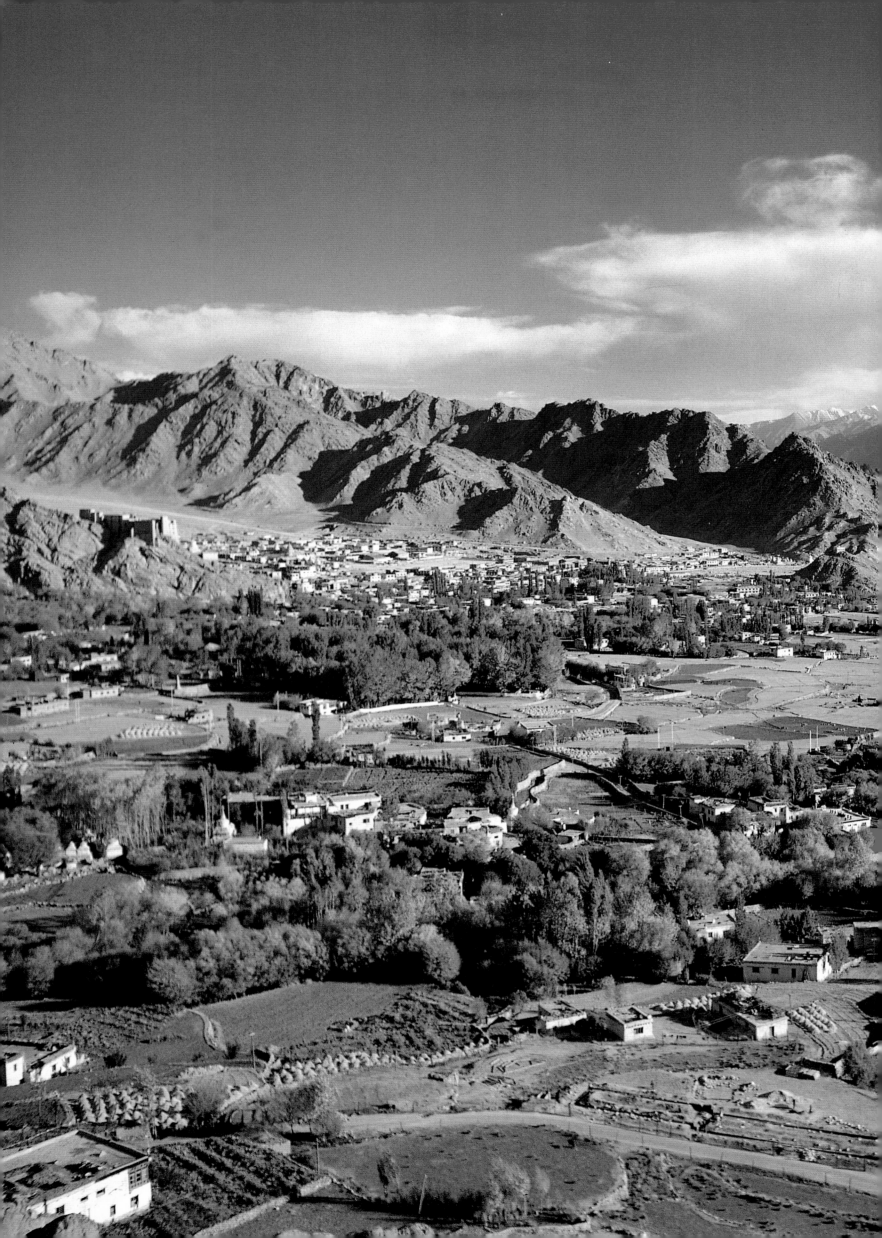

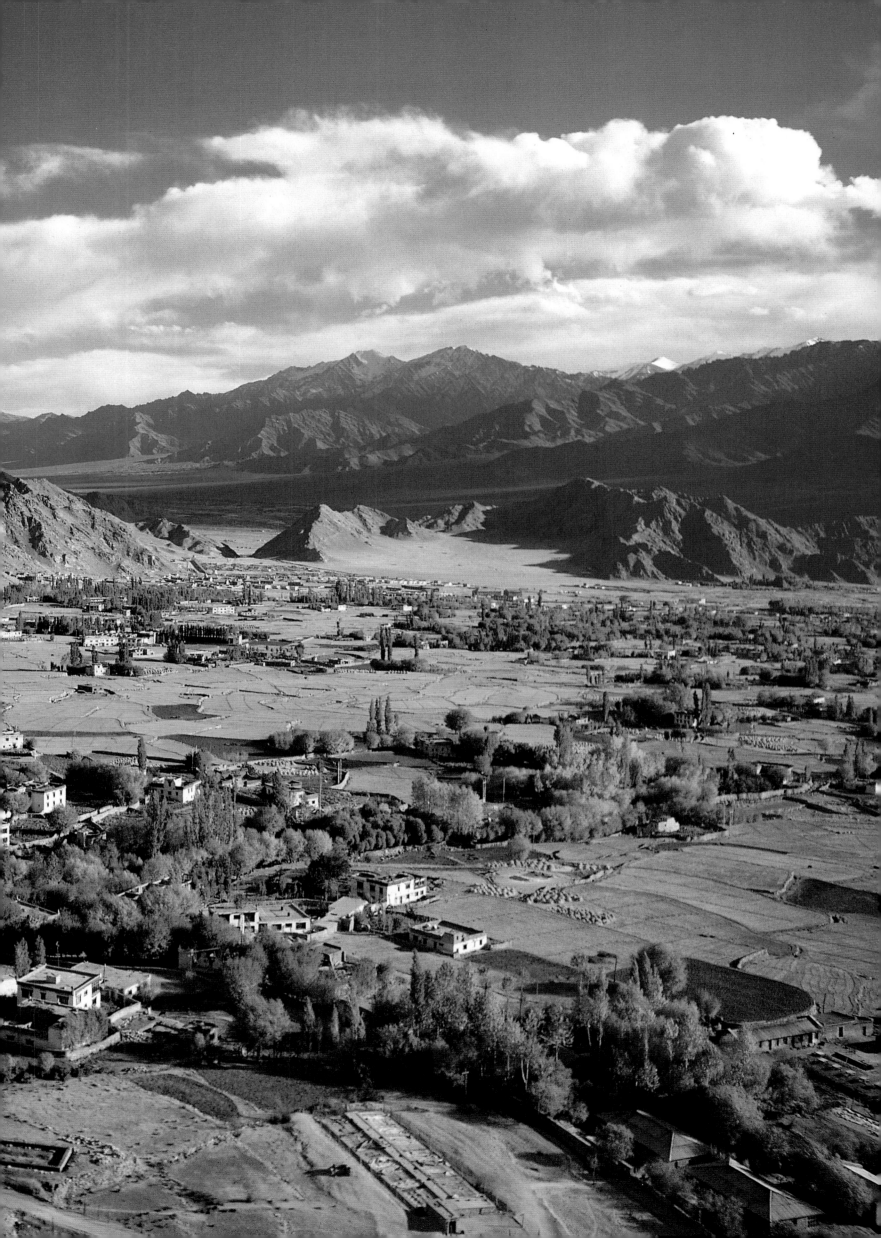

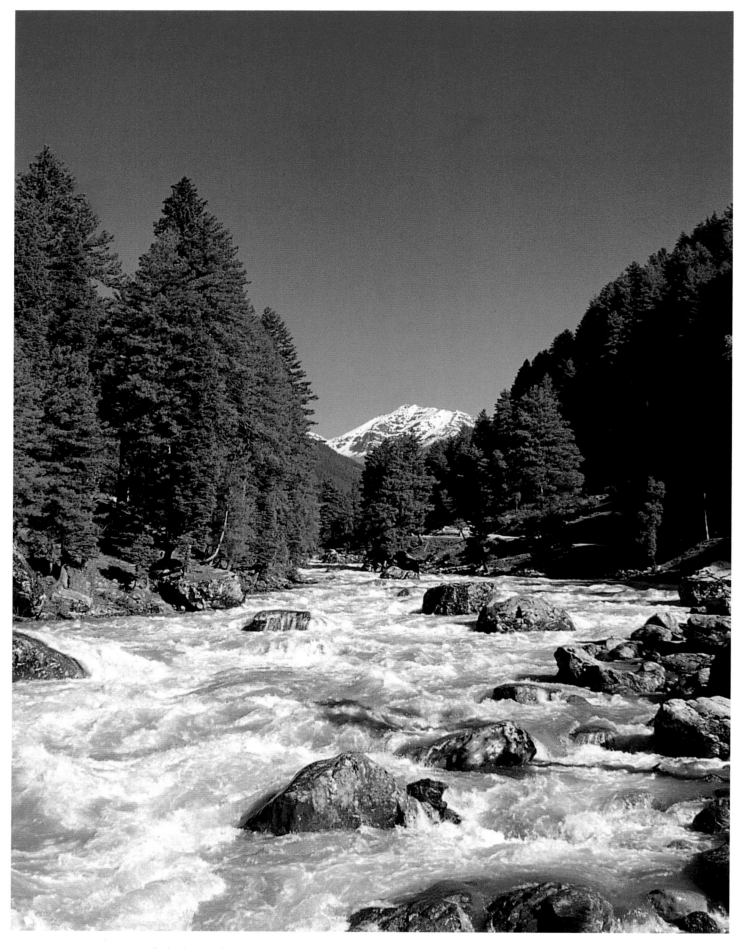

ABOVE: *In the higher reaches of Kashmir, at the Pahalgam resort, evergreens cover the hills beside the Lidder River,*
*which flows ice-blue waters from the melting snows in the mountains.*
FACING PAGE TOP: *A fisherman is out at the sea in the early hours of the morning.*
FACING PAGE BELOW: *A view of the mustard fields in full bloom in the suburbs of Srinagar in Kashmir.*
FOLLOWING PAGE TOP: *The changing contours of the golden sand dunes of Thar Desert in western Rajasthan. Following page below:*
*The sunrise at Kanyakumari at the southernmost tip that witnesses the confluence of the Arabian Sea, the Bay of Bengal and the Indian Ocean.*
*An enchanting experience that can be cherished for eternity.*

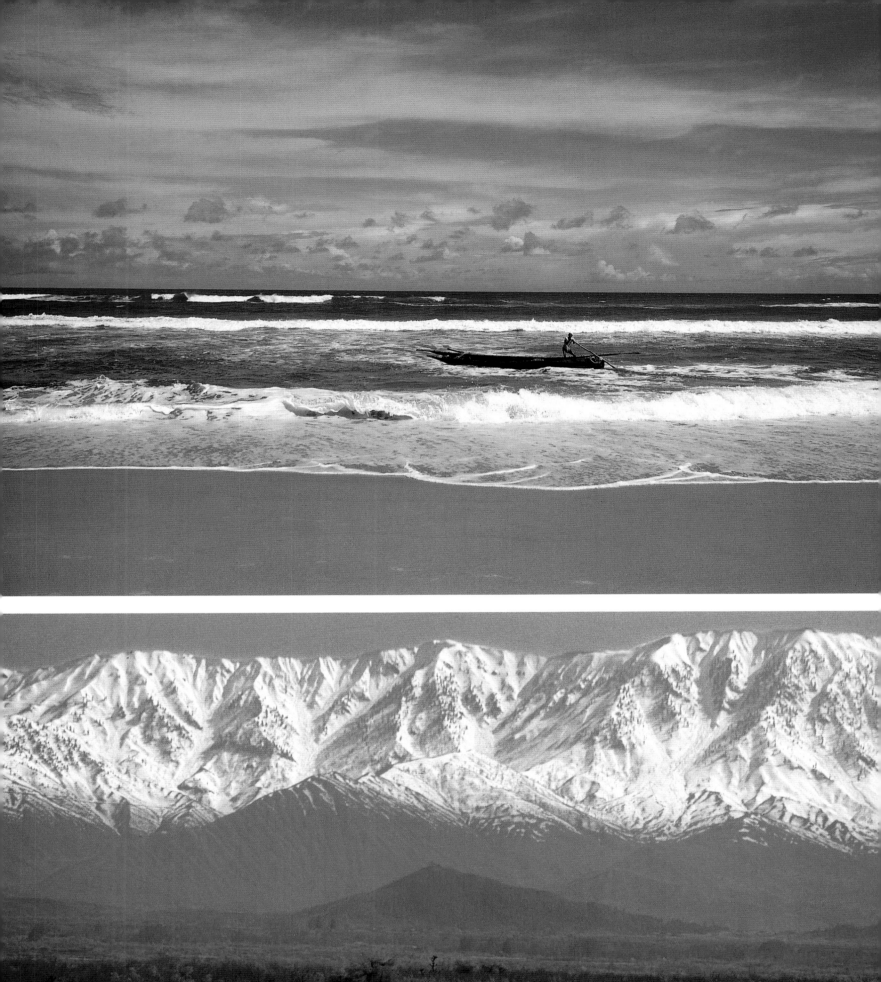

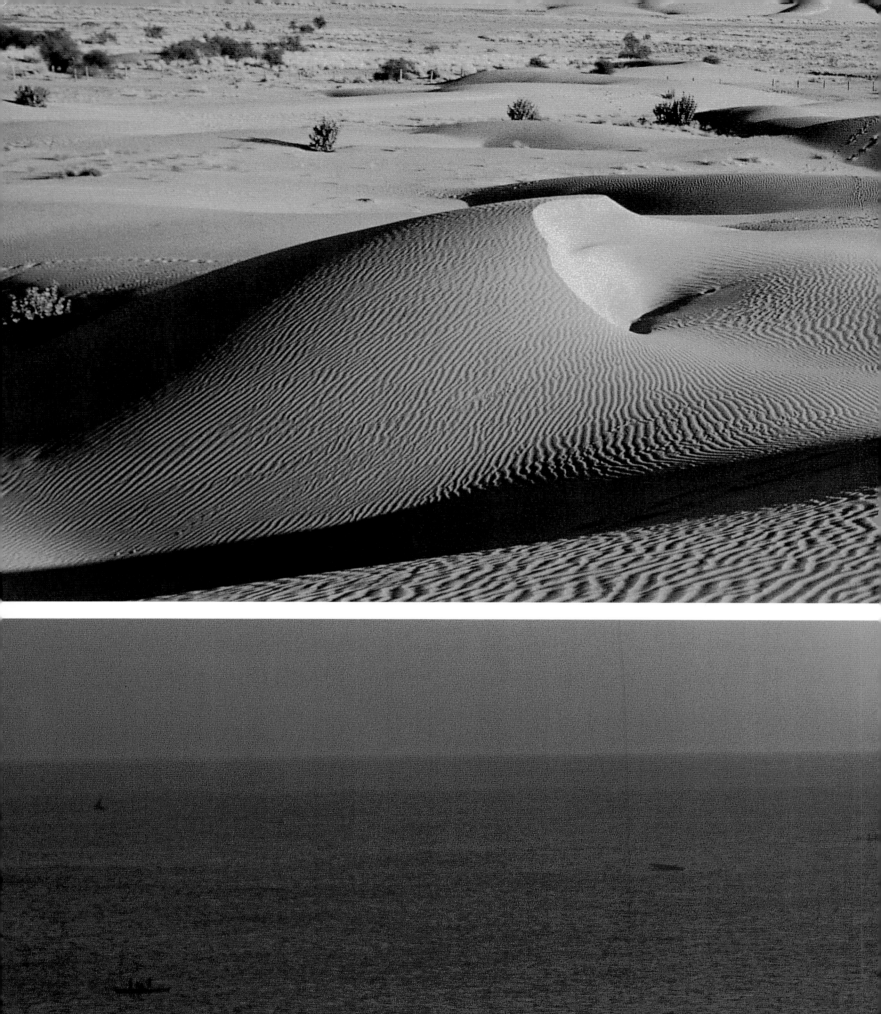

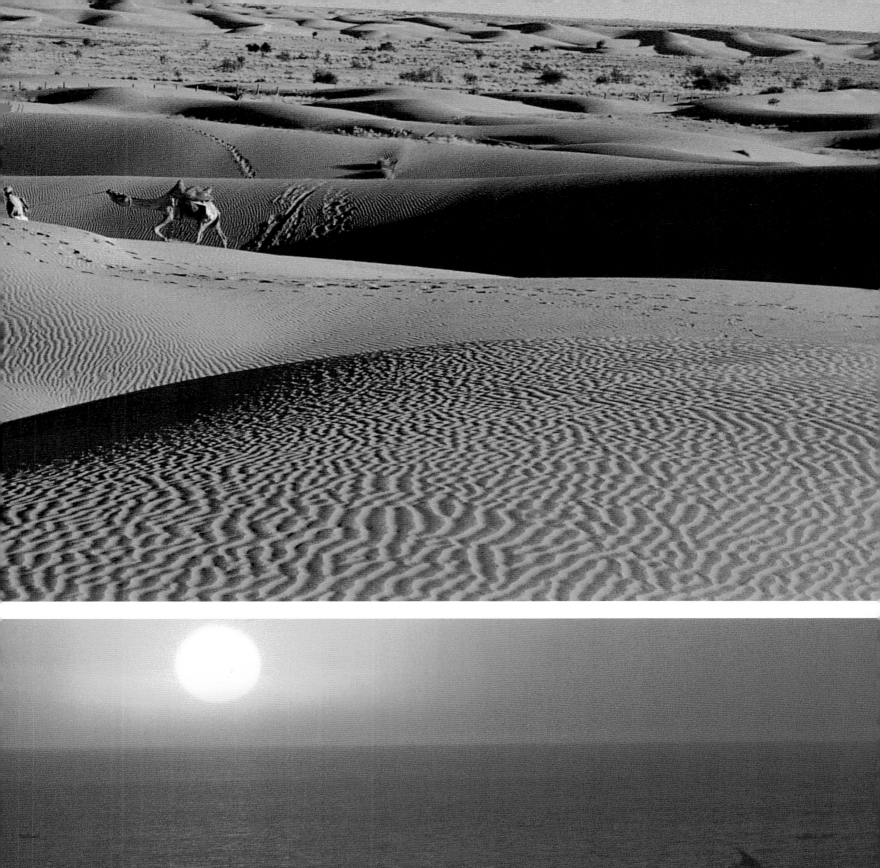

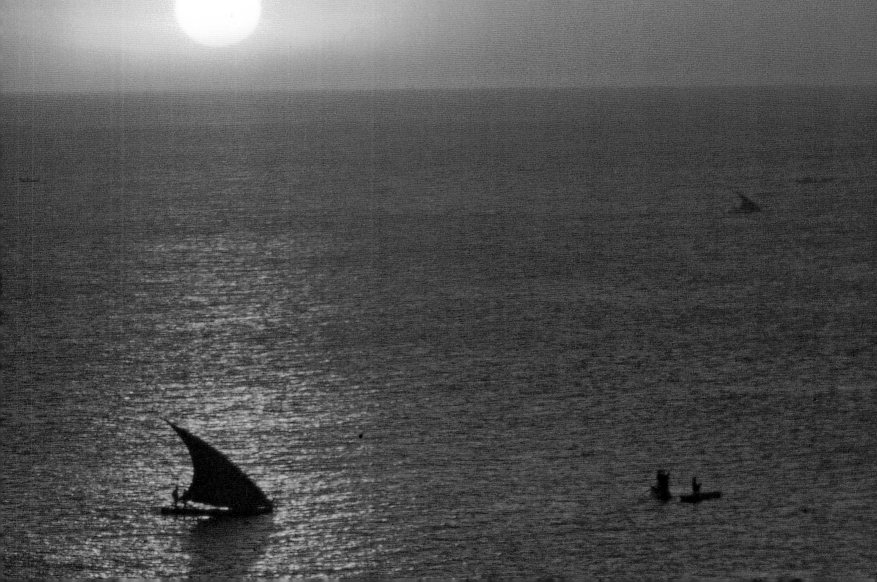

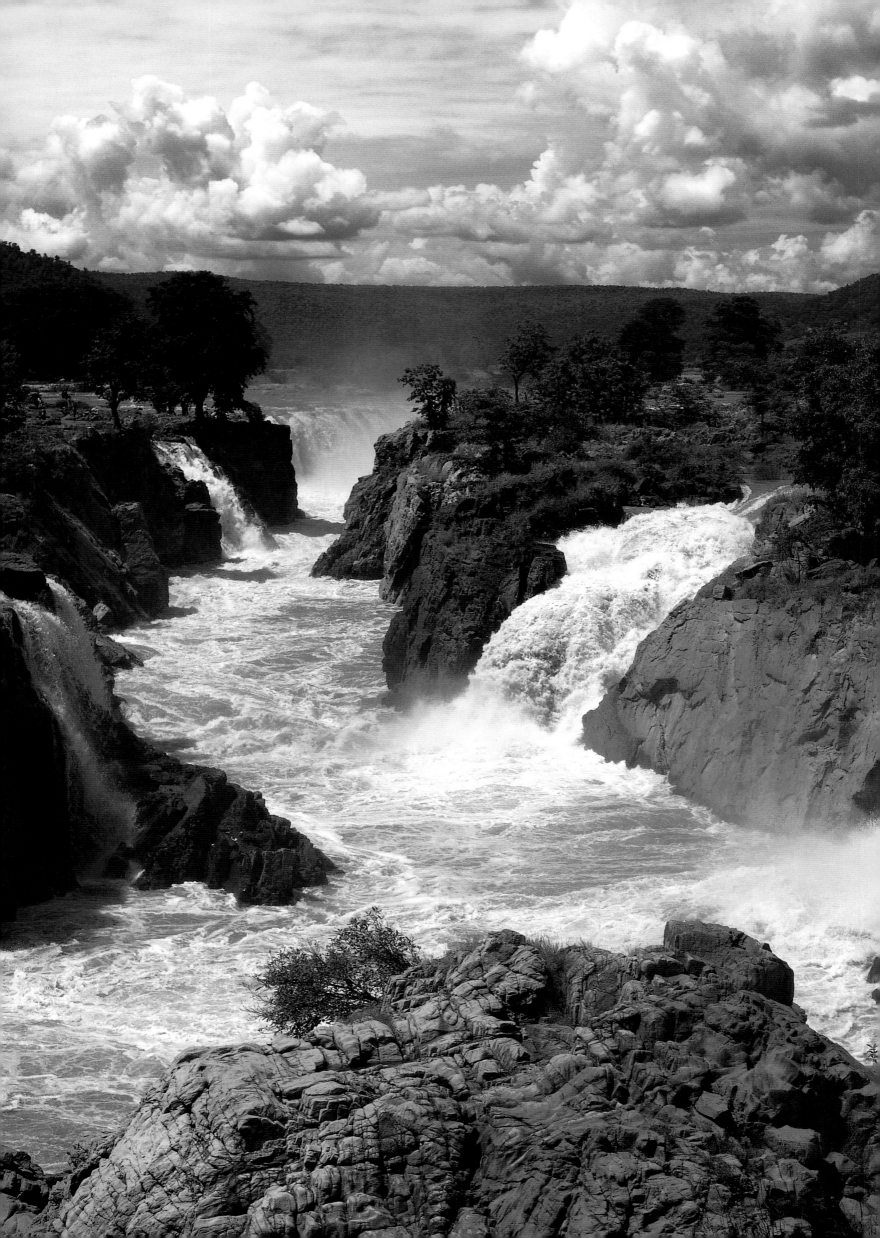

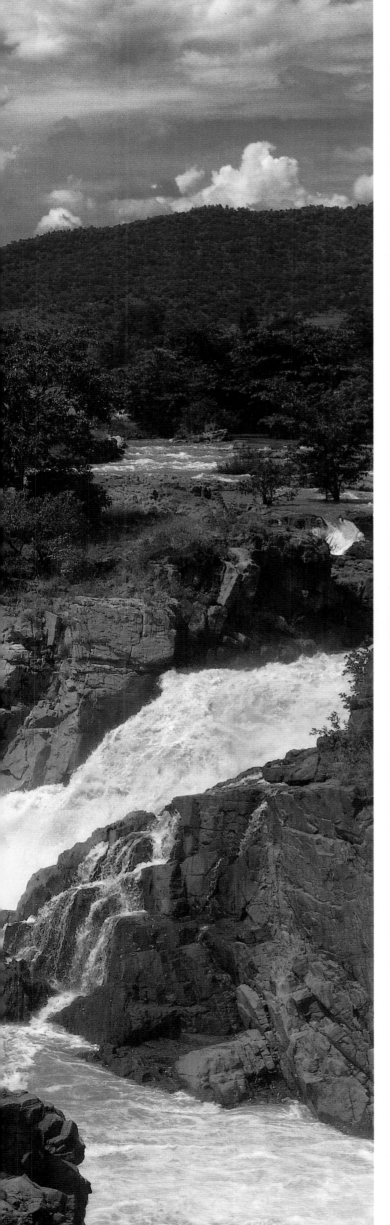

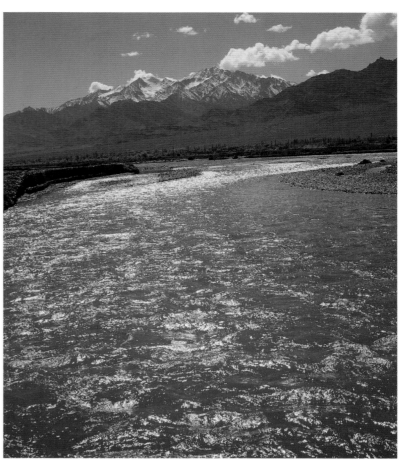

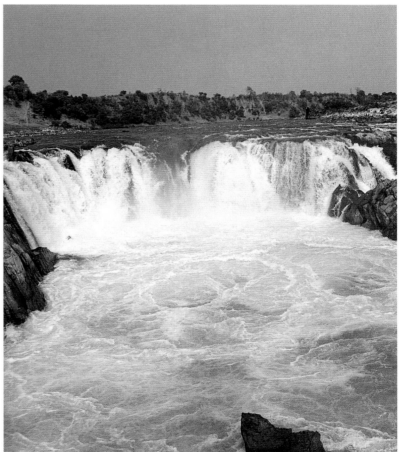

FACING PAGE: *The alluring Sivasamudram Falls in Karnataka.*
TOP: *The River Indus flows through the barren mountains of Ladakh, creating small emerald green valleys in a land, which is quite inhospitable.*
ABOVE: *The cascading Dhuandhar Falls near Jabalpur in Madhya Pradesh originate from the Amarkantak plateau. True to their name, they seem to fall like "streams of smoke" from a considerable height.*

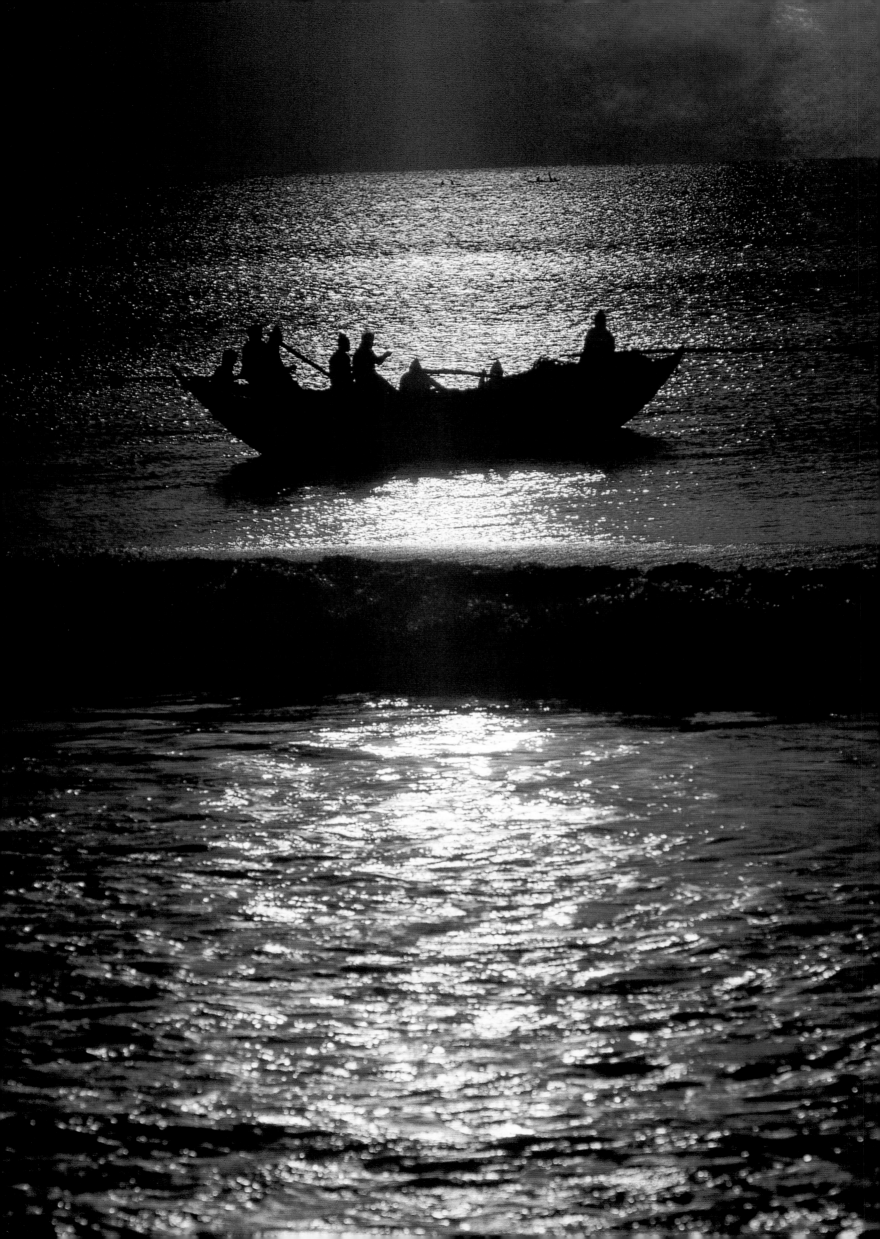

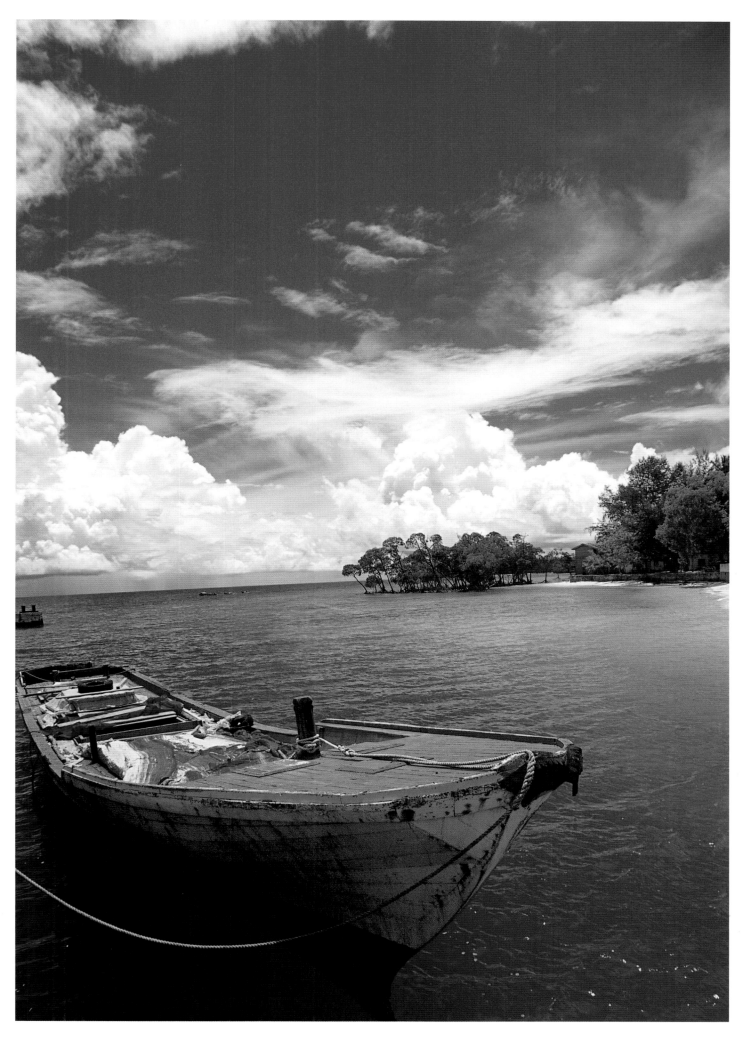

FACING PAGE: *Watching the sunrise from a beach is a magical experience.*
ABOVE: *The crystal clear waters of the Havelock Island, 54 kilometers from Port Blair in Andaman Islands.*

FACING PAGE, TOP: *The blooming water lilies are a nature-lover's delight.*
FACING PAGE, BOTTOM: *The colorful croton leaves*
ABOVE: *The striking blues & greens of nature.*

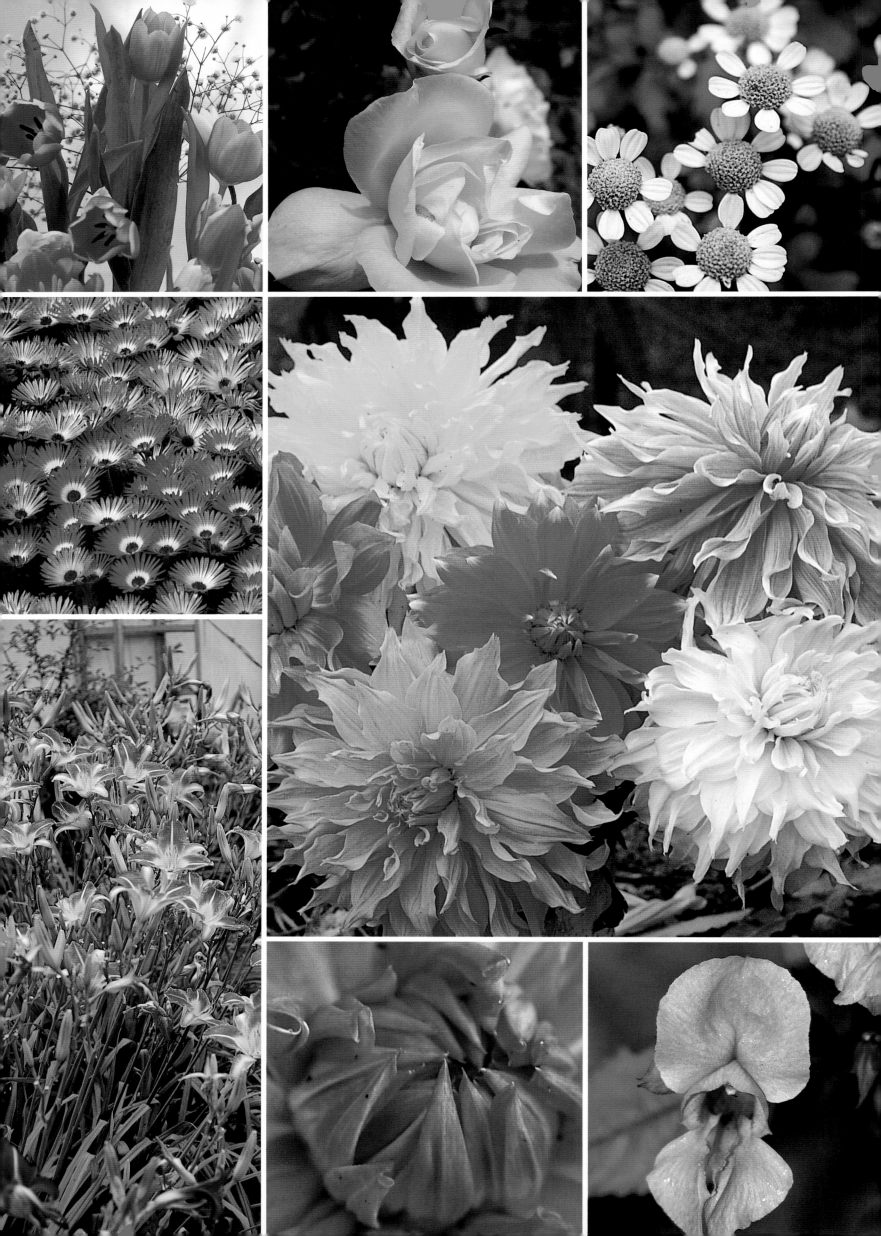

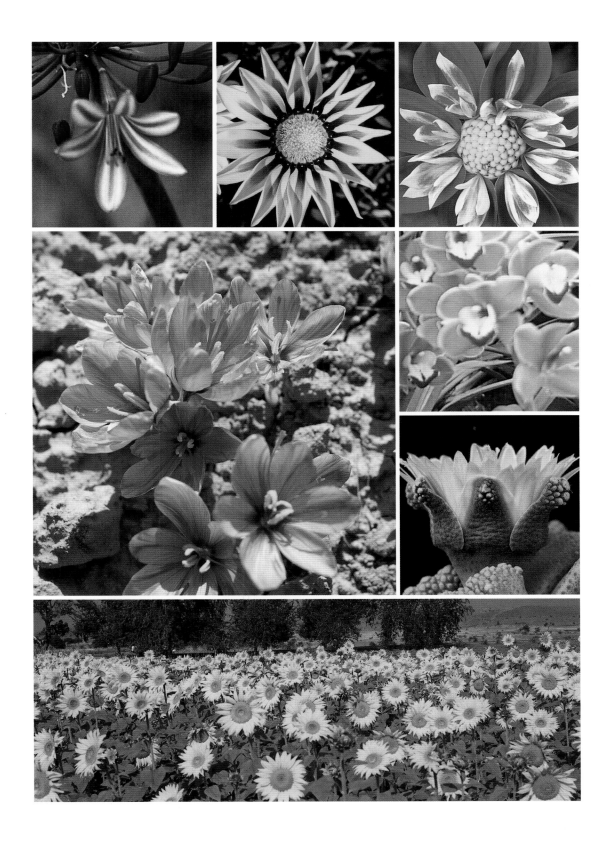

*As one of nature's loveliest creations, flowers permeate every aspect of our lives.*

FACING PAGE: *Gulmohar, one of India's most striking ornamental trees is a blaze of scarlet in the month of May. Small white flowers growing on the ground below further enhance its beauty.*
ABOVE: *An almond tree in full bloom in Kashmir with white and pink flowers is a glorious sight.*
TOP: *Bougainvilleas, with their sensational colors and lush foliage, are one of the most delightful features of our gardens.*

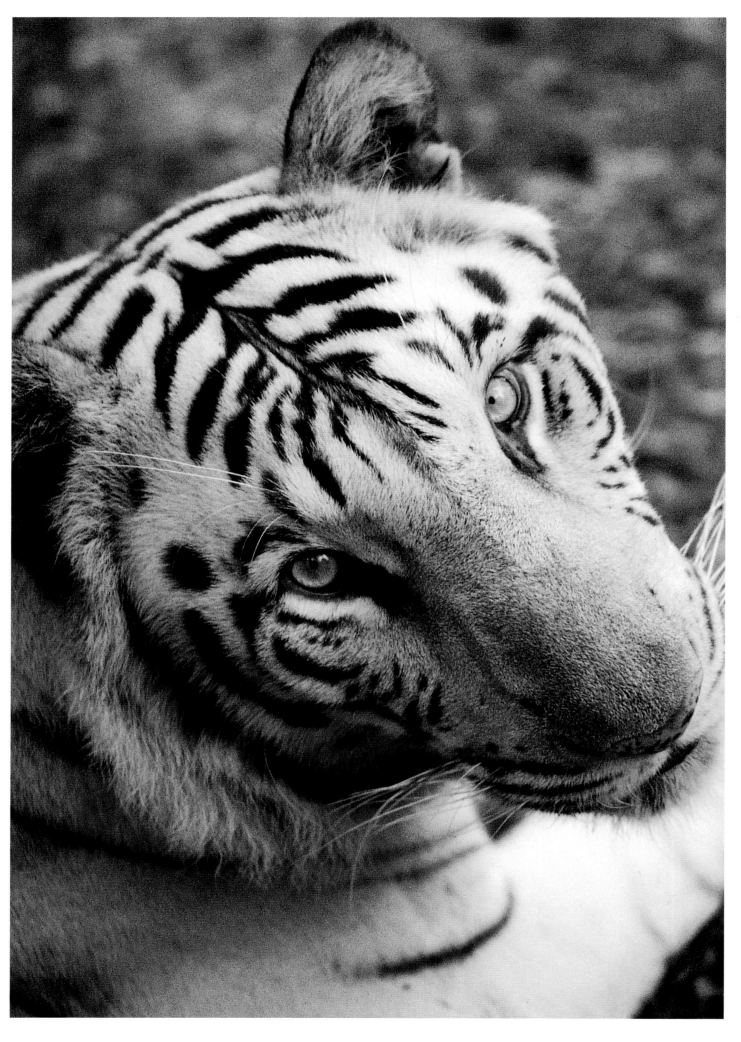

ABOVE: *The White Tiger is similar to an ordinary tiger in its habits and habitat except for its color.*
FACING PAGE: *The tiger is the most magnificent of the larger cats and is found in Asia from the Siberian wastelands to the tropical forests of Malaysia and Indonesia.*

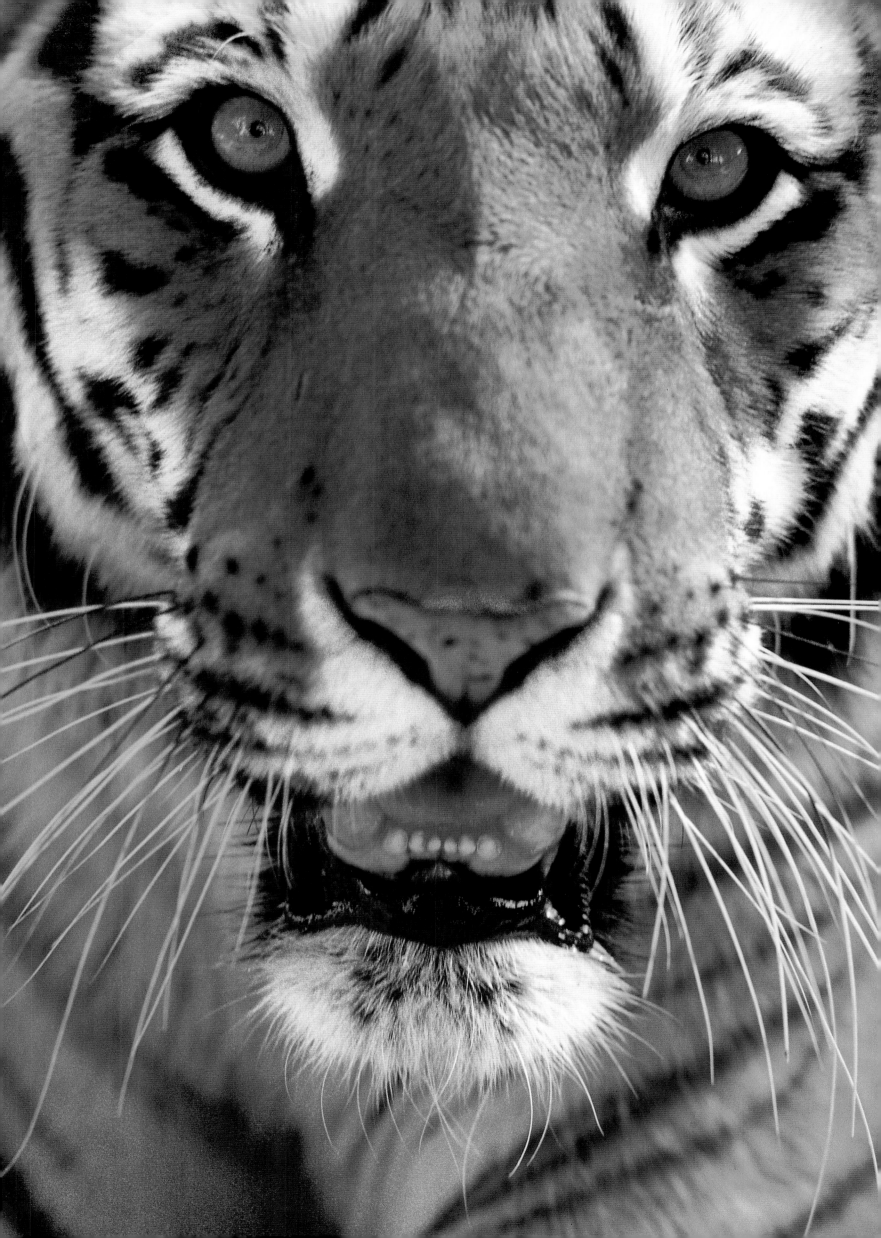

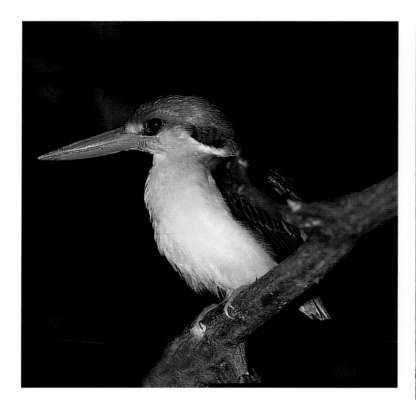

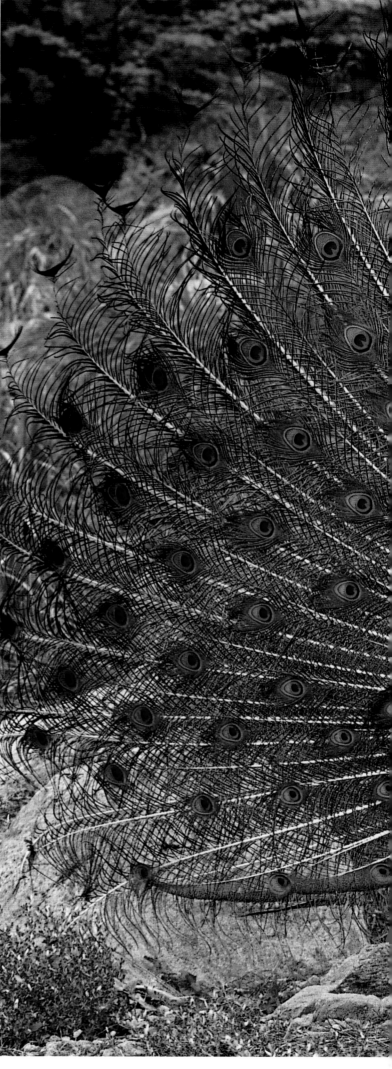

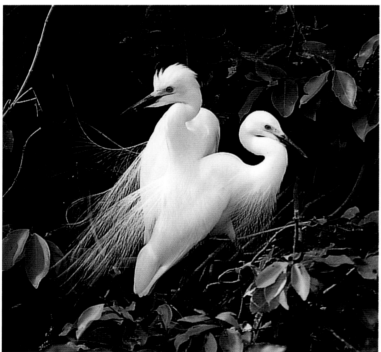

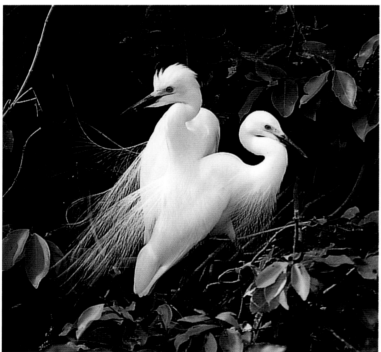

FACING PAGE: *Peacock, the national bird of India, is seen displaying its brilliant plume of feathers while dancing.*
TOP: *The White-breasted Kingfisher is the most familiar of all species of kingfishers.*
ABOVE: *The Cattel Egret inhabits the paddy fields and marshes.*

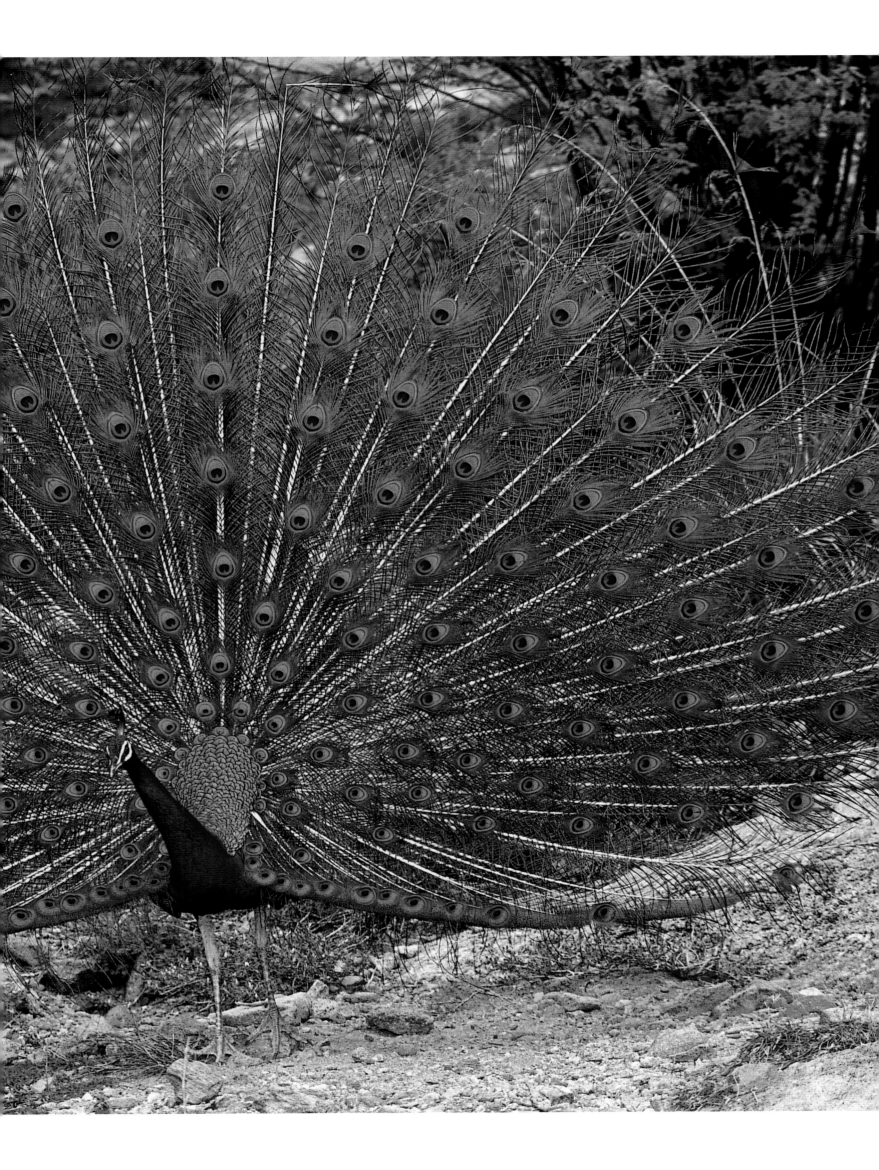

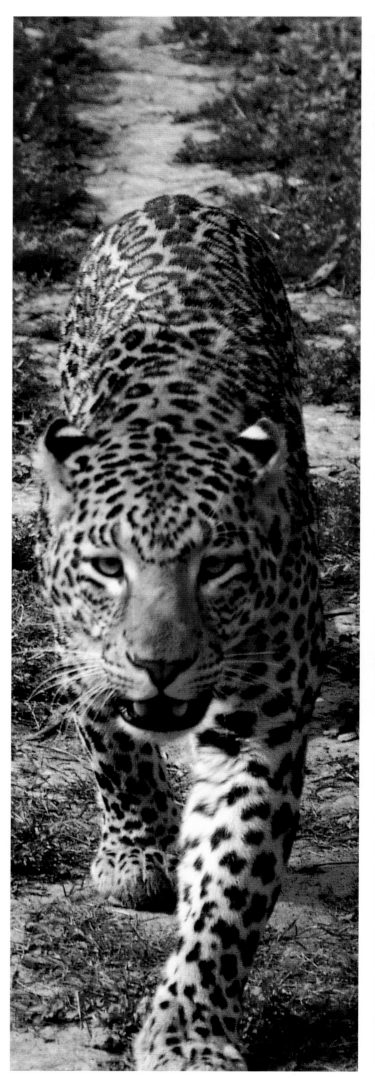

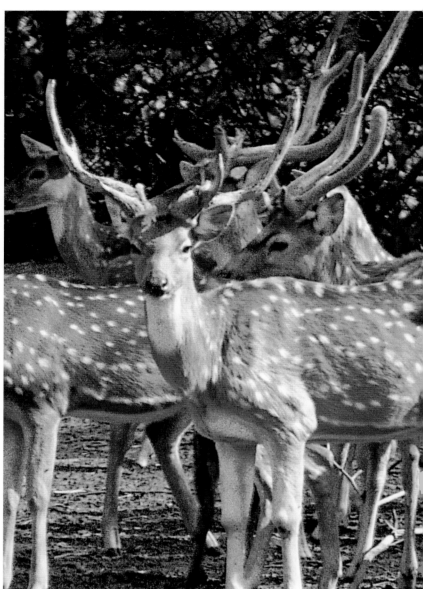

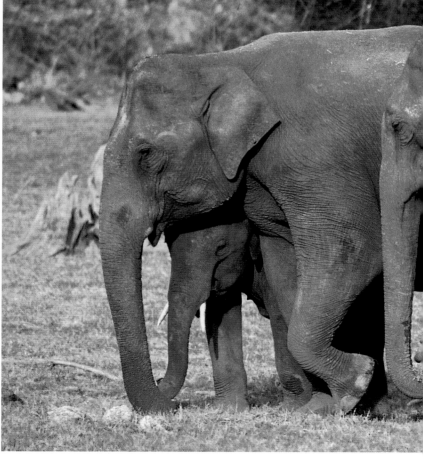

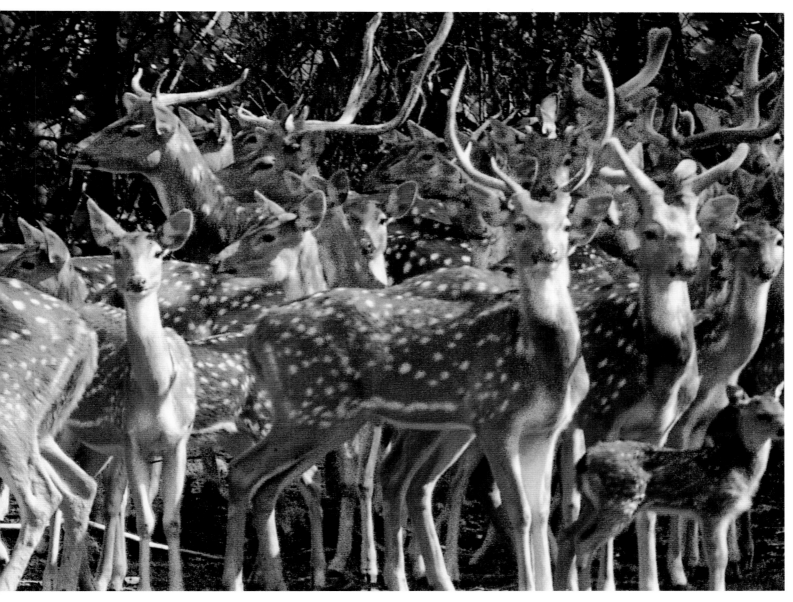

 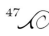

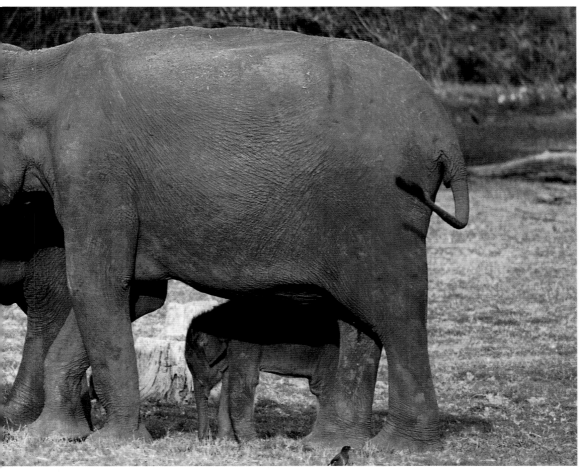

ABOVE: *Spotted Deer, found in the forests of Himalayan foothills are commonly seen in herds of ten to thirty and sometimes even more.*
LEFT: *Wild elephants in Kahini, Karnataka.*
FACING PAGE LEFT: *The leopard or panther, the most cunning of the cats, is found throughout India and also in other parts of Asia and Africa.*

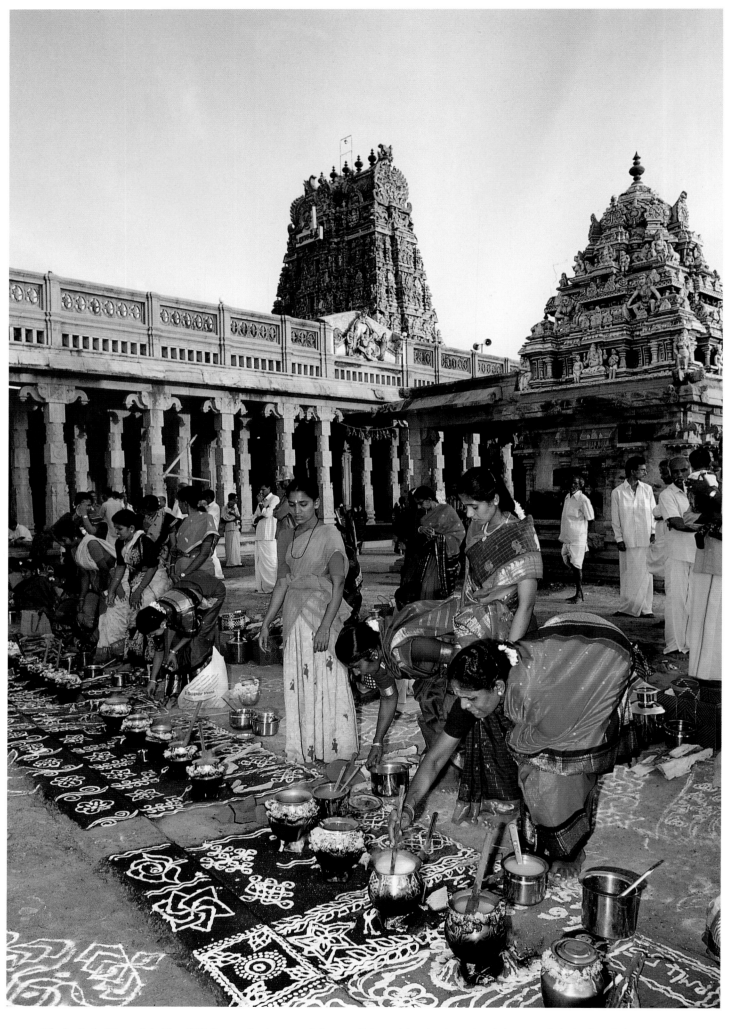

*The festival of Pongal, in Tamil Nadu, marks the season's harvest. It is a celebration in praise of the sun and the land, and the sustenance provided by the cattle. Women prepare a sweet rice pudding, 'pongal' that they offer to the gods as Thanksgiving.*

# People of India
## *Lifestyle, Fairs & Festivals*

India is referred to as a subcontinent, but considering the land's incredibly diverse population, "continental" is probably a better description. Few continents have such a heterogeneous mix of ethnic groups as India. Travel just a few hundred miles in any direction of the country and you will easily find people whose language, food and dress varies completely from any group you may have encountered elsewhere in India.

country's population. India is a country filled with people whose complexions range from the fairest to the darkest, and who have eyes of black, brown, green or blue. From this great melting pot of races and beliefs has emerged the unparalleled richness and variety of Indian culture, based on assimilation, adaptation, tolerance and the ability of people to coexist in a complex and composite society.

Consider the facts: The population of India stands at more than one billion, which after China, is the second highest population in the world. More than 1,600 languages are spoken in India, and the Indian government recognizes 18 dialects. There are four major language families in India: the Indo-Aryan, such as Sanskrit and its descendants; the Dravidian, of which Tamil is the most ancient; the Indo-Tibetan, heard along the eastern and western ridges of the Himalayas; and the Austro-Asiatic used by some tribal groups.

Every major world religion is represented in India, which is also the place of origin for several faiths. Christianity and Islam arrived here very early in their beginnings. The Apostle Thomas is said to have brought Christianity, while coastal traders from Arabia likely initiated the first wave of Islam in India. Hinduism was the gift of the Aryans, who were the cosmic thinkers and singers of nature. Buddhism, Jainism and Sikhism were also born in India, and they are all reformist movements that have radiated throughout the world. Jews, and also, Zoroastrians—known to us as Parsis—escaped the persecution of their homelands to find shelter here.

For many historical reasons, most major racial groups of the world met and mingled here, and thus turned India, as one writer has put it, into one of the greatest ethnographical museums of the world.

While the facts above can give a sense of the great size and diversity of India, they do not communicate the colors, textures, vibrancy and exuberance of the

A country's history is shaped partly by its geography. Neither the high mountain passes of the Himalayas or the seas that wash India's peninsula could keep out invaders attracted to a land fabled for its spices, jewels, gold, ivory and textiles. Immigrants fled to India in search of refuge, while traders and merchants traveled long and perilous routes across the country's deserts and peaks to exchange goods and ideas.

Over thousands of years of Indian history, successive waves of settlers and invaders, including the Aryans, Parthians, Greeks and Central Asians, came into the country and merged with the indigenous population. In the east, Indo-Tibetan and Indo-Burman peoples swept into India in waves from the Annamese Peninsula, or filtered down through the eastern Himalayan passes to settle in the sub-montane areas. They all brought to the country their own customs, faiths and observances, which were woven into the rich texture of Indian life, and ultimately, became heirs to a civilization that began almost 5,000 years ago.

A complex demographic profile has resulted in India from the mingling of major racial types — Australoid, Mongoloid, Europoid, Caucasian and Negroid. It is believed that when the Aryans entered India from the western mountain passes to settle across the north, these pale-skinned people encountered the local Dasa tribe, a dark-skinned people described in the Rig Veda. While the Aryans established a predominant position in the northwest and the Indo-Gangetic Plain, those of Mongoloid descent remained in the highlands of the

northeast, and their closeness to the Southeast Asian world is reflected in the motifs used in their crafts. In the south, people of peninsular India have Negroid characteristics, and on the Andaman Islands, a tribe of true Negritos can be found.

Many have influenced and enriched the cultural fabric of India, from the ancient Greeks and Kushanas to the Islamic monarchs from Turkey and Central Asia, and from the golden-skinned Ahoms of Assam to the mighty Cholas of the south. Powerful empires, such as those of the Mughals and of Vijayanagara, held sway over vast territories, and their strong patronage of the arts and crafts inspired excellence.

Each group brought to India their own ways of living, and of looking at life—their arts and crafts traditions, their poetry and philosophy, their dancing and music. The India of Aryan Vedic civilization was a repository for knowledge—not just the profound spiritual thinking of the Vedas and Upanishads, but also, the precision of mathematics and sciences, such as astronomy and medicine. The concept of "zero" originated in India. Vedic altars, built to specific designs, called for highly sophisticated geometrical skills. Thus, the historical Indian mainstream was a generous platform of creative dialogue, where different ideas, cultures, faiths and people met and merged and became richer. From this symbiosis was born the essence of our "Indian-ness."

We will now throw another element into this melting pot: the tribals, or Adivasis, the original inhabitants of India. To this day, seven out of every hundred Indians is a tribal. The great tribal belts cut a swathe across the states of Gujarat, Chhatisgarh, West Bengal, Bihar, Andhra Pradesh and Orissa. In the northeast, the states of Mizoram, Nagaland, Meghalaya, and Arunachal Pradesh are mainly tribal.

Subjected to the migratory tendencies of others, tribals were often pushed back to strongholds in the hills, or the jungles or coasts. Sometimes, they were migrants themselves, whose origins are lost in the mists of history, but who also formed distinctive ethnic groups, as in northeastern India. Most often isolated in their own areas, there were occasional nomadic groups, who moved across desert, plateau and river valleys in search of work and food. All of these groups had their distinct socio-cultural identity.

The tribals personified, deified and worshipped nature,

which provided them with food, and other important things, such as medicine, clothing, resources for tools, and materials for building houses, fences, canoes, looms and weapons of war. Artistic expressions and rituals of tribals reflected their life and their appreciation of nature. The beads they used in jewelry or to ornament masks were as brightly colored as the flowers tribals saw growing around them in real life.

Nothing was fragmented in this holistic perception tribals had of time—neither man nor the calm, unhurried rhythms of nature. The fabric of their life combined work with festivity, worship with song and dance, and myth with reality.

Whether tribal, rural or urban, there is one characteristic that unites the Indian people: the love of color and ornamentation. In India, color has been raised to the level of an art form. In areas where natural color is absent, as in the dune landscapes of Rajasthan and parts of Gujarat, its use by inhabitants is lavish, as if to compensate in everyday life that which the gods have denied. It is most evident in daily dress, where brilliant reds, vibrant saffrons, ochres and greens meet bright pinks and deep blues. It is a technicolor presentation from head to toe.

Meanwhile, where nature has been generous with color, there is a marked absence of color in dress. In the southern coastal state of Kerala, an area drenched in colors—from the vivid turquoise of the sea to the deep greens of tropical foliage and groves of palms—women would wear cooling shades of white, such as ivory and cream, to ward off the brilliant rays of the sun. Far to the northeast, in the foothills of the Himalayas, the Naga tribes weave cotton cloth on back-strap looms. Here, the basic colors are black, deep blue and red, but the simple skirts, kirtles and shawls are meant to enhance extravagant jewelry and ornaments made of materials such as beads, seeds, dyed animal hair, cane, ivory, cowry shells and brass. These items are fashioned into necklaces, circlets, armlets and intricate headdresses, plumed with hornbill feathers and encrusted with the shiny wings of beetles.

Indeed, in days gone by, dress was a clear indicator of identity in India. What you wore revealed who you were in terms of community, location, caste, marital status, or special status within a community. In most parts of India, basic clothing remains simple draped

cloth, a tradition that has existed for thousands of years. The most famous of such garments is the sari, which is worn by women whose styles of draping vary depending on their regions and communities. It is interesting to note that traditionally, looms were built to the width of the sari that was worn locally.

Men wear draped garments, also, like the dhoti and the lungi. It is said that the convention of stitched clothing was introduced with the coming of Islam, and among the garments worn most often are the salwa kameez and pyjama kurta of northern India. In areas like Rajasthan, long skirts and bodices are worn. Among the most colorful and uniquely Indian items of dress is the men's turban. Perhaps in no other country is there such a wide range of turbans, tied in different ways, and made of materials ranging from coarse cotton to the finest silk, with many of the latter fashioned for special occasions, such as weddings and festivals.

There is certainly no dearth of festivals in India, where it is said that there are more festivals than days of the year. Small, local village rituals of worship and propitiation are celebrated with as much fervor as high holy days across the nation, occasions that can draw floods of people. Fairs and festivals are moments of remembrance and commemoration of the birthdays and great deeds of gods, goddesses, heroes, heroines, gurus, prophets and saints. These are times when people gather together, linked by ties of shared social and religious beliefs.

Each of India's many religious groups—Hindus Muslims, Christians, Sikhs, Buddhists, Jains, Parsis, and others—has its own set of celebrations. The spirit and color of these religious or seasonal festivals draw together seemingly diverse groups across faiths, for Indians believe in sharing happiness, and a festival or celebration is never limited to one family or one religion. The whole neighborhood participates in such occasions, marked by sharing sweets and visiting family and friends. Thus, all communities join together for the joyous lights of Diwali, and the words "Id Mubarak!"—translated literally as "Blessed Festival" and meaning "May your religious holiday be blessed!" –are exchanged between Muslims and non-Muslims over a bowl of sweetened vermicelli.

In India, the celebrations of fairs and festivals mark the rites of passage between birth, death and renewal. These moments are determined not by a calendar, but

by the sun as it enters new seasons, and in the cycles of the waxing and waning moon. Each full moon has its own meaning and is placed in the context of its own rituals, sacred or social: May, to commemorate the birth of Gautama, the Buddha; July, to honour the guru or teacher; and November, in remembrance of the birth of Guru Nanak, founder of the Sikh faith. The sighting of the new moon at the end of Ramadan, the ninth month of the Muslim calendar, is eagerly awaited; it signals the end of a month of fasting and the advent of Id-ul-Fitr, celebrated with prayers, feasts and family get-togethers.

Along with the concept of consecrated time, there is also the idea of sacred space, which goes beyond the immediate environs of temple, gurdwara or mosque. The banks of a river, the meeting place of waters, a holy tank, forests, mountains, the seashore, the tomb of a beloved pir or saint—all are places for celebration and communion, where ritual prayers and blessings are followed by feasting, song and dance.

Festivals symbolize a link between the home, the village, and the larger outside world. Within the home, celebrations are expressed by the love and care given to its decoration by the women of the house. Freshly washed courtyards are embellished with designs made with flower petals, colored powder or rice flour. Walls are painted with epic scenes, or are made brilliant with embedded bits of mirrored glass. Auspicious mango leaves or marigold flowers adorn doorways. Each festival in each religion has its own particular foods and sweets, appropriate to the season and the crops, and days are spent in their careful preparation.

Outside the home, there is the brotherhood of community worship, moments when the barriers of caste and even creed are forgotten. There is the joy of the congregational darshan, or view of the deity; the sharing of amrit; the specially blessed food; the idols used in leading long-winding processions; and the chanting of holy verses. Festivals reinforce the presence of god in the life of the individual and the family, and bind them to the community. They are also moments for the young people of India to absorb and be part of age-old, yet still vibrant and living traditions.

Festivals are also about fun and enjoyment, especially when they coincide with agricultural events, such as harvests, when it is time to let go of the cares of daily life. The riotous exuberance and earthiness of Holi, the spring festival of colors, is almost Bacchanalian in

character, and has the lighthearted atmosphere of a true Indian carnival.

In different parts of India, celebrations around festivals have their own special characteristics. Mathura in northern India is famous for its uninhibited Holi and devout Janamashtami (the birth of Lord Krishna), while Kolkata is the city to see the Durga Puja, the ten-day worship of the great goddess who defeated the demon. Ganesha Chaturthi— dedicated to Ganesha, remover of obstacles, whose very presence is auspicious—is best experienced in the state of Maharashtra. And nowhere outside of Kerala can the sheer spectacle of the caparisoned elephants of Trichur Puram, or the snakeboat races of Onam, be matched. And differences of observance can lend local color to certain festivals. Celebrations for the Dussehra, which is famous equally in the south Indian city of Mysore, the Himalayan Valley of Kulu and the holy city of Varanasi, follow distinctly regional cultures.

The mela, or fair, can also be, and quite often is, connected to a religious festival or observance, and brings together a large variety of social groups. There are priests and mendicants; artisans and craftspeople; bards, jesters, dancers, musicians, and other performers; hawkers of fiery snack foods and iced drinks made of fruits and milk; vendors of toys, clothes and household merchandise; sellers of camels, horses or cattle; and families who have traveled from near and far.

The largest melas take place over a number of days, as in Pushkar in Rajasthan. Here, the mela looks like a gigantic encampment, a multitude of small tents stretched out as far as the eye can see. As dusk falls, the lights of lanterns and campfires sparkle in the gathering darkness, creating an air of romance and magic. At some fairs, the ambience of romance is very real, for this is where the young gather to arrange their betrothals.

At the Tarnetar Mela in Gujarat, and the springtime Bhagoria in the Jhabua district in Madhya Pradesh, young men and women wear their finest attire to the fair; and as they sing and dance together, shy glances and smiles often lead to marriage.

The yatra, a pilgrimage, has a more serious purpose, and its intention is religious. In its most literal sense, a yatra can be undertaken at any time, for essentially it is the individual's journey to an especially holy place to meditate, pray for salvation, or to give thanks. And on major occasions at the great pilgrimage sites, hundreds of thousands of people gather, drawn by the irresistible magnet of faith.

The site of the yatra is sanctified by centuries-old tradition, and so many are near water—a holy river or its source, a sacred tank or lake, or the confluence of waters. To immerse oneself in these pure waters is essential, for then one is cleansed of sin and renewed. The consecrated time is governed by the phases of the moon and sometimes, as in the Kumbh or Gomateshwara pilgrimages, can be as far apart as twelve years. Even annual pilgrimages draw vast crowds, as in the Rathayatra of Orissa, where thousands of the devout join hands to pull on thick ropes, thus physically transporting the giant temple chariots on their journey across the town of Puri in Bhubaneswar.

In India, as everywhere in the world, solemn pilgrimages can be fairs, and fairs can be festivals. What is important is the meeting and mingling of people, the common language of shared human experience, and the perception of the world as the larger family. All festivals in India encourage this outward vision, a generosity of heart and mind, and indeed, is this not what celebration is all about? For in the end, all celebration is an exaltation and reaffirmation of life itself.

*AshaRani Mathur*

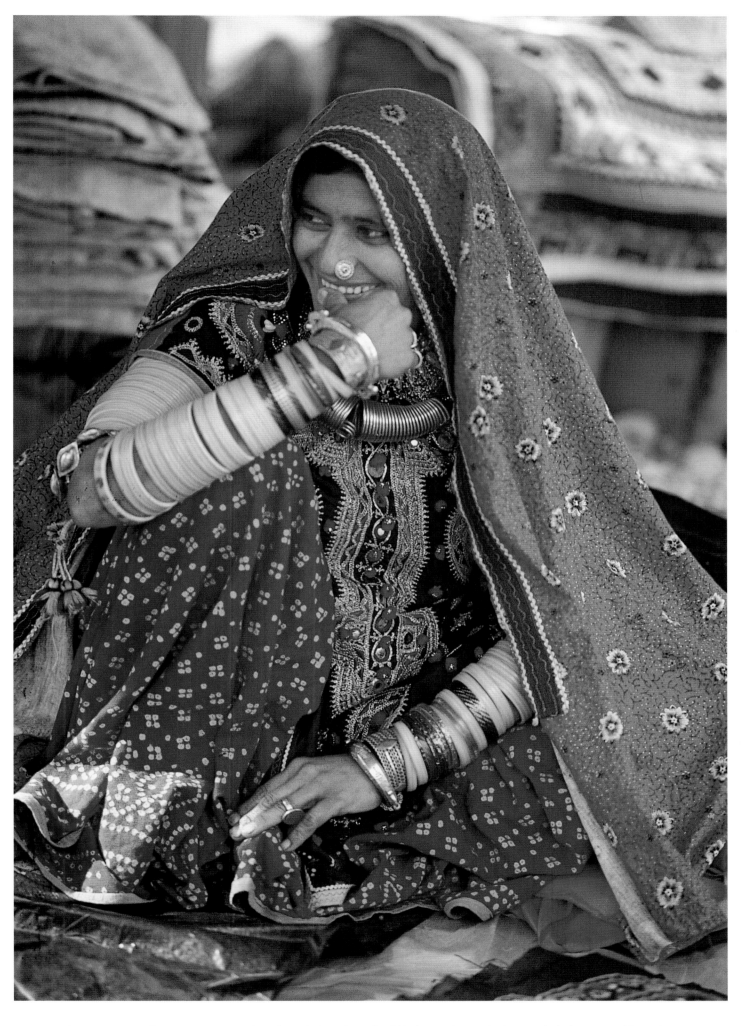

The women of Kutch, in Gujarat, wear a long, layered skirt that is handblock printed or tie-dyed, over which they sport a blouse that is embroidered and mirror-worked. A long mantle embellished with trimmings is draped over the head and completes the ensemble. Lac and ornate silver bangles, anklets and necklaces are very much a part of their daily wear.

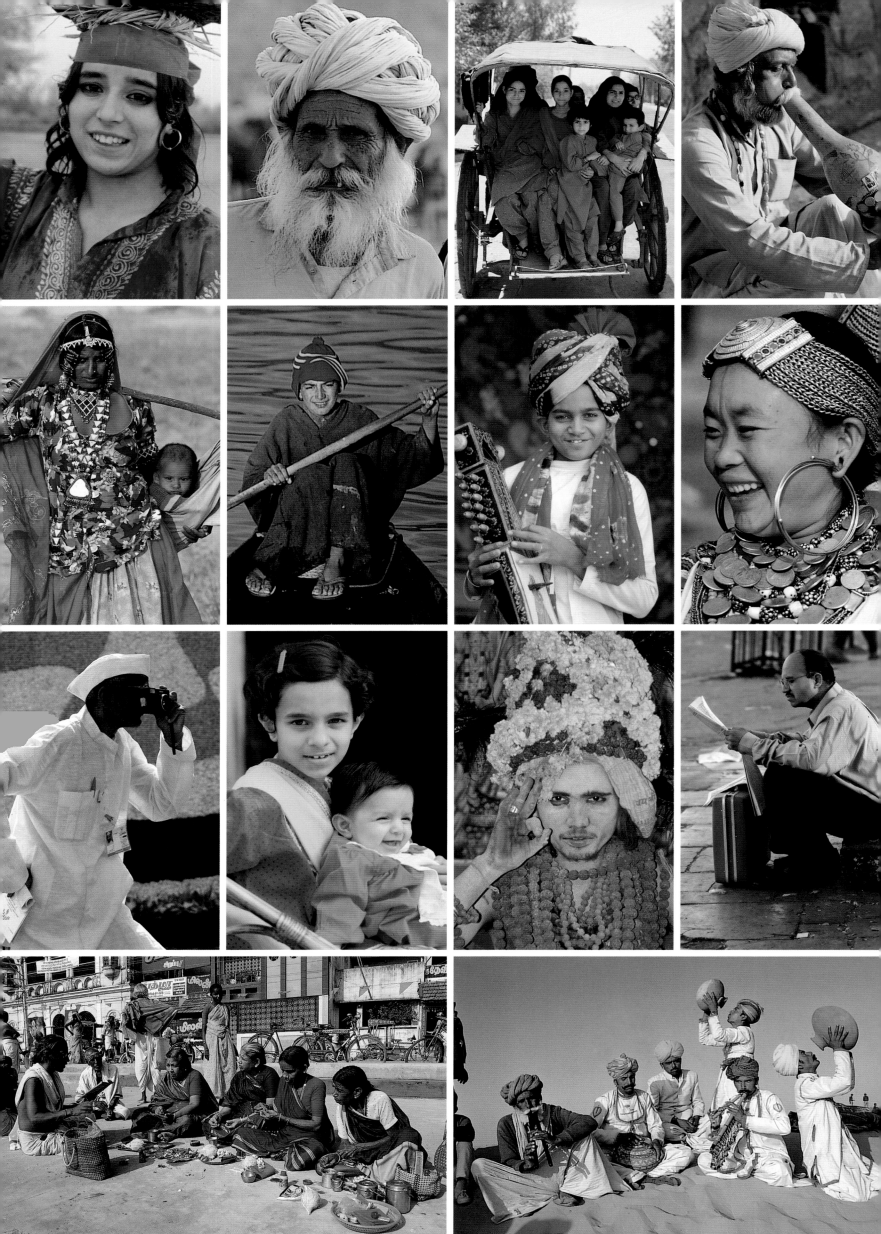

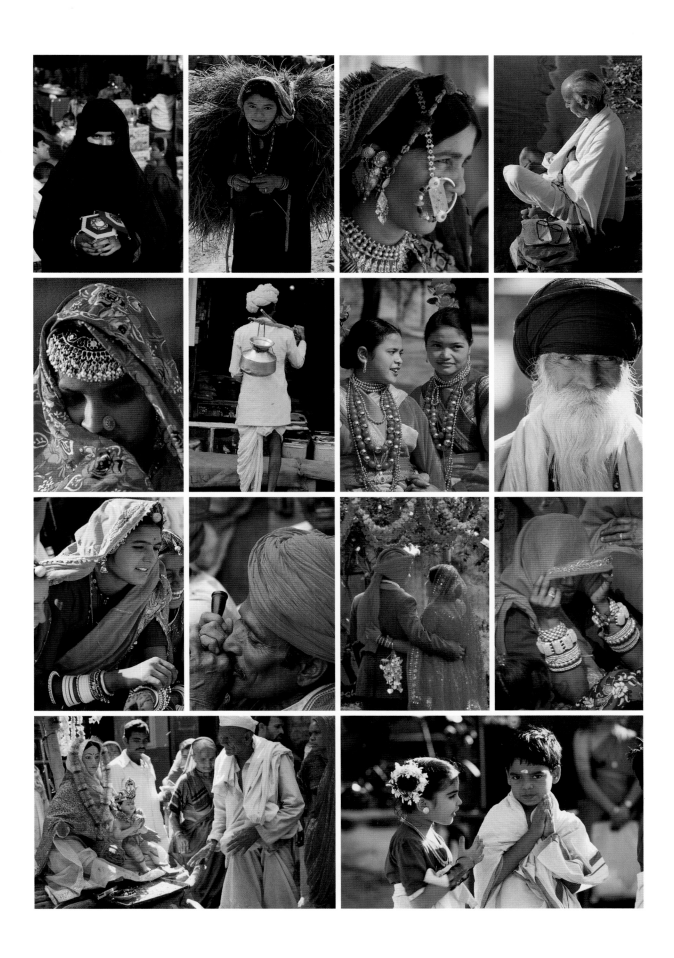

*A mélange of people call India 'home'. From the Himalayas to the seas, spread across the deserts and the Indo-Gangetic fertile plains, they bring vibrancy, character and uniqueness to a land as ancient as time itself.*

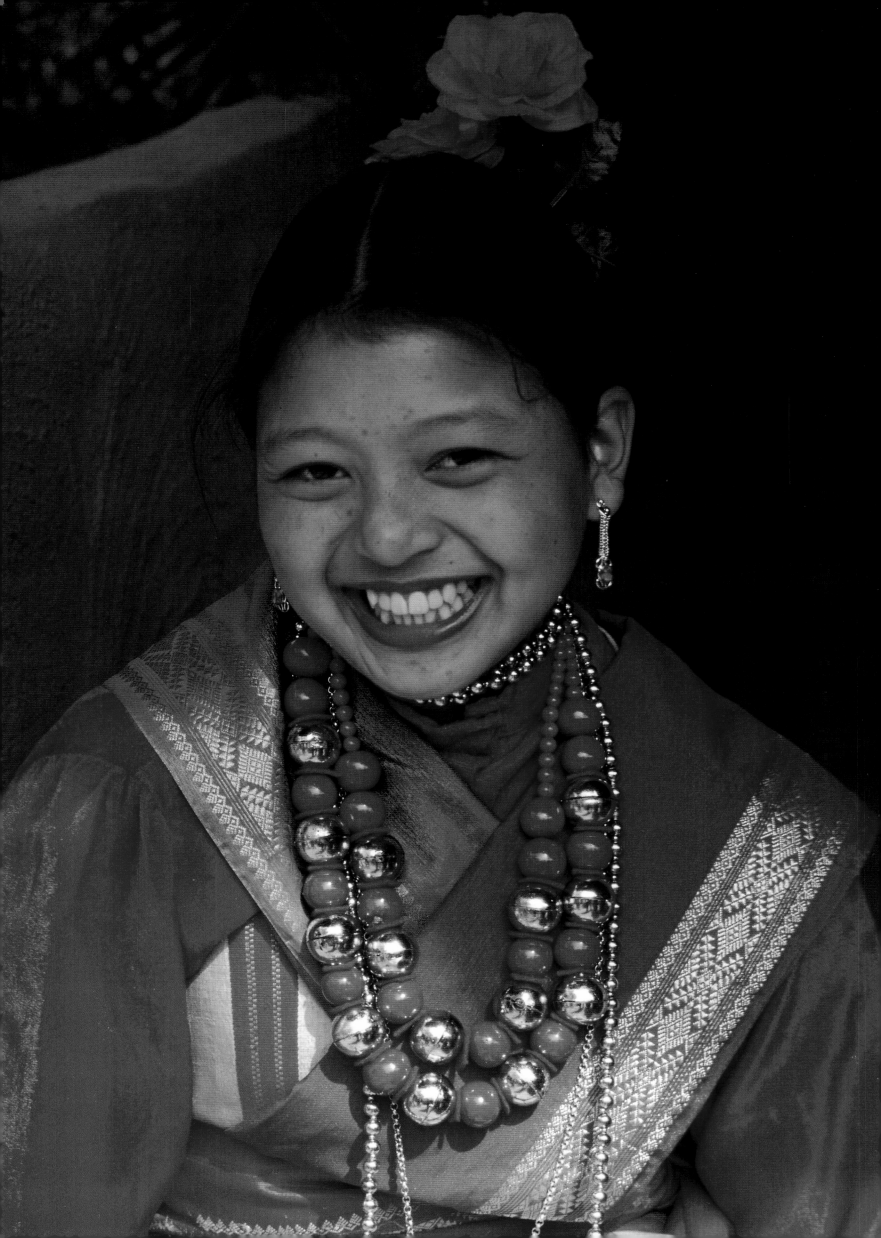

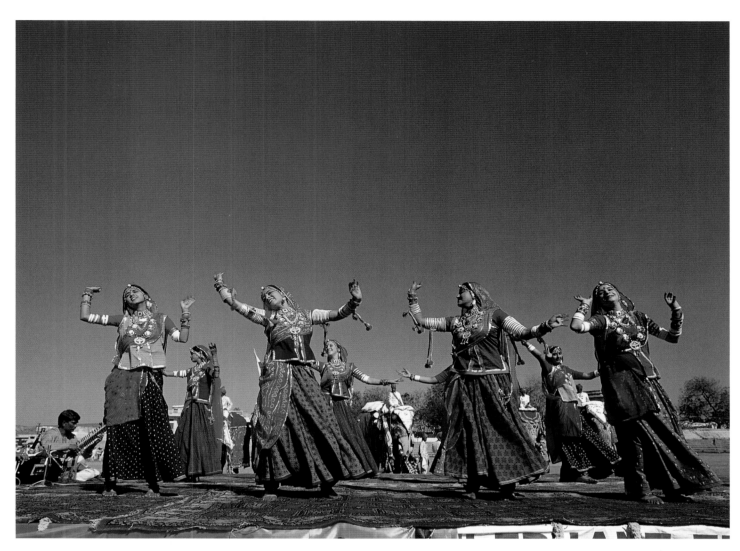

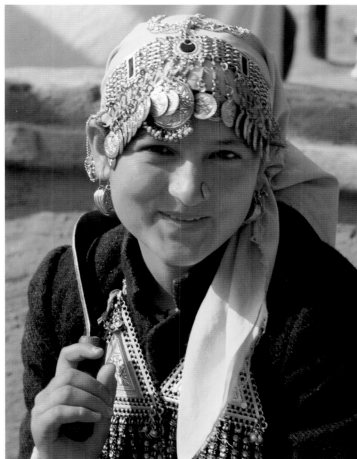

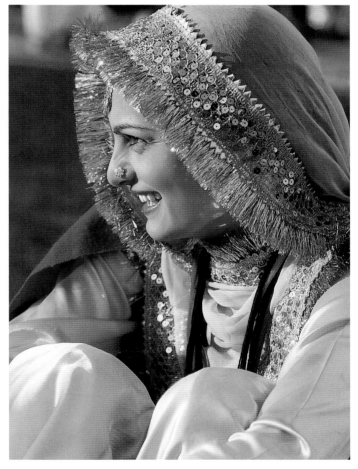

*Dressing up is an integral part of the Indian woman's life. Whether she is from the unique eastern states, or from flamboyant Rajasthan,*
*Himachal Pradesh or Punjab, the love for color, jewellery and ethnic costumes is linked from the past to the present,*
*through an abstract legacy of customs and rituals.*

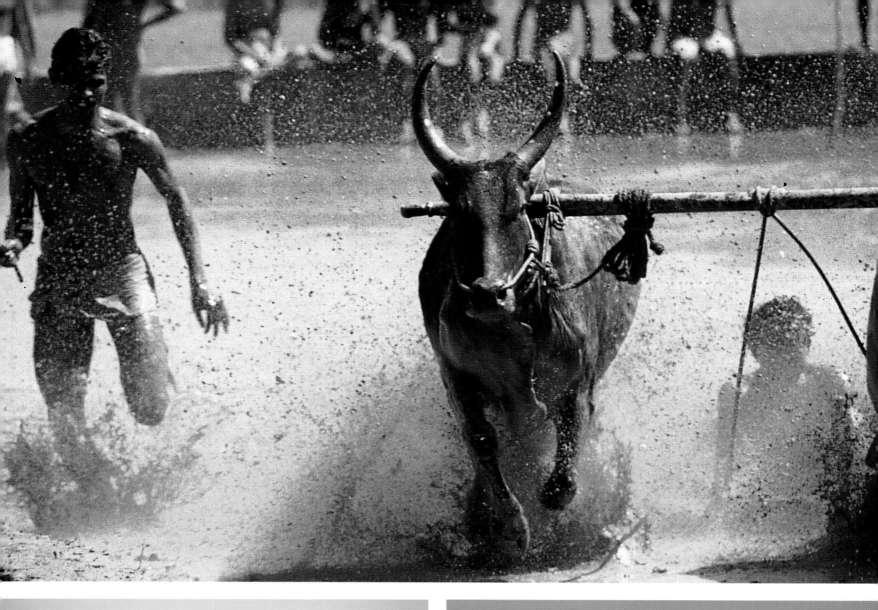

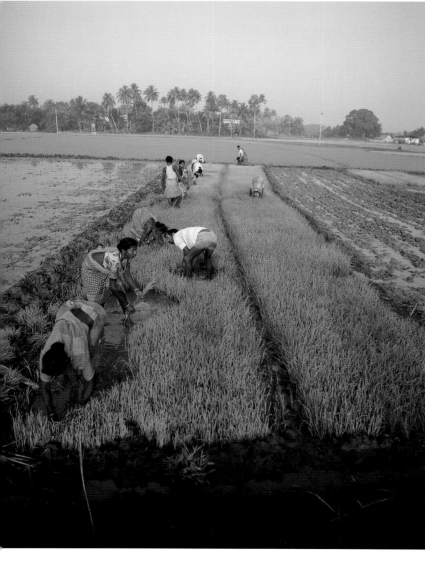

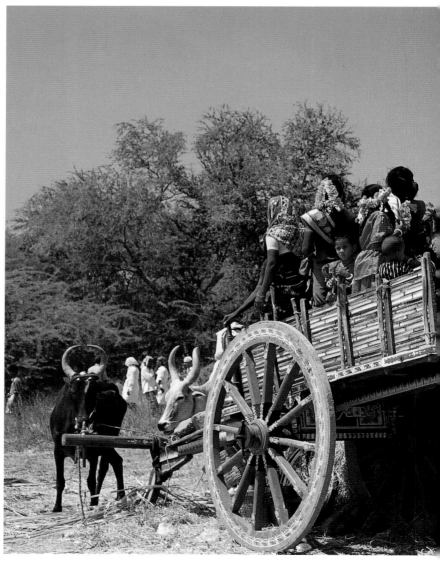

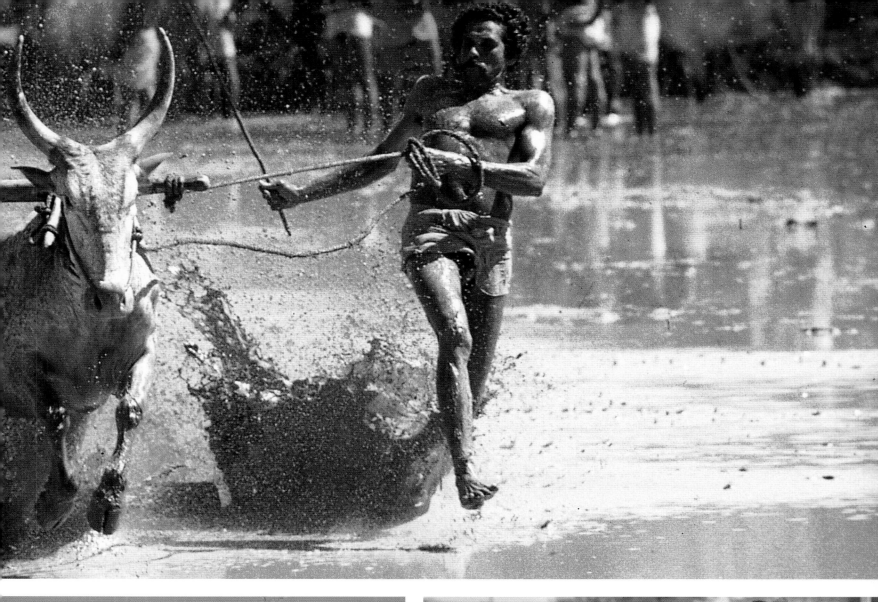

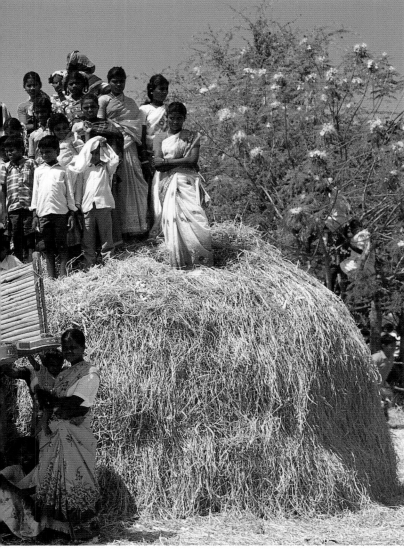

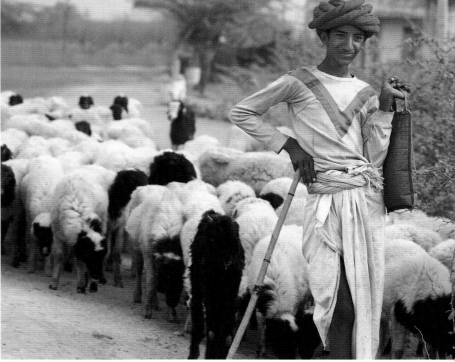

India's pastoral communities are largely dependent on dairy and
have made it the largest milk-producing country in the world.
TOP: *A cattle race through the paddy fields of Kerala.*
ABOVE: *A Rajasthani shepherd tends to his flock of sheep.*
LEFT: *Entire village communities gather to make hay in Tamil Nadu.*
EXTREME LEFT: *Transplanting rice saplings in the rice-growing belts of India.*

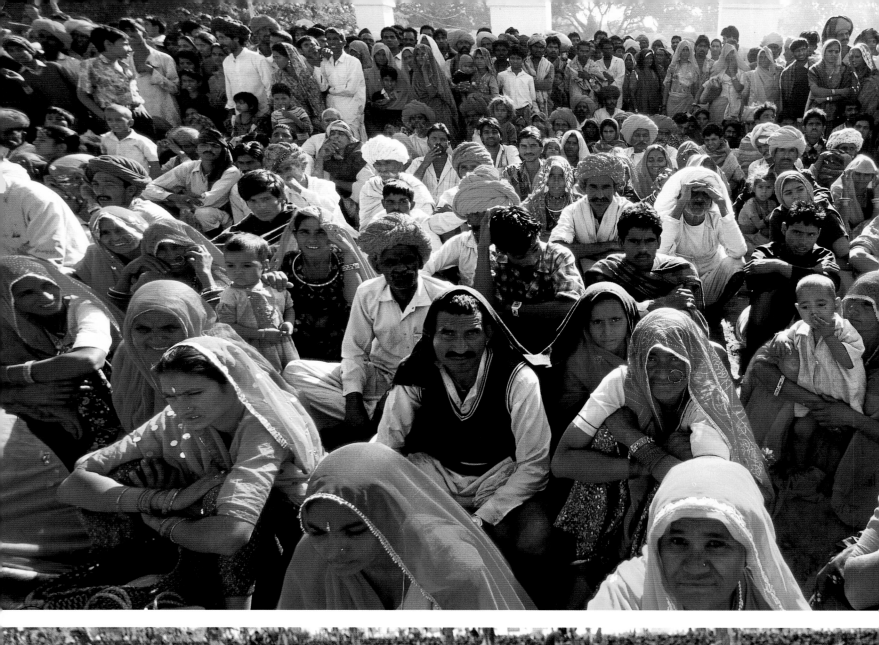
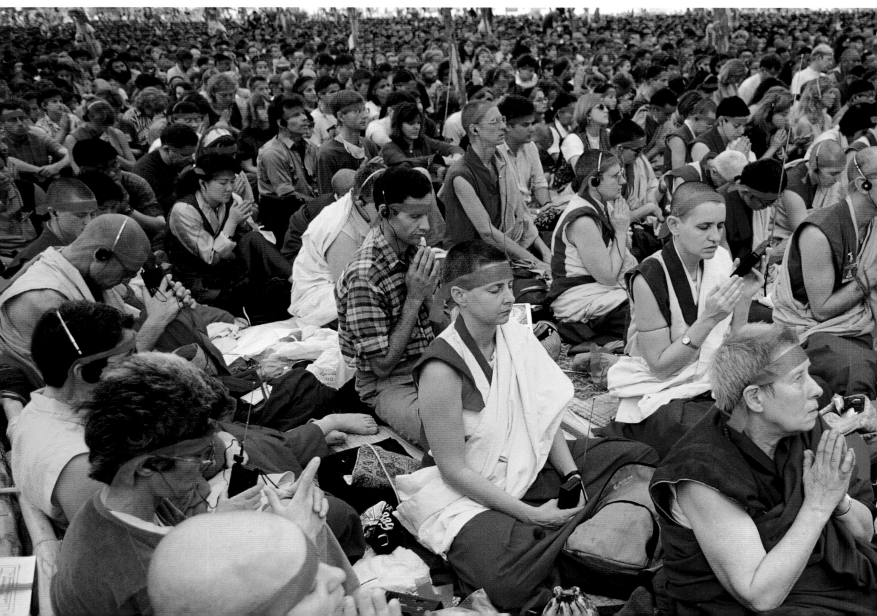

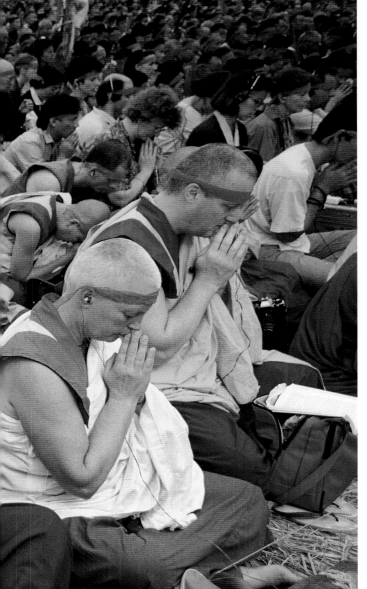

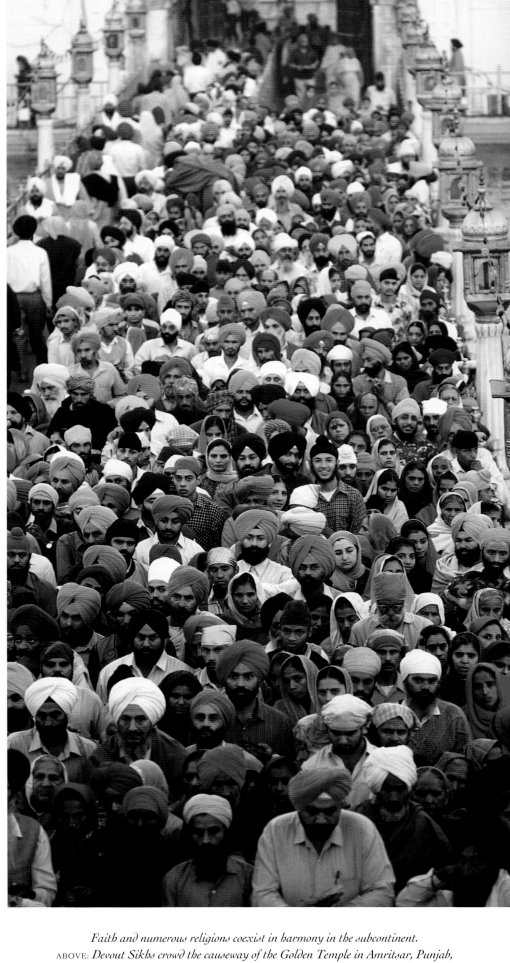

Faith and numerous religions coexist in harmony in the subcontinent.
ABOVE: *Devout Sikhs crowd the causeway of the Golden Temple in Amritsar, Punjab,*
*to celebrate the birth anniversary of the founder of their faith, Guru Nanak.*
LEFT: *A congregation of Buddhist monks at the Kalachakra ceremony at Sarnath,*
*Uttar Pradesh, when novitiates are ordained into their ranks.*
TOP LEFT AND FOLLOWING PAGES: *The millions, who gather at Brahma's temple at Pushkar,*
*Rajasthan, for the annual camel fair, have been doing so for thousands of years,*
*combining the religious, the social and the commercial.*

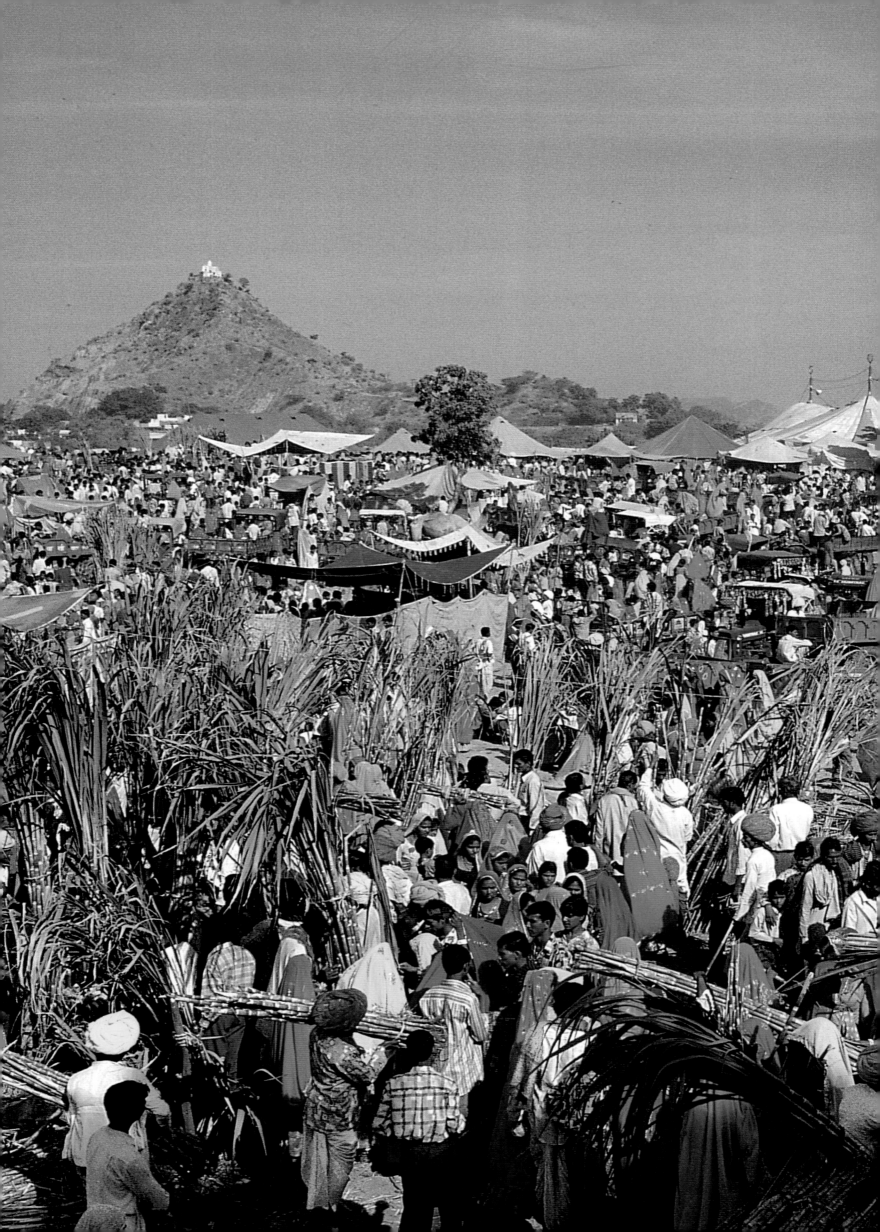

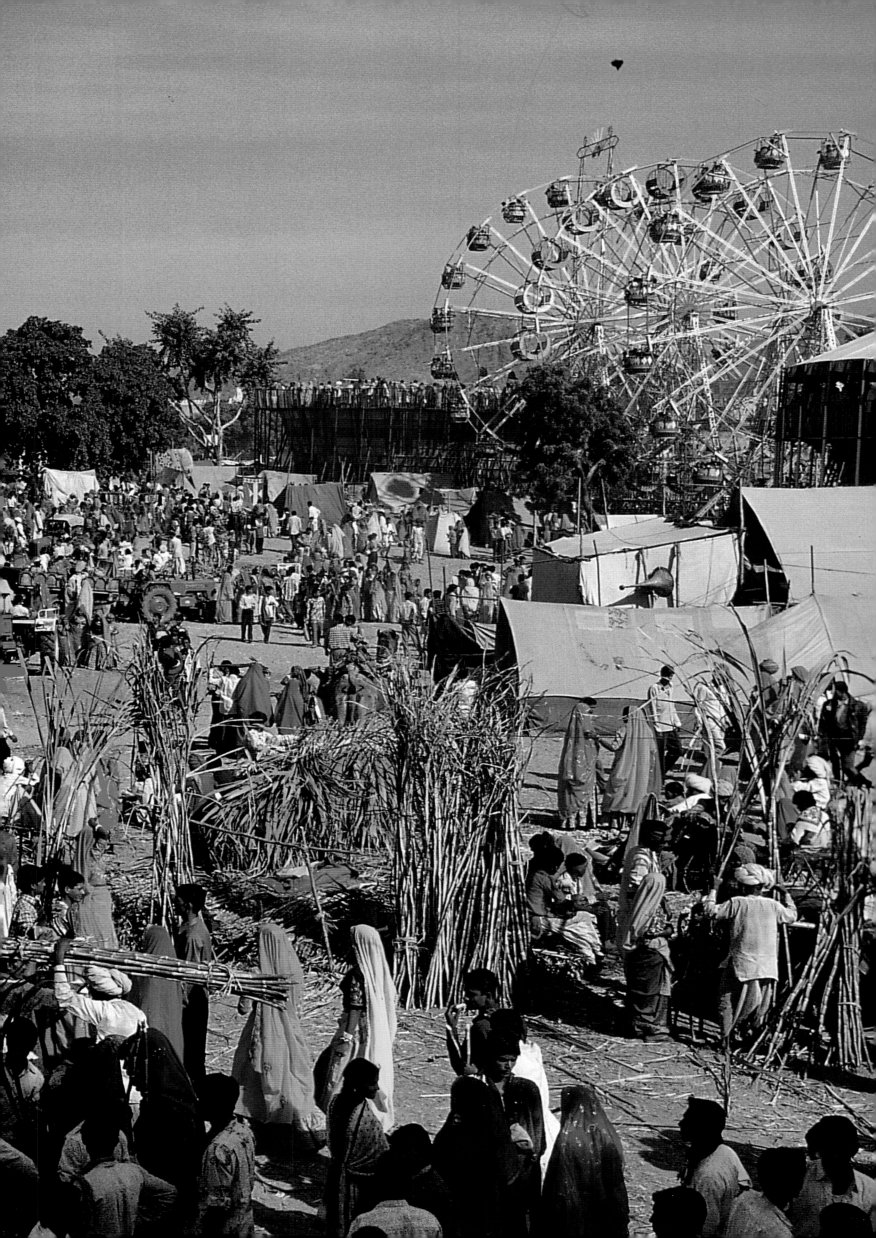

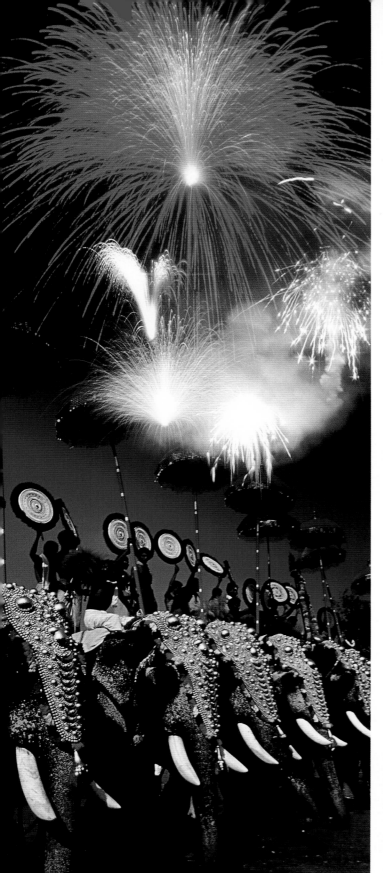

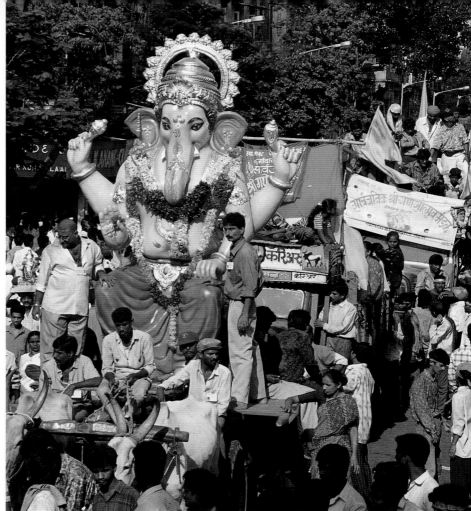

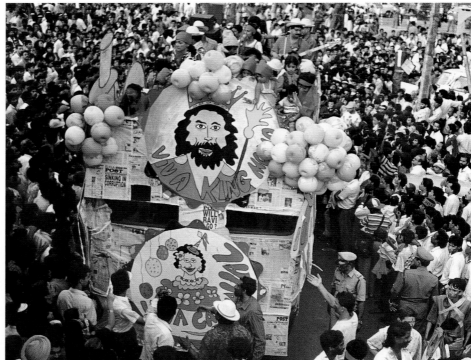

LEFT: *Caparisoned elephants line up for the street celebrations that mark Trichur Puram in Kerala.*
TOP RIGHT: *A Ganesha idol is taken in procession for immersion in Maharashtra.*
BOTTOM RIGHT: *A colorful procession during the Goa Carnival.*

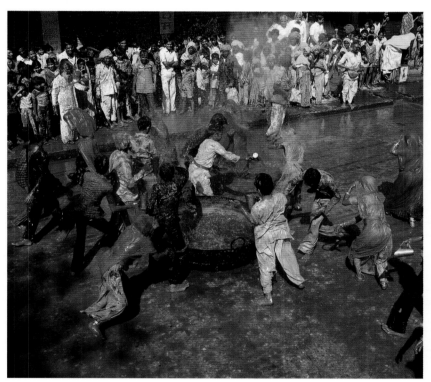

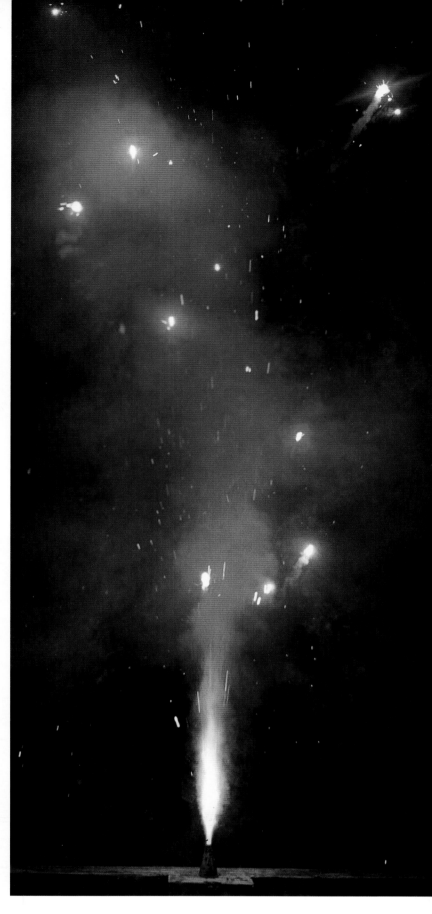

TOP LEFT: *Married women come together to pray for the health and longevity of their husbands in the north Indian celebration of Karvachauth.*
BOTTOM LEFT: *Holi, the spring festival of colors, being celebrated in Rajasthan.*
RIGHT: *Diwali is celebrated on the full moon night of autumn with a dazzling display of firecrackers signifying wealth, as well as the vanquishing of evil and the triumph of good.*

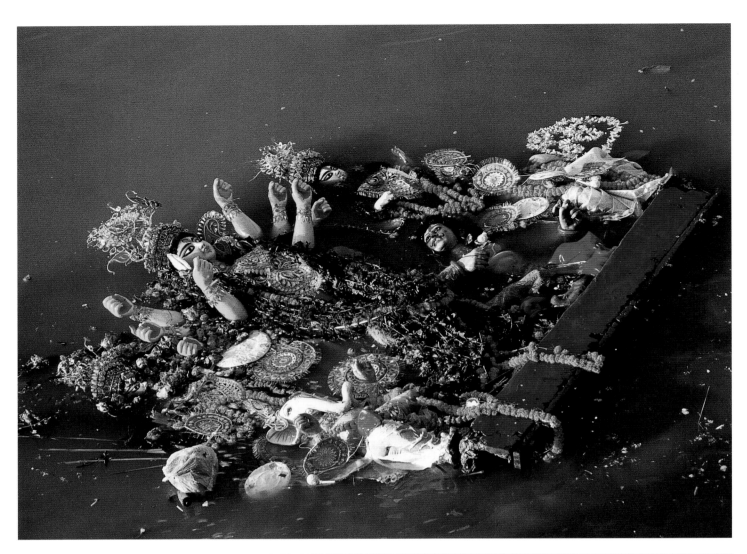

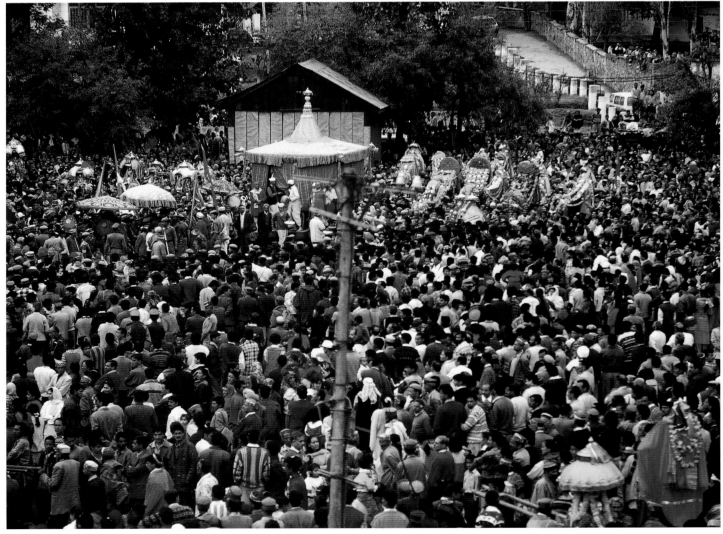

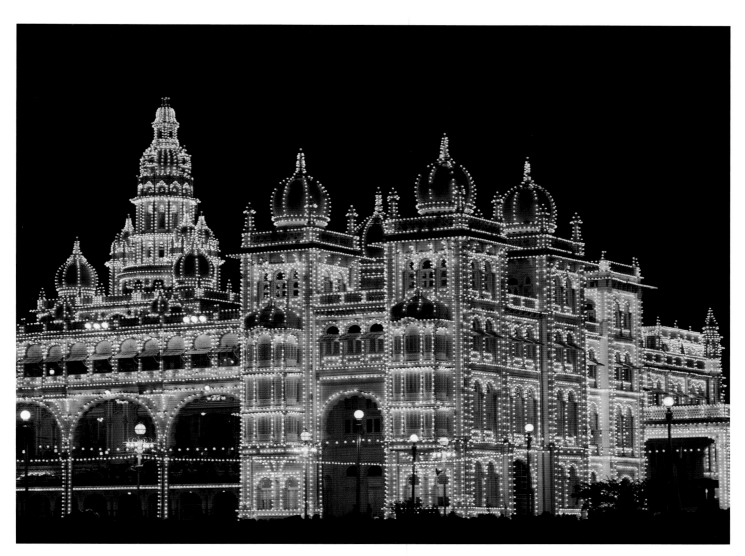

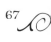

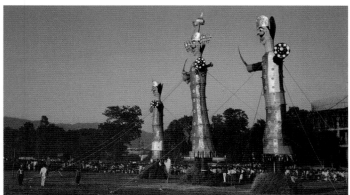

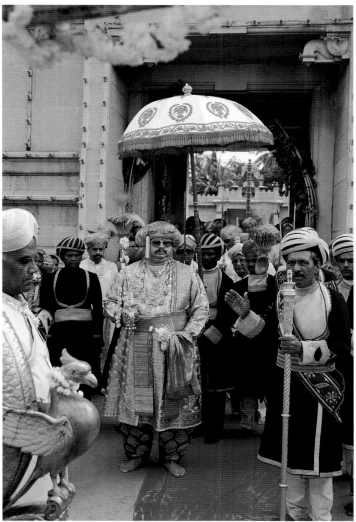

Every festival has its own local flavor and rituals that give it unique significance. Dussehra, for example, takes on different hues throughout the country, even though its message is unwaveringly the triumph of good over evil.

FACING PAGE TOP: *In Bengal, Dussehra is celebrated as Durga Puja, a ten-day event during which the people join the Goddess Durga in day and night-long revelries before the immersion of her images ring out the celebrations.*

FACING PAGE BELOW: *Hundreds of thousands gather at Dholpur Maidan in Kullu, Himachal Pradesh, where gods from all over the valley have been carried in palanquins to join in the celebrations.*

TOP: *Mysore Palace, illuminated especially for the Dussehra celebrations.*

LEFT: *Till recently, the erstwhile Maharaja of Mysore, Karnataka, presided over Dussehra celebrations in the city.*

ABOVE: *In north India, the Dussehra festival ends with the burning of the ten-headed effigy of demon-King Ravana over whom Lord Rama triumphed.*

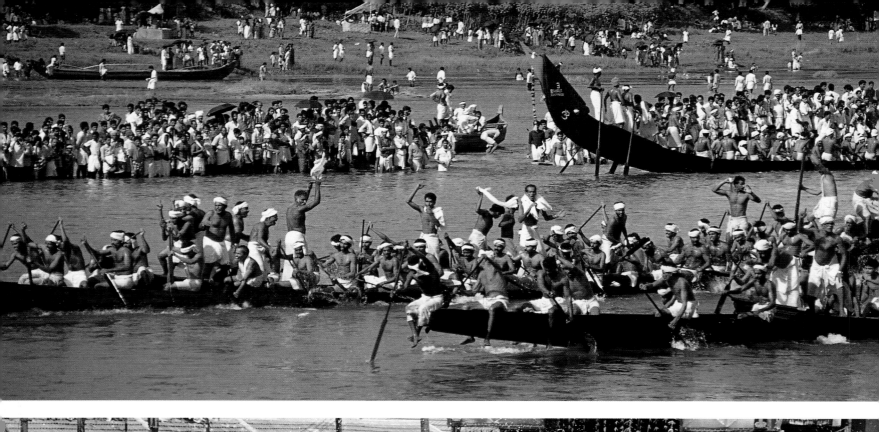

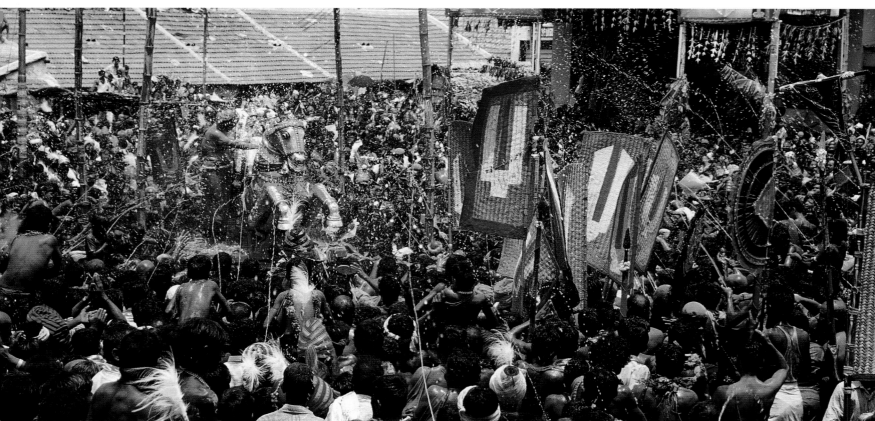

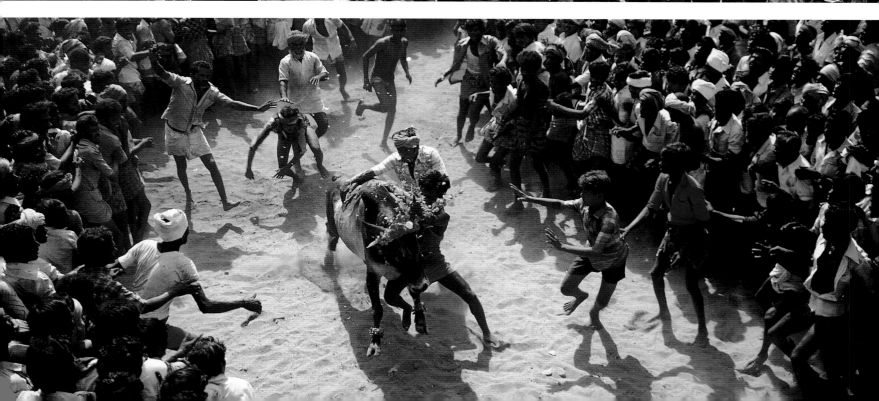

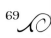

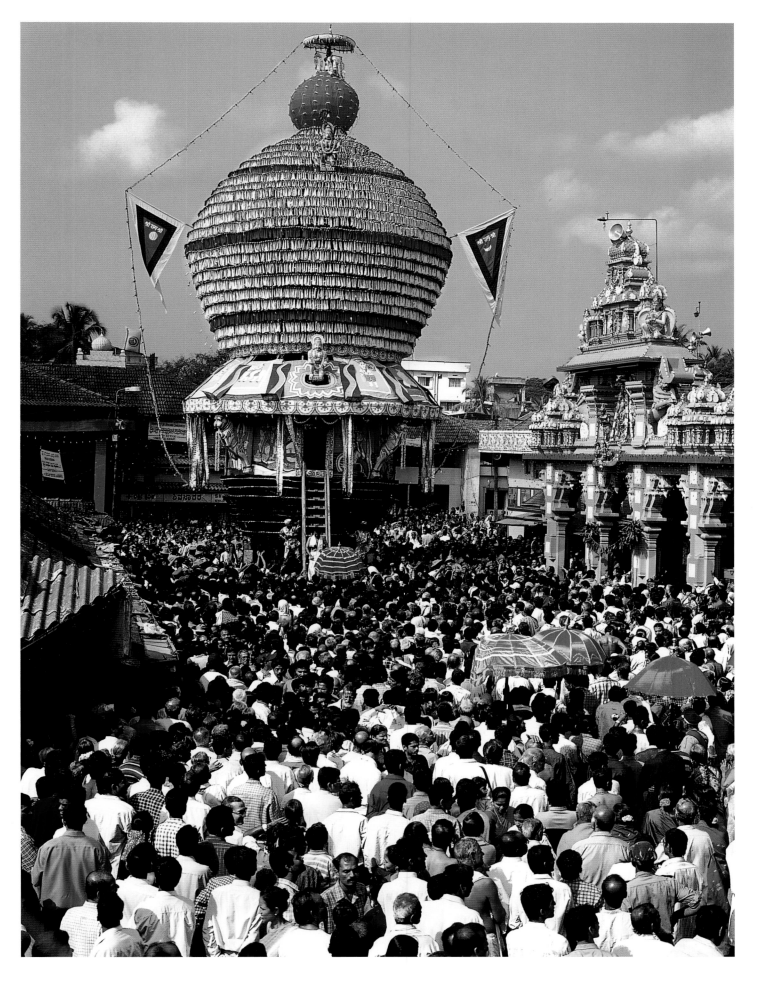

A particular masculine virility marks some of the celebrations in south India.

FACING PAGE TOP: *Snakeboat races in the palm-fringed backwaters of Kerala are a special feature of Onam.*

FACING PAGE MIDDLE: *People congregate from all over to commemorate the marriage of Lord Shiva and his consort, Meenakshi, at the Chitrai festival in Madurai, Tamil Nadu.*

FACING PAGE BELOW: *In Tamil Nadu's version of bull-fighting, young men dare to take on a racing bull as part of the festivities of Pongal.*

ABOVE: *The Temple Chariot festival during Choorna Utsav in Krishna Temple at Udipi in Karnataka.*

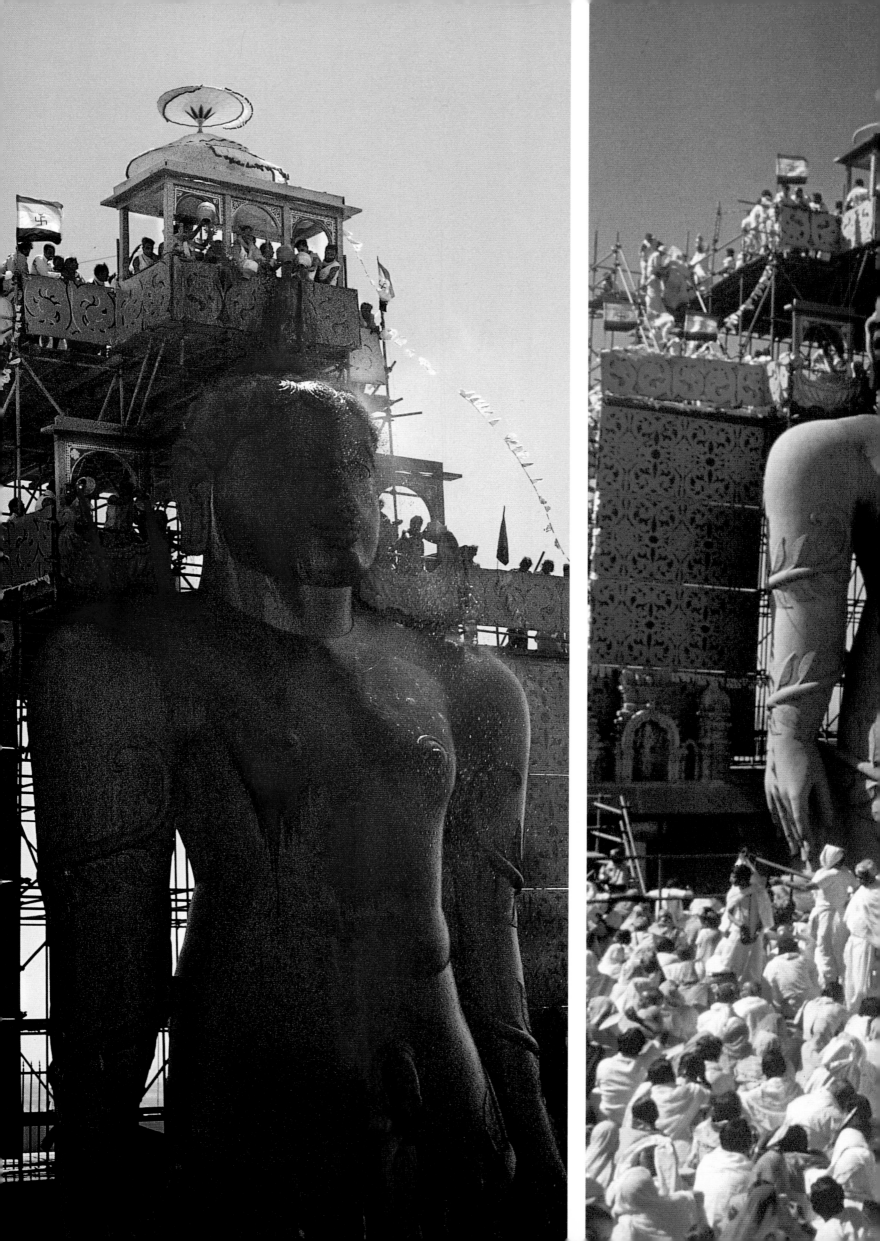

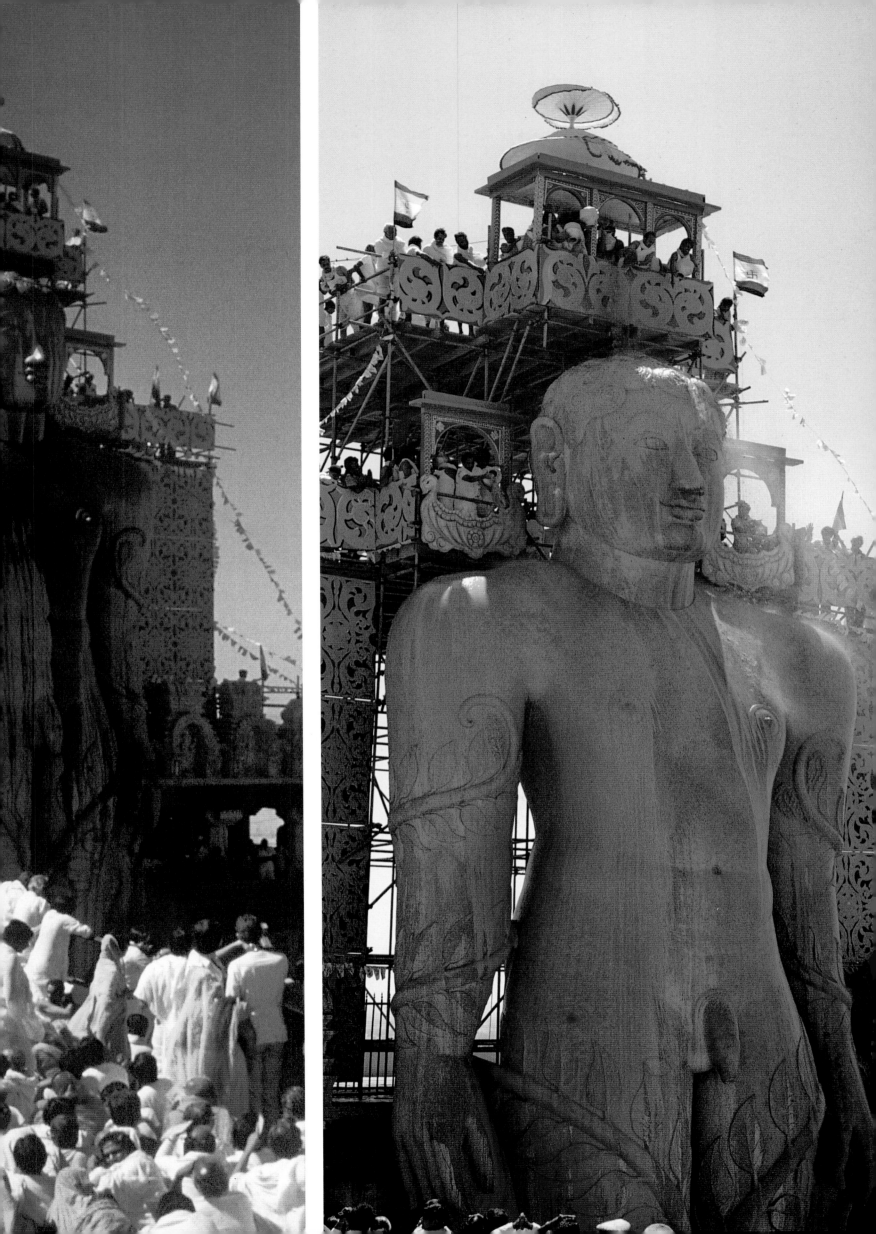

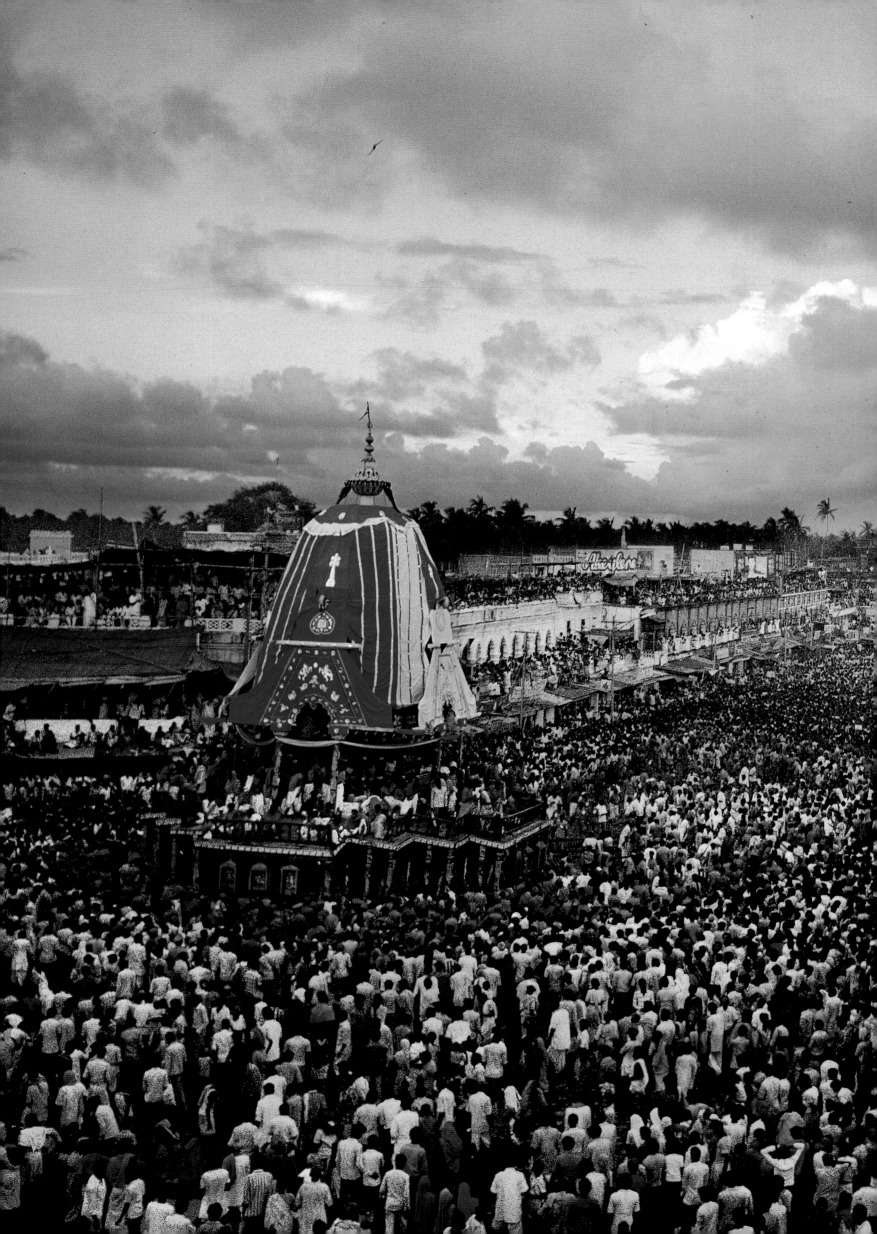

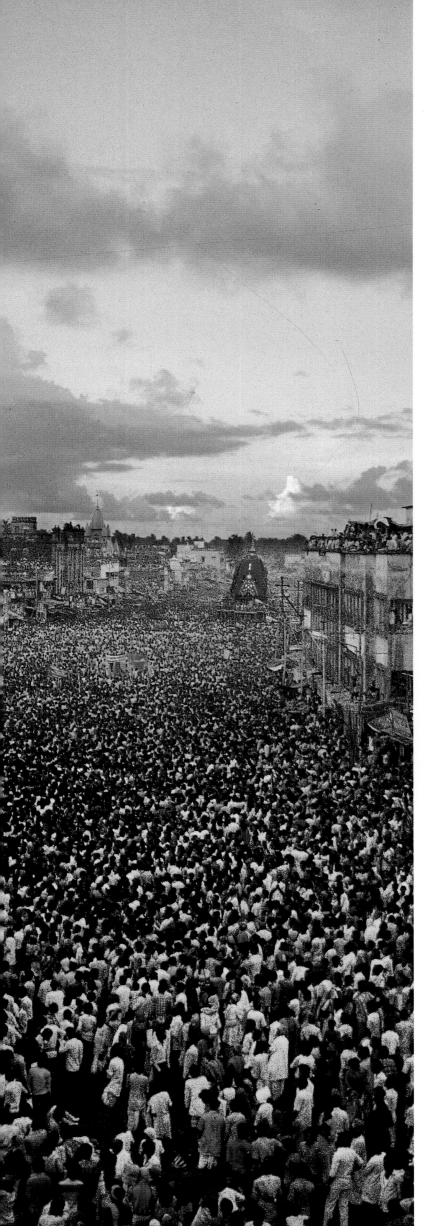

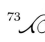

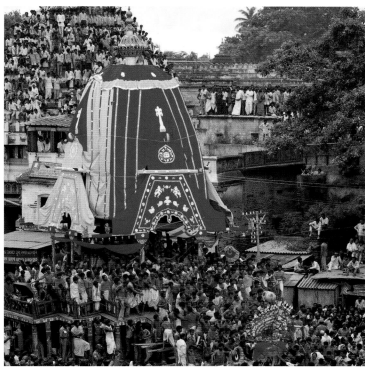

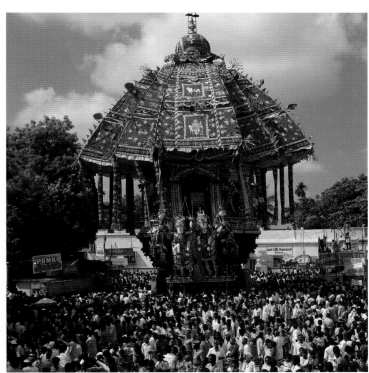

*Temple Chariot festivals are colorful events that involve
thousands of people, who throng the streets to participate in
the sacred act of pulling the God's chariots.*

LEFT AND TOP: *The Rathayatra which takes place in the temple town
of Jagannath Puri in Orissa. Thick ropes are used to pull the ancient
wooden chariots carrying idols of the Lord Jagannath (Krishna),
his brother Balram and sister Subhadra, amidst the chanting of holy
verses. The sea of humanity and the surge of energy has added
at least one word to the English lexicon, 'juggernaut'.*

ABOVE: *The magnificent chariot of the Thyagesa Temple in
Thiruvarur in Tamil Nadu being drawn in procession by
ropes made from the husk of coconuts.*

PRECEDING PAGES: *The enormous, monolithic statue of Jain
ascetic Bahubali Gommateshwara in Sravanabelagola,
Karnataka, is ritually bathed once every twelve years.
Jain devotees and observers from all corners of the world converge
here to witness this sacred head-anointing ceremony.*

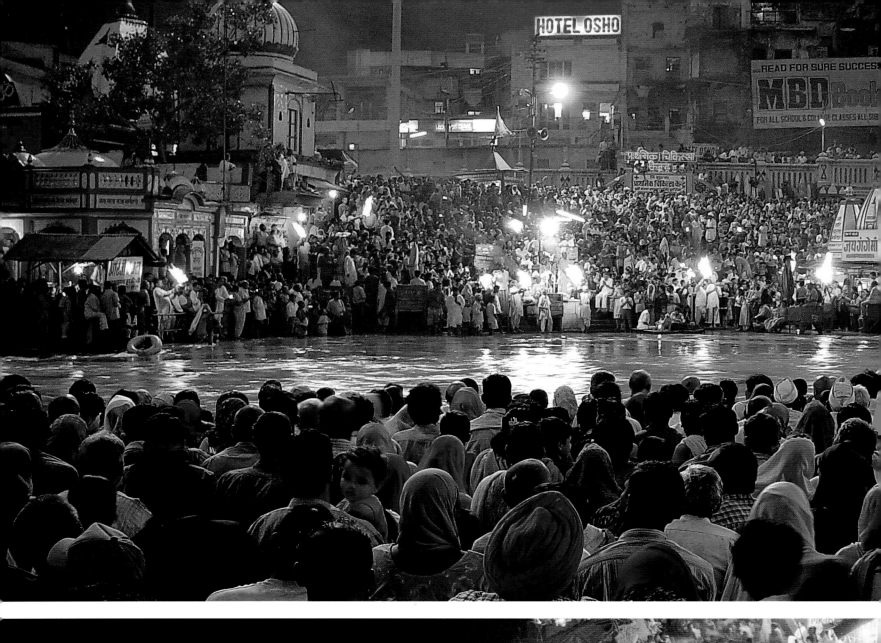
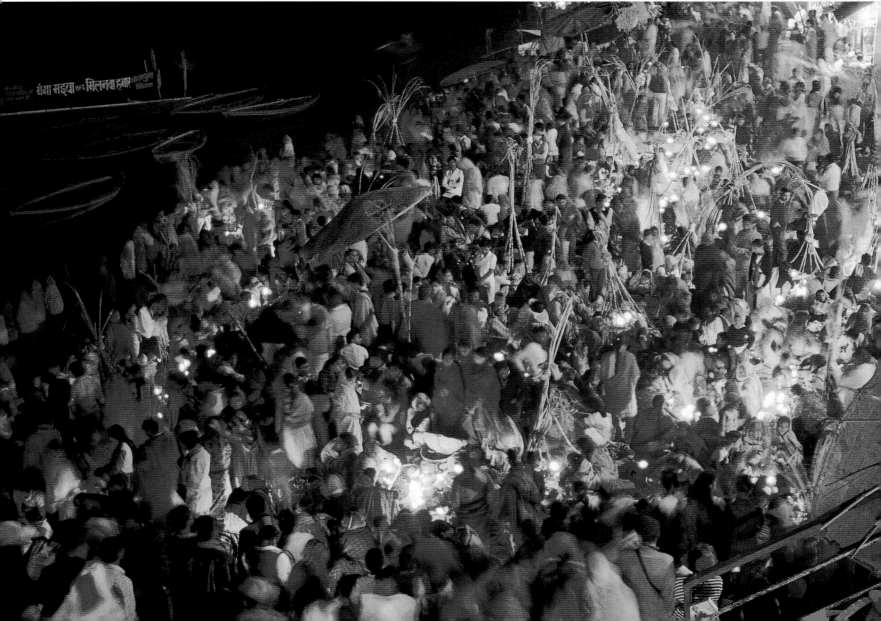

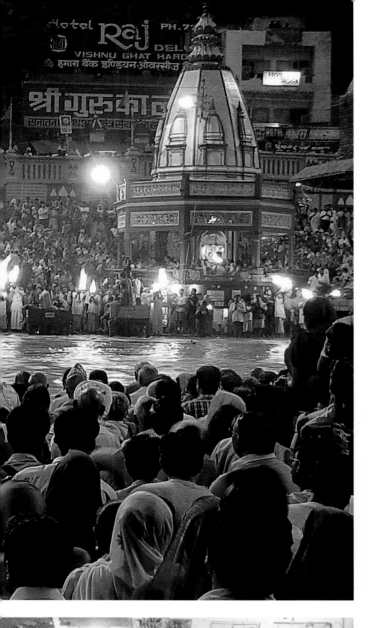

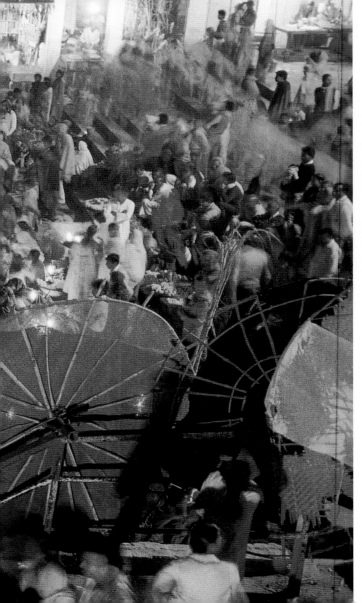

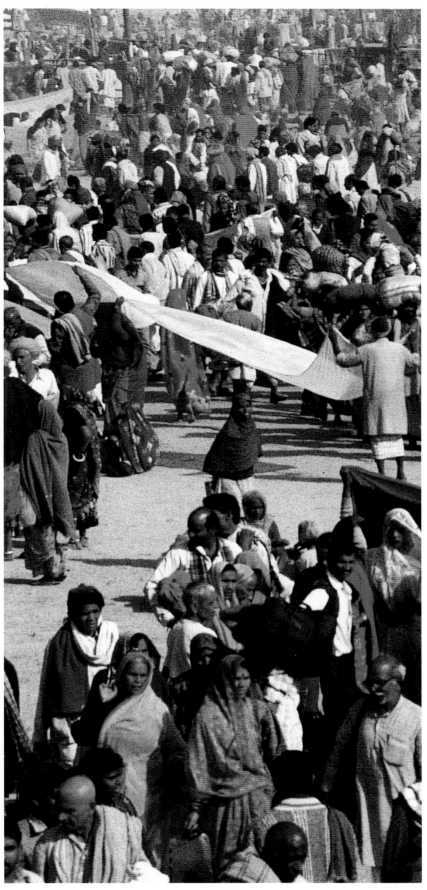

*Rivers are mother goddesses, venerated for their life-giving waters,
and are characterized by mythological personification.*
FACING PAGE ABOVE: *Daily evening prayers being offered to the Ganga at Haridwar.*
FACING PAGE BELOW: *Dawn over the bathing ghats of Varanasi on the occasion
of the full moon festival, when the devout float oil lamps on the River Ganga.*
ABOVE: *The same ghats on the occasion of Kumbh Mela, India's holiest festival
celebrated once every twelve years though there is an annual assembly as well;
pilgrims bathe in the river on the occasion of Kumbh.*

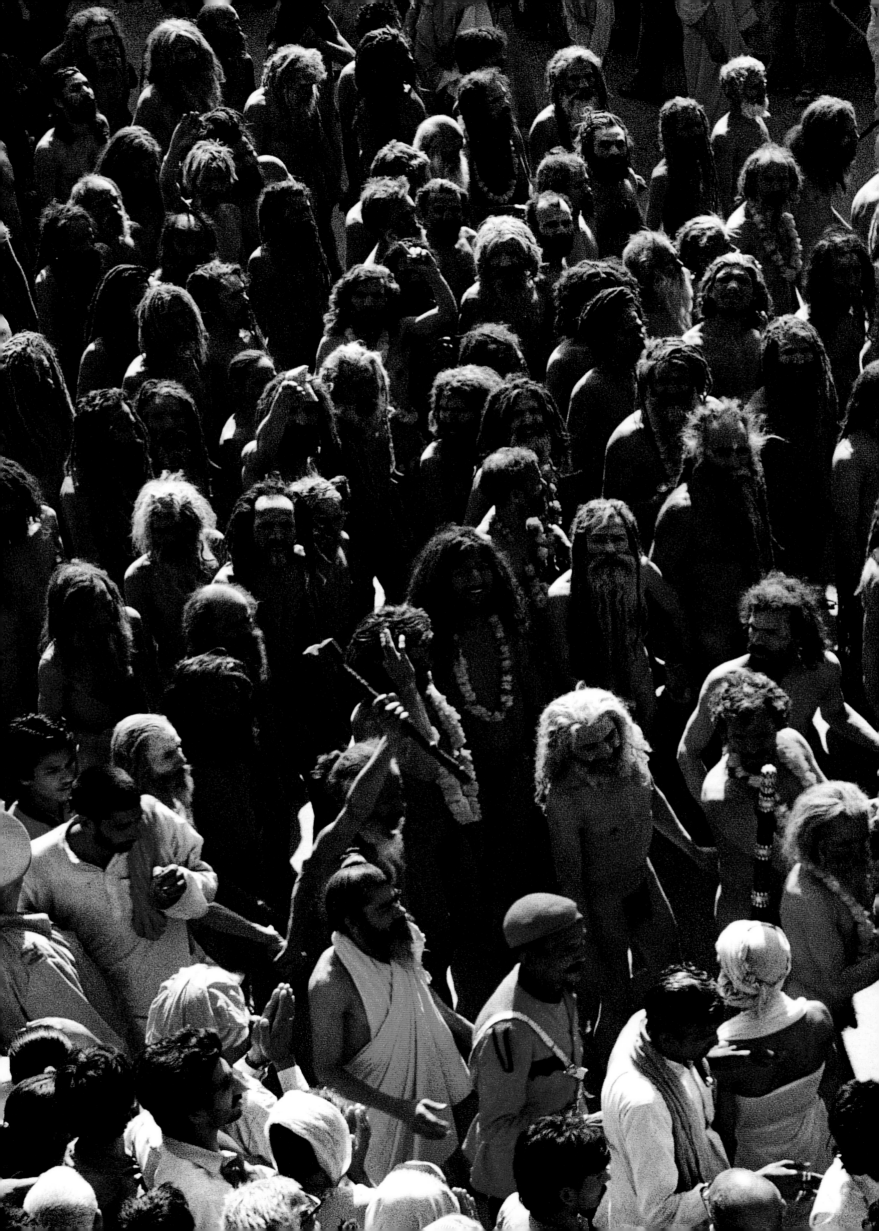

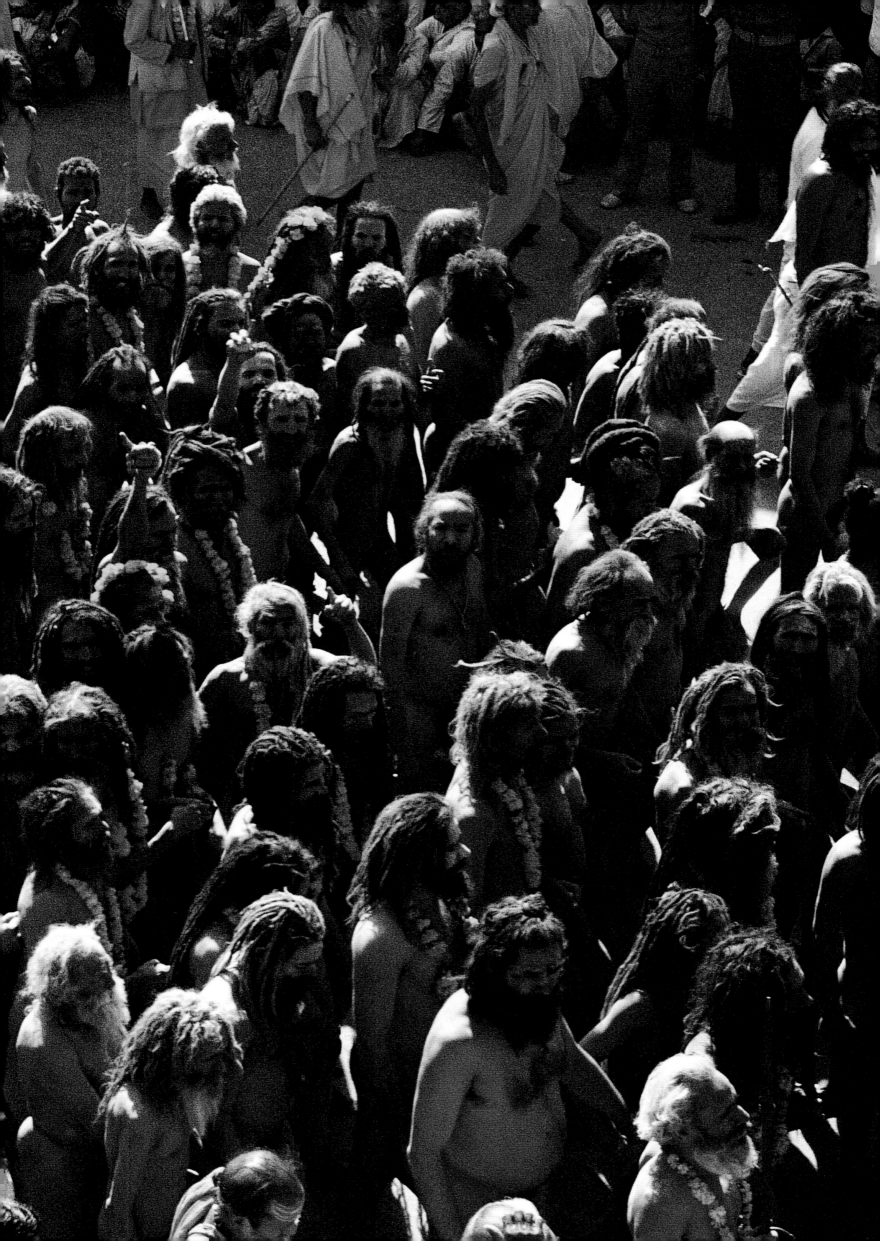

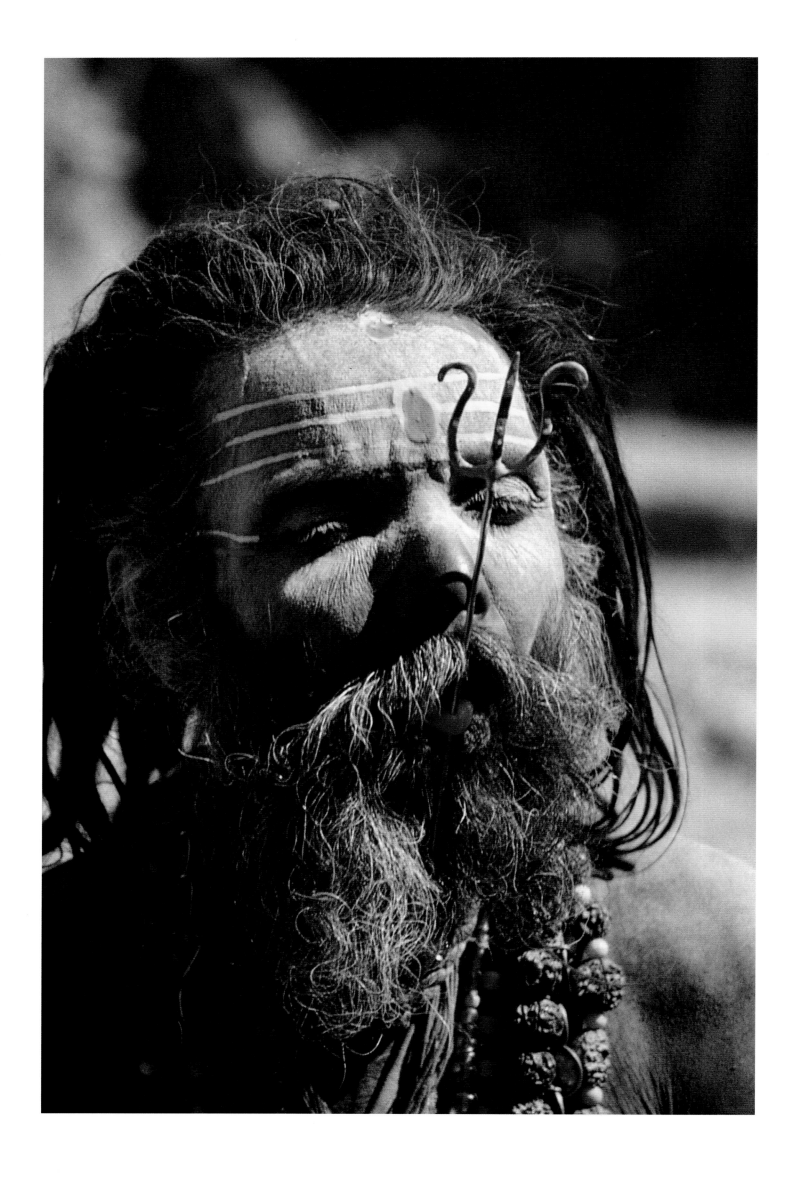

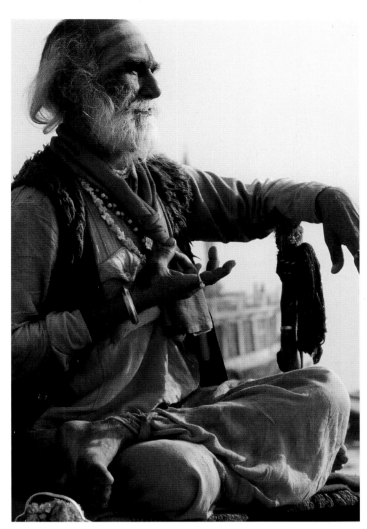
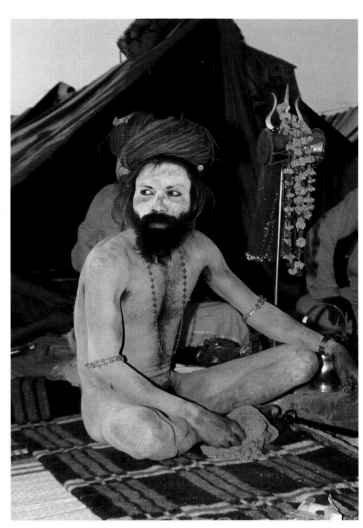
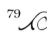
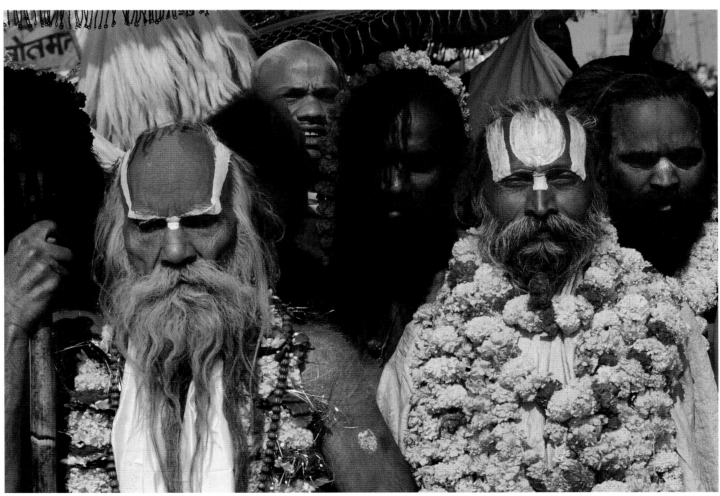

PRECEDING PAGE: *A procession of Naga sadhus, ascetics shorn of all clothes sets the tone for the Kumbh Mela.*
ABOVE: *Holy men and mendicants from all over India gather for the greatest show of Hinduism on earth.*
*Besides Haridwar, the Kumbh is also held at Allahabad, Ujjain and Nasik.*

80

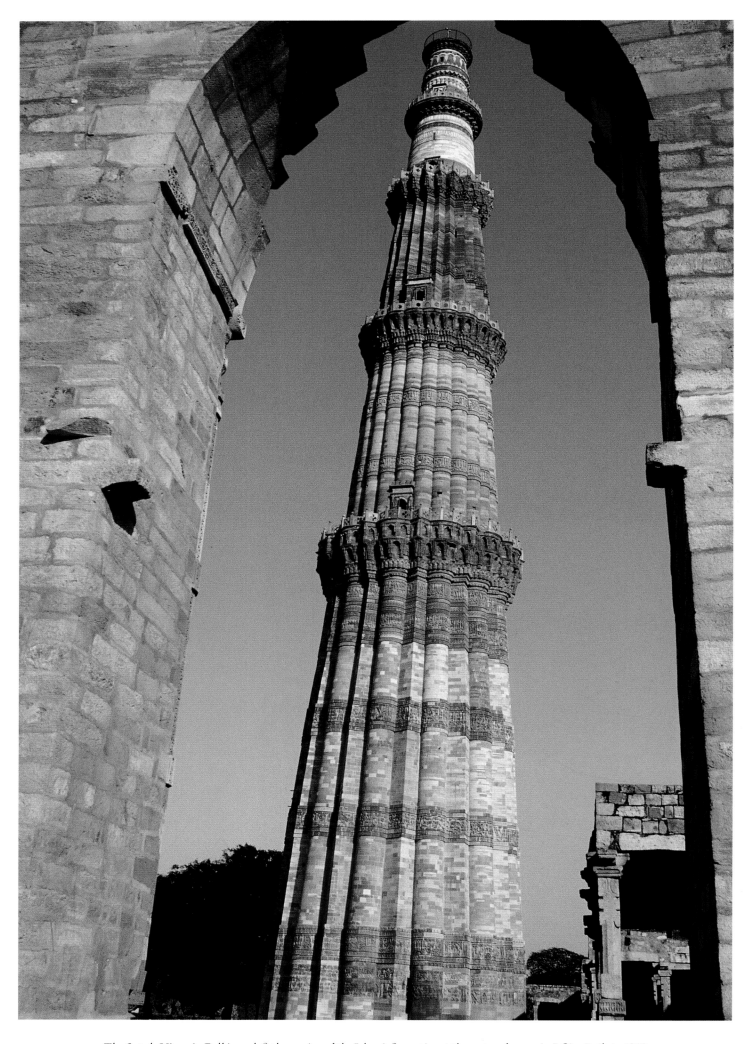

*The Qutab Minar in Delhi marked the coming of the Islamic dynasties at the centre of power in India. Built in 1200, by Qutbuddin Aibak, the five-story victory tower is carved with geometric designs, Koranic verses and calligraphy.*

# Delhi
## & The North

The Himalaya Mountains, in many ways, help to shape the landscape of northern India. The country's great rivers begin in the high snow-capped peaks, flowing down to the valleys to wash across the plains and through the forests. The rivers nourish the land, and fill the smaller rivers and streams that provide vital water for India's fields of wheat, mustard, corn, sunflowers, potatoes, lentils and tomatoes, and also, the quiet shaded orchards of mangoes, guavas and lychees.

Early settlers prospered on these fertile plains and built towns and cities, where manufacturing and trade created bustling centers of prosperity amid the fields and orchards. The wealth of the plains settlements attracted invaders from the north, and over the centuries many of them chose to stay and add their skills and customs to their adopted land. The great temples, mosques, churches and monasteries in India help to tell the story of the country's history, and the movement of people across its expansive plains, washed by the streams and rivers that originate in the glaciers of the Himalayas.

Over time, legends evolved about the most distant peaks of the Himalayas; it was believed these high sanctuaries were the homes of gods and goddesses, and that other mythical beings dwelled where mere humans dared not to venture.

In the lower, more hospitable heights of the mountain range, where deodar and pine forests give way to orchards and terraced fields, the hill people of Himachal, Uttranchal and Kashmir live in the midst of extraordinary beauty. When India's plains swelter in the oppressive summer heat, these "hill stations" attract many who wish to trek and mountaineer in the cool of the lower Himalayas.

The lakes and meadows of Kashmir long have been celebrated as being a paradise on earth. Here, as tourists flow into the state again after many years of strife, a new generation of visitors is discovering life on a houseboat, and the experience of spending a day on a shikara, as it is rowed across the Dal Lake with a heart-shaped oar. The crafts of Kashmir are world-renowned, especially Kashmiri carpets. The designs found in the region's woodcarving and papier-mâché are inspired by Kashmir's mountain orchards and gardens, and also, the leaf of the prevalent chinar tree.

In spring, the fruit trees of Kashmir burst with cherry, apricot, peach and almond blossoms—harbingers of the summer harvest. Kashmir is also one of the few places in the world where saffron grows, and in the spring, the saffron fields filled with purple blooms are a stunning and unforgettable sight.

In the extraordinary landscapes of Ladakh in the far north, visitors are awestruck by the pristine high-altitude desert, where mountains rise in almost unimaginable colors against the sky. The Indus River feeds the towns that have developed in a portion of this area. On the rocky heights are several Buddhist monasteries, which house exquisite paintings and an austere way of life. Perhaps the best known is the Hemis Monastery, where pilgrims and visitors arrive each year for an annual festival.

The other mountain states of Himachal and Uttranchal are filled with lakes and forests, and the glaciers and snowy mountains in their portion of the Himalayas stir the imagination, and calm the mind with their beauty. Himachal is known for its apple orchards, and its pine and deodar forests. In Uttranchal, oak and rhododendron forests and high-altitude meadows give way to orchards, where apricots, peaches and plums are grown. When the Dalai Lama fled Tibet after the Chinese invasion in 1961, he and many of his followers came to live in Dharamsala in Himachal Pradesh, and this hill town, along with the neighboring town of McLeodganj, developed a special character in the decades that followed. The presence of the Dalai Lama, and the monasteries and Buddhist temples that have been built here, make this corner of the hills quite unique.

There are many places of pilgrimage in India's mountains, and sacred festivals that draw large numbers of devotees to shrines located there. The source of the Ganges River is considered to be an especially holy place of pilgrimage. Some of the pilgrims set out on a journey called the Char Dham Yatra hat leads them to the four most holy shrines in the mountains: Gangotri, Yamunotri, Kedarnath and Badrinath.

In the plains, on the banks of the Ganges River, is the holy city of Varanasi, one of the oldest, continuously inhabited cities in the world. It is believed that those who die in Varanasi are freed of the cycle of rebirths and attain moksha, or salvation. Visitors to Varanasi often join local people as they make their way at dawn to the steps of bathing ghats beside the river. As the sun rises over the Ganges, voices are raised in chant, and devotees take a dip in the river, praying to the Ganges and to the sun as they immerse themselves in the holy water. Not far from Varanasi is Sarnath, where it is said Buddha preached his first sermon. Spiritually inclined people of all faiths come to the stupa at Sarnath to ponder Buddha's eternal message of peace and compassion.

Among other sacred places located on the Indo-Gangetic Plain is the holy town of Mathura, which is associated with Lord Krishna and his childhood spent years among the cowherds of Vrindavan. Mathura, located between New Delhi, and Agra, the city of the Taj Mahal, was once an important center of sculpture, and during the Gupta period, artists who lived here beside the Yamuna River crafted images of extraordinary beauty. The Yamuna still flows past the temples and ghats of Mathura, and visitors to the city's museum can admire some of the statues that made Mathura a famous art center.

Further north are the temple towns of Haridwar and Rishikesh, where the Ganges runs through narrow banks, still retaining the chill of its glacial origin. In Haridwar, temples line the banks of the river and devotees come from distant corners of the country, and the world, to worship at this sacred place. A few miles north of Haridwar, temples and the ashrams of learned teachers and spiritual gurus are a magnetic pull for those interested in spiritualism, yoga and meditation. In recent years, the rapidly flowing water north of Rishikesh has become a popular venue for whitewater rafting, and during the sport's season, there are camps along the river's sandy banks, where

kayaks and rafts invite the adventurous to explore the Ganges in their own way.

Also along the banks of the Yamuna River, in the Indo-Gangetic Plain, stands New Delhi, the capital of India. New Delhi's evolution embodies the diverse strands that have been woven together to create the north India of today.

Long ago, on an open plain beside the Yamuna, a major tributary of the great Ganges, a martial king established his capital. An army of invaders defeated the king, and in the centuries that followed, each new group of conquerors established their own citadel of power, leaving New Delhi's modern-day residents to live among a scattering of ruins that punctuate the burgeoning urban turmoil of a city on the move.

Each conqueror laid claim to one section of the land, and the last of them all, Great Britain, built a great imperial capital that clearly showed confidence that British rule in India would endure for centuries. In just a matter of decades, however, the British were gone, and the settlers who arrived soon after overflowed the city's well-planned avenues and parks to create new "colonies" to erase the architectural evidence of the past.

Today, as the city continues to grow, its residents still speak of the seven original cities of Delhi, even as new buildings and shopping malls obliterate reminders of their existence. The new population is focused on the future rather than the past—even though history remains on their doorstep, insistently claiming attention from all who pass.

The people of Delhi speak of north, south, east and west, and also of new directions, such as "south of south Delhi". As the population spills over into the neighboring state of Haryana, fields turn to fashionable farmhouse mansions and then to crowded streets of housing and markets in what seems like the blink of an eye. This pattern is repeated across much of northern plains, and even into the foothills of the Himalayas, as the hum of development fuels aspirations of a growing population with upwardly mobile ambitions.

In the distant past, the Indo-Gangetic plains was well-watered forestland, which hosted small settlements of pastoral people who lived beside the river, and cleared small tracts of farmland for their modest crops and

cattle herds. As they began to trade and their wealth grew, small towns appeared, as did temple cities of power and prosperity. Kingdoms emerged, and wars scarred the land. Empires came and went, and so did grand capital cities, where elaborate palaces proclaimed the might of a victorious ruler.

In the north, Kashmir became a center of learning and political power. In the west, many small areas ruled by rajas, or kings, eventually came to be known as Rajasthan, the land of kings. In the east, in the area now called Uttar Pradesh, craftsmen and farmers prospered greatly on the banks of the sacred Ganges River, without which the great forests and farmlands, forts and palaces, and temples and cities would not have been possible. The Ganges became a conduit of trade, providing a means of transport for people and their goods, and offering fertile alluvial soil for settlements to thrive. And in the middle of the desert, plains and mountains of central India, emerged the city known as New Delhi, the capital of India.

The name "New Delhi" is actually quite recent. The Mughals called their urban settlement Shahjahanabad, and the rulers who preceded them named their settlements Mehrauli, Lal Kot, Tughlaqabad, Siri and Dilli. New Delhi has not stopped growing since the end of British rule. In every part of the city are reminders of the past, from domed tombs of the Tughlaq and Lodi dynasty, to enormous forts, such as Tughlaqabad, and the hints of other forts, like Siri, of which only fragments remain to hint of what was once an enormous circular citadel. The water tank, which once supplied the Siri Fort, still remains, and the madarsa, a religious center of learning, is beside it. In the center of the city, near the commercial center of Connaught Place, there survives a medieval observatory, called the Jantar Mantar, built by a scientifically inclined Maharaja of Jaipur. And one of the city's most beautiful parks is built around four tombs of the Lodi dynasty that preceded the Mughal Empire.

The Mughals left a rich architectural legacy in Delhi, beginning with the remains of what is called the "Old Fort"—the Purana Quila, built by Emperor Humayun and a ruler called Sher Shah, who also built the Grand Trunk Road, which once ran from Lahore to Kolkata, and is still one of the major highways in the country. Emperor Humayun's Tomb, built by his widow, is considered the precursor to the Taj Mahal, with its splendid dome and high plinth, set in a formal garden

divided by waterways. The location of Humayun's Tomb was influenced by the fact that an important Sufi shrine already existed in the area. For more than 700 years, worshippers have come to the Dargah of Sufi Saint Nizamuddin Auliya to pray and sing at his grave and also, in the courtyard outside his tomb.

In what is called "Old Delhi", the city established by the Mughals, is the Red Fort, built by Emperor Shah Jahan, who also built the Taj Mahal in Agra. Across the road from the Red Fort is the stately Jama Masjid in Chandni Chowk, one of the most crowded and picturesque bazaars in the city. Here, in small alleys, are purveyors of a dizzying array of goods, including silver jewelry, paper, pearls, saris, flower garlands and spices. For a moment, you may feel as if you have stepped back in time, until the ring of the ubiquitous cellular phone returns you immediately to the 21st century.

Small shops dealing in attar, or perfume essences, are among the treasures that can be found in Chandni Chowk, as you dodge cycle rickshaws, scooters, cars, buses, pedestrians and cows. Among the shops in Chandni Chowk stands an exquisite Jain temple, which also is a hospital for birds and a sacred Sikh shrine. Old courtyard homes, once set in garden spaces and quiet corners, can be found by the visitor who seeks them, and who can endure the frenetic pace in the old city's narrow, crowded thoroughfares.

Just a few miles away, via a short scooter or rickshaw ride, are the spacious avenues and bungalows that were built by the British. The change of style is surprisingly sudden: the wide vistas of India Gate, and the tree-lined avenues that radiate from the park along Rajpath—once called "King's Way"—that leads to the Rashtrapati Bhawan, the imposing Presidential Residence and the Secretariat built in classical western style. The circular Lok Sabha, the House of Parliament, is beside the Secretariat, and on the streets that lead to Rajpath are other grand government buildings, such as the National Archives and the National Museum, constructed of buff and pink sandstone, in keeping with materials used for the grand structures at the top of Raisina Hill.

Moving south from Rajpath, are other grand structures, including the embassies of other nations, which are located on Shanti Path, the Avenue of Peace. Beyond here are the private homes of India's capital, some opulently bursting out of the modest plots of land on

which they stand. More humble single-story structures are being demolished with increasing frequency to make way for blocks of flats, in response to pressure from the city's rapidly growing population.

As prices for housing rise, more people in Delhi are choosing to move south to the suburbs in Gurgaon, where massive malls and tall apartment buildings create a landscape that looks like that of almost any other city in the world today. Delhi also has spread east, beyond the Yamuna, as new blocks of housing continue to rise on what was once farmland in the neighboring state of Uttar Pradesh.

The rapid growth of the city has led to a fascinating juxtaposition. Villages are being overtaken by urban structures, with farmers' cattle carts and tractors are sharing space with the trendiest imported cars. Cycle rickshaws vie for space with Mercedes Benz, and women in swirling skirts pat cow dung in the shadow of advertising for the latest computers or television shows. New Delhi is a city on the move, and the future and past attempt to coexist as the city's busy, hurrying residents try to keep up—or catch up—with the shifting, churning, turmoil of the rapidly changing present.

New Delhi, Agra and Jaipur make up a frequently visited tourist circuit for first-time visitors to India. Trains conveniently connect the cities; so do new and improved highways, which make it possible for visitors to fly to New Delhi, drive to Agra to see the Taj Mahal, and then travel to Jaipur to take in the architecture and fabulous craftsmanship of the desert state of Rajasthan.

However, there is a great deal more to see in these places. Agra was once the capital of the Mughal Empire, and its architecture is still spectacularly impressive. The Fort in Agra is a splendid structure with delicately decorated palaces and a beautiful mosque within the rugged walls. The tomb built by Empress Nur Jahan for her father, Itimad-ud Daula has been described as a "jeweled casket" for its fine Pietra dura inlay of semi-precious stones set in marble. The craft of inlay work reached a high point at the Taj Mahal, and the descendants of craftsmen who helped to build these great structures may still be found in Agra, using their skills to create smaller objets d'art, some of it of the very finest quality.

A short distance outside Agra is the well-preserved royal town of Fatehpur Sikri, where Emperor Akbar built his Capital on a hill that was the home of the Sufi saint, Salim Chisti. The saint's tomb is still a place of pilgrimage, and the palaces in which the emperor once lived and worked remain a beautifully conserved slice of the past, fascinating visitors who are entranced by the architecture, as much as they are by their thoughts of the grand, royal life which once existed within these walls.

Visiting New Delhi, Agra and Jaipur is a good start for those wishing to explore north India, for these places introduce visitors to the subcontinent's many layers, and to the way in which multiple centuries seem to exist simultaneously in the daily lives of its people. By traversing this triangle, one can experience the spectacular openness of the western desert, the ice-clad Himalayas, and the densely populated plains, which together create the area's unique landscape. This is a place of endless discovery, even for those who have lived their entire life in the inspiring and varied region of north India.

*Monisha Mukundan*

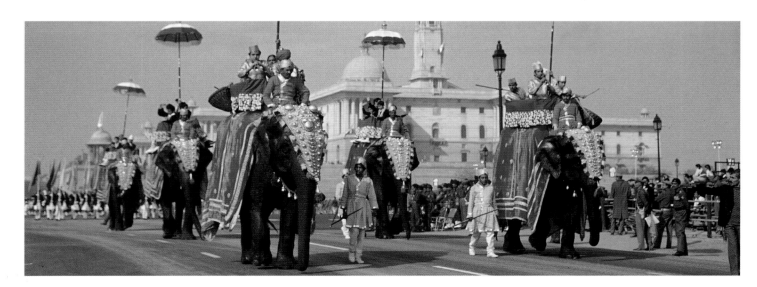

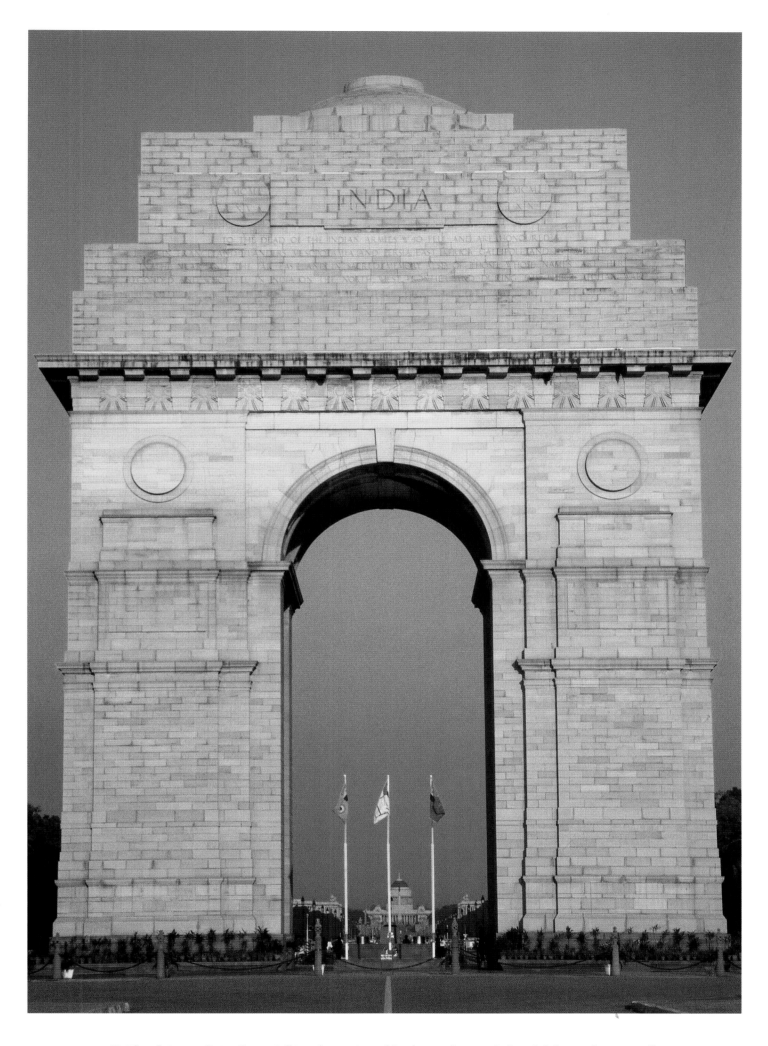

*Sir Edward Lutyens designed New Delhi as the new Capital for the British, to mark their shift from Calcutta to Delhi.*
*At its heart is India Gate, the war memorial that commemorates the soldiers who lost their lives in the Second Afghan War.*
*Rashtrapati Bhawan is visible through its arch, built as the viceregal lodge, which is now the official residence of the President of India.*

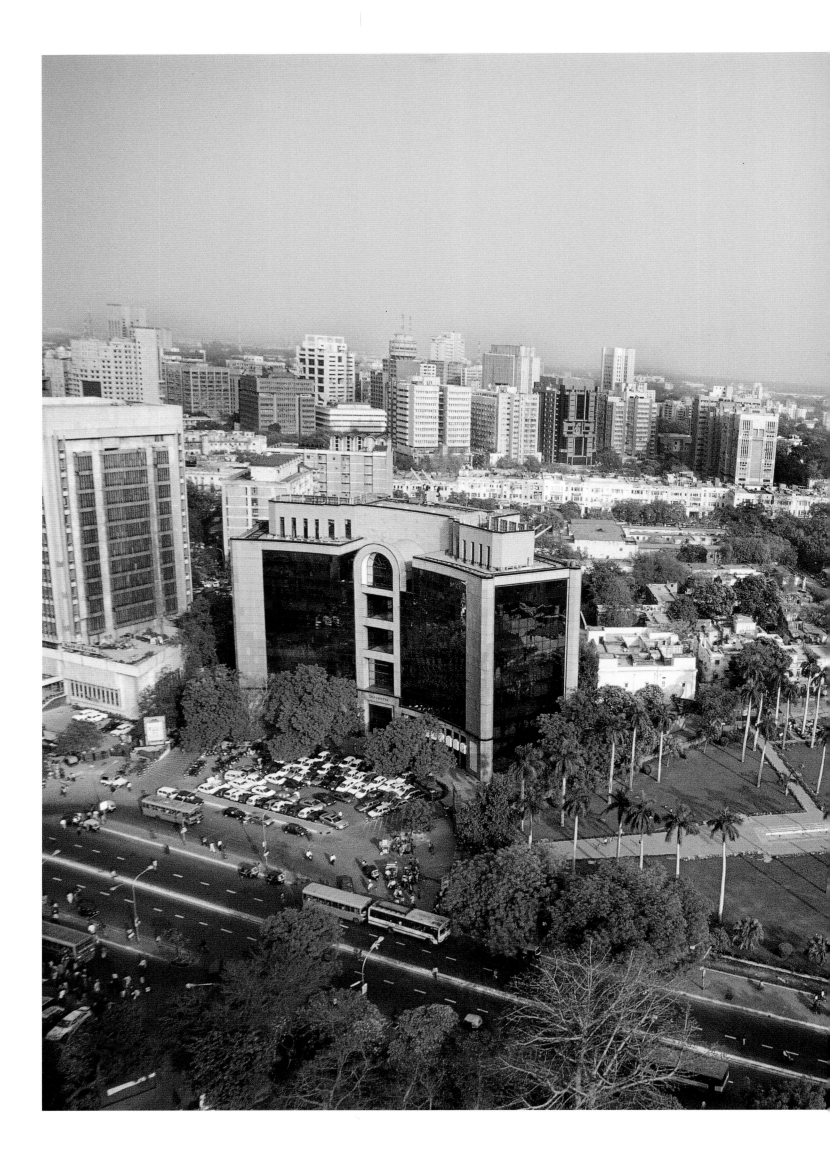

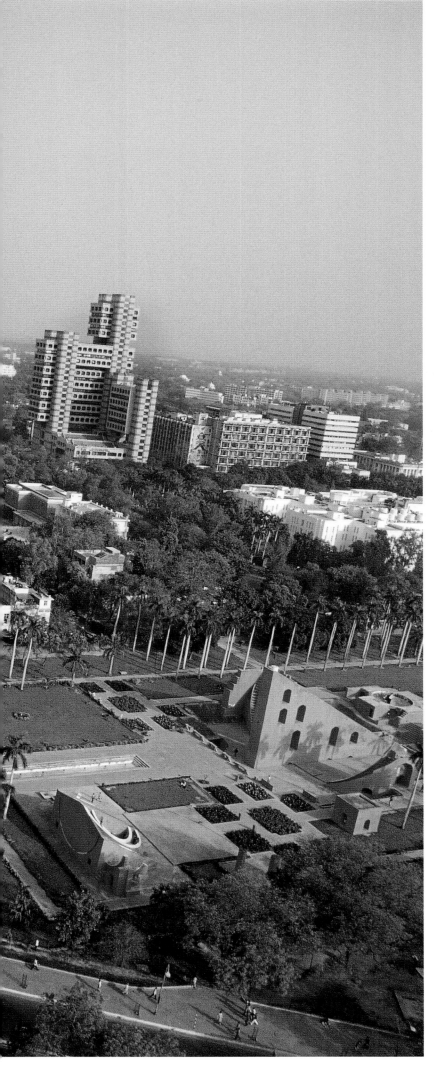

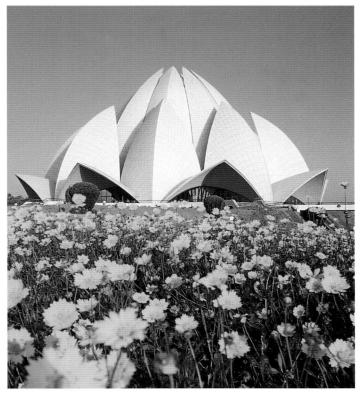

LEFT: *New Delhi has a garden character, even in the modern shopping district of Connaught Place, where highrise structures have sprung up close to the Jantar Mantar, the stone observatory built by Maharaja Sawai Jai Singh II of Jaipur in 1724.*

TOP: *Birla Mandir or the Laxminarayan Temple, is the hub for the Hindu devotees.*

ABOVE: *The lotus-leafed, marble-clad Bahai Temple was completed, as recently as 1986, and is surrounded by gardens.*

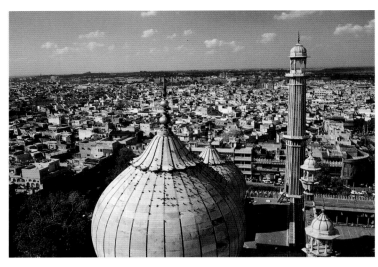

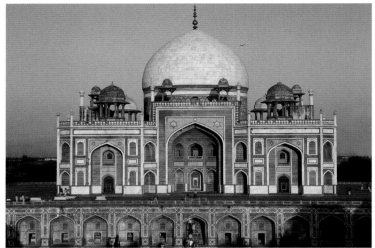

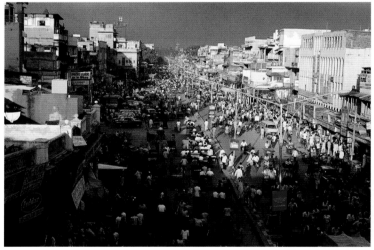

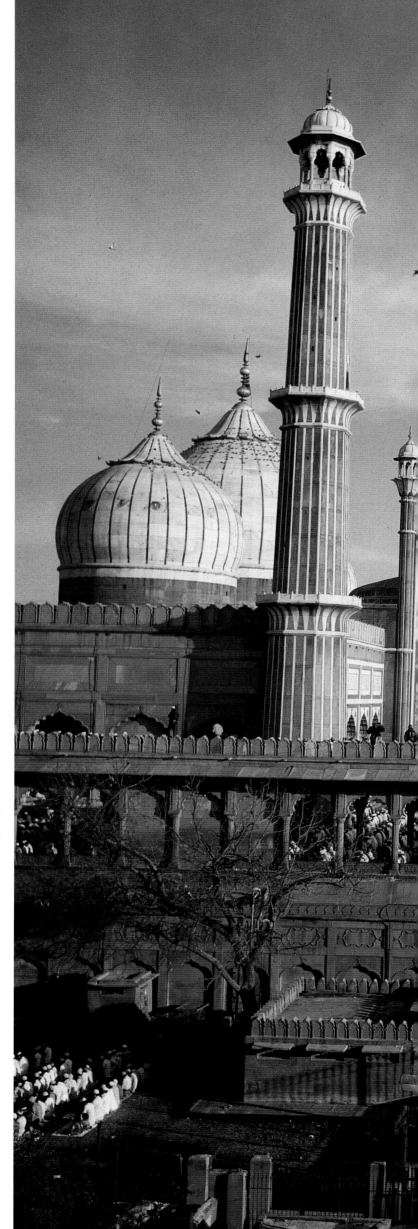

The city owes much of its Mughal flavor to the dynasty that was started by
Babur, a Mongol chieftain, who made Delhi and Agra the seat of his power.
TOP: *A view of the Old City from Jama Masjid, India's largest mosque built
during Shah Jahan's reign, characterized by a lofty entrance gate,
massive flights of stairs, marble domes and slender minarets.*
MIDDLE: *Humayun's Tomb, a forerunner of the
Taj Mahal, was built in 1564, by the emperor's widow, Haji Begum.*
ABOVE: *Chandni Chowk, now a bustling center for wholesale trade, was once
the domain of elite power in Emperor Shah Jahan's regime.*

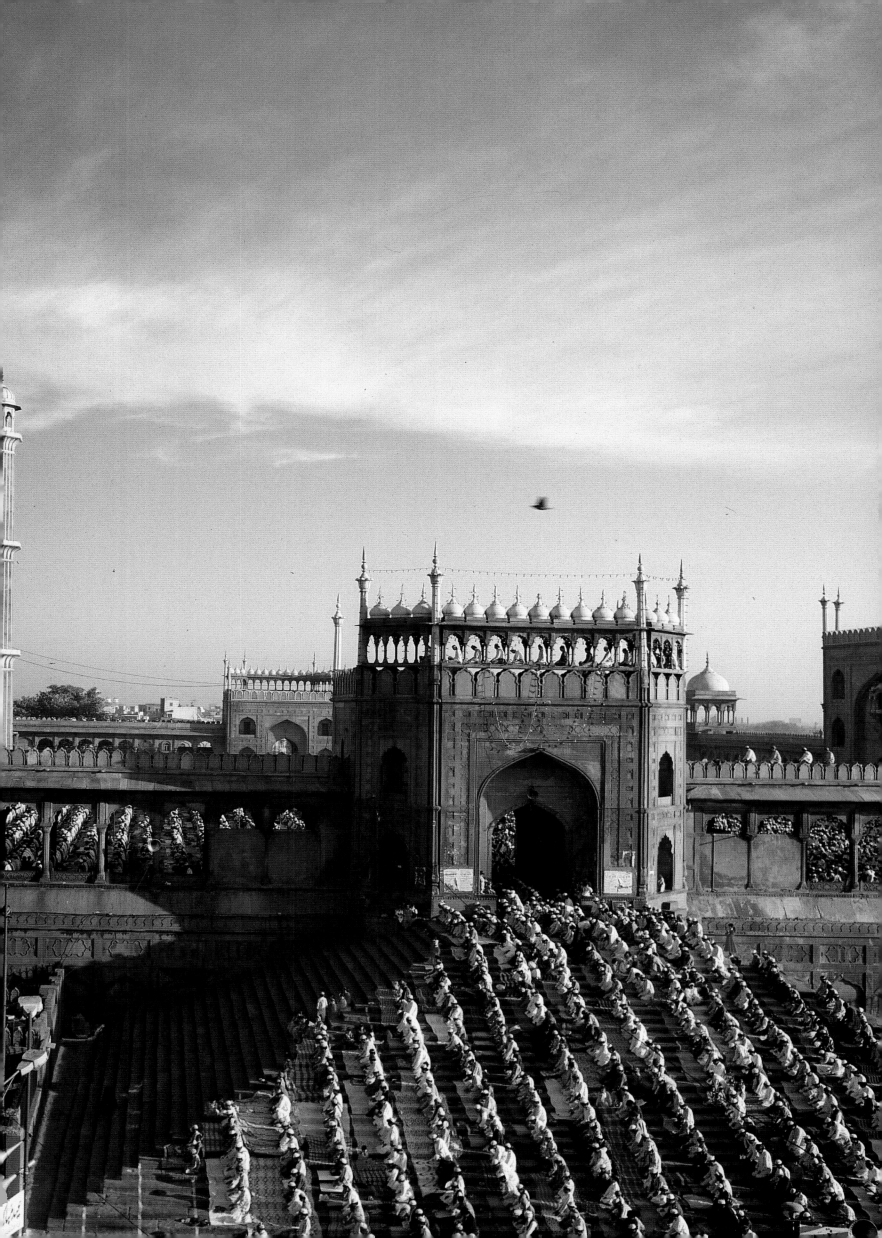

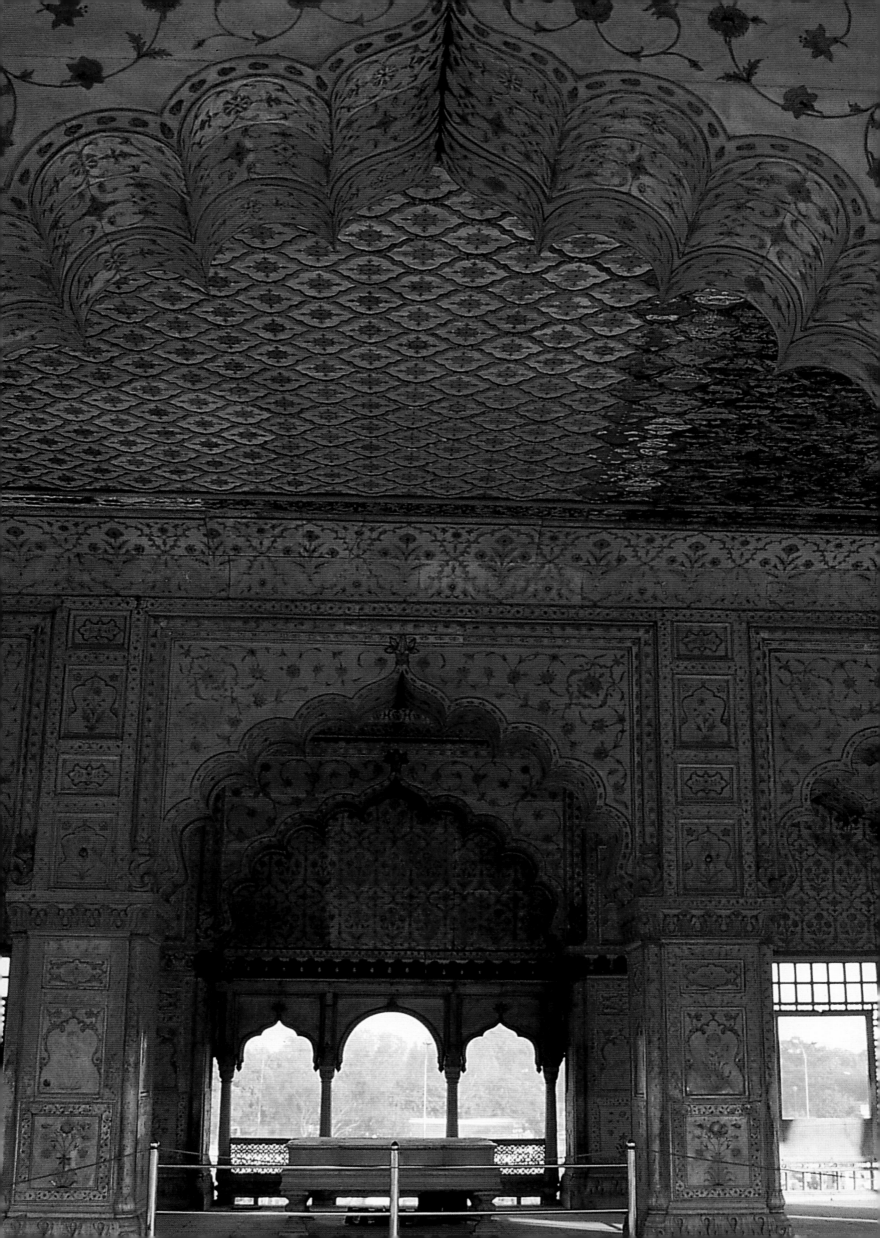

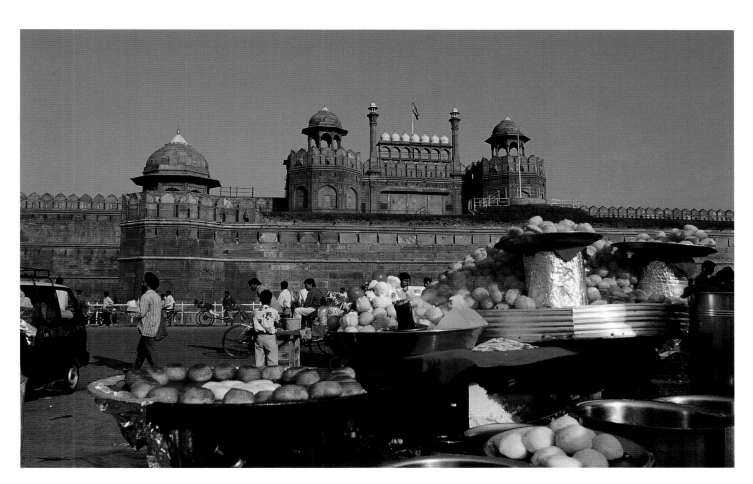

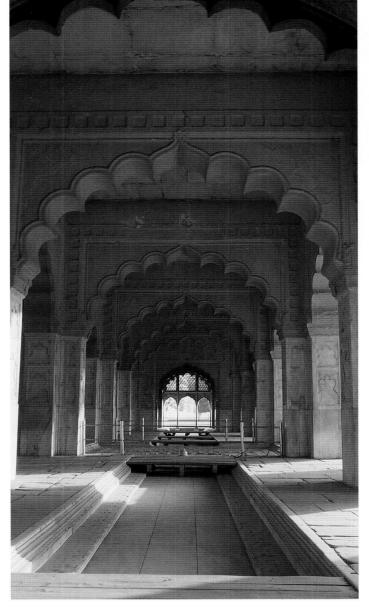

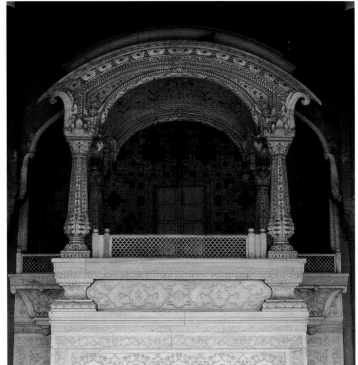

FACING PAGE AND ABOVE: *Emperor Shah Jahan ordered the building of the Red Fort on the banks of the Yamuna, when he shifted his capital to Delhi from Agra in 1638. The irregular octagon of the massive fort has high battlements and contains exquisite palaces inside. The last Mughal was exiled from the Red Fort to Rangoon (in Myanmar), but today the Prime Minister unfurls the national flag from its ramparts every year. Fine traces of the pietra-dura inlay of precious stones, gold and silver still remain, though the legendary Peacock Throne was whisked away by Nadir Shah to Persia.*

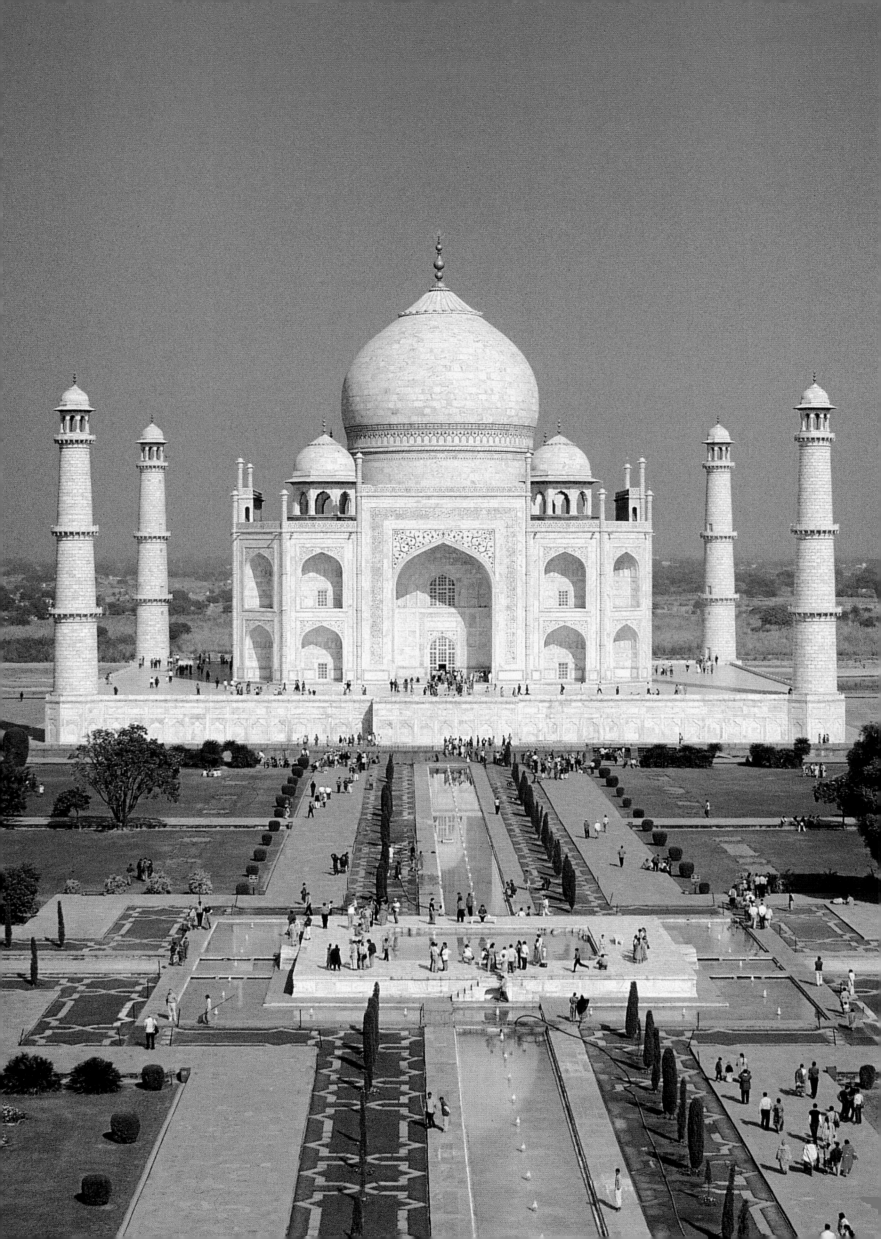

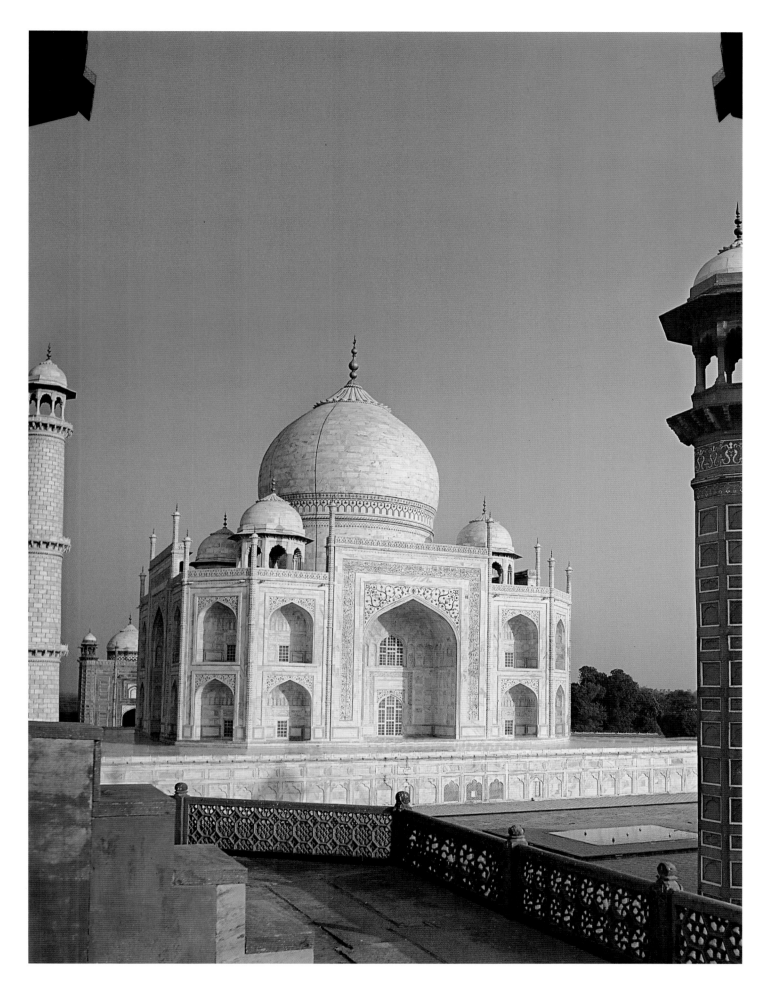

FACING PAGES AND ABOVE: *The world's most perfect building, the Taj Mahal, is a tomb built to commemorate the memory of Shah Jahan's empress, Mumtaz Mahal. Built entirely of marble, it is planned in a garden setting, and flawless in its execution. The monument took 22 years to build, and when completed, its builder was a prisoner in the fort across the river, even as his son Aurangzeb ruled over Hindustan.*

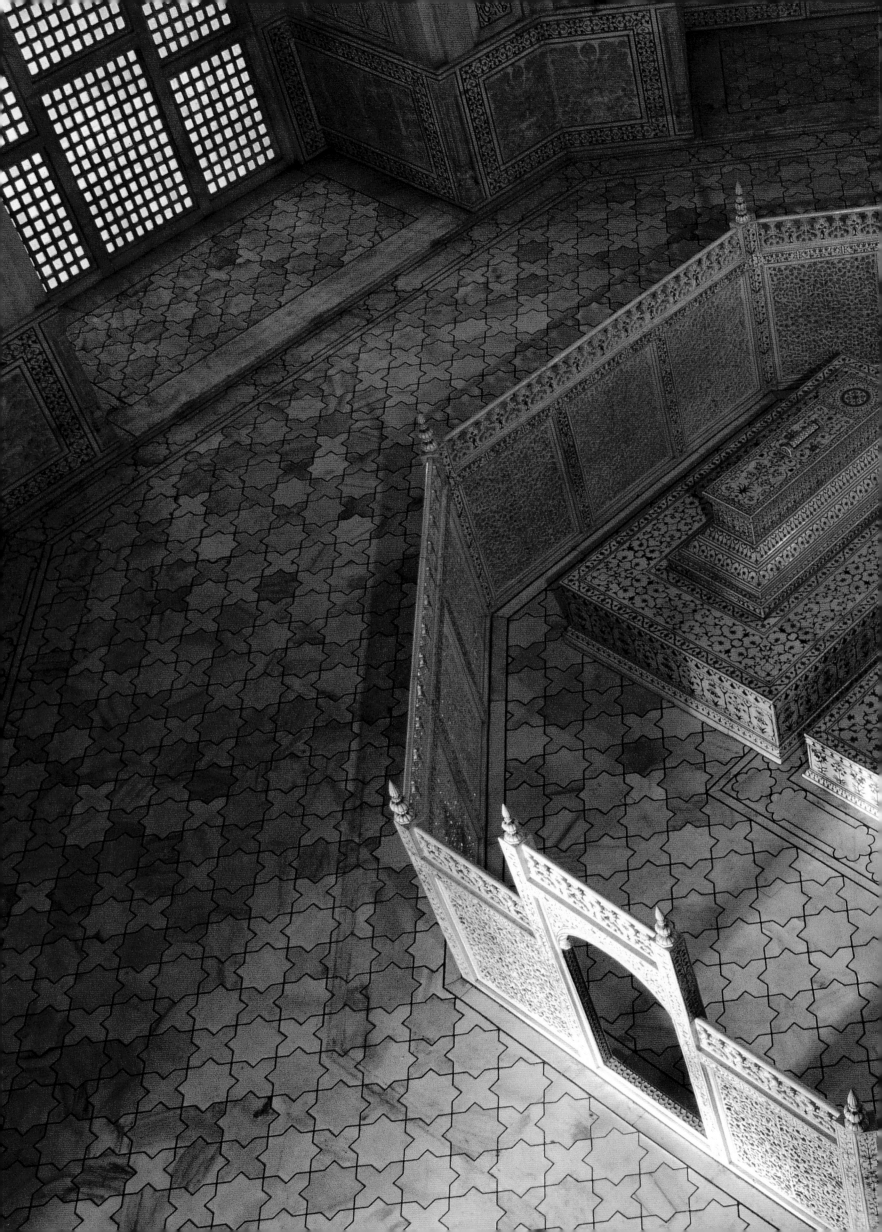

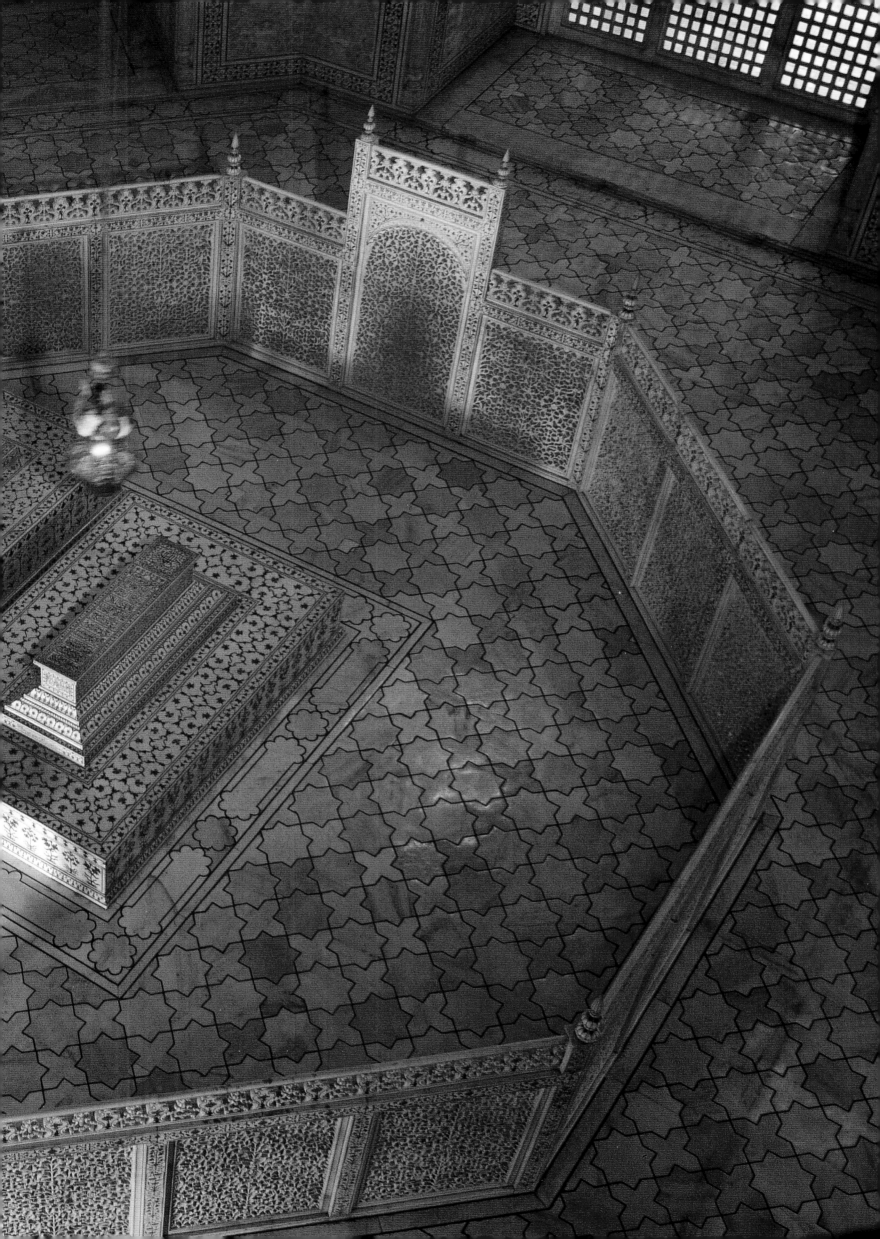

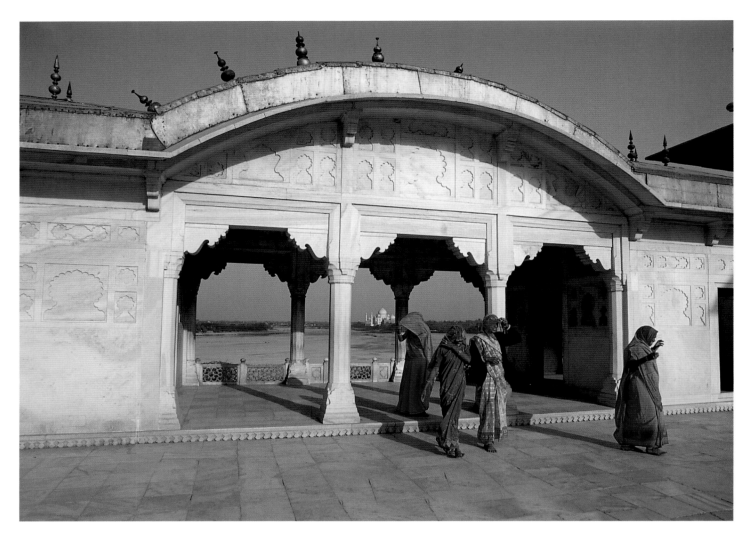

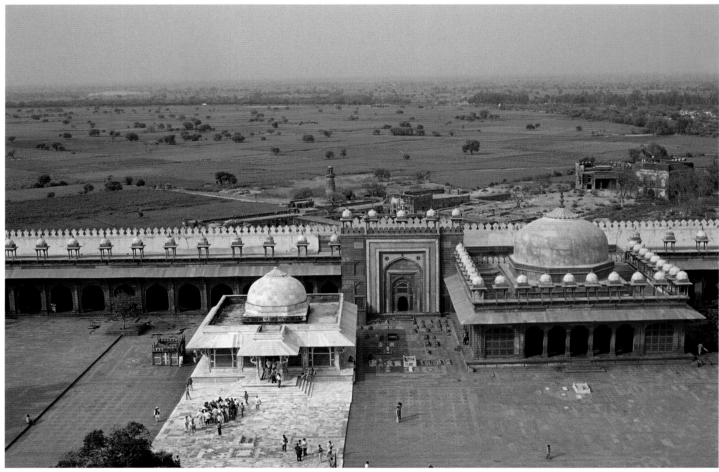

TOP: *The fort at Agra, built of red sandstone, was the center of imperial power under Babur, Akbar, Jehangir and Shah Jahan.*
*As in Delhi, it is built beside the Yamuna, and the Taj Mahal is visible from its ramparts.*
ABOVE: *Forty kilometers from Agra is the abandoned city of Fatehpur Sikri, planned and laid by Akbar as his Capital,*
*a gesture of Thanksgiving in the memory of Sufi saint, Sheikh Salim Chishti.*
PRECEDING PAGES: *The only asymmetrical part of the Taj Mahal is Shah Jahan's cenotaph, laid beside his wife's by Aurangzeb after his death.*
*The marble caskets are adorned with pietra-dura inlay and calligraphy, and are surrounded by a pierced marble screen.*

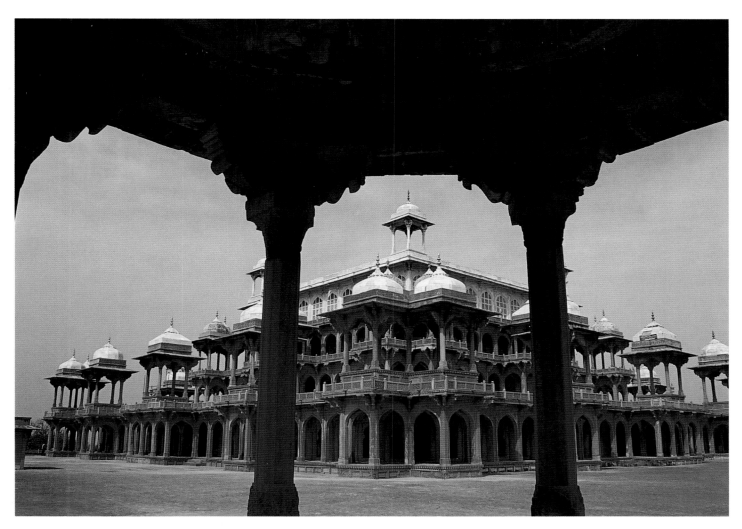

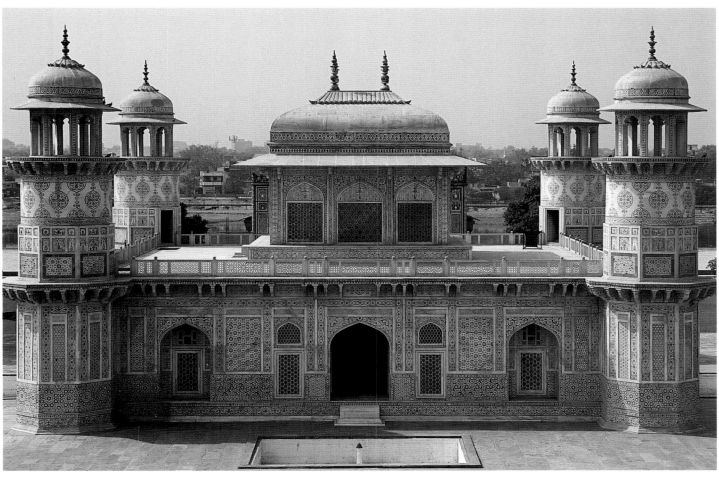

TOP: *Akbar's tomb at Sikandra, in Agra, reflects the synthesis of Hindu and Islamic architectural styles that came to characterize most Mughal buildings of the period.*
ABOVE: *Itimad-ud Daula's tomb at Agra was built by Jehangir's wife Nur Jahan in the memory of her father, the Prime Minister in the imperial court. It is particularly noteworthy for its fine proportions and delicate ornamentation.*

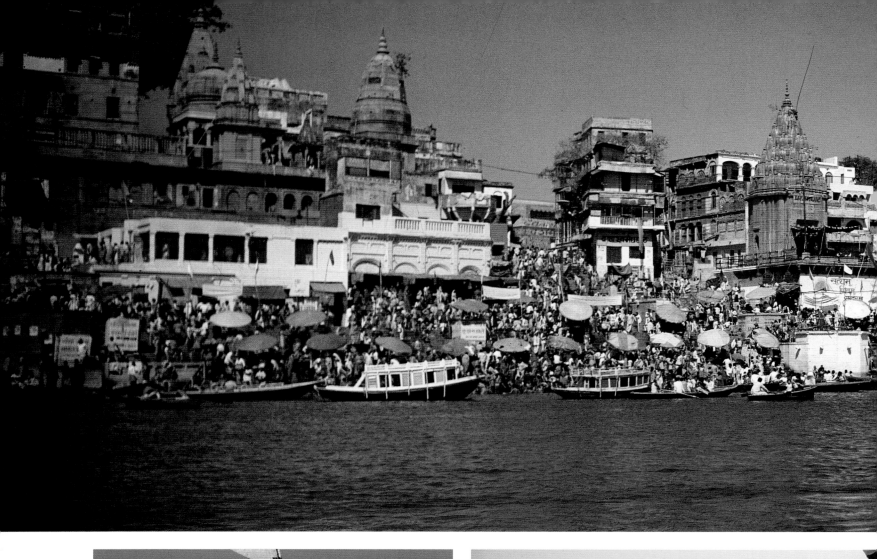

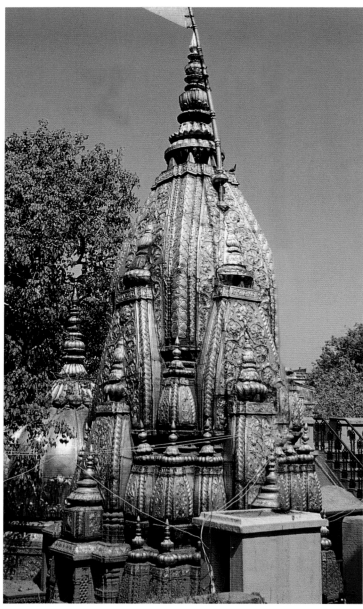

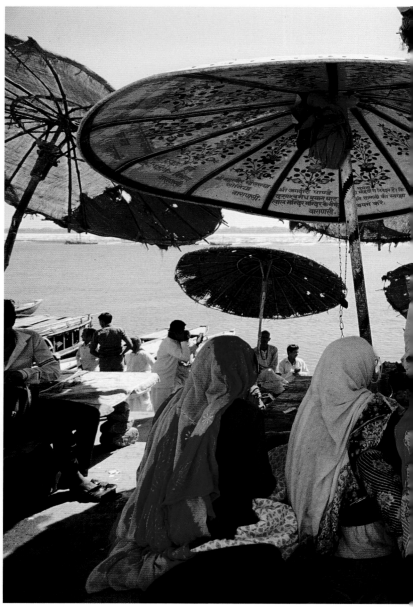

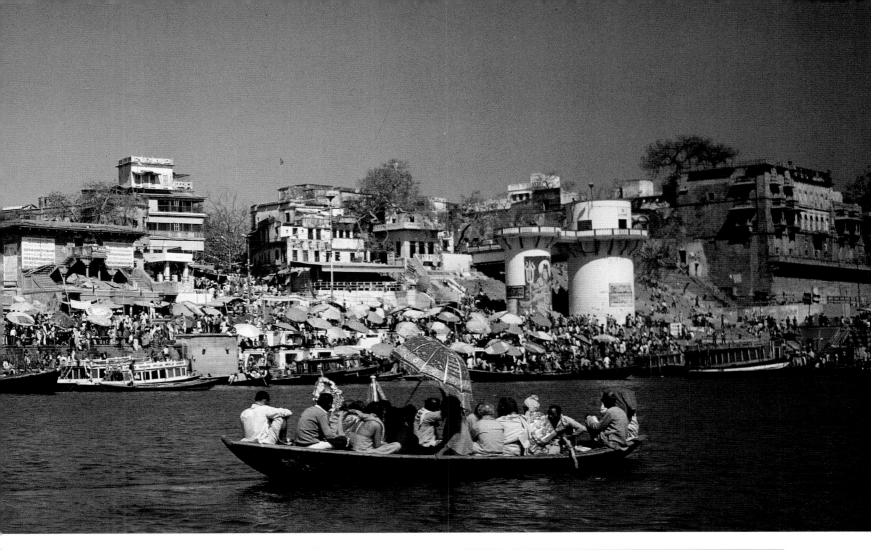

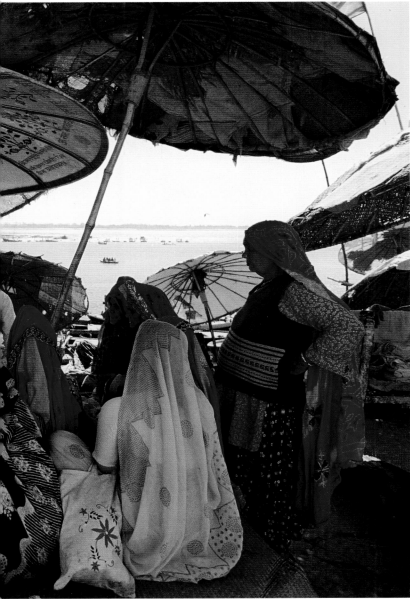

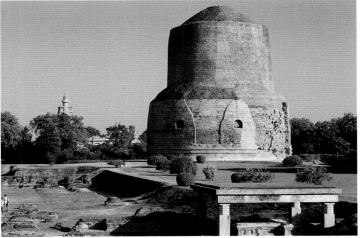

TOP: *Varanasi, on the banks of the Ganga, is at least three-thousand-years-old and is India's holiest city. Its banks are crowded with priests, devotees and tourists, who savour their ride on the boats moored by the river's west bank.*

FACING PAGE BELOW: *The spires of the Vishwanath Temple built by Maratha queen, Ahilya Bai, in 1776, over the site of the original temple, has Lord Shiva as its presiding deity.*

FACING PAGE LEFT: *A 'ghatia' or ghat priest seated under a bamboo umbrella on the river's banks, explains the various religious rituals the pilgrims must undertake. Varanasi has 52 such ghats for bathing, prayers and cremation of the dead.*

ABOVE: *The Dhamek Stupa at Sarnath is close to Varanasi. This is where Gautam Buddha delivered his first sermon after his enlightenment. The edifice was built by the Mauryan Emperor Ashoka in the third century BC, and remains an important center of Buddhist pilgrimage.*

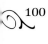

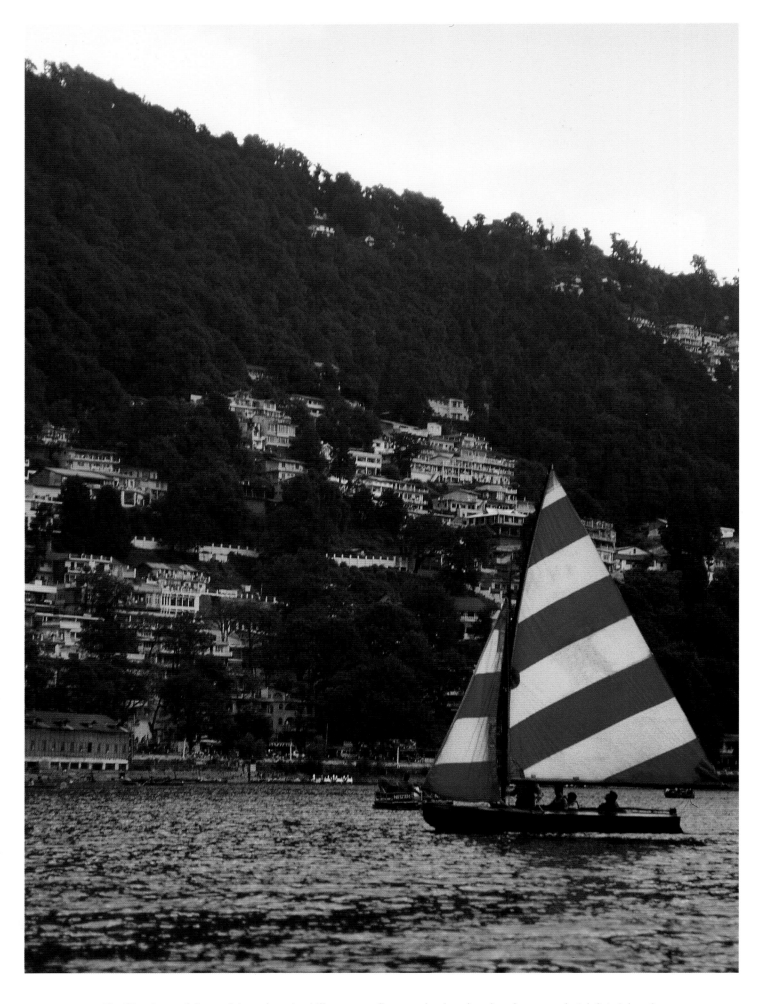

The Himalayas of the north have charming hill retreats and resorts, but have long been known as the 'abode' of the gods.
ABOVE: *Nainital Lake with its sailboats is one of north India's most charming hill stations,*
*deriving its name from the eyes (nain) of the Goddess Parvati.*
FACING PAGE: *The picturesque town of Srinagar in the Garhwal Himalayas of*
*Uttaranchal is known for its university, temples and magnificent views of the Ganga.*

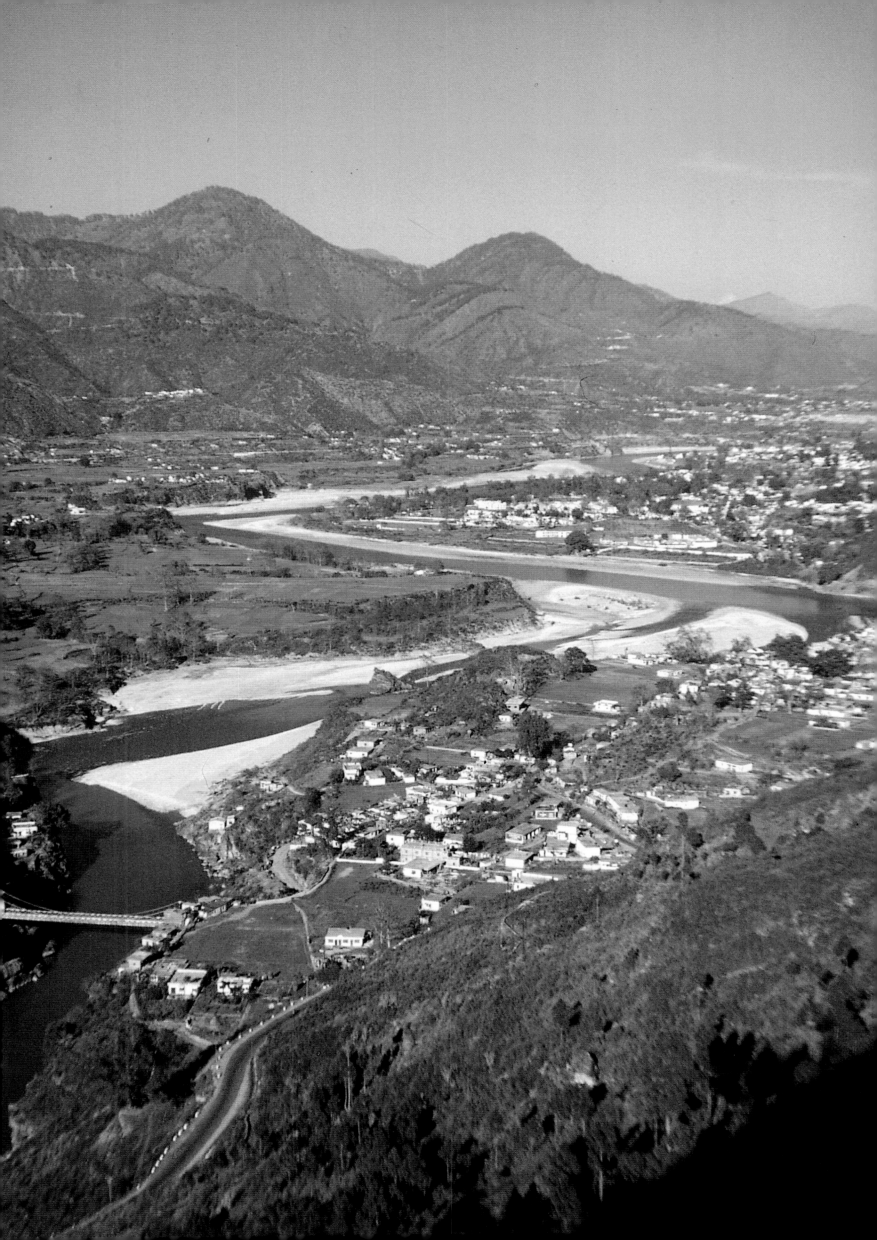

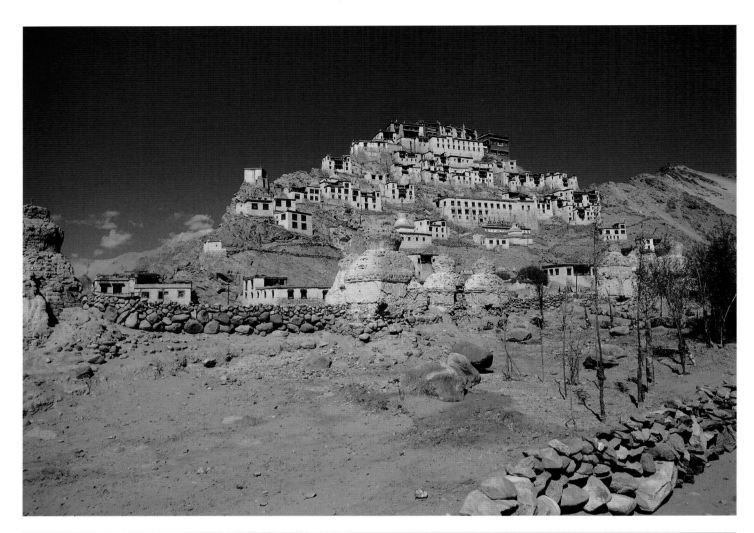

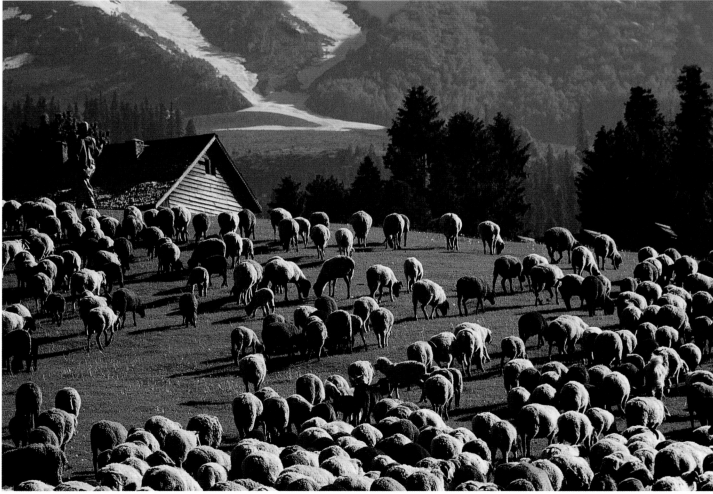

*Kashmir is widely believed to be a paradise on earth.*
TOP: *A view of the famous Thikse Monastery in Ladakh.*
ABOVE: *Sheep graze in the meadows of Gulmarg during the height of the summer season.*

 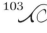

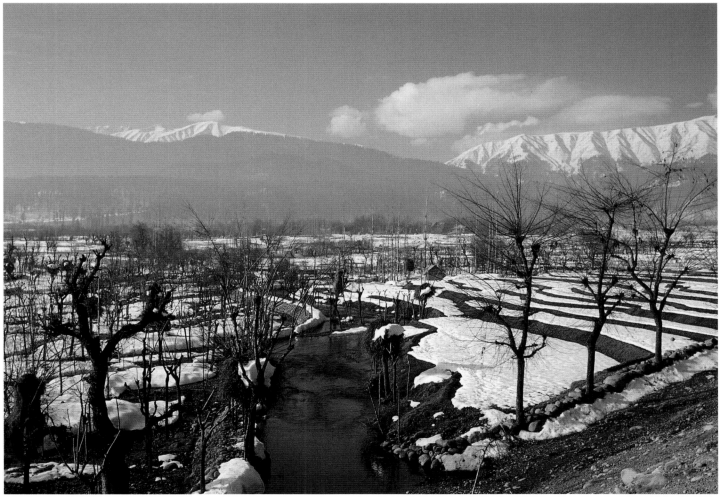

TOP: *Springtime, for Dal Lake, spells the advent of the tourist season for the shikarawallahs and moored houseboats on its banks.*
ABOVE: *Tangmarg, en route Gulmarg, is mantled with snow in the winters.*

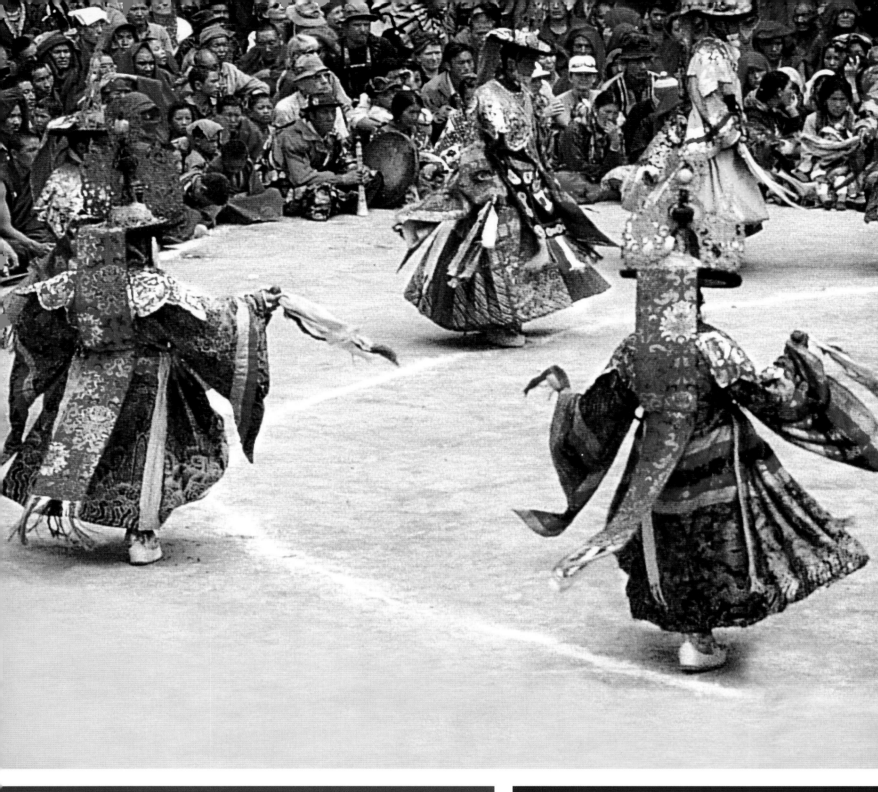

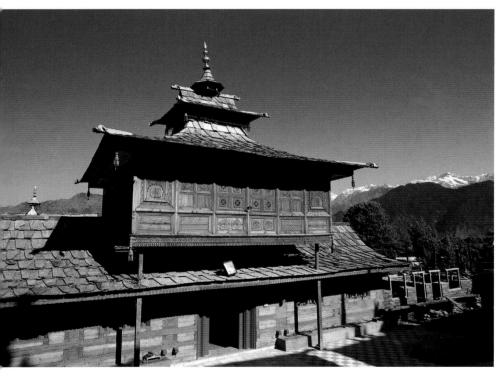

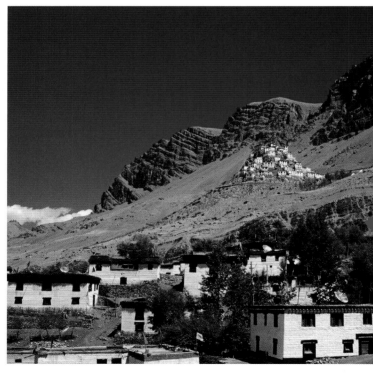

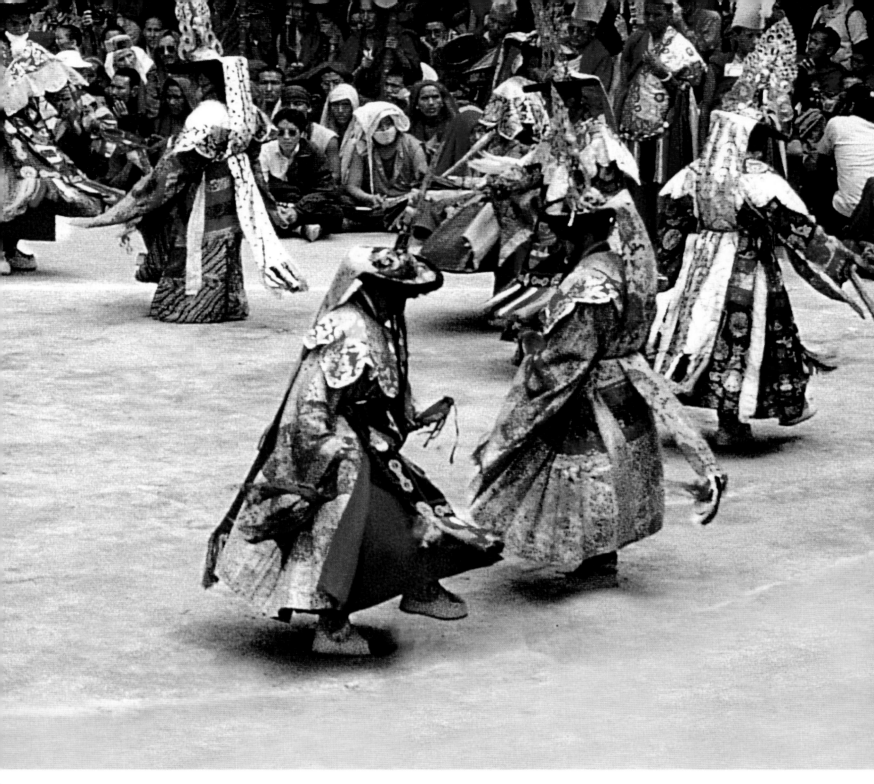

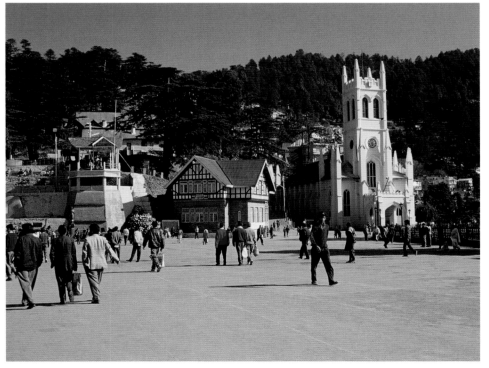

TOP: *The Chham dancers of Lahaul-Spiti perform ritual dances with masks covering their faces.*
FACING PAGE BELOW LEFT: *The Pagoda style of architecture is unique to Himachal's Sarahan Valley, as seen in this temple complex of Bhimkali.*
FACING PAGE BELOW RIGHT: *Key monastery in Himachal's Spiti Valley continues to be a seat for Buddhist learning.*
LEFT: *Christ Church on Shimla's ridge is the social and cultural hub of this hill town.*

(Top & middle photos courtesy of Somesh Goyal)

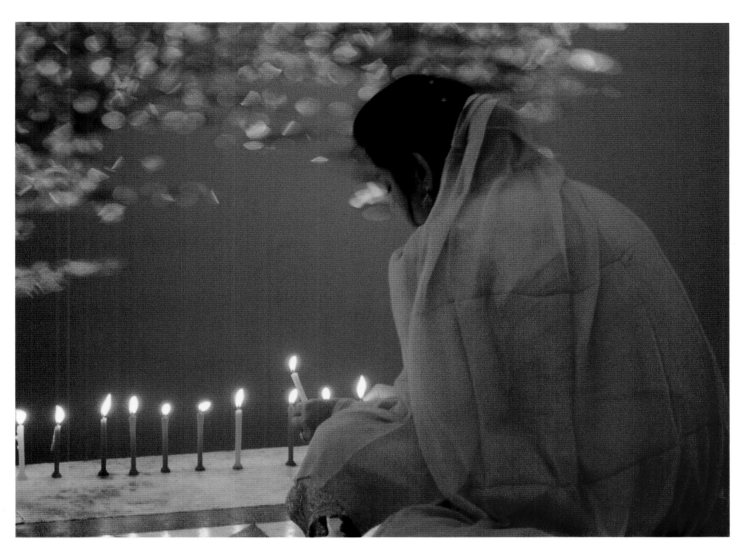

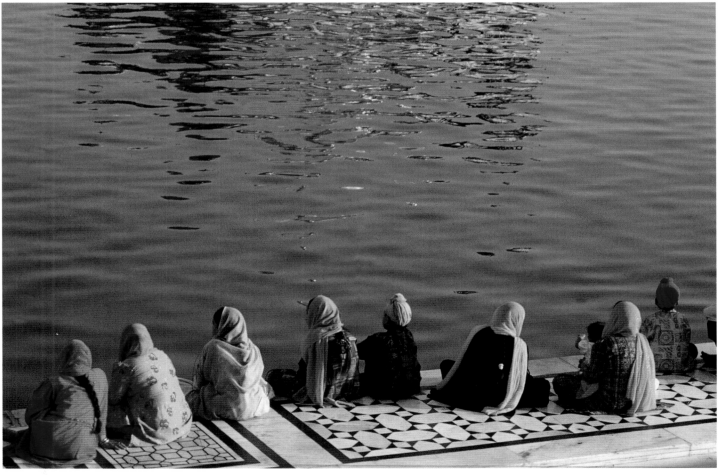

FACING PAGE AND ABOVE: *Amritsar is the holy city of the Sikhs of Punjab. The Golden Temple is at the heart of India's youngest religion, which enshrines the Guru Granth Sahib, the holy book. Pilgrims light candles, sit beside the holy waters of the Sarovar, or stream across the causeway to the temple to pay homage at the shrine.*

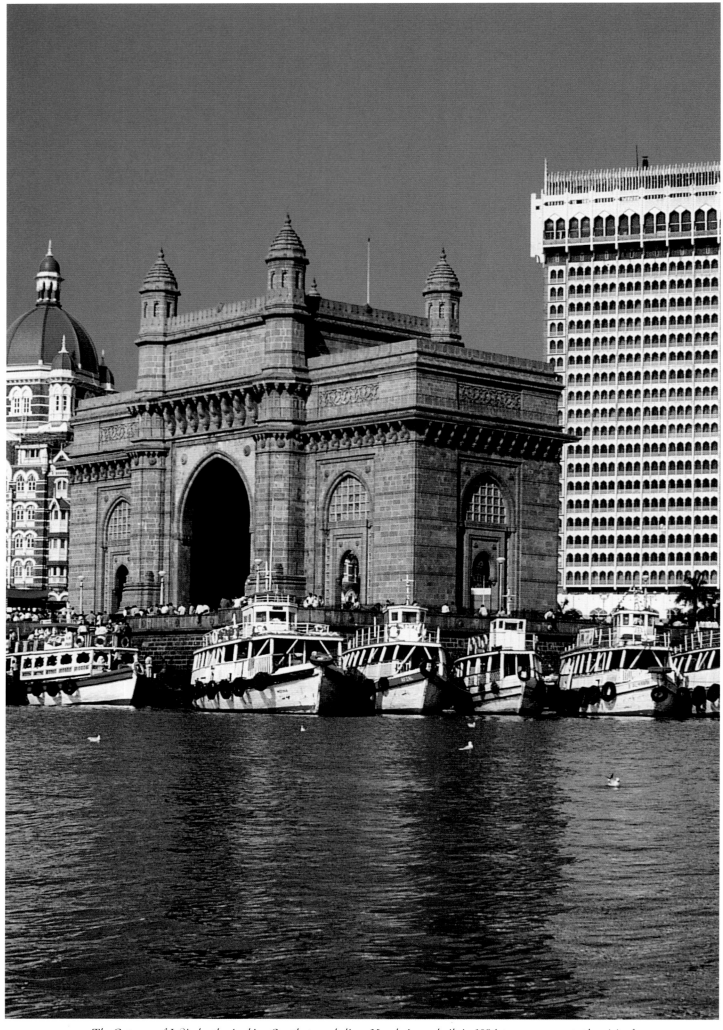

*The Gateway of India by the Arabian Sea that symbolizes Mumbai, was built in 1924, to commemorate the visit of King George V and Queen Mary in 1911, to attend that year's Grand Durbar in New Delhi.*

# Mumbai

The Golden Gateway of India, the city of Mumbai has welcomed both crowned heads and commoners to the subcontinent. Since its early beginnings, Mumbai has evolved from a scattering of seven islands, into a closely linked modern metropolis, surrounded by the mysterious richness of central India.

Mumbai, formerly Bombay, remains unrivaled as the "City of Dreams", in its color and vitality, and its innate ability to always provide a tiny foothold for those who come to the big city carrying a bundle of hopes. Nothing can compare with Mumbai's infectious zest for life, and the way it reinvents itself with every new generation.

From a city of textile mills exporting cotton to distant parts of the world, to an industrial and banking capital, and now, as an electronic industry leader and entertainment destination, Mumbai is no longer just one city, but a conglomerate of many small satellite cities—a megalopolis, but with its roots still firmly in the ground.

Mumbai is the capital of the state of Maharashtra. The British made the city the gateway to India by building railway lines that allowed them to transport the natural wealth from the interior of the country to Mumbai's brimming harbor.

The city's original inhabitants, the Kolis, still cling to their fishing hamlets by the sea. The heavy, moist winds of India's monsoons, which once brought the ancient argosies from Rome and Greece, also bring lashings of rain to India's countryside. At the end of the monsoon season, the festival of Nariel Poornima is observed by the Kolis, along with Mumbai's older inhabitants, who appease the sea with offerings of coconuts.

In the third century B.C., the islands of Mumbai formed part of the western fingertips of the Emperor Ashoka's kingdom. They merged into the Chalukyan Empire of the sixth and eighth century A.D., leaving behind the stunning rock-cut architecture of the Elephanta Caves on an island just off Mumbai, which is less than ten miles northeast of Apollo Bunder. The Buddhist caves at Kanheri, approximately 26 miles from Mumbai, were created between the second and ninth century A.D.

By the 14th century, the area was in the hands of the Muslim rulers of Gujarat. It was the Sultan of Gujarat who gave the islands to the Portuguese, who were in control further down south in Goa. The Portuguese left their imprint on the mainland at Bassein Fort, where today there are ruins of their once grand palaces and cathedrals. The Portuguese made a gift of the islands to England's King Charles II when he married their princess, Catherine of Braganza, in 1661. However, history has it that Charles II gladly passed on the islands, rumored to be malarial swamps, to the merchants of the East India Company at a cost of ten pounds—to be paid to him annually, in gold.

By the end of the 18th century, merchants had cleared the islands and made the city and its excellent harbor the most important place in the Arabian Sea. Mumbai attracted skilled shipbuilders from the Parsi community, and merchants and traders from Gujarat, Konkan and further inland from Maharashtra—Karnataka, central India, and Rajasthan, from whence came the Marwaris, India's hard working and thrifty community of money lenders and merchants.

After the partition of India in the 1940s, the dynamic community of Sindhis contributed their own business acumen to Mumbai. Following cycles of drought and displacement due to natural calamities or financial distress, people from India's southern states and Bengal also began to migrate to Mumbai. What is remarkable is the way in which each of these different communities managed to live and work, with very little conflict, side by side in the crowded streets, alleys, suburbs and slums of Mumbai, like Dharavi hailed as the "biggest slum"' in Asia.

Money rules in Mumbai, but the city earned its "cosmopolitan" label by its people sharing in the wealth

the city generates. Many of the best educational and training institutes have been sponsored and financed by previous community leaders. Parsis, Christians, Jews and Armenians, and various Hindu and Muslim merchant communities, all realized that Mumbai's prosperity could only be maintained and enhanced by the creation of good educational institutions.

India's City of Dreams is also the subcontinent's celluloid capital, made famous by the "Bollywood" films that have given Mumbai a very glamorous and almost mythological reputation. The "Bollywoodization" of style, fashion and food, not to mention the fast life that surrounds Mumbai's hectic film circuit, has now become an integral part of the city's modern identity.

 110

In the quiet of evening, or in the light of the early morning sunrise, the presence of the city's ancient landmarks provides reassurance to Mumbai's residents. At low tide, the faithful still make their way to the mosque at Haji Ali. Close by is the temple of Mahalakshmi, built in honor of the goddess of wealth, Lakshmi. They also meet on the waterfronts of the city: on Marine Drive, the Worli Seaface, the Bandra Bandstand or Juhu Beach. Or they return to the Gateway of India, at Apollo Bunder, to look at the sea, and the city of hopes and dreams.

Even more sea and sand waits at the seductive beaches of Goa. When sailors told tales of siren songs breaking across the waves from an emerald coast, they must have been talking about Goa. For not only is it the paradise of a traveler's dream, it is a place that can affect you deeply, making you want to return again and again.

Goa's fabled beaches have quaint villages nestled between lush green coconut palms and trees laden with tropical fruit. Rivers, carrying silt and rich iron ores that now form part of the industrial landscape of a once predominantly agricultural state, crisscross the land. But the real wealth and history of Goa lay in the world's desire for "black gold"—pepper and spices—that brought the Portuguese naval general Alfonso de Albuquerque to its shores in the early 16th century.

The churches, cathedrals and surrounding buildings of Old Goa are beautiful and deeply moving reminders of the Portuguese era. The most famous of these is the Cathedral of Bom Jesus where St. Francis Xavier

is buried. When Xavier's body was brought back to Goa from China in the 1500s, legend says the body was in perfect condition—even after a sixteen-month journey—and this was deemed a miracle. Until recently, the tradition in Goa was to open Xavier's coffin once very ten years so that the faithful could see and worship the undecayed body.

Other strong traditions remain in Goa, such as the famous Carnival that takes place every February, when a large procession winds through the streets, and both young and old dance, laugh and sing as a way to reclaim their lost heritage, if just for the day. This sense of loss and sadness for a past they know can never return is countered by their earthly love of all the good things of life, which defines the Goan experience.

Madhya Pradesh forms part of India's central heartland. It is the largest state in the country, spread out like a piece of flattened gold on the anvil of the ancient plateau of central India. Hidden in its crevices are rich river valleys, forests that house game sanctuaries such as Kanha and Bandhavgarh, the remnants of once mighty kingdoms and palaces, and areas still rich in tribal culture. The once fabled wealth of the region can be seen in the variety of it textiles and silver ornaments, and the tribal artifacts in the Bastar region of the south.

Though most of Madhya Pradesh is now hot and dry, with its natural forests sadly depleted, its ancient wealth continues to earn the admiration of visitors. Here, it is as if the entire Indian culture has been compressed into one great package. There are prehistoric cave dwellings at Bhimbetka, just an hour's drive from Bhopal, the capital of Madhya Pradesh, and the Stupa at Sanchi, located about 30 miles from the city. They are reminders of the great Emperor Ashoka and his mission to spread the teachings of the Buddha through magnificent examples of art, architecture and sculpture.

Each one of the main cities of Madhya Pradesh represents a center of power or famous dynasty. Some descendants remain to preside over these magnificent fortresses and walled cities. Among them are Gwalior, Indore, Ujjain, Jabalpur and Bhopal, which all have adapted to the demands of the modern age. Mandu, with its mosques, tombs and deserted corridors, which link the remnants of pleasure gardens, haunts visitors with the scent of its romantic past.

Nowhere, however, does the past come alive more than in the fabled temple sculptures of Khajuraho, the center of the kingdom of the Chandelas, who ruled here between 950 A.D. and 1050 A.D. Even today, it is a remote destination, which is perhaps one reason why the extraordinarily sensuous and lifelike sculptures that adorn the walls of Khajuraho's exquisite temples so enchant and arouse visitors. The ideal time to visit Khajuraho is during the annual Dance Festival, when contemporary dancers and musicians perform against the backdrop of the temples, with their gods and goddesses caught in a mood of playful love and enchantment.

From there, following in the footsteps of the Buddha, is Bihar, a state with so much ancient history and culture it can be difficult to comprehend. Here, the Himalayas can be glimpsed from the banks of the Kosi and Gandak rivers, and also, there once stood the legendary kingdom of Sitamarhi, where Sita, the wife of Prince Rama of the epic, Ramayana, was born. In northern Bihar, Mithila and Madhubani folk paintings are world-renowned.

Wherever you go in Bihar, there are reminders of the Buddha's teachings. The name itself is a derivation of "Vihara"—the Buddhist monasteries that dot the landscape. It is a land of travelers, who came to Bihar along what is considered the world's oldest highway, the Grand Trunk Road. Through the centuries, Bihar has attracted merchants, who have come to trade, and also, great teachers and scholars.

The Buddha himself traveled to this region to find enlightenment at Bodh Gaya, approximately 100 miles from Patna. Innumerable places of both Jain and Buddhist pilgrimage are also found here. They all form a continuous link with the other centers of Buddhist teaching and learning, such as the ancient University of Nalanda, which attracted visitors from far and wide from the fifth century B.C. through the 12th century A.D., when Muslim invaders destroyed it.

At the height of its fame, the Univeristy of Nalanda maintained a library of as many as nine million volumes. The Buddha is said to have stopped at Nalanda during the last great journey of his life, when he was at least 80 years old. And Mahavir, the great teacher of the Jains, is said to have sermonized to his disciples at Rajgir.

Mahavir's followers pay homage at Pavapuri, about 60 miles from Patna, where he traveled on his final journey. Patna, the present day capital of Bihar, has been in continuous existence for more than 3,000 years, and like so many cities that have bordered the Ganges River, it was a prosperous and thriving metropolis, with different names at different points of its history.

It is from here that Chandragupta Maurya extended his kingdom to the frontiers of the Greek province on the banks of the Indus River that Alexander the Great left behind after he returned home following his victory against King Porus. Pataliputra, as Patna was formerly known, is celebrated in the writings of Megasthenes, the Greek traveler, who spoke of its immense pillared halls with lotus-petal carvings. And in direct contrast to Patna, the modern age of Bihar is represented both at Ranchi and Jamshedpur, the "Steel City" of India.

However, there is nothing to match the most entrancing of all the Indian states, Rajasthan. The land of warrior kings and heroes, and women of such legendary beauty and strength that even today the bards sing of their valor and charm through the long nights in the desert, Rajasthan holds all the mystery and magic of the Indian experience in its grasp.

It is a land of contrasts and extremes—a culture built around legends that still walk the streets of its capital city, Jaipur, with the patient plod of a camel's gait. It is a place familiar from a thousand tourist photographs, but at every turn of the road there is always one more turbaned Rajasthani nomad, farmer, or cattle herder who will offer such brilliant a smile that you will be left stunned at the memory. Or you may be moved by the shy glance under a translucent veil of a young bride in all her silver and embellished finery. Or perhaps, the sudden appearance of a golden-hued fortress in the early morning sunrise, such as the one at Jaisalmer that rises like a mirage out of the landscape, will stop you in your tracks.

Part of Rajasthan's charm lies in its people. The tradition of hospitality is so deeply ingrained here, it is obviously inherited from princes and princesses of the past. Today, there are real Maharajas and their Ranis, who welcome you to their magnificent hotels and luxury resorts, crafted from ancient pieces of marble and mosaics.

The people in this region are said to share a nomadic past. Nomads claim they are the descendants of the sun and the moon—having passed through fire and air to walk upon the earth—so it is hardly surprising that

they betray at least a bit of their celestial background. Even women balancing their pots of water and carrying them over long stretches of the landscape, where water is seasonal and rare, stride with the grace of royalty, and are adorned with silver on their waists, ankles, neck and arms.

When the Muslim invaders came down to annex the Rajput kingdoms one by one, tradition was that the women would silently walk into huge funeral pyres to perform sati, led by the example of the most beautiful of them all, Padmini, the queen of Chittor. Fortunately, some did manage to survive the onslaught of the Mughul rulers at Delhi, and the Rajput princes exchanged some of their gracious lifestyle, which is evident today in the painting architecture, clothes and food of Rajastahn.

Each city of Rajasthan has a distinct character. At the most superficial level, there are the colors. For example, pink distinguishes Jaipur, and Jodphur is associated with blue. White marble defines the city of Udaipur, with its exquisite Lake Palace floating in the midst of the Pichola Lake. There are also the small worlds of the rulers: the temples, palaces, lakes, pleasure pavilions, mountains or jungle resorts. The key word here is "heritage." As more of these erstwhile owners come to understand the true implication of heritage tourism, the treasures of the past are being opened to the international traveler and seeker of rare experiences.

Gujarat is a land inhabited by people said to be nomads, the Gujjars, who traveled down with their herds of cattle from Central Asia searching for greener pastures. Even today, if you travel along the hundred kingdoms that make up the area known as Saurashtra on the way to the peninsular region of Kutch, you will find small groups of traveling herdsmen and their cattle. Each of them wears a distinctive style of short-pleated jacket, tight trousers, and a beautifully woven woolen blanket. And just as in Rajasthan, the variety of embroidered garments the women carry with them as part of their dowry, or the silver they wear—or, as in the case of the older women, the tattoos they exhibit—are all indicative of the nomadic way of life.

At one time, each region, or even, village, would have its own distinctive pattern that was used in their

textiles. From very early times, these dyed, woven and printed textiles were exported from the region to parts of West and Southeast Asia. With its ports on the Arabian Sea, trading always has been a part of the Gujarat tradition. There are, for instance, remnants of an ancient port at Lothal, that archaeologists say dates back 4,500 years to the Harappan Age, when people in this region might have enjoyed trade links with early Mesopotamia and Egypt.

At Dwarka, the celebrated temple town linked with Lord Krishna, who is a favorite of the cowherds, the sea is said to have submerged five earlier cities. At Somnath, people will stand on the beach and tell you that from that point to the South Pole, there is no landmass to be encountered. This is, perhaps, ample proof that the old mariners of Gujarat knew their way around.

Ahmedabad, the capital of Gujarat, now has a twin administrative township called Gandhinagar, once famous for its textile mills. Some of the tremendous textile wealth and versatility of the region can be seen at the Calico Museum at Ahmedabad. And at the Gandhi Ashram on the banks of the Sabarmati River, the simple wheel with which Mahatma Gandhi inspired his people to make the hand-woven Khadi cloth that would bring the cotton mills of Manchester to a halt, stands as a reminder of what the real essence of the word "homespun" is all about to a Gujarati.

Gujurat's other wealth can be witnessed in its marvelous temples, like Palitana, where an entire city of temples known as the "Place of Victory" has been carved into the finest of marble fantasies. Palitana sits high atop a hill, and was created in honor of the teachers of the Jain religion. The earliest temples here were built in the 11th century, but after the Muslim invasion, many of them had to be rebuilt.

Other such temples, such as Mount Abu, also a sacred place of pilgrimage to the Jains, or the Sun Temple of Modhera, exhibit the superb craftsmanship of Indian masons and sculptors. Over time, their skills were adapted to suit the tastes of the Muslims, who occupied parts of Gujarat. Perhaps the most exquisite example of their work is the "Tree of Life" frieze, which is carved on the side of a mosque at Ahmedabad.

*Geeta Doctor*

 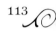

*Pilgrims stream across the narrow causeway that connects Mumbai with the island mosque of Haji Ali, built in the fifteenth century to commemorate the trader, who renounced his riches after a journey to Mecca. The causeway gets submerged at high tide.*
FOLLOWING PAGE TOP: *Marine Drive (also nicknamed Queen's Necklace, the way it looks at night) is a sea-facing boulevard that connects the financial capital of Mumbai with the suburbs.*
FOLLOWING PAGE BELOW: *Juhu Beach in the north of the city provides Mumbai with its daily carnival of crowds, vendors and joyrides.*

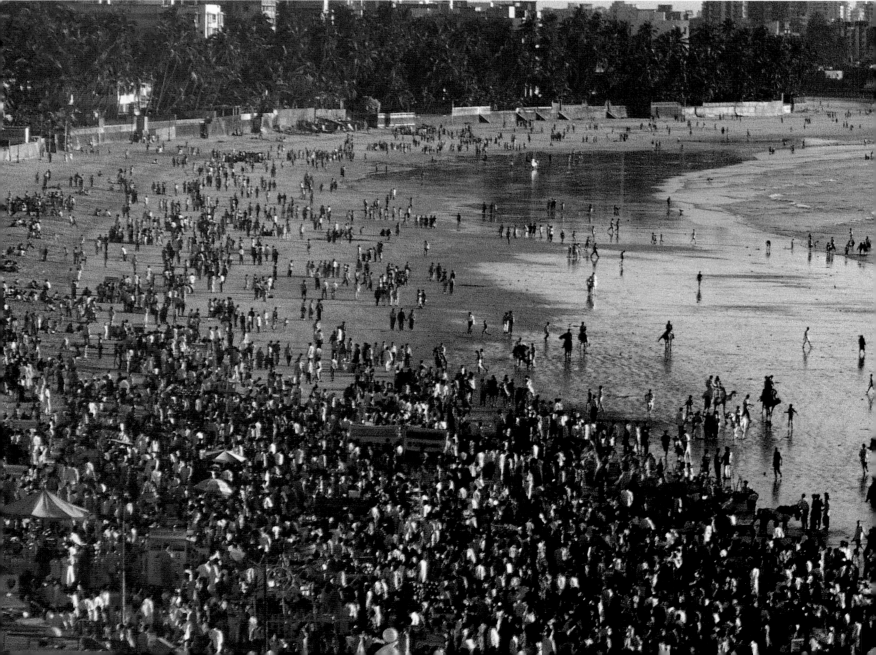

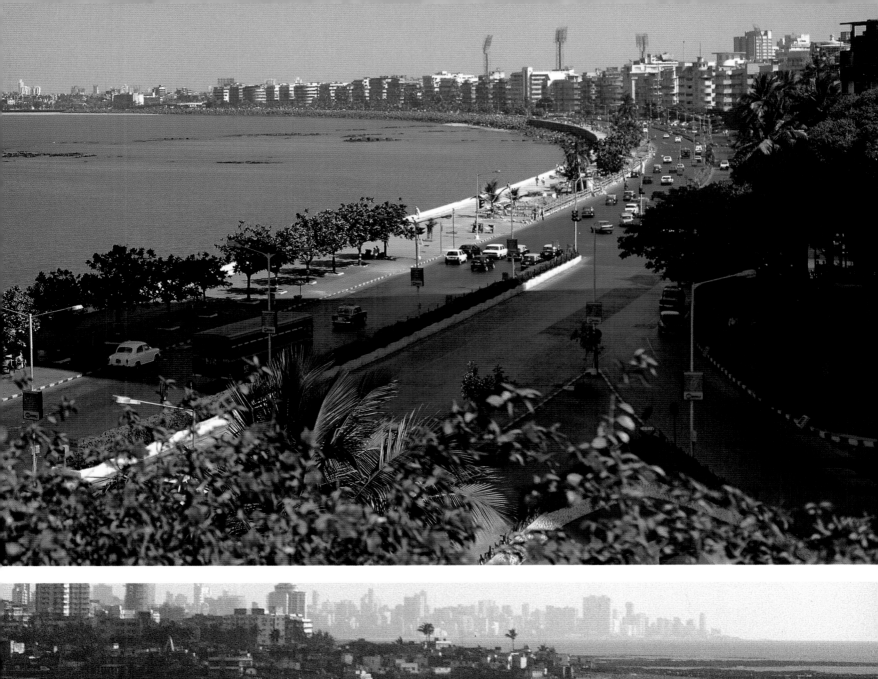
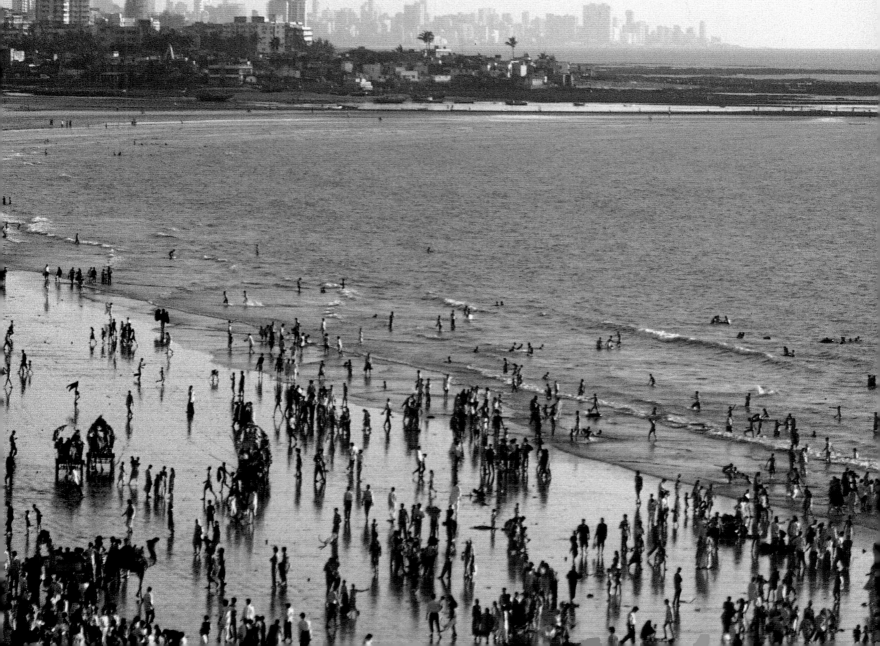

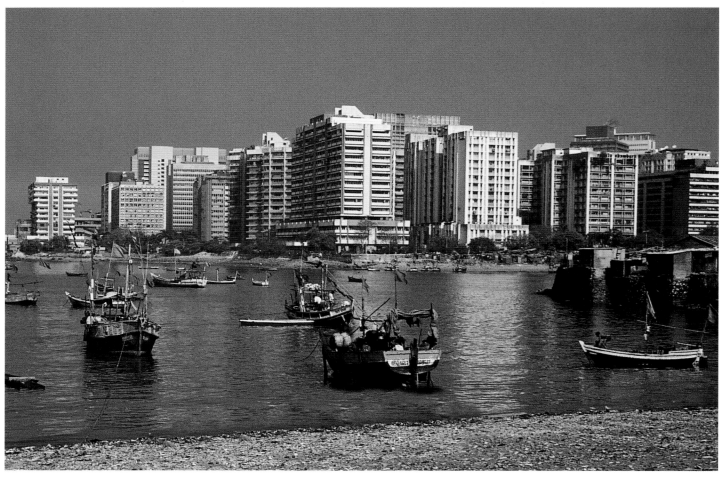

TOP: *Mumbai is characterized by its Gothic, Indo-Saracenic and Art-deco architecture.*
*The Rajabhai Clock Tower was financed by Sir Cowasjee Readymoney in 1875.*
ABOVE: *A view at Sasoon Docks from where the concrete highrise apartments of modern*
*Mumbai hold a testimony to its growing importance in world trade.*

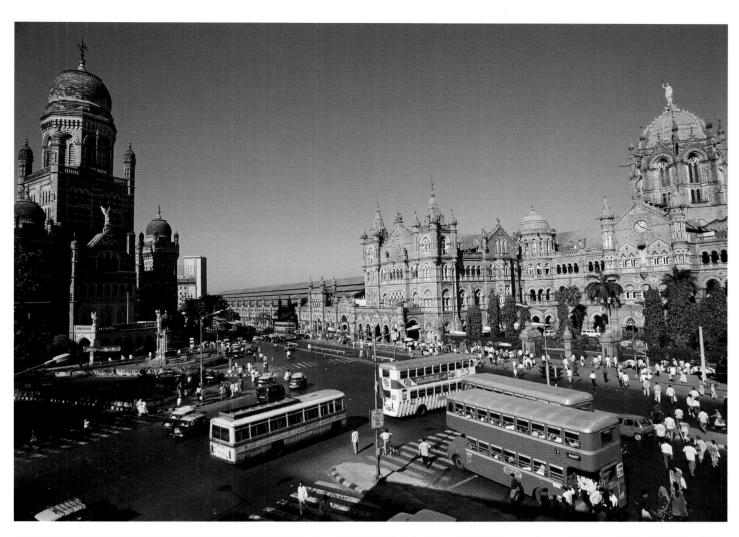

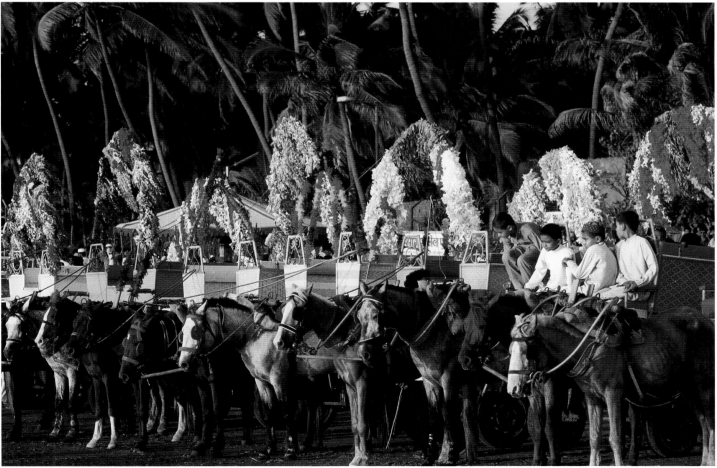

TOP: *Victoria Terminus (now renamed Chhatrapati Shivaji Terminus) was designed by F. W. Stevens in the mid-nineteenth century. This is not only the headquarters for Central Railways but also Mumbai's lifeline for its commuters. It is now listed as a World Heritage Site.*
ABOVE: *Horse rides await visitors at Juhu Beach, the popular location for innumerable film shoots.*

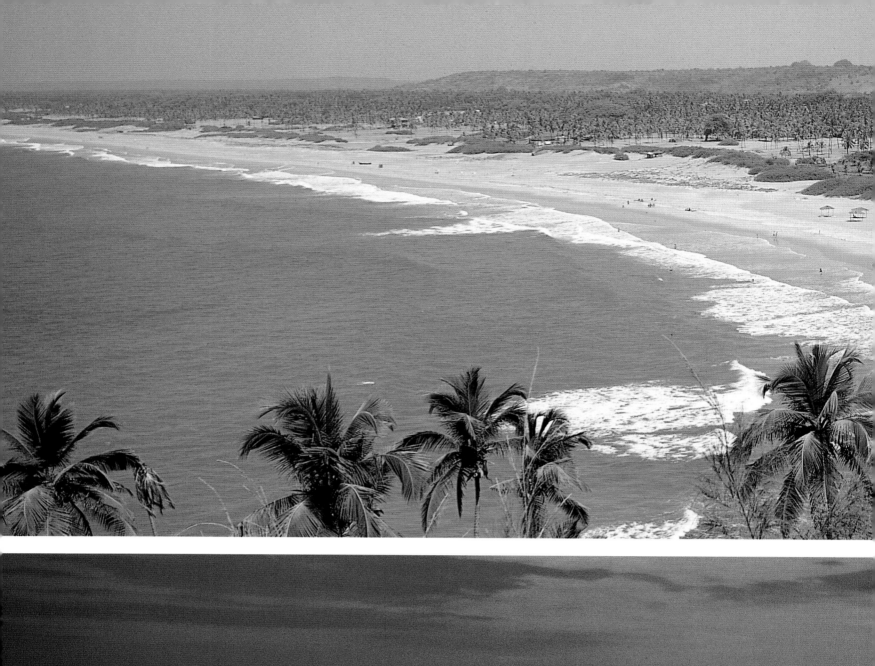

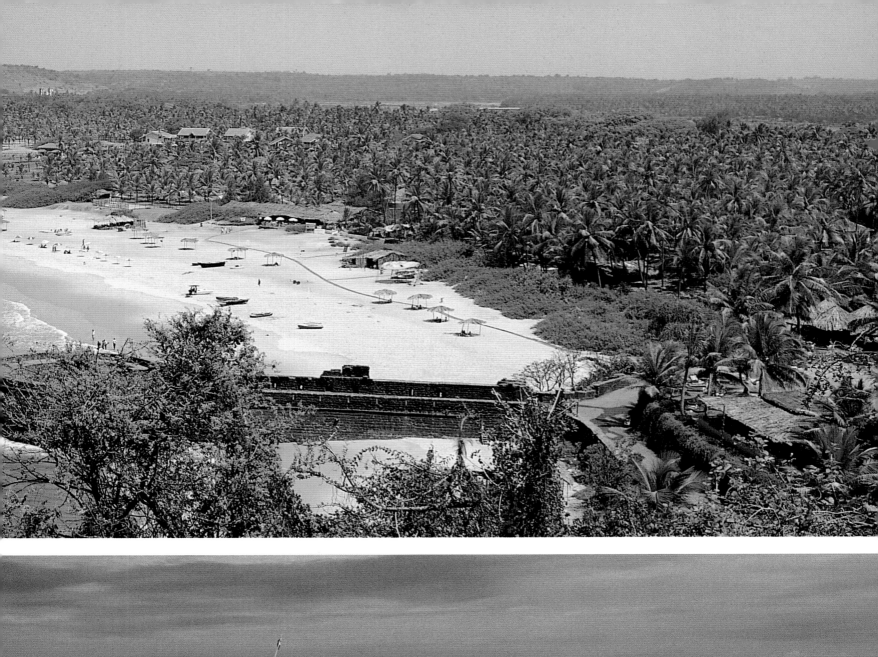

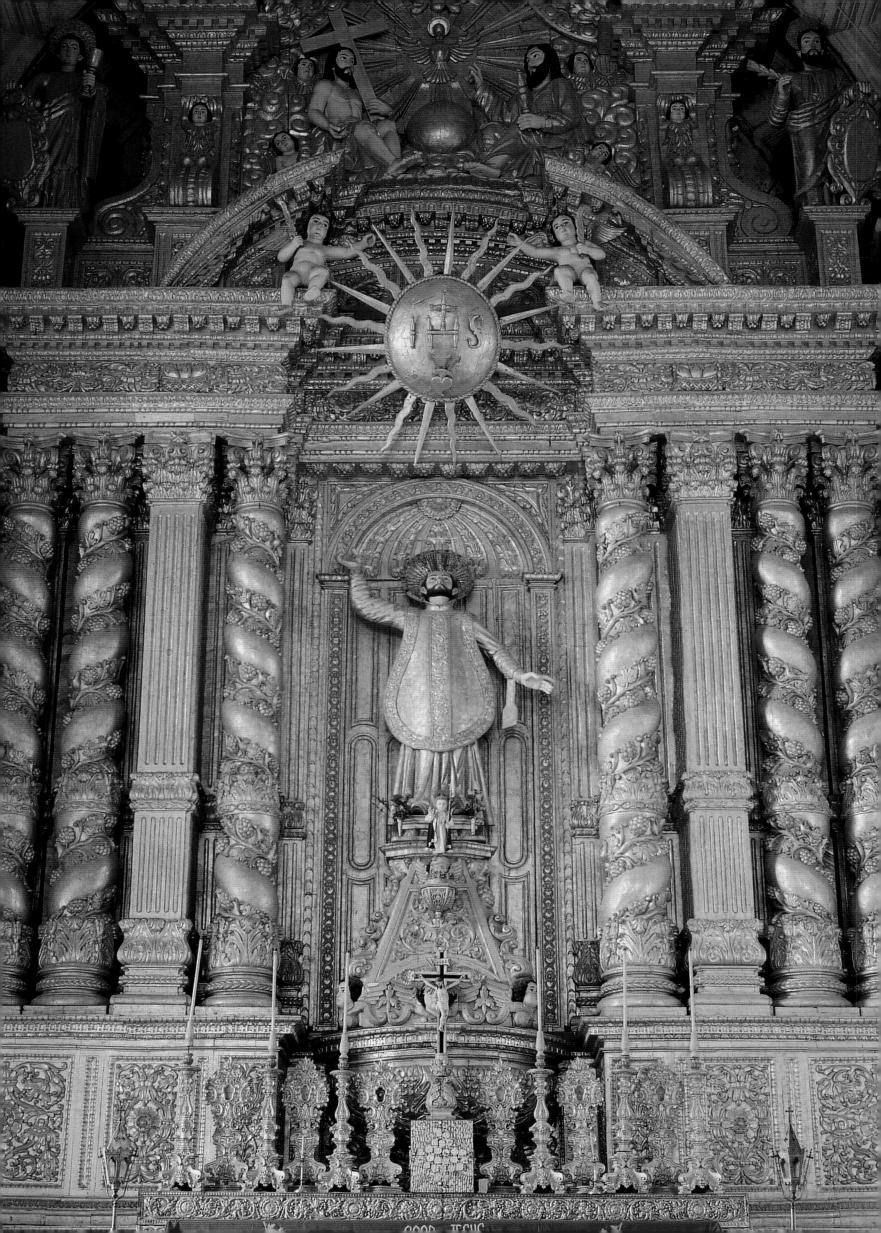

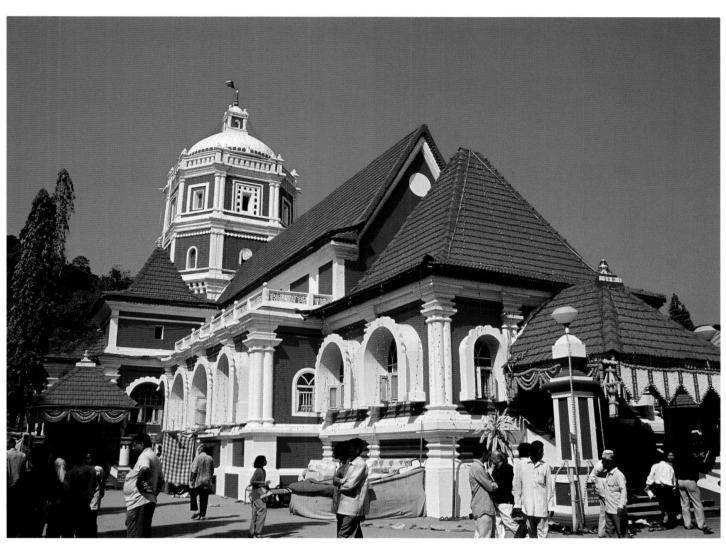

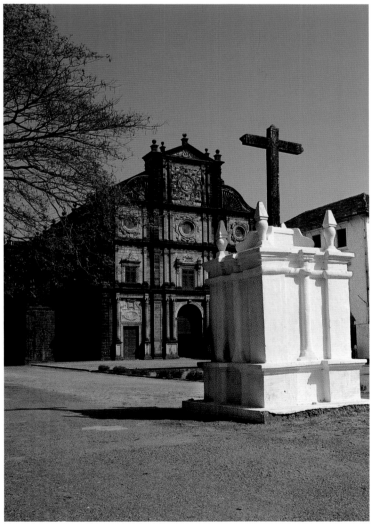

PRECEDING PAGES (118-119): *Vagator Beach, north of Goa's Capital, Panaji, like many others in this small state, is clean, serene and au naturale. Known for its splendid beaches, Goa is India's favourite holiday haunt by the sea.*
PRECEDING PAGES TOP: *The ramparts of the fort at Aguada add a picturesque touch to the white sands of the beach, arguably Goa's most popular resort.*
PRECEDING PAGES BELOW: *Fishing boats at rest while nets dry on Goa's Benaulim Beach.*
FACING PAGE: *The sacred relics of St. Francis Xavier, the patron saint of Goa, have been miraculously preserved in the chapel of the Basilica of Bom Jesus, since his death in 1552.*
LEFT: *A World Heritage Site, the gilded Basilica, revered by Roman Catholics, is located in Velha Goa.*
ABOVE: *The Shanta Durga Temple holds an important place for Hindu pilgrims. Interestingly, it has a tiled roof similar to that of Goan architecture, combined with a tower that is distinctly provincial in style.*

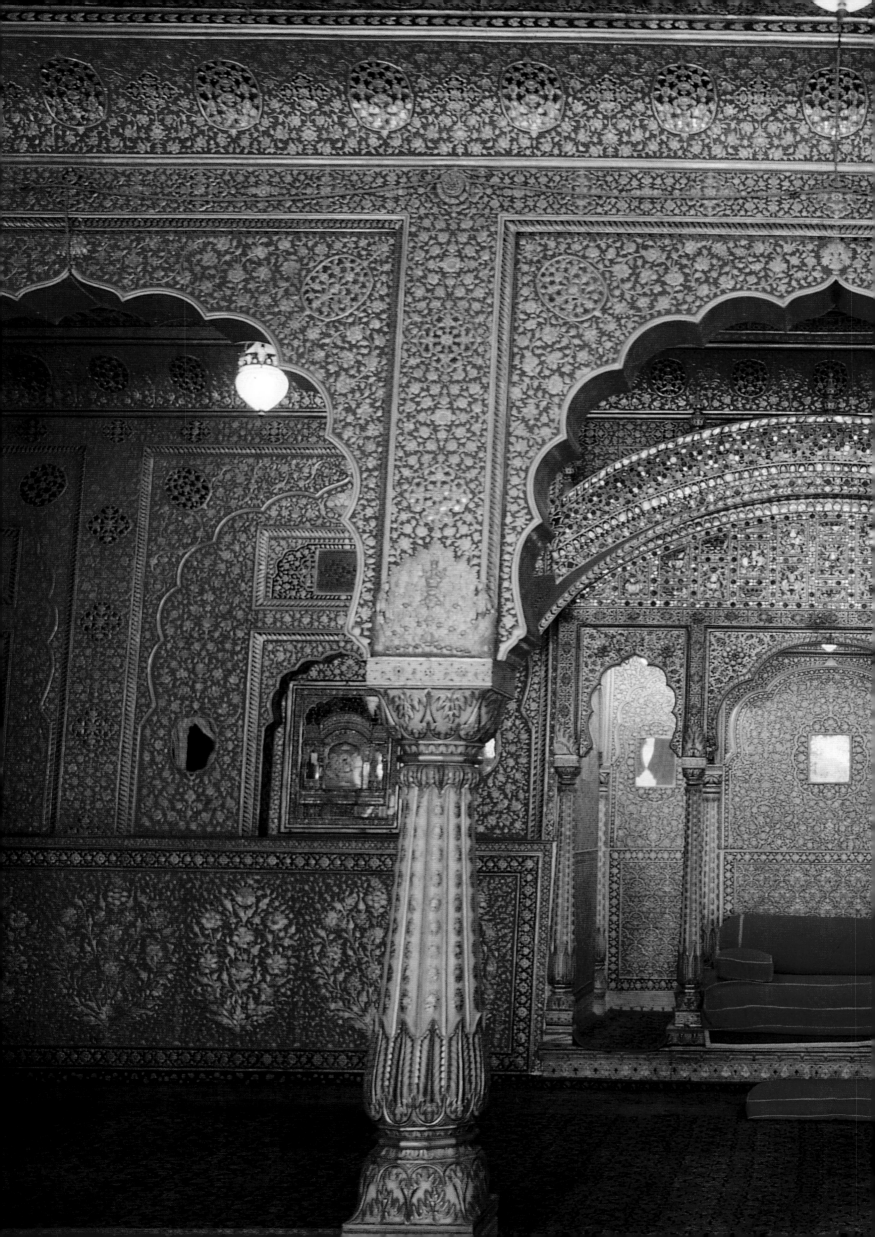

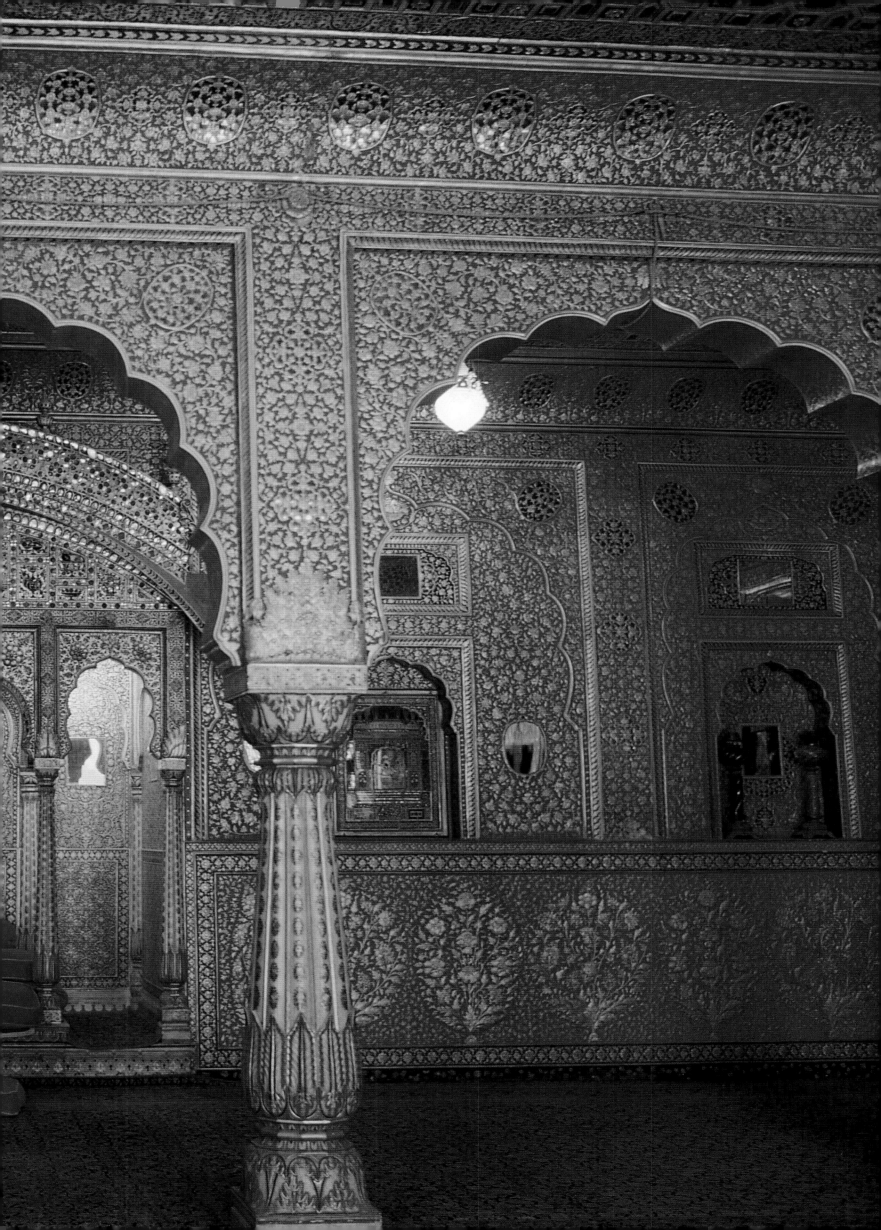

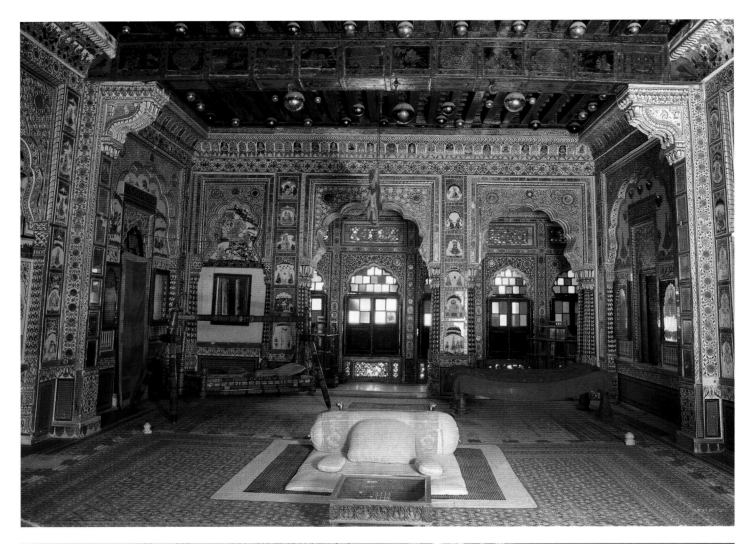

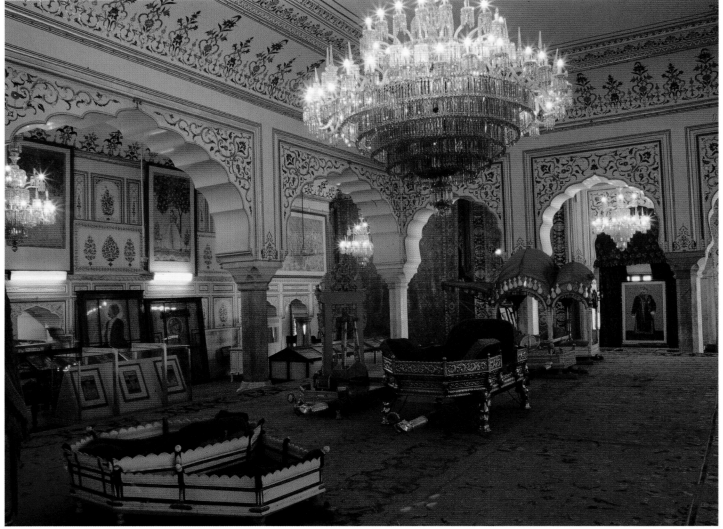

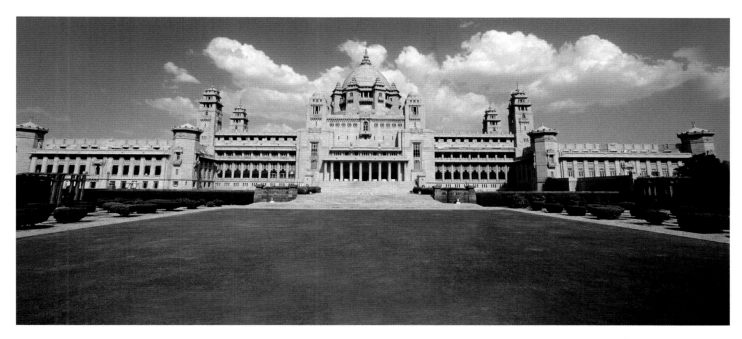

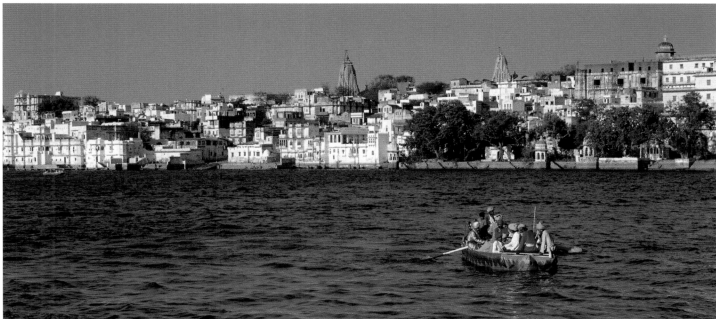

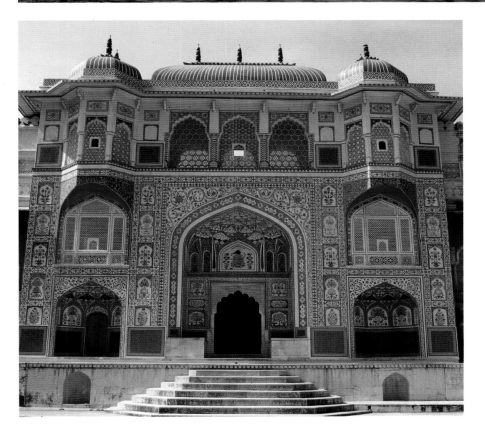

FACING PAGE TOP: *The jewel-like colors of Phool Mahal, Mehrangarh, in Jodhpur.*
FACING PAGE BELOW: *The decorative interiors of the City Palace, Jaipur.*
PRECEDING PAGES: *The opulent Anup Mahal in Junagarh Fort, Bikaner.*
TOP: *Umaid Bhawan Palace, India's most recent and largest palace, was completed in the mid-twentieth century in the Art-deco style. As of now, it is a unique combination of a hotel-cum-museum-cum-royal residence.*
ABOVE: *The Sisodia rulers of Udaipur kept adding to the City Palace citadel, built besides the lapping waters of Pichola Lake.*
LEFT: *Ganesha Pol, the 'Elephant Gate' marks the entrance to the zenana, the women's wing of private apartments at the fort in Amber, the Capital of the Kachchawas before they shifted to Jaipur.*

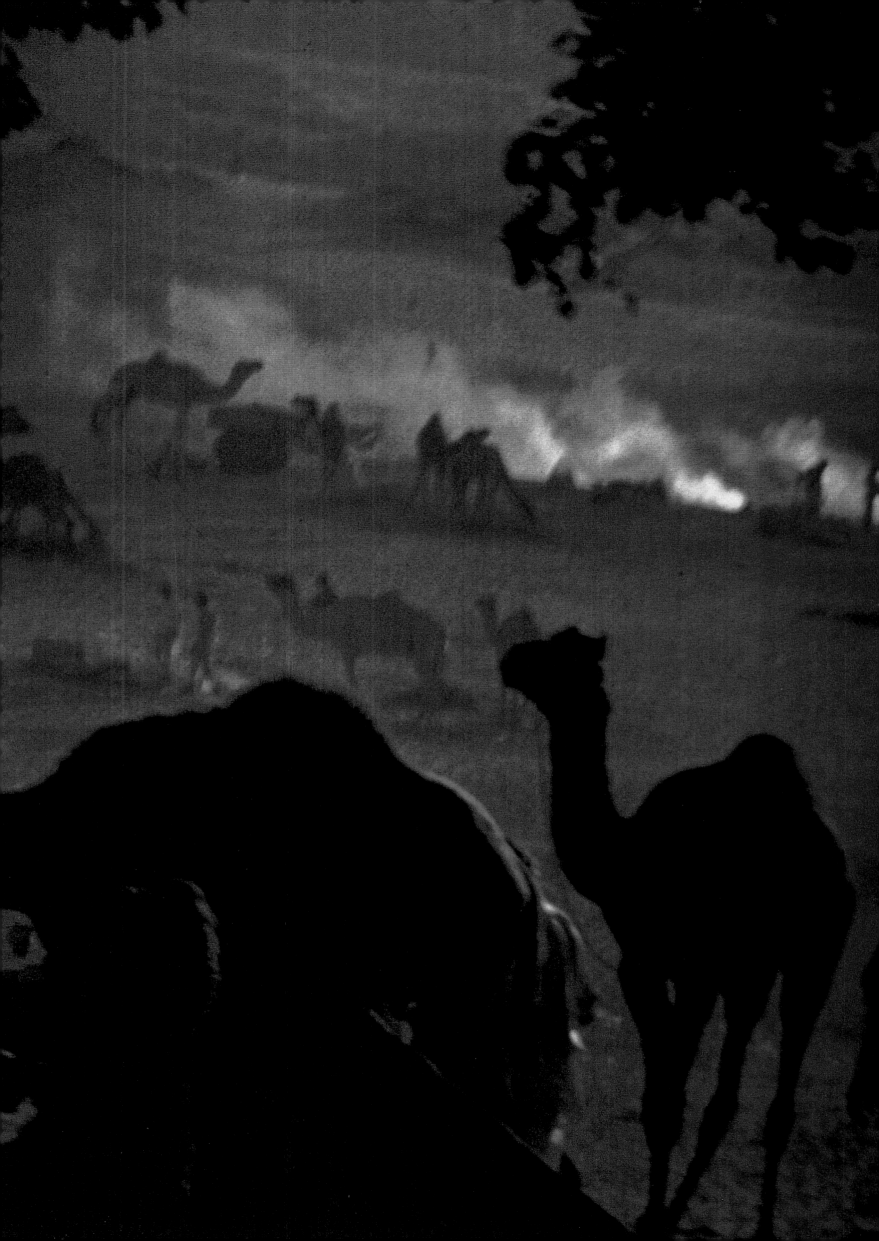

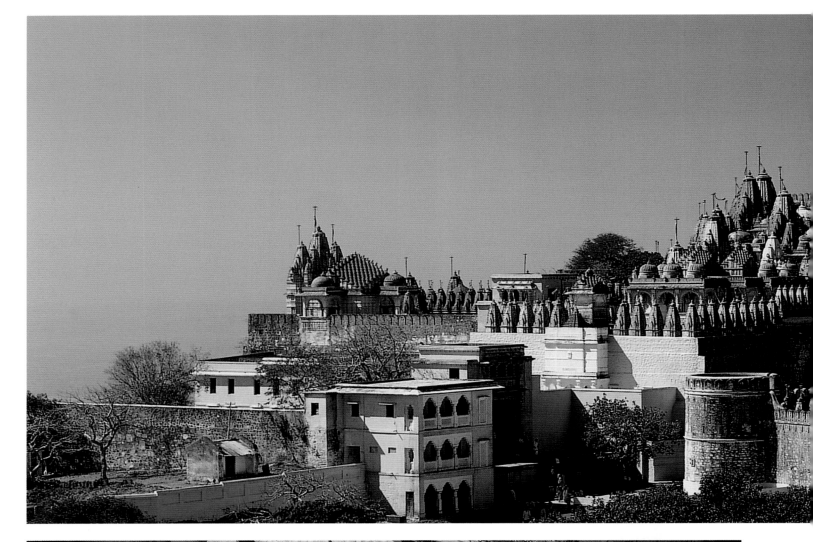

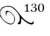

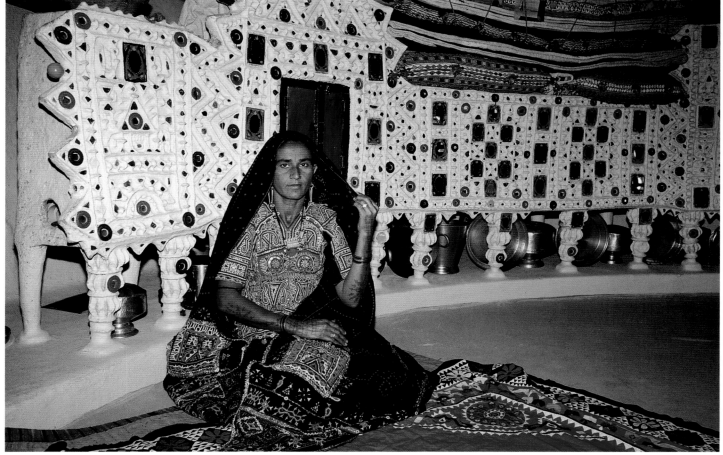

ABOVE: *A Kutchi woman in her traditional attire of embroidered, mirror-worked clothes and silver jewellery.*
PRECEDING PAGES: *Pushkar, the small town close to Ajmer, hosts the world's largest camel fair during the full-moon period of October-November.*

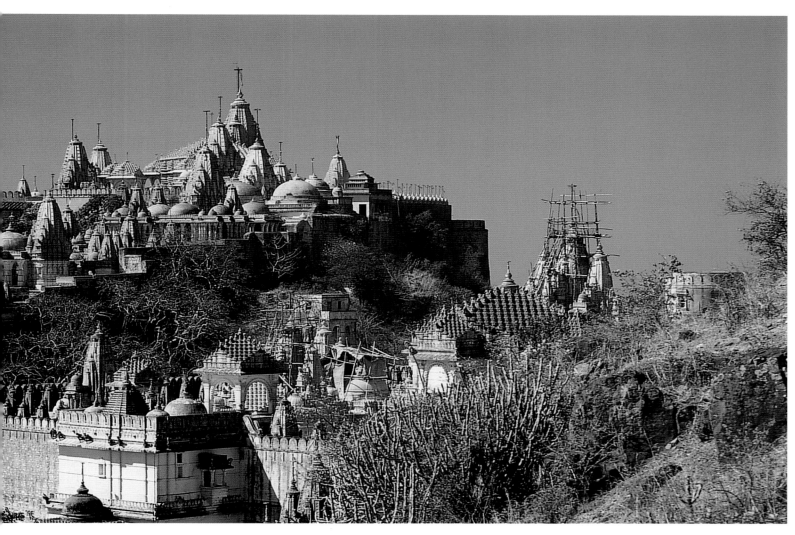

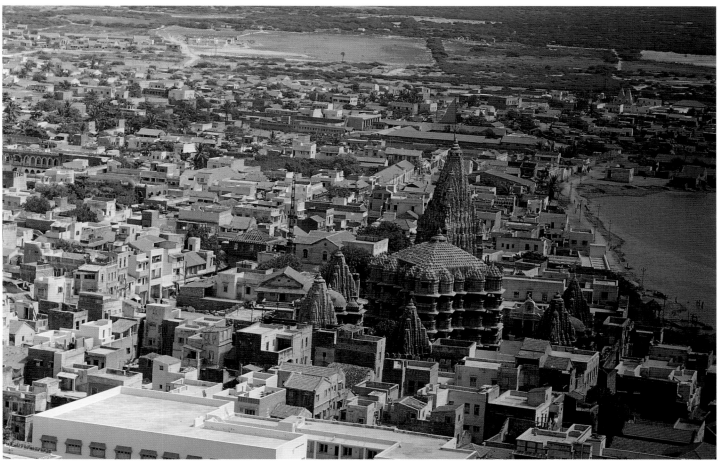

*The holy city of Dwarka, believed to have been Lord Krishna's Capital 5,000 years ago,*
*is accorded the sanctity of one of the four sacred dhams of pilgrimage centers of Hindus.*
TOP: *The peaks of Shatrunjaya Hill at Palitana in Gujarat are crowned by*
*863 carved marble Jain temples of the sixteenth century, grouped together in nine clusters.*

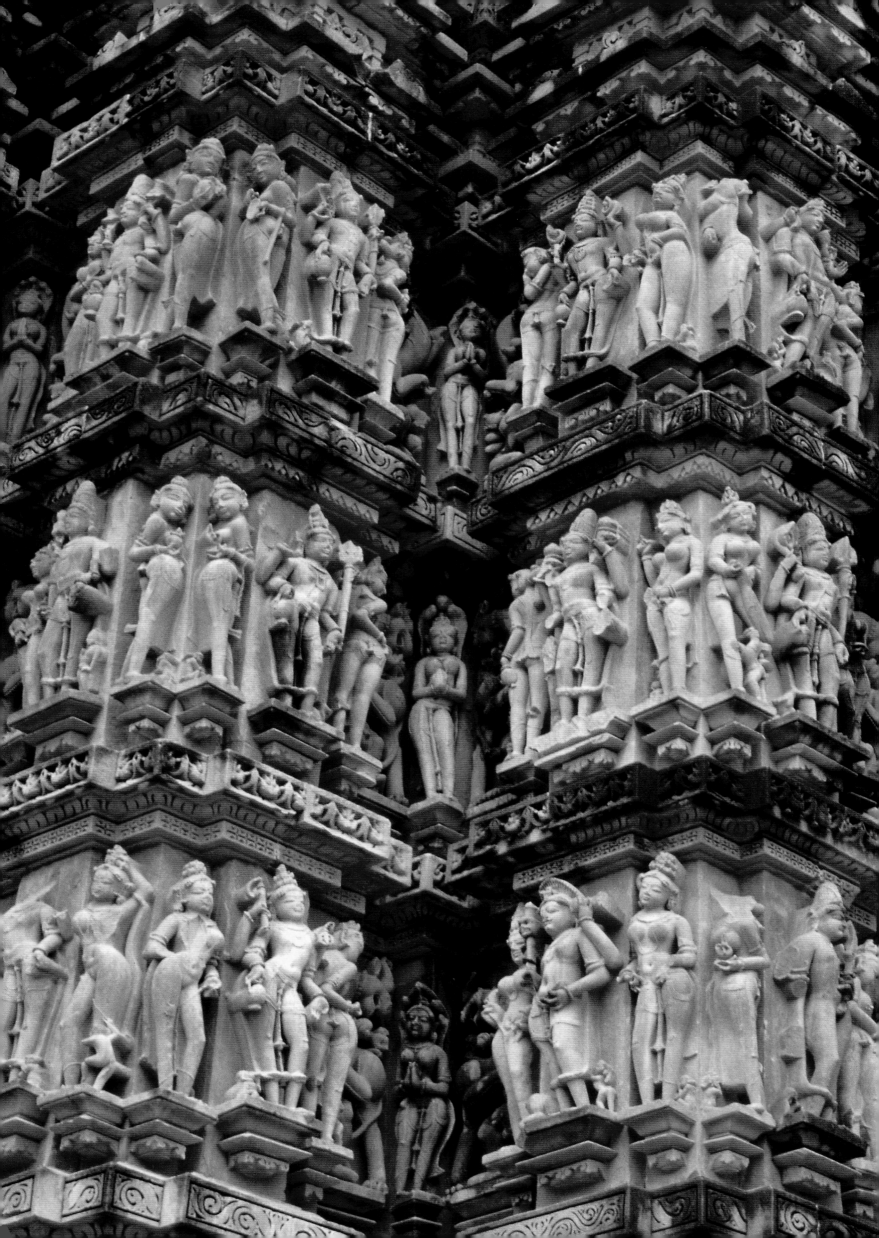

*Madhya Pradesh, in the heart of India, has an outstanding architectural legacy.*
FACING PAGE: *The medieval temples of Khajuraho are renowned for their erotic sculptures.*
TOP: *The sprawling Gwalior Fort with its expressive tile-work, represents secular Rajput architecture.*
MIDDLE: *The 'marble rocks' at Jabalpur's Bhedaghat are actually limestone.*
ABOVE: *The cenotaphs of the Bundela Kings of Orchha are built along the banks of the Betwa River.*

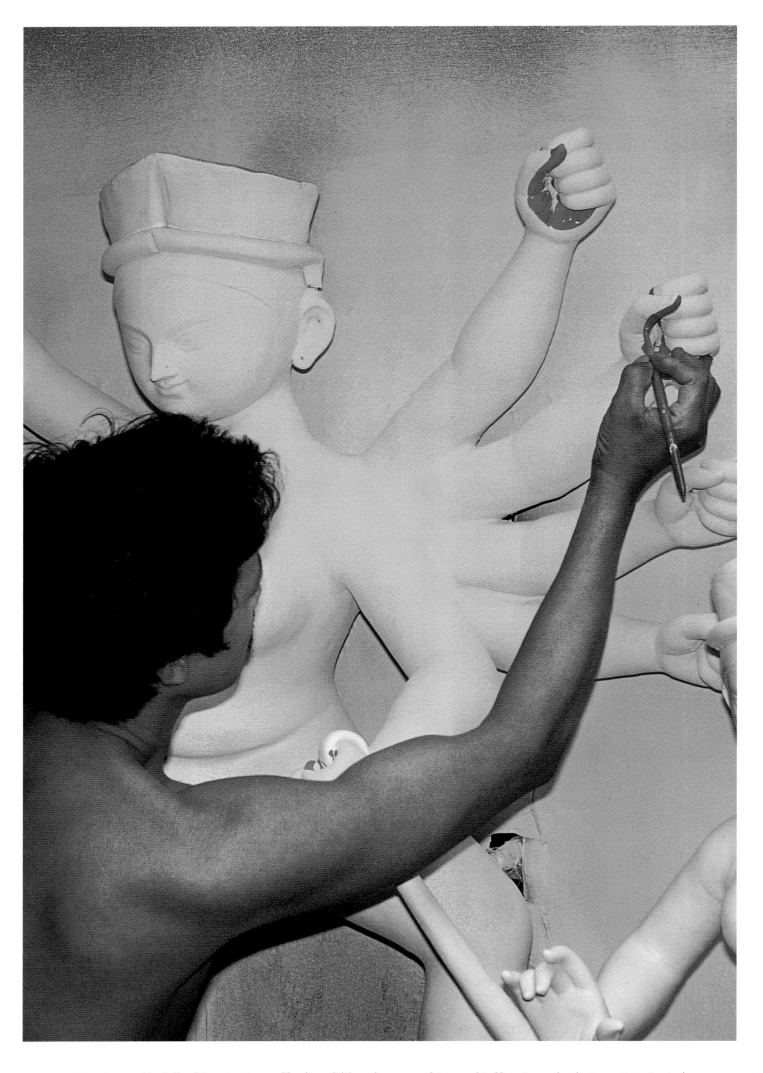

*An artist uses his skill and imagination to add color and life to the ten-armed image of Goddess Durga for the Durga Puja Festival.*

# Kolkata
## *And The East*

A century ago, Kolkata was the jewel in the crown of the British Raj—part of a global empire upon which, it was said, the sun never set. Then called Calcutta, the city of Kolkata lay at the mouth of the Gangetic Delta in the east, ripe with rich possibility as an international trading center.

Today, however, the story of Kolkata is altogether different. While it still remains the "Gateway to the East", much of its glory has long faded. There is resurgence in trade and buoyancy that is enthusiastically accepted by new investors; however, for the moment, Kolkta remains shadowed by dark clouds of controversy. People are dying in the streets, political vagaries abound, and there is a belief held by many outsiders that disease lurks in every nook and cranny of the city

Every day, Kolkata is subject to fresh epithets that keep controversial and dark rumors about the city alive and kicking. Yet, for the citizens of Kolkata, it is often just business as usual on any given day. By and large, they find the dubious labels attached to the city to be amusing.

In Kolkata, it is freely acknowledged that "poverty and pride" do exist "side by side", and this is what gives the city its intrinsic disposition. Kolkata is full of contradictions, and often, life here is filled with extremes. The weather here is mostly humid, with temperatures soaring above 100 degrees Fahrenheit in the summer. For those not used to heavy downpours, the monsoons can be trying, with flooded roads and a general sense of chaos. Rain and humidity have played havoc with the brick-and-mortar exteriors of old buildings, leaving the walls bereft of plaster, and allowing moss to gather at the cornices of elegant mansions.

The autumn months usher in Kolkata's biggest festival, venerating the Goddess Durga, and suddenly, the city is laden with the fragrance of shiuli flowers and joss sticks, overriding the smell of urine and garbage. Hordes of citizens, wander the city, shopping and making merry. The goddess watches over the festivities for five glorious days, while Kolkata enters a veritable "Mardi Gras mode" with children and adults worshipping Durga, and with little care about caste or creed.

Winter in Kolkata is temperate and generally, good-natured and indulgent. Dilettantes discuss Tagore and Che Guevara. Leftist students debate over the relevance of Chairman Mao. Artists arrive in droves to display their canvases, created in other parts of India. The annual book fair keeps the city's writers in a state of perpetual argument, and classical musicians and dancers hold regular soirees. Some of the finest parties of the season are thrown with abandon, keeping guests rollicking into the wee hours of the city's chilly December and January nights.

Physically, the city is no beauty that would leave the casual tourist gasping. It is no Suchitra Sen— the Bengali actress regarded as India's Greta Garbo. Yet, if you allow the River Hooghly to entice you on a humid monsoon evening, or listen to some of north Kolkata's old buildings as they "speak" to you in the hush of a winter, telling you of the reasons why they are lonely, and in a state of semi-ruin, you will find that the city's exposed bricks and chipped Portuguese wrought iron balconies are magically alive.

Most major Indian cities have a long and checkered history. Delhi has had many births and deaths since the time of the Mahabharata. Patna supposedly existed during India's conquest by Alexander the Great. Varanasi is, in all likelihood, the oldest living city in the world. However, by contrast, Kolkata is unashamedly young. It even had a specific birth date—that is, until the ruling authorities summarily stopped the city from blowing out the candles on its annual anniversary cake.

Until recently, August 24, 1690, was acknowledged in Kolkata as the day when English adventurer Job Charnock formally founded the city. Charnock suppos-

edly sailed up the Hooghly River with a small band of carpetbaggers, escorted by thirty soldiers. Tired after his long journey, Charnock's heart gladdened when he chanced upon, in the midst of driving monsoon showers, the sleepy fishing village of Kolikata and the neighboring weavers' villages of Gobindopur and Shutanuti

At the time, Charnock was not aware that rich merchants, like the Setts and the Basaks, had already migrated to this place from the great trading port of Satgaon in Bengal, and had cleared jungle and built their homes. Shutanuti and Gobindopur were already bustling trading centers for cotton, muslin and chintz. But as Charnock anchored his ship on the river, he dreamed of building a grand empire.

Soon, Charnock became a colorful, local hero. He successfully procured a trading license from the Mughal emperor, and as his ambition took flight, wild rumors began to surround him. Charnock kept a meticulous logbook, and it is clear that he came to live like a local raja, adapting with ease to Indian life and clothes. Around 1663, he rescued a Hindu woman from the scorching flames of a sati pyre and married her.

However, it was actually his son-in-law, Charles Eyre, who married Charnock's daughter Mary, who formally bought the rights to the fishing and weaving villages from their Bengali landlords— members of the Saborno Roy Chaudhuri family, who still live in Behala, in the southern fringes of the Kolkata. Eyre's deed of purchase is dated November 10, 1698, and the sum of 1,300 rupees was exchanged in the deal.

Job Charnock is buried at St. John's churchyard in Kolkata, in a well-preserved mausoleum. His epitaph reads: "He was a wanderer, who after sojourning for a long time in a land not his own, returned to his Eternal Home." But Charnock's claim to being Kolkata's official founder is, at the moment, being bitterly contested.

There was a small band of Armenian merchants present in Kolkata who had already set up their businesses well before Charnock's arrival. They had built modest homes and a wharf to receive and dispatch goods. The Portuguese had also started a trading post in Bengal back in 1535, and the Dutch had followed some hundred years later. The French arrived in 1673, and started their factories at Chandernagar. And despite any controversy that may exist today, it is undeniable that the influence of the East India Company and, later, the British Empire, have left an indelible mark on Kolkata's colonial culture.

The metropolis originally grew around a fort, tavern and theater, and had a population of 10,000 inhabitants. Until 1911, Kolkata was the second city of the British Empire, considered to be more important than Hong Kong or Sydney. Trade became the staple diet of the East India Company. Rice, spices, sugar, saltpeter, jute, indigo, tea and opium were procured lawfully—or by force—even as the power of the Mughal emperors began to wane in Delhi, and the British strengthened their foothold in India. Ships laden with goods set sail for England, and sometimes with a Bengal tiger or two hidden in the lower deck.

As Kolkata grew, it became a home away from home for many men and women who arrived as part of the British Empire. Soon the city was divided into the "Black Town", where the natives lived, and the "White Town" where the sahibs—European colonials—dwelled. Churches and lavish homes became part of the skyline. The White Town grew around the original Fort William and extended south, skirting the bend in the Hooghly River, and going past the temple of Kali at Kalighat. Meanwhile, Black Town spun its web of narrow, haphazard lanes toward the northern fringes, where, around the temple of the Goddess Citteshwari on Chitpur Road, some of the local rajas and zamindars built sumptuous palaces beside rows of untidy houses and crossbred mansions.

The East India Company—also known as the John Company—was quickly growing in arrogance and wealth, and this made the haughty Nawab of Bengal, Siraj-ud-daula, who was notorious for his corruption and sexual promiscuity, insanely jealous. His army stormed Kolkata on June 19, 1756, scaled the walls of Fort William, and captured European inhabitants, sparing not even women and children. Dithering about their fate, Siraj-ud-daula had them locked in a tiny cell that came to be known as the infamous Black Hole of Calcutta. The incident was certainly the first blow to British pride.

However, after Siraj-ud-daula's final downfall in the battle of Plassey in 1757, his weak and doddering heirs were compelled to pay stupendous sums of money to the East India Company. Company servants, as part of the deal, made huge personal profits, sending the directors in London into a state of utter alarm. Robert Clive rose to be the Governor of Bengal and regulated

the trade, but the damage had already been done. Since this time, much has changed in Kolkata, but the feel of the old lanes and by-lanes recall the city's past with a sense of loss and nostalgia.

Today, the first impression of Kolkata is of uncontrolled crowds and noise. Wade through this noise pollution and you might still be able to glimpse what was once a fabled kingdom. Hidden behind huge billboards, or garish Hindi cinema posters flaunting the latest Bollywood star in a potboiler, your eyes may fall upon an ornate balcony or the façade of an elaborate dome. Look hard. These are the last remnants of what the tycoons of the East India Company built in their grandest headquarters.

Kolkata, when it was the fabled Calcutta, was a Georgian contemporary of Bath and Edinburgh, boasting wide, tree-lined streets with embellished gas lamp posts, grand palaces and administrative buildings. The Victorians converted Calcutta into a busy port, their version of a Liverpool, and built shipyards, mills and impressive railway stations. Today, there is an inherent schizophrenia in these buildings, at once grand and recalling old times and yet, frightfully out of place and falling apart, surrounded by a plethora of faceless construction and matchbox high-rises.

The Victoria Memorial Hall, nevertheless, is certainly Kolkata's most famous edifice, housed in a sprawling garden spread over acres of land and filled with statuary. The Memorial was constructed at the behest of Lord Curzon and its foundation stone laid by the Prince of Wales in 1906, although the building did not officially throw open its doors until 1921. Designed by Sir William Emerson, then President of the Royal Institute of British Architects, its admirers have compared it to the Taj Mahal in Agra.

The Victoria Memorial resembles Belfast City Hall, and is a repository for Raj memorabilia, including some of the best paintings and etchings of those past times. Portraits by Zoffany and Tilly Kettle, landscapes by William Hodges, and work by Charles D'Oyly, and the uncle and nephew duo, the Daniells, line its walls. Here, too, is Queen Victoria's writing table, and other items that trace the history of Kolkata.

The Government House, now known as the Raj Bhawan where the Governor of West Bengal resides, is another of Kolkata's famous buildings, but with a history that

is much older and much more animated. It is the handiwork of the flamboyant Marquis Wellesley, who ordered the construction of a grand headquarters that would be a worthy symbol of the mighty British Empire. When completed in 1802, this palace had a startling resemblance to Robert Adam's Kedleston Hall in Derbyshire. Located on the west of the Esplanade it has, among other decorations, gravel paths imported from Bayswater by Lord Hastings, a Chinese cannon provided by Lord Ellenborough, and gardens originally designed by Ladies Amherst and Mayo. It is still a stately residence that has housed numerous governor-generals and Indian nationalists.

In North Kolkata, the "palaces" of the Raj compete for attention with those built by the native rajas. Even in the southern portions of the city, with the lavish homes and mosques built by the banished sons of Tippu Sultan, and the Nizam's Palace on Lower Circular Road, Kolkata's famous habitats can still tell an exciting story or two.

After the bloody Indian Mutiny, when Wajid Ali Shah, the Nawab of Oudh, lost his crown in 1857, he sought shelter in Garden Reach and recreated the atmosphere of Lucknow at Matiaburz. Here, he came to live in resplendence with his harem, eunuchs and dancing girls, his pigeons, and an assortment of magnificent animals. His residence was a world unto itself until, one hot summer night, one of his tigresses managed to give the attendant a slip, swim across the river to the Botanical Gardens, and frighten a meek curator who was preparing to go to bed.

There is a never-ending cornucopia of anecdotes such as this attached to Kolkata's various palaces. They keep legend and myth alive in the aging corridors of history, and give the city an enchanted, mythical dimension.

The goddess Durga, in her many splendorous incarnations, is the resident deity of Kolkata. Devout Hindus worship her as Kali at her temple in Kalighat and Dakshineshwar. Some believe that the city is named after her, and they shout, "Jai Kali Kalkattewali!", before setting out from their homes. Others, before beginning a long journey, chant, "Durga! Durga!" As Bhavani, she looms large over the Police Headquarters in Alipur. And as Durga, mother not only to her brood of two daughters and two sons, but to the rich and poor alike, she showers her benevolence in one of the grandest autumn carnivals celebrated in Kolkata.

Durga Puja, the city's largest festival, breeds its own indigenous cottage industries. In Kumortuli, next to Sonagachi, where the sex workers still ply their trade, the goddess is crafted from straw and silt from the river, and adorned with glittering jewels fashioned from tinsel, gold and silver foil, and shola pith. It is believed that a little clump of mud from the threshold of the prostitutes is generously mixed with the rest of the silt for good luck. The hour for painting the eyes of Durga, when she first glimpses the world, is done after much consultation with the local priest and his tattered almanac. Elaborate pandals fashioned out of bamboo poles, cloth, and a variety of exotic materials, such as terra cotta pots and bright plastic buttons, are constructed to house the devi.

The stunning decorations and twinkling lights of the celebration turn Kolkata into a temporary fairyland in the evenings. The lights come from Chandernagar, and the drummers arrive from their villages to play various, complicated beats on their dhaks at auspicious hours. Everywhere, there is cheer and laughter, and recitations by the priest from the holy book of Chandi fill the air.

Kolkata can never be faulted for committing a cultural faux pas, for it can be argued that its way of being has given other cities the impetus to acquire a cultural personality and delve into their past. A mix of varied identities, a dash of unalloyed pride, and a deeply committed allegiance to traditions that are wonderfully secular, give this city its refinement and unity.

The Tagores, a prominent family of Kolkata, have helped to raise the city's strong cultural identity that has endured through the years. Rabindranath, grandson of Prince Dwarkanath, began writing during his childhood and later won the Nobel Prize in 1913 for his collection of poems, Geetanjali. His genius as a dramatist, poet, novelist, artist, actor, teacher and social reformer is well known. Satyajit Ray, the Oscar-winning filmmaker, is yet another great son of Bengal. And although she was not a Bengali, the late Mother Teresa, a recipient of the Nobel Prize for Peace, is considered to be a noble daughter of this state.

The reform movement in Kolkata is not new. From the time of the earliest settlers, men and women have stepped out from their daily lives to reach out and help the less fortunate. The first name that comes to mind is that of Raja Rammohan Roy (1772-1833). He not only challenged the bigotry of traditional Hindu society by breaking away from its tentacles and starting the Brahmo Samaj in 1828, but he also founded liberal educational institutions along with his friend, Prince Dwarkanath Tagore, and others.

Ishwarchandra Vidyasagar (1820-1891) was the son of poor Brahmin parents from Midnapur, and is still remembered for his contribution to the Bengali language and his extraordinary charity. The name of Swami Vivekananda (1863-1902) is so intrinsically linked with the Ramakrishna Mission and Belur Math that it is difficult for those who do not know about his early life to imagine he had been skeptical of his guru, the great saint, Ramakrishna Paramahansa.

Swami Vivekananda found an ardent devotee in an Irishwoman named Margaret Noble (1867-1911), better known as Sister Nivedita. Sarala Devi from the Tagore family, Matungini Hazra, Bina Das and Begum Sakhawat are some of the other women who ushered in social and political change in Kolkata.

The city also will never forget the firebrand, Aurobindo Ghose (1872-1950), who gave India's Independence Movement a provocative voice through his writings. He transformed from a revolutionary on the run into a sage. At his ashram at Pondicherry in south India, he came to be known to his disciples as Sri Aurobindo.

Netaji Subhas Chandra Bose (1897-1945) is undoubtedly Kolkata's most dynamic political luminary. His life is intensely romantic, and his determination to overthrow the British Raj by founding the Indian National Army with Japanese support is a story every child in Kolkata grows up to venerate.

But these are all just a handful of names plucked from the vast sea of Kolkata's ongoing reform movement. Patriotism and charity are inherent in the life of the quintessential Kolkatan.

*Jaybrato Chatterjee*

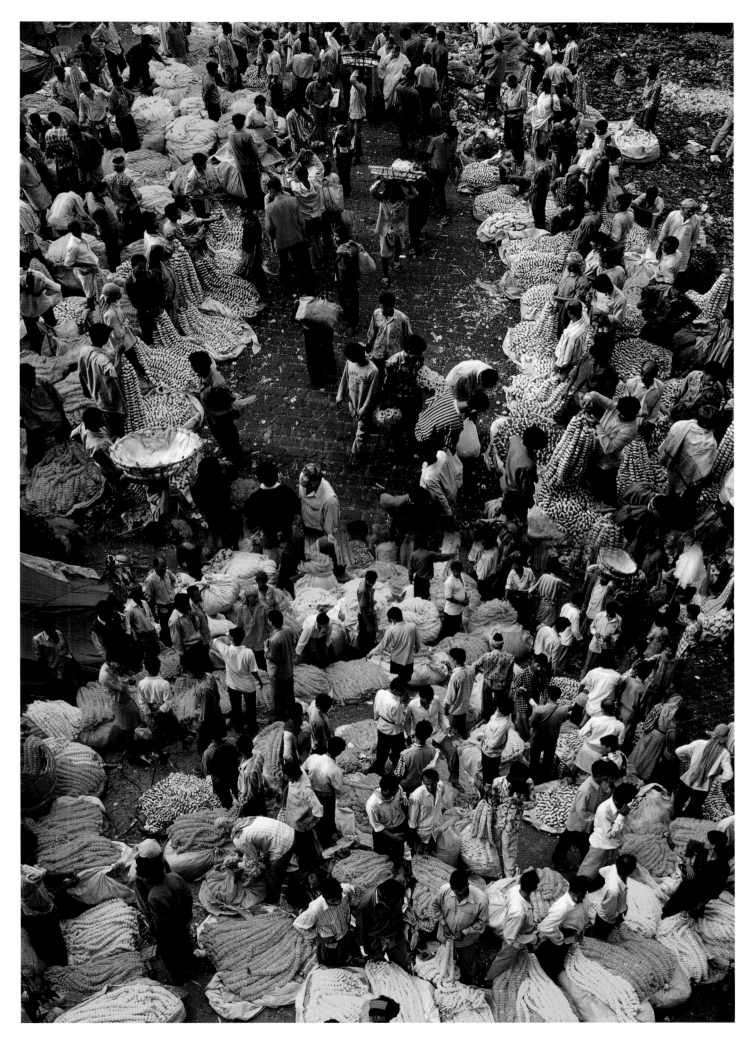

*A striking picture of the blooming flower market of Kolkata, which commences from Machighat and ends at Burrabazar near Howrah Bridge.*
*It is considered one of the largest flower markets in the country with nearly 400 shops and 5,000 florists selling an enormous variety of flowers.*

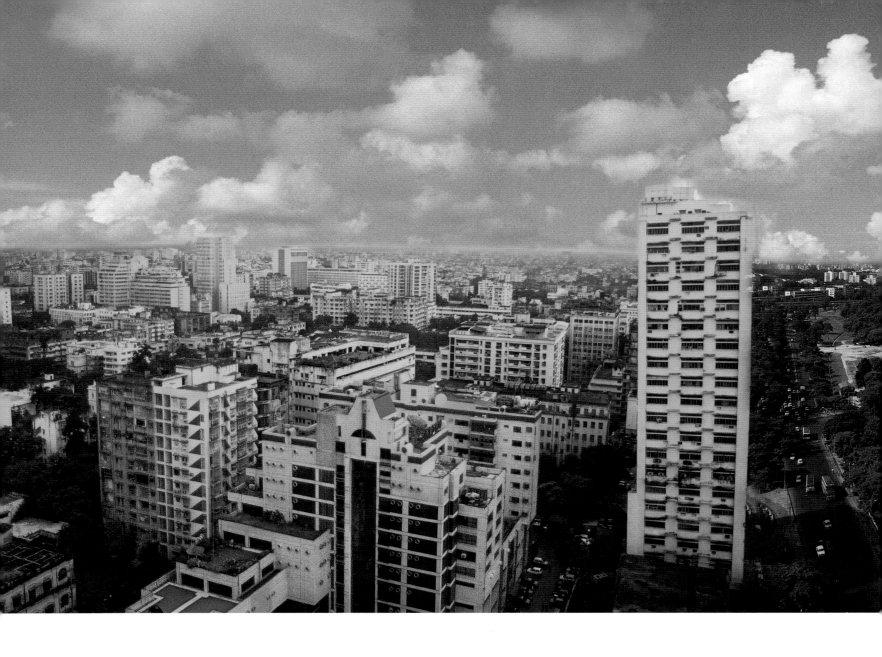

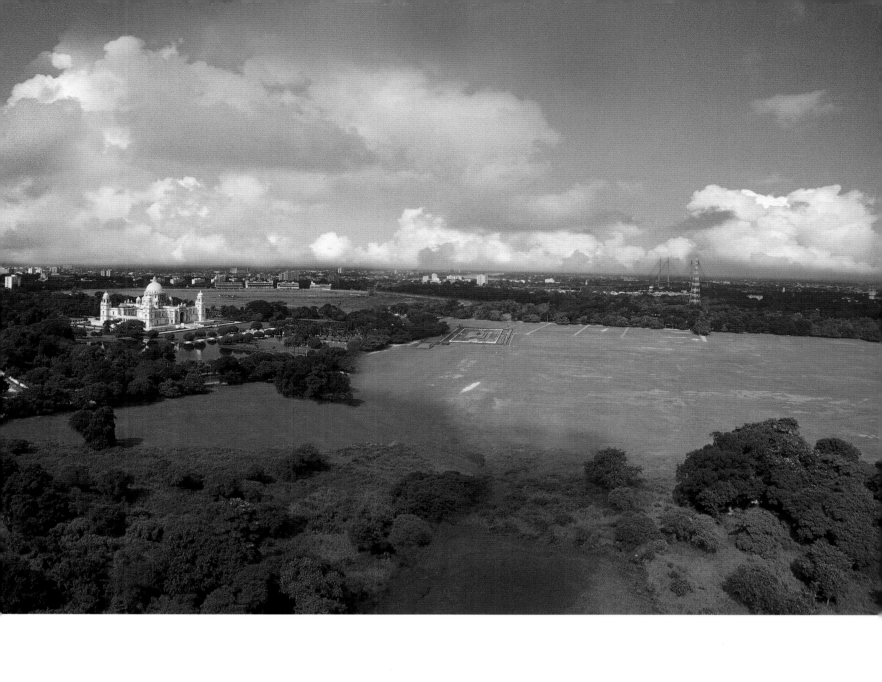

*A panoramic view of the city of Kolkata depicting a fine blend of the old and the new,
with the Victoria Memorial, a colonial architectural marvel holding forth on its own.*

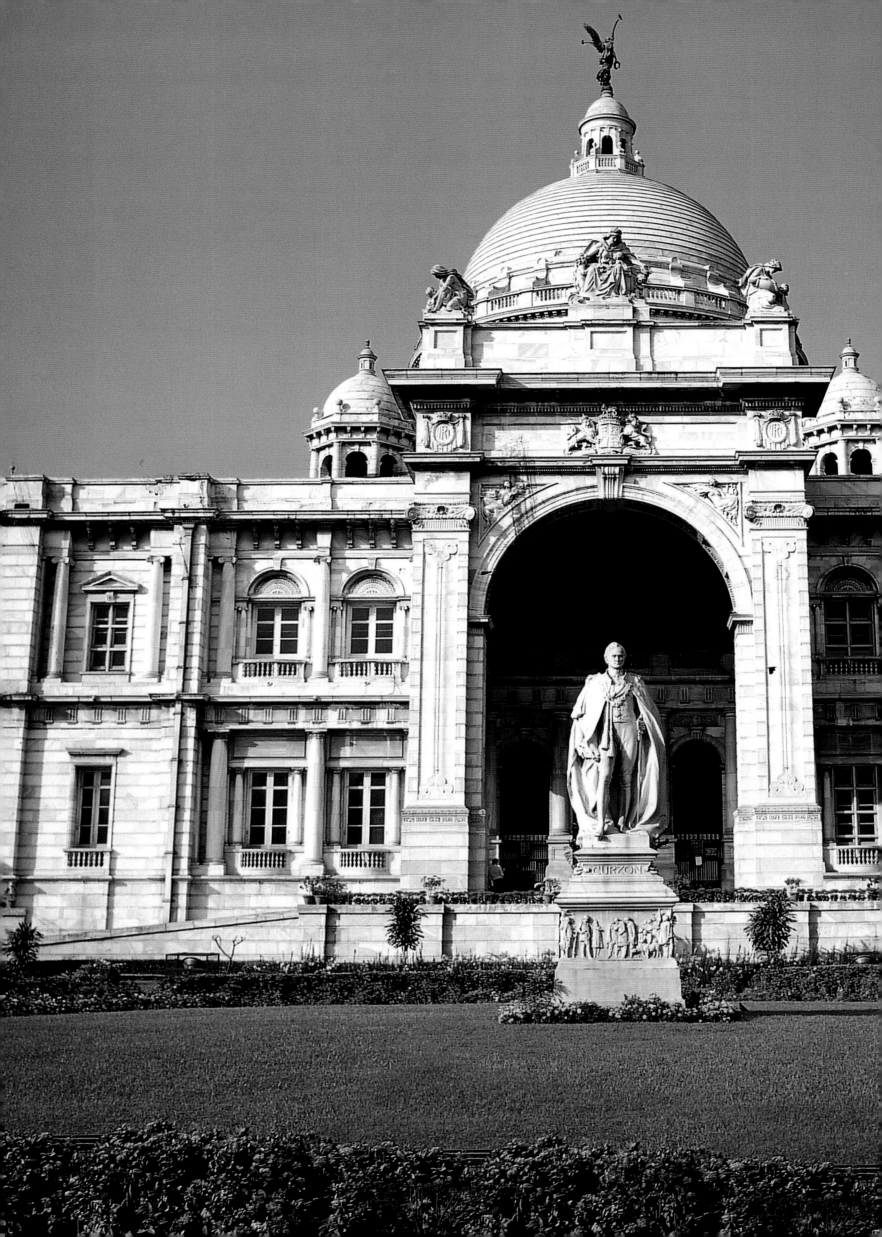

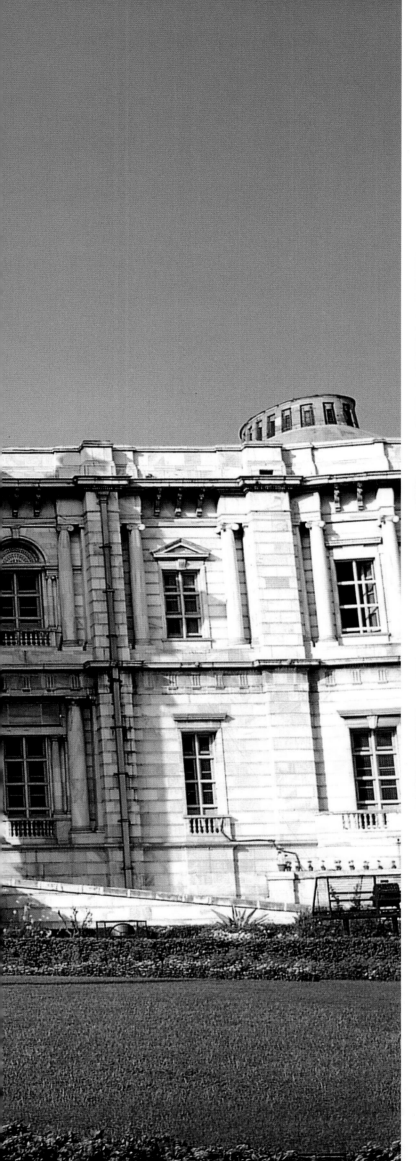

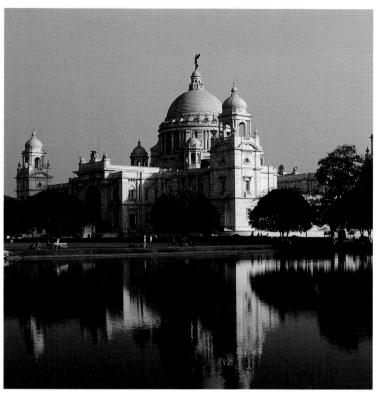

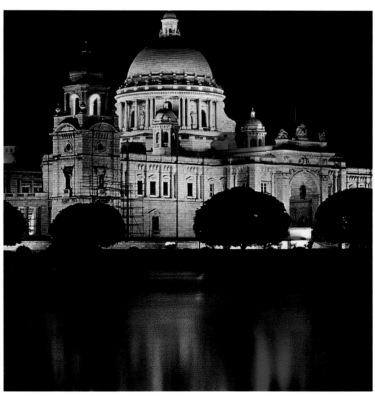

LEFT AND ABOVE: *Kolkata's most famous monument, the Victoria Memorial was conceived by Lord Curzon, a Viceroy to India and inaugurated by King Gerorge V in 1906. This sprawling memorial made from pure white marble now functions as a museum with paintings, manuscripts and rare archival collections of the British rule in India. This domed classical masterpiece is often compared to the renowned Taj Mahal in its beauty and design.*

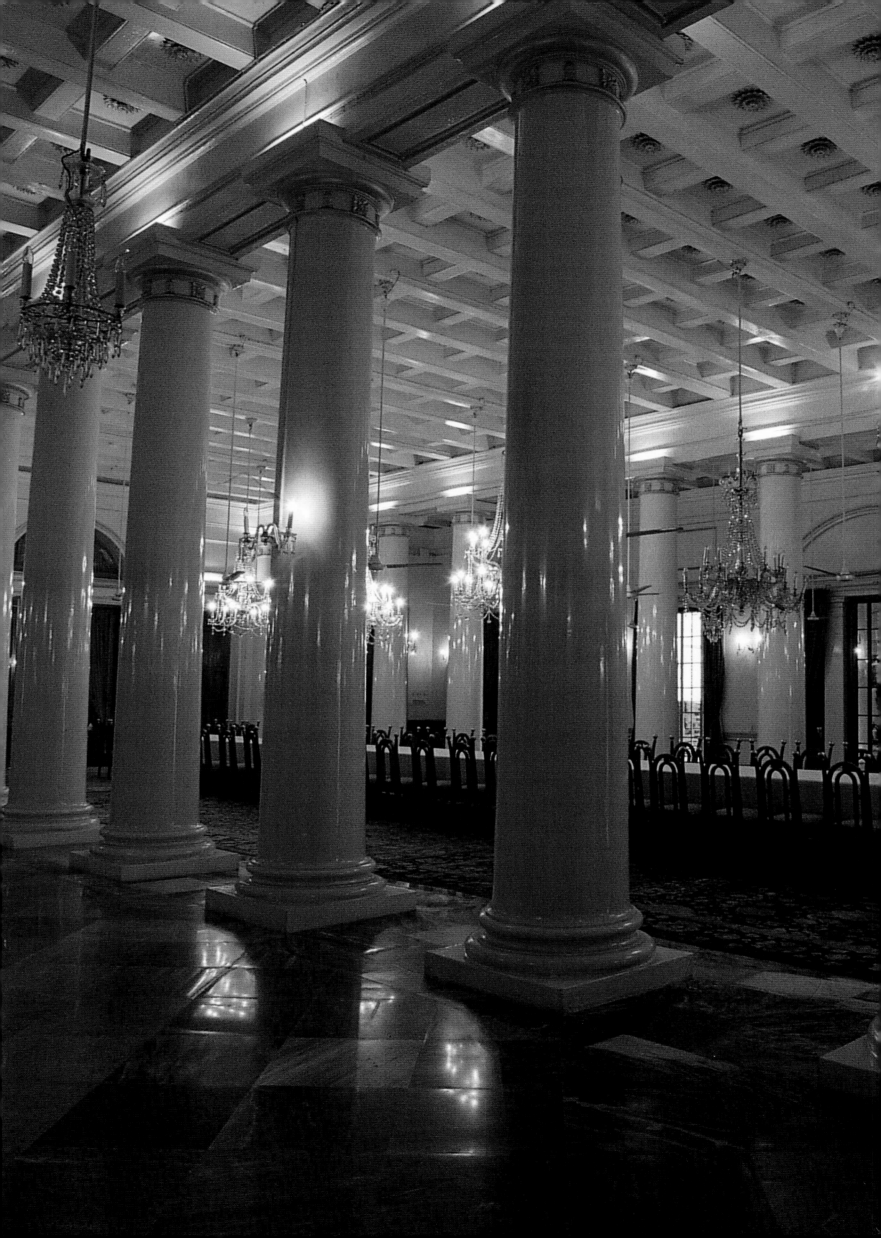

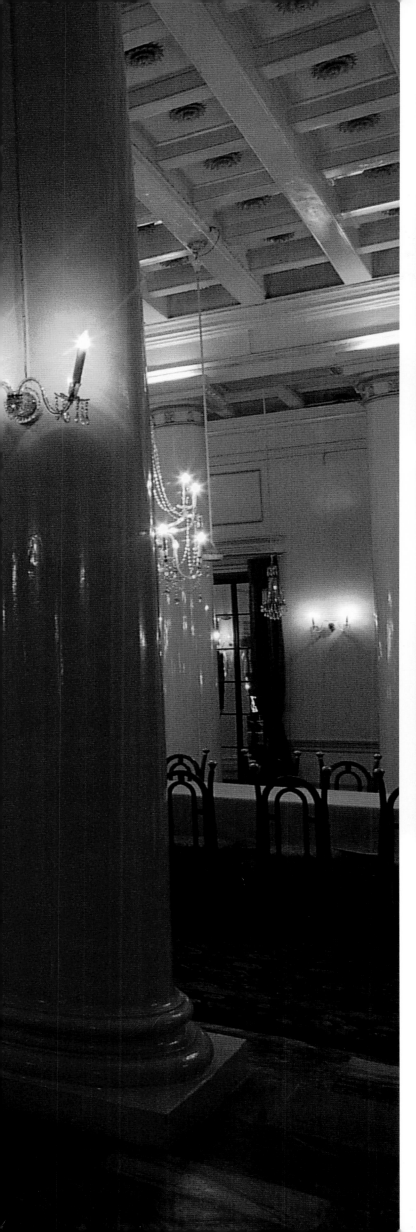

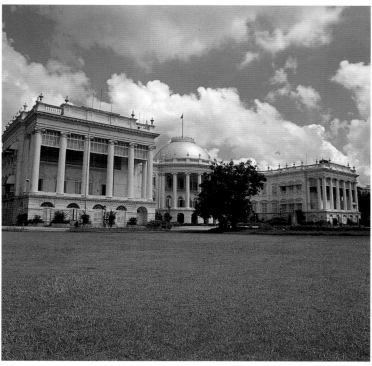

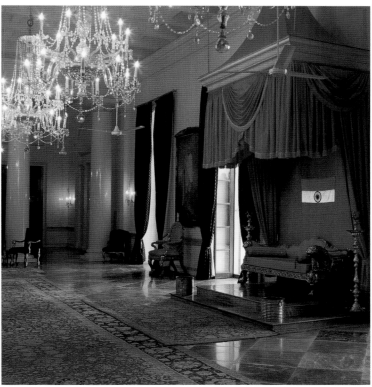

*The Government House, now known as the Raj Bhawan, is a befitting symbol of the British rule in India, given its neo-classical grandeur. The picture shows the plush interiors of the Raj Bhawan that now serves as the official residence of the Governor of West Bengal.*
FOLLOWING PAGES: *A view of Kolkata's busiest and crowded vegetable market near the Sealdah Railway Station, a true reflection of the life in Kolkata.*

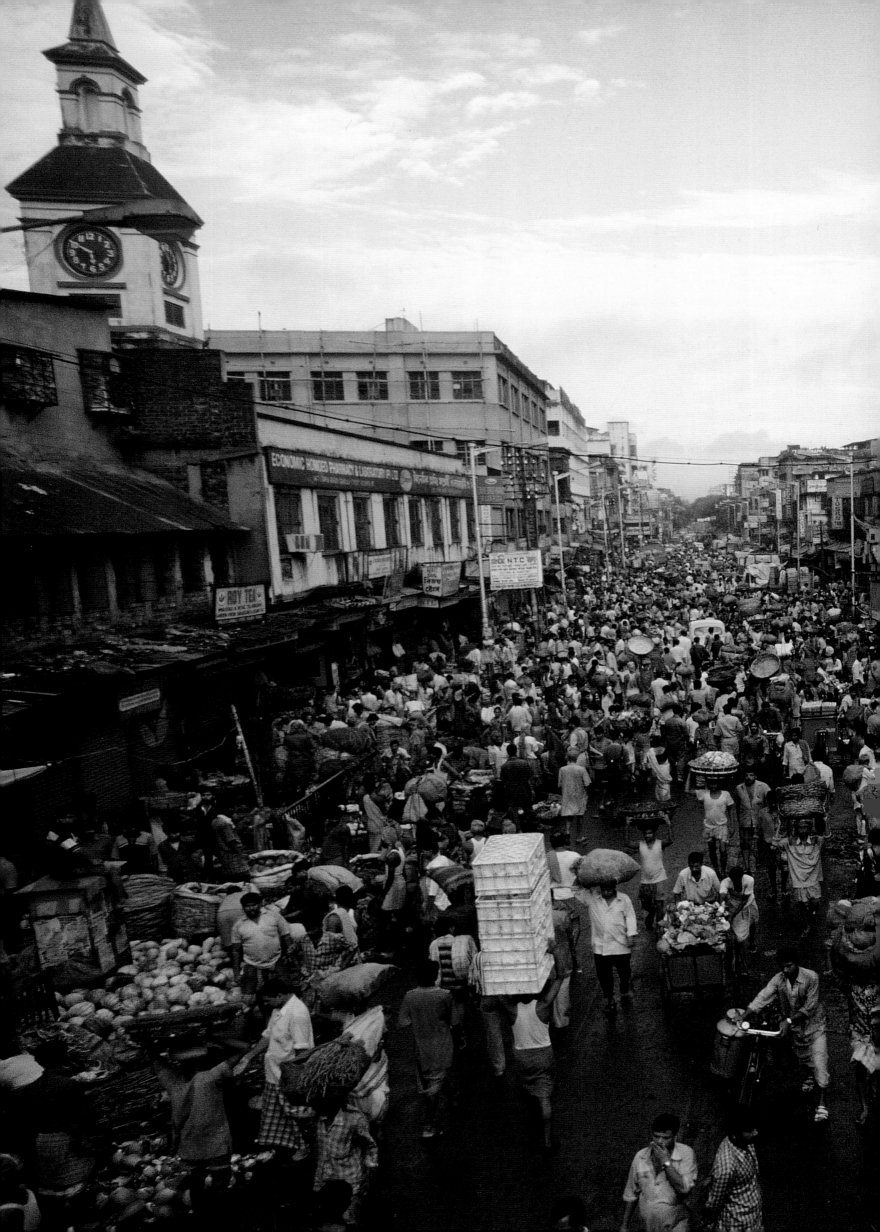

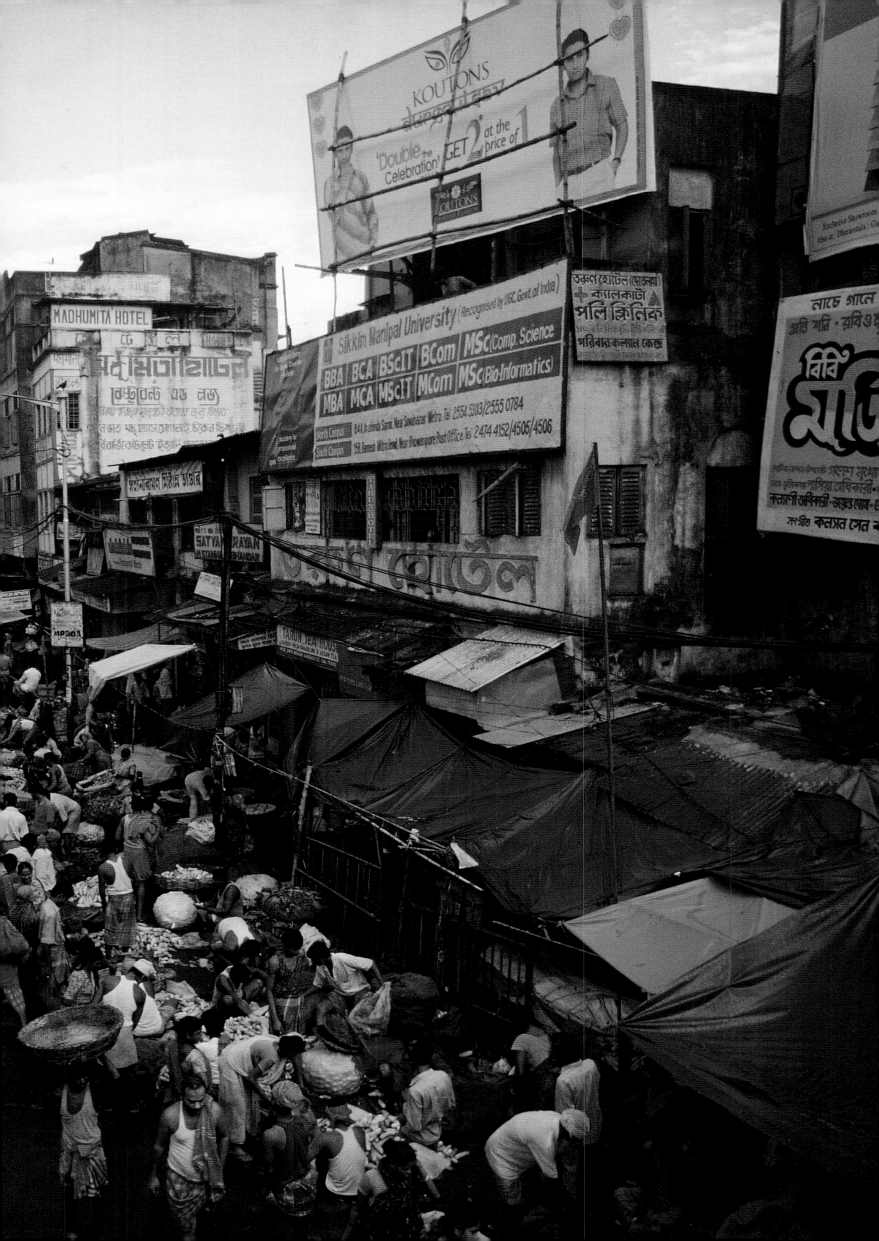

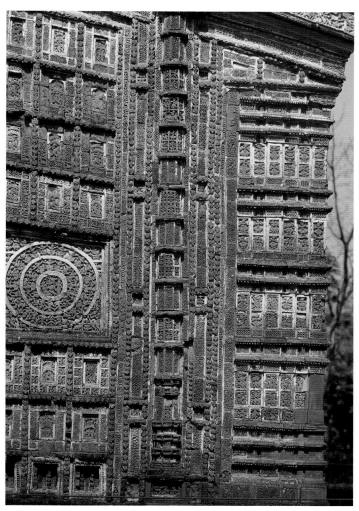

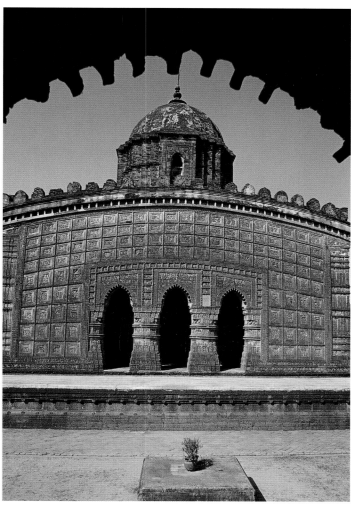

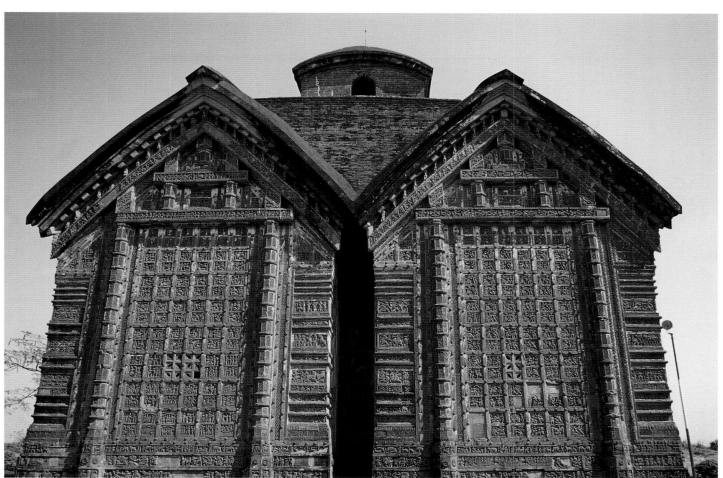

FACING PAGE AND ABOVE: *Vishnupur, once the Capital of the Malla Kings, is renowned for its ethnic terra cotta temples made from local red clay. Situated more than 150 kilometers from Kolkata, these 30 temples spread over a lush green area of three kilometers, vary in both design and scheme, distinctly carved with scenes from India's famous epics, gods, goddesses, flowers and daily life.*

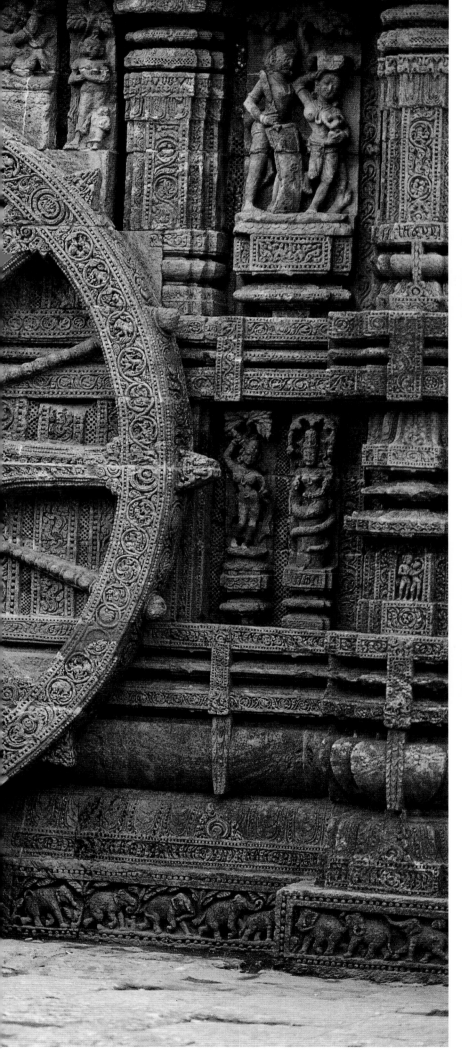

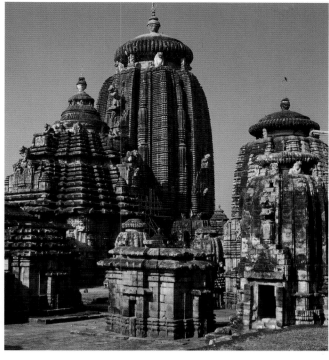

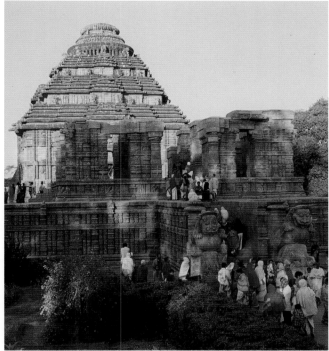

FACING PAGE: *The magnificent Sun Temple at Konarak built by King Narasimhadeva in the thirteenth century, is a masterpiece of India's temple architecture. The superbly carved temple is shaped like a colossal stone chariot, carrying the Sun God, Surya, across his daily journey in the sky. The chariot's twelve pairs of wheels symbolize the twelve months of the year, while the seven horses signify the number of days in a week. The Sun God is depicted as standing in the chariot surrounded by several other images.*

TOP: *The eleventh-century Lingaraja Temple in Bhubaneswar, is dedicated to Lord Shiva, or Tribuvaneshwar, meaning the Lord of the three worlds and the city also derives its name from this origin. The main shrine towers at a height of 55 meters, surrounded by a number of smaller shrines in the compound.*

ABOVE: *The overall design and the consummate skill with which each sculptural and decorative detail has been carried out, make this temple one of the highly evolved examples of Orissa's Temple architecture.*

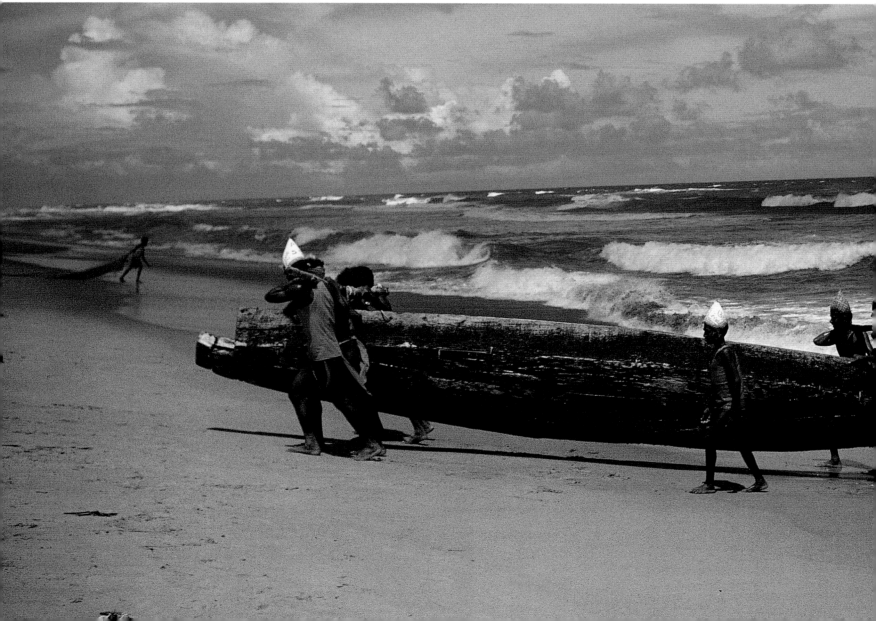

154

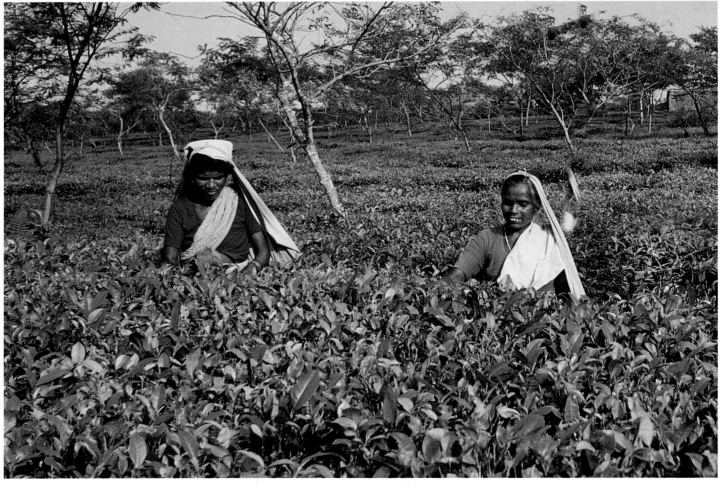

TOP: *A view of the snow-clad Himalayan peaks from Darjeeling in eastern India and the famous tea plantations of the region.*
PRECEDING PAGE TOP: *Visitors enjoying the beautiful expanse of the beach at Puri, Orissa.*
PRECEDING PAGE BELOW: *Fishermen carry a long boat on the beach at Gopalpur-on-Sea, Orissa.*

*The seventeenth-century Kamakhya Temple, near Guwahati, is an important pilgrimage site for the Hindus.*

*A priest discusses the intricacies of religion, seated against the exquisitely carved pillars of the Chidambaram Temple, in Tamil Nadu.*

# Chennai
## *& the South*

It was from the ancient coast of Coromandel that the culture of India spread to the lands of the East, and it was to the Malabar and Konkan Coasts in the west, and the Fisheries Coast in the east, extending southwards from Coromandel, that the Arabs, Jews, Greeks, Romans and Chinese first came to India. These coasts embrace what is now South India, a river-crossed peninsular where civilizations as old as 2,000 years still thrive.

South India today is the hub of the India's IT world. It is the best consumer product market in the country, and has more restaurants and pubs than most places in the subcontinent. Here also in the people is the conservativeness that allows tradition to thrive alongside modernity. In South India, the past is to be respected as much as the present is to be pursued, and the faiths of ages are an integral part of everyday life, even as the symbols of international materialism are flaunted.

Madras, now Chennai, is where the first steps were taken in the journey from India's past to its present, when the "Queen of Coromandel" became the "Gateway to South India". Modern India grew from the seeds sown in Madras over a 250-year period, beginning in 1639. Today, every one of the other South Indian states—Kerala, Karnataka and Andhra Pradesh—have their own gateways to the south in Trivandrum, Bangalore and Hyderabad. But Chennai remains the most favored destination from where to begin an exploration of southern India.

Chennai, capital of India's southernmost state, Tamil Nadu, is a city that was created by the British. In ancient villages and towns, towers of 1,000-year-old temples soar alongside church steeples that honor St. Thomas, and mosques that owe as much to the Arab era in the southernmost reaches of the state, as the Muslim march from the north. South India's shrines of all faiths are a reflection of the serene harmony in a state best known for its magnificent temples, many of them masterpieces of the builder's and sculptor's art. But looking beyond its temples, Tamil Nadu is host to many surprises.

Chennai offers a cornucopia of attractions. It is filled with historical landmarks and a rich architectural heritage. Visitors can enjoy Chennai's beaches, zoos, museums, parks and restaurants. The vast array of jewelry, silks and handicrafts available for sale can be hypnotizing to those who love shopping, or who are simply spectators of the sport. At center stage in Chennai is the music and dance of its classical past.

In Fort St. George, you will walk with a history that not only tells the story of the beginnings of the world's biggest empire, but also, India's modern development. Classical architecture, as much as the Indo-Saracenic style that replaced it, laid the foundations for the buildings of New Delhi; they captured international imagination, and are now part of a Chennai scene that would take a building enthusiast days to absorb, particularly, if he is conscious of the ghosts of the past who walk the city's streets.

Chepauk Palace, and the university buildings of Chennai are among the finest examples of Indo-Saracenic architectural style, while the police headquarters and several halls of government represent the best of the classical style that was imported to India. The effects both styles have had on countless other buildings in the city make Chennai an architect's delight.

While negotiating through congested George Town where "Indian" Madras began, you can follow the trail of the apostle, St. Thomas, or stroll through one of the city's many "quadrilaterals"—the four streets that surround a temple and its tank. In the heart of the city, you can follow the trail through Chennai's only wildlife sanctuary, and on the outskirts of town, you can pick your way through the wholesale fruit and vegetable markets. If that's not enough walking, you can visit the scores of silk and jewelry shops in T'Nagar and be overwhelmed by a magical world of design, texture and color. And at the end of it all, there are restaurants with extensive menus, offering cuisines ranging from Parisian to the most traditional vegetarian.

Chennai is the starting point of a "Golden Triangle"

that is a heady mix of art and kitsch, serenity and devotion. The road to Mahabalipuram, the second point of the triangle, is where 7th–century sculptors created a wondrous open-air museum of magnificent stone art, which is now listed as a World Heritage site. But before heading there, visit Kalakshetra in Tiruvanmiyur, where the ancient dance of Bharatanatyam is taught outside under the trees, and traditional and modern cultures converge.

In the Cholamandal Artists' Village, artists create modern art that is the core of what is now called the Madras School. Chennai also has two amusement parks to visit, and also, Dakshina Chitra, where the traditional homes of the four southern states have been built on the sand dunes. The last stop before Mahabalipuram is Crocodile Bank, where a few thousand crocodiles, representing a dozen species, along with other reptiles, compete for visitors' attention, while snakes here are being "milked" for their venom.

The third point of the triangle is sacred Kancheepuram, one of the seven holy cities of India, and a "town of a thousand temples". Kancheepuram offers a plethora of historic temple art, the serenity of spiritual wisdom, and the blessings of a pontiff of Hinduism at the matha of the Sankaracharayas. An architecturally eye-catching modern library of the ashram, with its wealth of Indological material, is also located here. Owing much to this world of faith, art and scholarship are the local weavers, who create the most famous silks of India in an almost unimaginable range of colors and designs.

Mahabalipuram is just one of the landmarks along Tamil Nadu's long coastline. Off the southern coast—the Fisheries Coast— where divers sought the pearls of the Gulf of Mannar, much development is still underway, with village after village displaying a church steeple taller than its neighbor's. The northern coast, the famed Coast of Coromandel, still shows the first traces of international trade in India, which developed into the Age of Empire: Pulicat, Sadras and Nagappattinam of the Dutch; Madras, or Chennai and Cuddalore, of the British; San Thomé (a part of Chennai); and Porto Novo of the Portuguese; Pondicherry of the French; and Tranquebar (Tarangambadi) of the Danish. All of these places still hold relics of the 300 years from 1500 to 1800, when trade strengthened imperial power and brought new religious persuasions to India.

Forts in various stages of decay, and many streets and homes, still recall their European past. Cemeteries,

tended and untended, and churches in a variety of architectural forms, where worship still occurs, are all part of the heritage trails to be followed in these former trading posts that were considered capital cities, at different times, by the occupants of these eastern settlements.

A heritage trail of a different kind leads to Thanjavur's "Great Temple", marked by soaring, sculptured towers, and enormous stones that leave you wondering how they were lifted in the 11th century. Other great temples of the hinterland of the sacred Kaveri River include the Gangaikondacholapuram and Darasuram, which, like Thanjavur's Great Temple, are also World Heritage Monuments.

On both sides of the Kaveri River lies Tamil Nadu's rice bowl, a lush farmland where every village has a shrine to be explored, and mango and banana groves that are, when laden with fruit, a testament to how good the gods have been to this green land.

Long ago, the Mahrattas moved as far south as this, and their heirs, the Princes of Thanjavur, still care for the palace and famed library and museum, where the bronzes are only a sampling of the work of the creators of the world's finest bronze statuary, who called this ancient land, Chola Nadu, their home.

Southwest of Thanjavur is Madurai, capital of the ancient Pandya kingdom. Here, too, are temple towers that reach for the skies, halls and corridors filled with richly sculpted pillars, and a buzzing bazaar. If the Meenakshi Temple is the heart of Madurai, its palace of another era is a reminder of how, throughout southern India, dynasty replaced dynasty, none in power for more than a couple of hundred years.

Between Thanjavur and Madurai is awesome Chettinad, where in 75 villages, near-deserted mansions as old as 200 years rise out of an almost parched wilderness to testify to a glorious age when a merchant community, the Chettiars, dominated the business and development of countries in South and Southeast Asia. Always returning to their "home," the Chettiars poured wealth into richly embellished and stately homes with personal ornamentation fit for kings and lavish hospitality.

Neighboring Tamil Nadu to the west is Kerala, known as the land of the coconut, but a place where every crop pleases. It is nourished by swift rivers rushing

down from the rugged mountains that form the eastern boundary of this sliver of a state. Here, where every village has its shrines of Hinduism, Christianity and Islam, and where people touched by the influence of India and West Asia count their blessings for the fertile soil, life thrives along Kerala's waterways—the sea and backwaters, and the rivers and lakes. In Kerala, boats are raced, and footballs are kicked in nearly every bit of available space, while residents spend just as much of their energy at wayside tea stalls, where the day's events are discussed endlessly, as is befitting India's most literate state.

Just across the border in Tamil Nadu is the magnificent Padmanabhapuram Palace, an architectural masterpiece that is a symphony in wood, and testimony to the skills of the woodworkers of Kerala. Their work can be marveled throughout the state, at many an old palace or mansion, and also, in modern homes.

A more colonial influence is visible in Kochi (Cochin), located near to where European sailors, from the time of Vasco da Gama, made landfall. Kochi reflects other influences, as well; Chinese fishing nets, and the synagogue and markers of "Jew Town," are reminders of the port city's past, when Chinese traders came here by ship to conduct business with local Jewish merchants.

Boats plying the backwaters from Cochin offer homes-away-from-home for visitors, or carry them to eco-friendly destinations that have made Kerala the tourism success story of India. It is a state where abundant water, almost jungle-like vegetation, the medicinal secrets of the ancients, and a highly literate culture, blend to create a formula that attracts increasing numbers of people from around the world.

A contrast to life on the beaches or along the waterways of Kerala is life in the western mountains, where elephants and the tigers roam in the jungles. In the Periyar Sanctuary, boats carry visitors around a reservoir surrounded by grassy slopes to see the wild gaur (ox) and sambhar (elk) grazing, and the elephants coming down to the water's edge to drink and frolic.

Where the jungle has been cleared on the lower Kerala slopes, the spices Europeans came searching for in the 15th century still flourish, as does the more recently introduced rubber plant. A carpet of green, and mile upon mile of tea estates— where visitors are always welcome—dominate the higher slopes of Kerala.

Two mountain spurs running from the Western Ghats into Tamil Nadu are the tea-carpeted Blue Mountains—the Nilgiris—and the sacred Palani Hills. In the former is Udhagamandalam, once known as "Snooty Ooty", the holiday playground of the sahibs, which today is the leading hill station of the south. In the Palanis is the quieter Kodaikanal, first developed by American missionaries, and is now the second major hill station in South India. In both places are an abundance of lakes and parks, forest trails and trekking paths, and the fresh air coolness of the heights, which attract hordes of holidaymakers during the summer vacation season, and all year, those who simply want peace, quiet and communion with nature.

North of "Ooty" are the tiger reserve of Mudumalai-Bandipur, and Karnataka, which once formed a major part of the Princely State of Mysore. These states, like the neighboring Andhra Pradesh, are places many people visit to escape the heat. Mysore, today, is more of a university town and a haven for the retired than it is the capital of one of the more progressive ruling dynasties of pre-Independence India. Life in Mysore is so low-key that its magnificent palaces, like the sumptuous Jagan Mohan Palace, are not seen locally as anything out of the ordinary.

These 19th-century architectural fantasies may reveal much of the splendor of a bygone age, but the real pomp and pageantry of Mysore can be witnessed during ten days in September and October when Dussehra is celebrated, and the city becomes a virtual fairyland of lights with a festival of food, fun and shopping. This is the time when elephant-dominated processions once again bring to life the richness of Mysore's past.

In the west of Mysore is Mangalore, on the Konkan Coast, where begins a stretch of almost virgin beach stretching to Karwar in the north to just short of Maharashtra. Karwar may be the best known of these coconut palm-shaded golden sands, but Ullal, Malpe and Bhatkal are every bit as beautiful and inviting to lovers of sun, sea and sand. East of the beaches are ancient towns, many of them capitals of past kingdoms, and even empires, which boast relics of a glorious past, when those who chiseled stone were considered masters of the arts.

In the north is Bijapur of the Adil Shahi dynasty, which lasted from the 15th to the 17th century. Here, the glory of Islamic architecture reigns. The massive Gol Gumbaz, the mausoleum of Sultan Mohammed Adil

Shah, is second only to the Taj Mahal in architectural splendor. Its dome, the second largest in the world, creates as much awe as its "whispering gallery" with the acoustical phenomenon of multiple echoes. South of this wealth of mosques, mausolea and minarets are three small towns where, during their heyday through the 4th and 9th centuries, Dravidian temple architecture evolved to a higher level: Aihole, Pattadakal and Badami are the distinct contributions of the Chalukyan rulers, synthesizing the genius of the Pallava stone-carvers with the design concepts of a more northern Dravidian civilization.

Apart from self-standing shrines and cave temples with beautifully carved ceilings and pillars, which create a museum of stone in north Karnataka, the fort on a hilltop in Badami reflects the Chalukyan talent for planning, whether for war, or times of peace. To the south of this triangle, in the heart of Karnataka, is all that remains of Vijayanagara, capital of a 15th- and 16th-century kingdom known from Europe to China. Today, known as Hampi, it is a ghost city of fantastic ruins. Spread over approximately 15 square miles in Hampi are reminders in exquisitely sculpted stone of what was once the capital of an empire that encompassed the entire south of India, and was known throughout the world for its artistic riches.

Further south are Halebid, and Belur, the later capital of the Hoysalas. Stone sculptors surpassed themselves here, for the delicacy of detail they created is un-matched in stonework anywhere in the world. Can filigree work be done in stone? Certainly, the Hoysala artisans thought so, that is what they achieved here—a unique offering to the world of stone sculpture.

An interesting contribution to this magical world is the 10th–century statue in Saravanabelgola of the Jain saint, Gomateswara, which is striking in its simplicity. Standing tall, it is a creation that holds the viewer in awe for the rare talent that captured serenity so unbelievably well in this sizeable work, which is nearly 60 feet tall, making it the tallest monolithic stone sculpture known in the world.

A short distance from this site is the tiger reserve of Nagarhole, and also, the bird sanctuary of Ranganathittoo, which offer an abundance of wildlife for the photographer, game watcher and naturalist, while the neighboring Kaveri River provides a plethora of fish for the angler. And, as if to complement nature,

man created the beautiful Brindavan Gardens and dammed the Kaveri River to form the giant lake, Krishnarajasagar. A fairyland of lights and flowers, Brindavan Gardens reflect in many ways the commit-ment of the more recent rulers of Mysore to provide a rare beauty for their people.

Gardens lend a blaze of color and provide a heritage destination different from the creations of Bijapur and Aihole, Hampi and Belur, in Srirangapatnam, the once proud capital of Tippu Sultan, who challenged British expansionism at the end of the 18th century and was known as the Tiger of Mysore. A summer palace, ornate with grand wall paintings, and several mausolea with simple domes and arches, create a handsome memorial for Tippu Sultan, who died fighting the British in Srirangapatnam in 1799.

To the west of Srirangapatnam is Bangalore, known as much today for being the Silicon Valley of India as it was "The Garden City" of the past. Parks and gardens, like Cubbon and Lalbagh, still abound in Bangalore, but it is no longer the sleepy cantonment, sanatorium, or haven for the retired as it once was. Today, the leisurely pace of the past is fast vanishing as the wealth generated by new technology, and the young people it has attracted, make Bangalore one of the most happening places in India. Whether it is dining out, dancing the night away, or shopping until you drop—for anything from silks to diamonds, haute couture to handicrafts—Bangalore is the place to be. And if you have the time, in today's capital of Karnataka vestiges of the finest hours of Tippu Sultan, the Raj, and the Maharajahs of Mysore can still be seen.

Head northeast from Bangalore and within a few hours you will arrive in Tirupati, in the shadow of the seven hills of Tirumala, atop which is the shrine of Lord Venkateswara, the richest temple, and the largest, best maintained and most efficiently run shrine complex in the Hindu world. The hilltop is covered with ample facilities for the thousands of pilgrims who gather there every day, and the tens of thousands who assemble on many holidays to catch a glimpse of Lord Venkateswara as they file past. This is where they beseech the Lord for his favor, make their vows and do penance, and offer the Lord their cash and gold, and even their hair. As a demonstration of unusual faith, matched by an order and magnificence rare in a country better known for its daily indiscipline, Tirumala—generally referred to by most as Tirupati—is extraordinary, and undoubtedly a gift from Lord Venkateswara himself.

To the west of Tirupati are Penukonda, the last citadel of Vijayanagara with its massive fortifications, and the temple town of Lepakshi with its colorful temple frescoes. As you head north for Andhra Pradesh's capital Hyderabad, you will find Nagajunakonda-Amaravathi, the heartland of Buddhism in the south during the third century. Today, a giant reservoir has submerged much of this heritage, but ruins of the past and relics in the museums recall Buddhism's finest hour in this part of India.

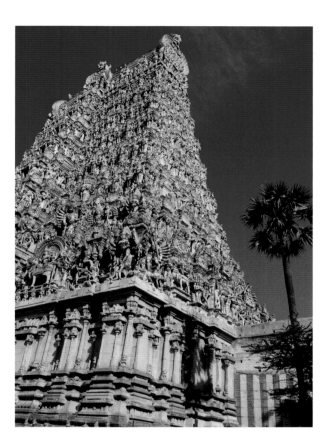

The city of Hyderabad, founded in the 16th century as a new capital to replace the fabled Golconda, once renowned the world over for its diamonds, is today known for its pearls, which come from nearly every pearl fishery in the world, and also, its bangles, made from every material imaginable. A city that retains much of the Islamic influence of Golconda, Hyderabad is a city of Islamic palaces, mansions and mosques, most dating from the time of the Nizam of Hyderabad, once known as "The World's Richest Man".

Other pieces in the mosaic of Hyderabad are its forts, its medley of architectural styles, its gardens and lakes, its respected institutions of higher learning, and its seemingly endless bazaars. Standing tall and keeping watch over the city's bazaars, like something from the tales of The Arabian Nights, is the Charminar, a massive arch built in the late 1500s and a landmark in Hyderabad.

Golconda's southern suburbs, and Secunderabad, which could be considered a northern suburb of the city, are reflections of military eras that took place ages apart. A great fort sprawling over hillsides, with palaces and mausolea throughout, is a feast for the eyes in the south of Golconda. Meanwhile, Secunderabad is a sleepy British garrison just coming out of its slumber to catch up with the bustle of Hyderabad.

Almost due east, back on the Coast of Coromandel, is Visakhapatnam, better known as "Vizag", with its great naval base commanding the Bay of Bengal, and the splendid beaches of neighboring Waltair. North of Vizag, nature reigns in the Bison Range and the Arakku Valley, where jungle trails lead to tribal settlements, and to rushing rivers brimming with fish.

Indeed, South India is a part of the world where the creations of nature and man are bound together inextricably.

 *S. Muthiah*

ABOVE: *Almost all activities in the temple city of Madurai in Tamil Nadu are oriented towards the colossal Meenakshi Temple built in the sixteenth century by Pandyan rulers.*
FOLLOWING PAGES: *While this largest Dravidian temple is famous for its beautiful gopurams and a lotus tank, the Ayirakkar Mandapam with its exquisitely carved thousand-pillared halls, is one of the complex's most distinguished features. The shrine is dedicated to Lord Shiva's consort, the Goddess Meenakshi.*

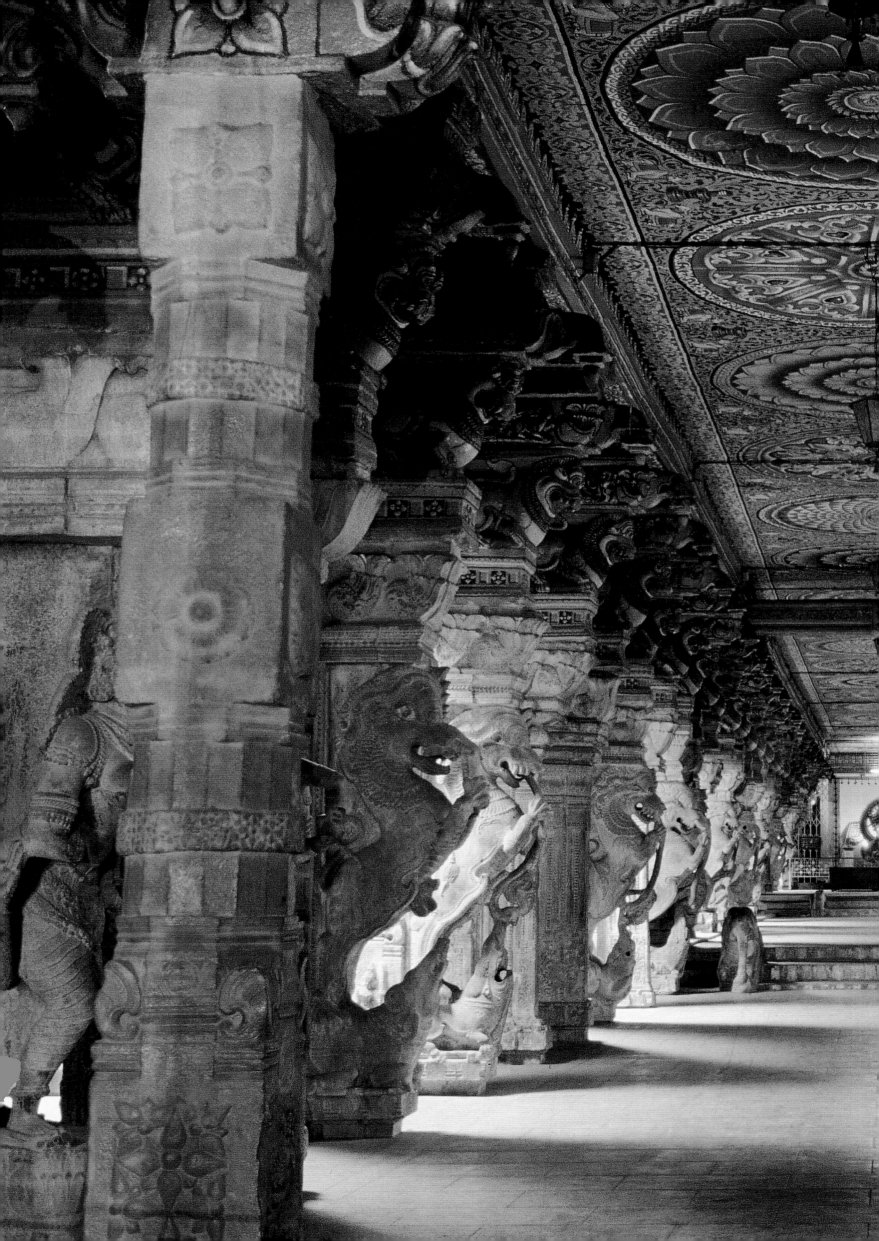

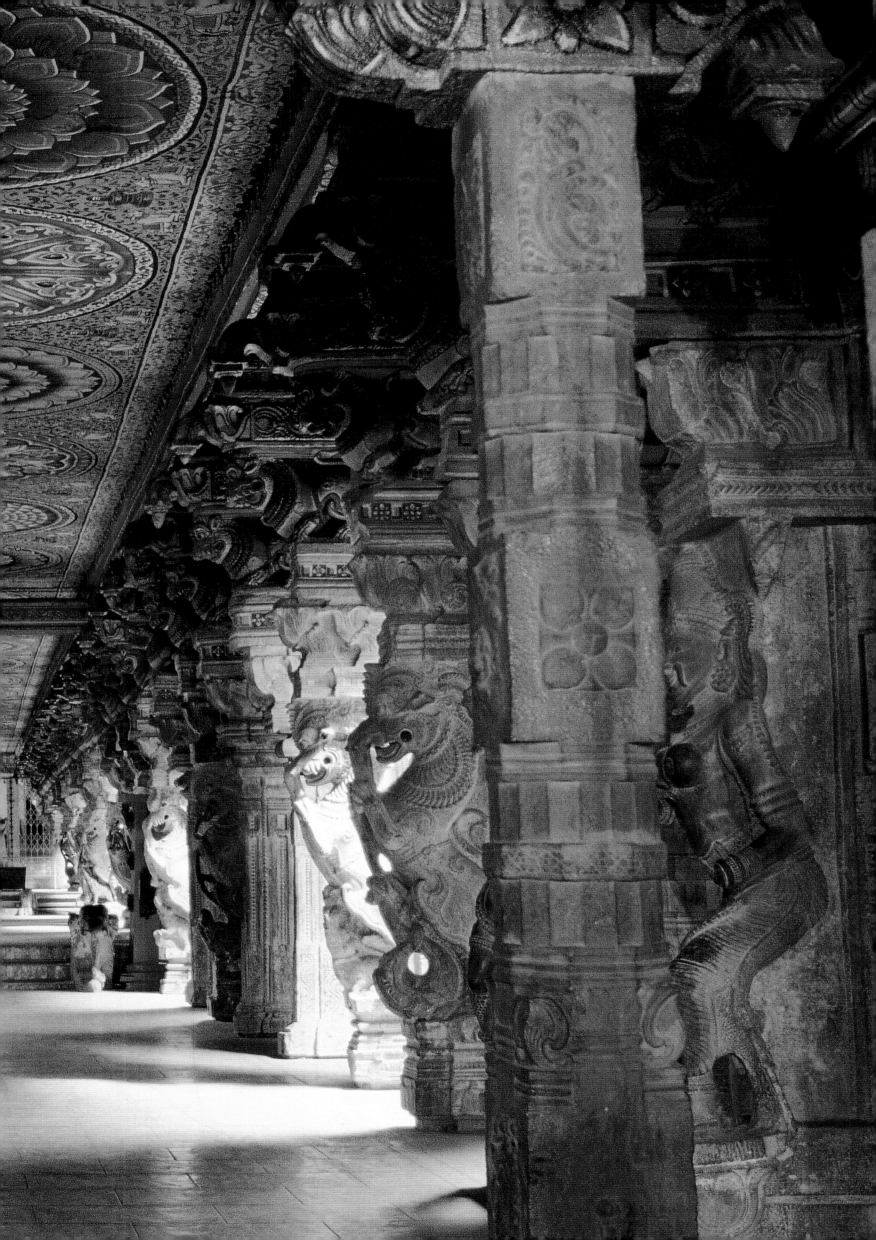

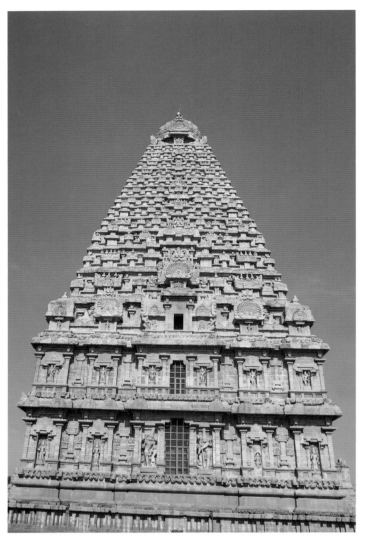

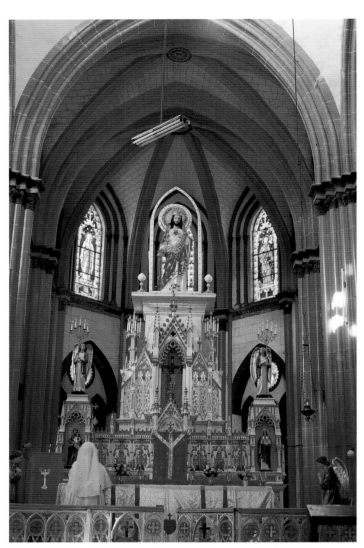

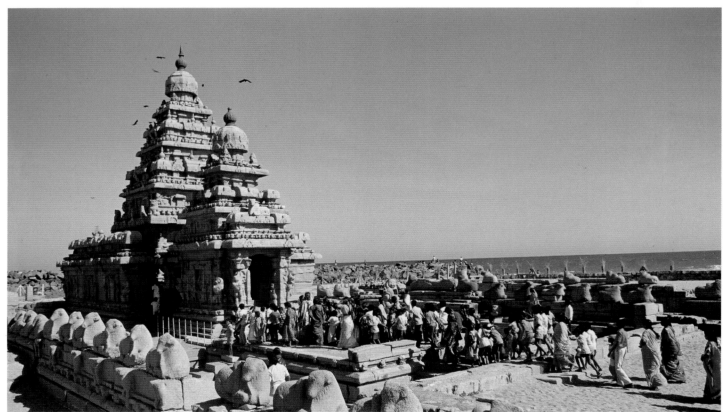

TOP LEFT: *The perfect symmetry of the Brihadeswara Temple at Thanjavur in Tamil Nadu,*
*undoubtedly makes it the most magnificent creation of the famous Chola art.*
TOP RIGHT: *Interior of a church in Pondicherry, once the Capital of French territories in India.*
*Now called Puduchcheri, it is famous for its churches and the Aurobindo Ashram.*
ABOVE: *The Shore Temple at Mahabalipuram in Tamil Nadu, was built by Pallava King, Nandi Varman II,*
*in the eighth century. It represents the final phase of Pallava art.*

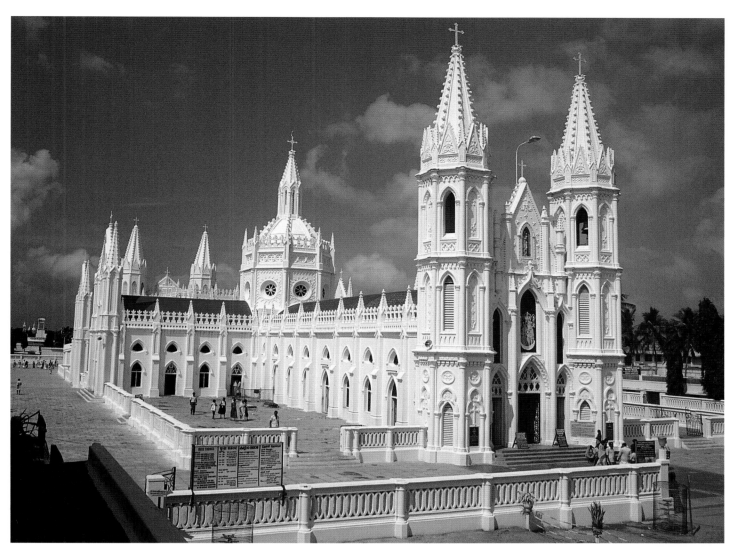

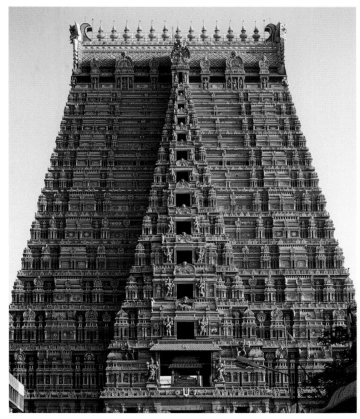

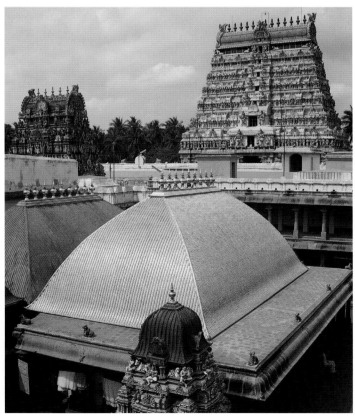

TOP: *People of all faiths come to worship at the Vailankani Church in Tamil Nadu.*
ABOVE LEFT: *The sixteenth-century Srirangam Temple built by the Nayakas in Tiruchirapalli, Tamil Nadu,*
*is located on an island formed by the Kaveri and Kollidam rivers.*
ABOVE RIGHT: *The Natraja Temple at Chidambaram in the Thanjavur district is dedicated to Lord Shiva.*
*According to a legend, Lord Shiva and his consort Parvati, who is represented here as Shivakama Sundari, are believed*
*to have performed a cosmic dance at the site where the temple now stands.*

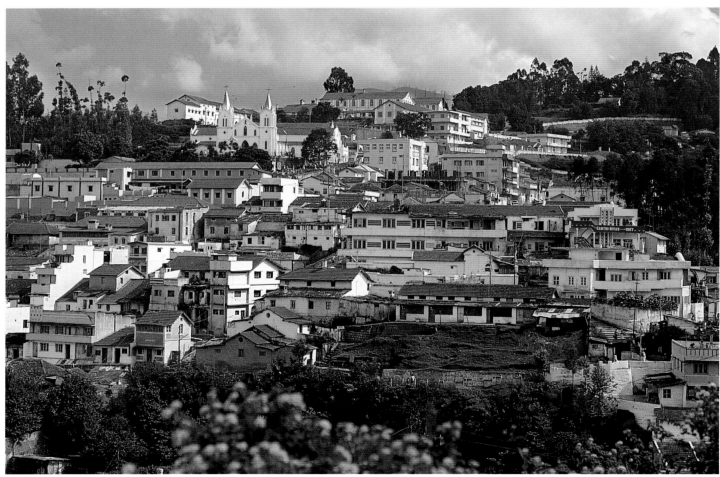

TOP: *Chennai, the Capital of Tamil Nadu, with its high-rise structures, colonial buildings, open beaches,*
*gardens and exquisite temples is rooted in tradition but open to modernity.*
ABOVE: *Conoor, a popular holiday destination, is also known for its tea and coffee plantations.*

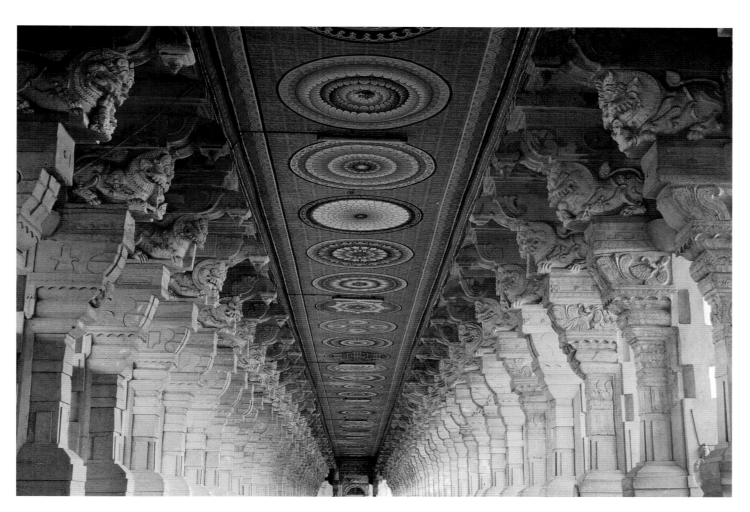

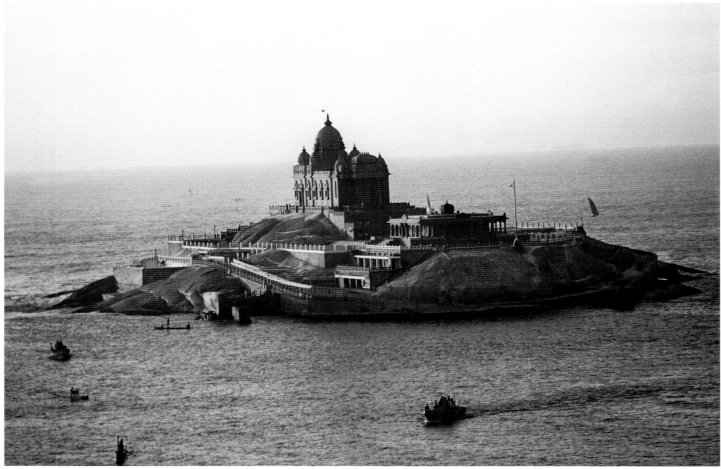

TOP: *The splendidly sculpted Sokkattan Mandapa in the Ramanatha Swamy Temple at Rameshvaram is an extremely long corridor with 1212 pillars. The sacred temple, dedicated to Lord Shiva stands in the middle of an island and is a prominent pilgrimage site for the Hindus.*

ABOVE: *The memorial dedicated to Swami Vivekananda is built on a rock, 1200 meters from the shore, at the southern tip of the Indian Peninsula. A unique point where the Arabian Sea, the Bay of Bengal and the Indian Ocean converge. Swami Vivekananda meditated on this rocky outcrop in 1893.*

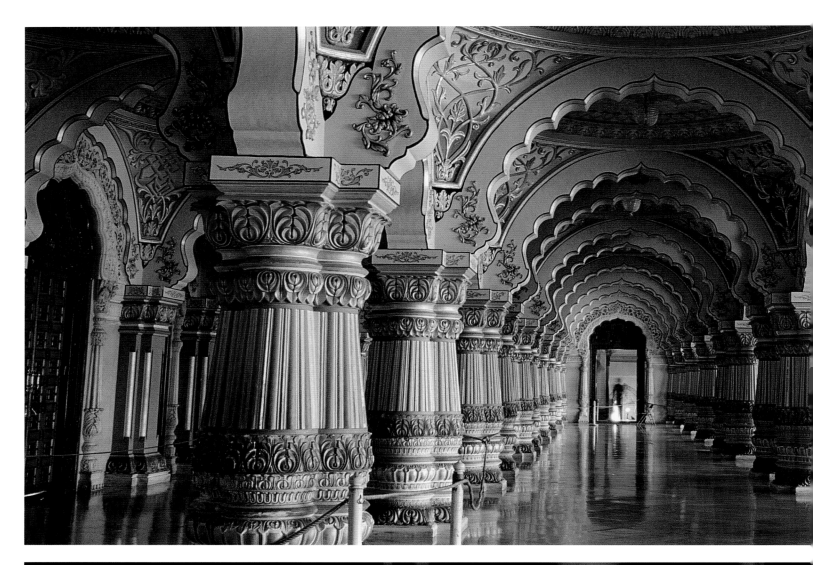

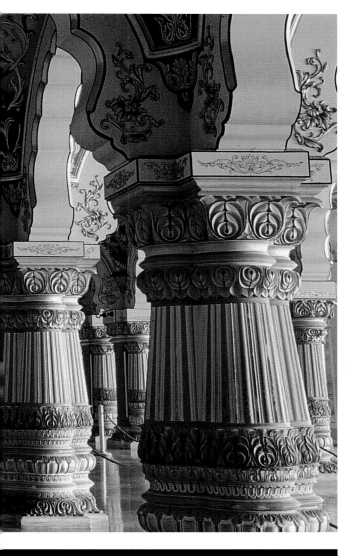

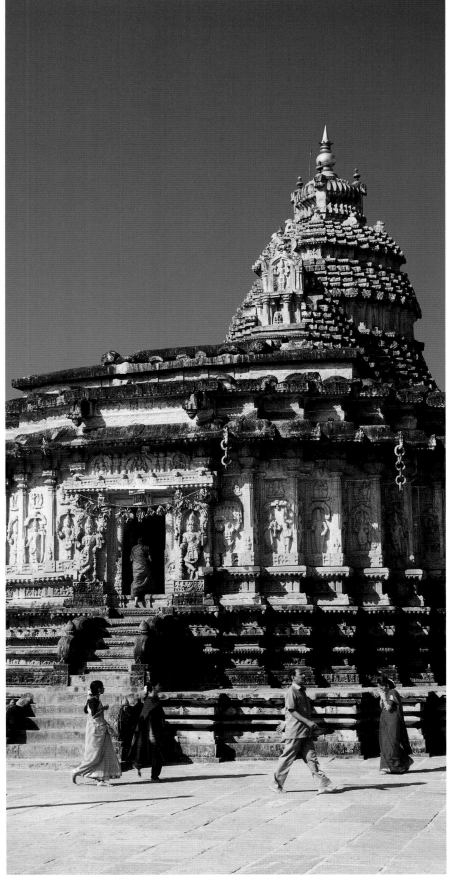

FACING PAGE TOP: *The magnificent Public Durbar Hall in the Mysore Palace, is exquisitely carved and decorated with gold and turquoise. The palace was designed in Indo-Saracenic style and built by Wodeyar rulers in the late nineteenth century.*
FACING PAGE BELOW: *The beautiful Brindavan Gardens, at a dam near the city of Mysore, is popular with visitors, more so, when it is illuminated at night.*
ABOVE: *The Vidyasankars Temple in Sringeri, Karnataka, has twelve zodiac pillars, which are so arranged that the Sun's rays fall on the particular pillar, which corresponds to that particular month.*

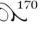

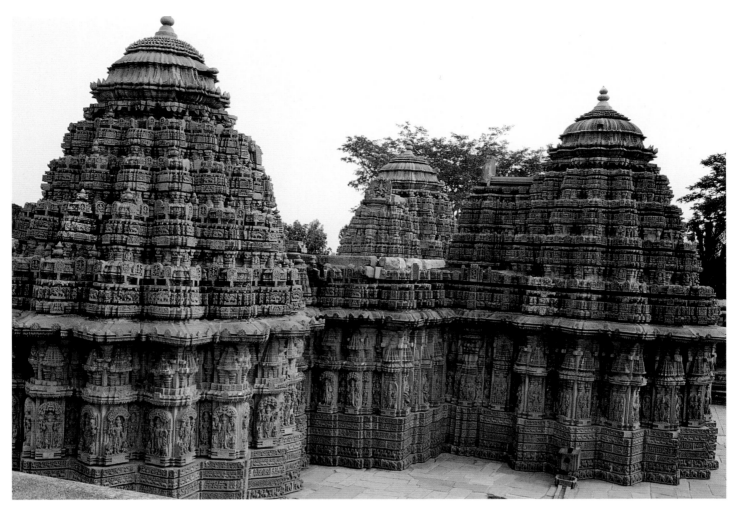

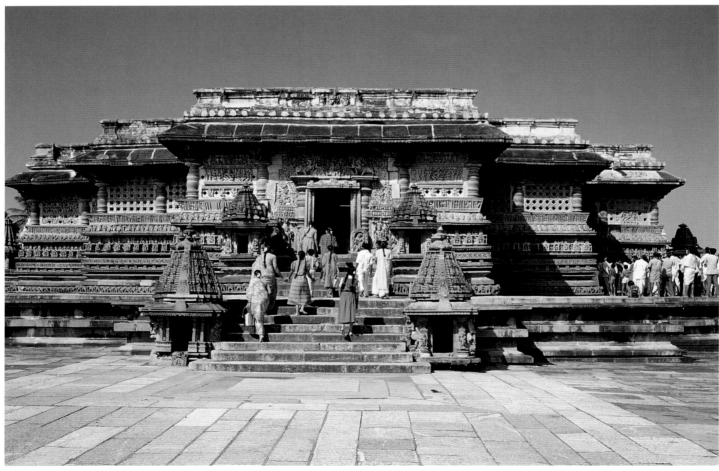

TOP: *The Keshawa Temple at Somnathpur, the last of the famous Hoysala temples was built in AD 1268. Janakachari, a renowned architect strived successfully to achieve perfection in both form and sculptural detail in the triple sanctuaried star-shaped Temple.*
ABOVE: *The Chenna Keshava Vishnu Temple in Belur was built in 1117, to commemorate the victory of Hoysala King, Vishnuvardhana, over the Cholas. This exquisite temple unfolds like a series of stories in stone with intricately carved interior and exterior walls.*

171

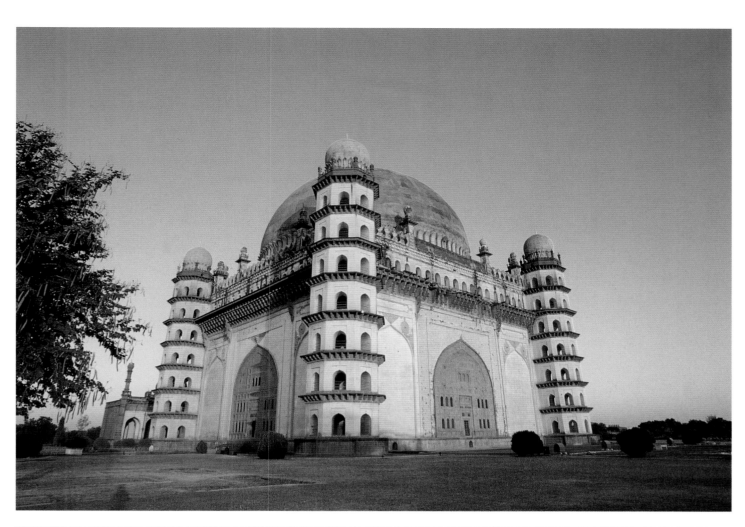

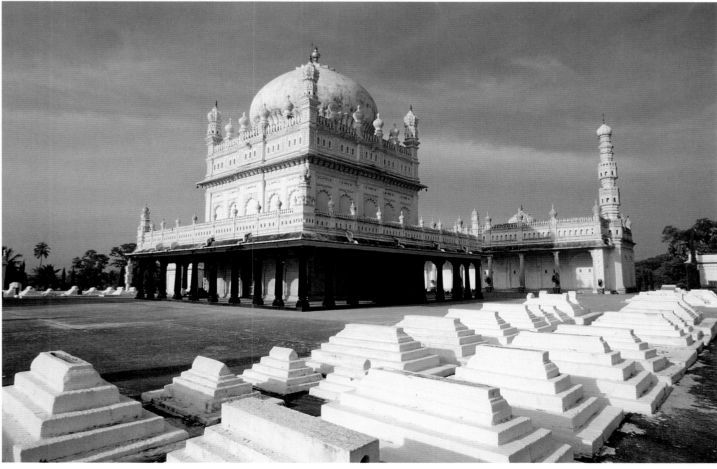

TOP: *The Gol Gumbaz in Bijapur, Karnataka, is famous for its enormous dome, which measures 2.8 meters in diameter and is second only to St. Peter's in Rome in size. The mausoleum of Mohammed Adil Shah, built in 1659, during his lifetime represents the architectural austerity of the Adil Shahi style.*
ABOVE: *The great Tippu Sultan's grave at Srirangapatna, his capital city, from where he fought many heroic battles, lies 16 kilometers from Mysore. He was buried in 1799, besides the graves of his family members in the Gumbaz decorated with Tippu's favorite tiger stripes.*

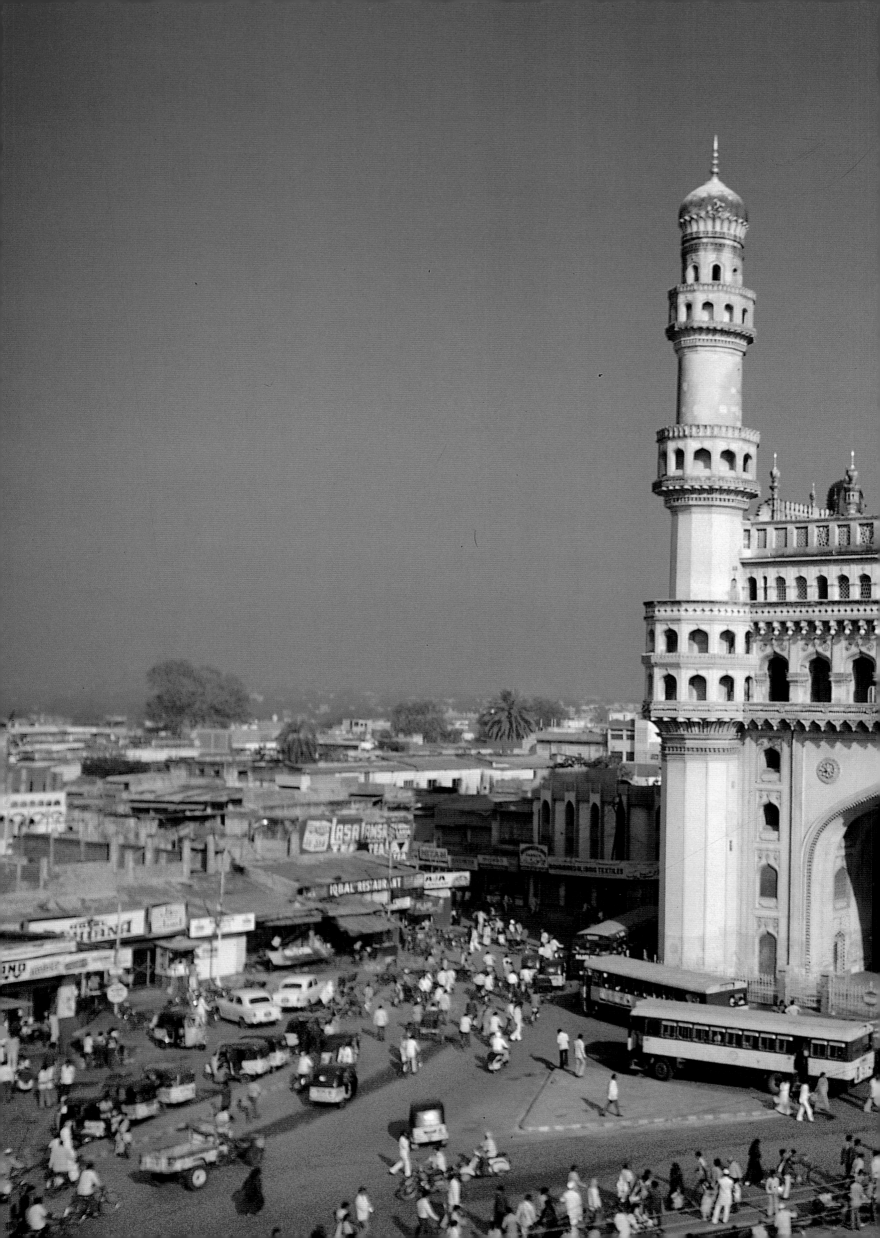

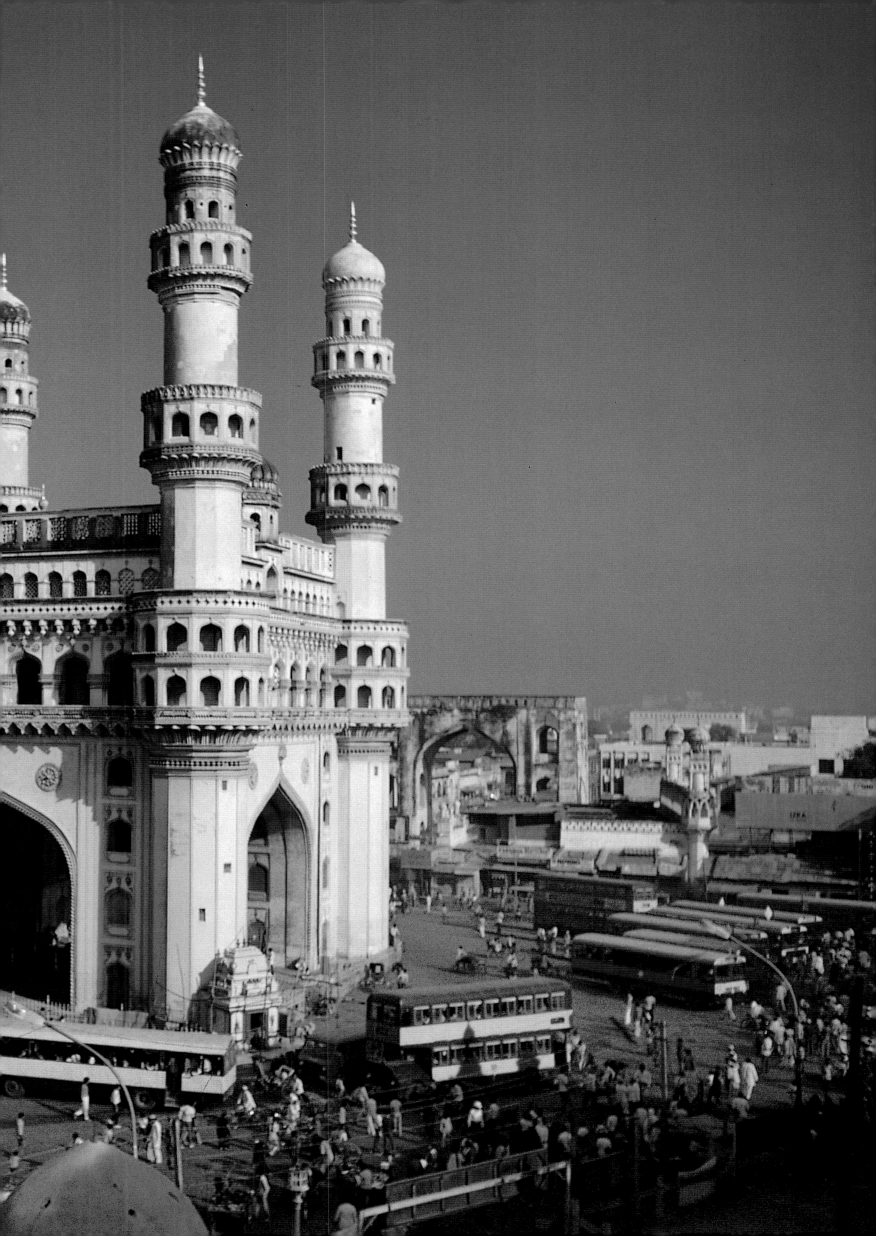

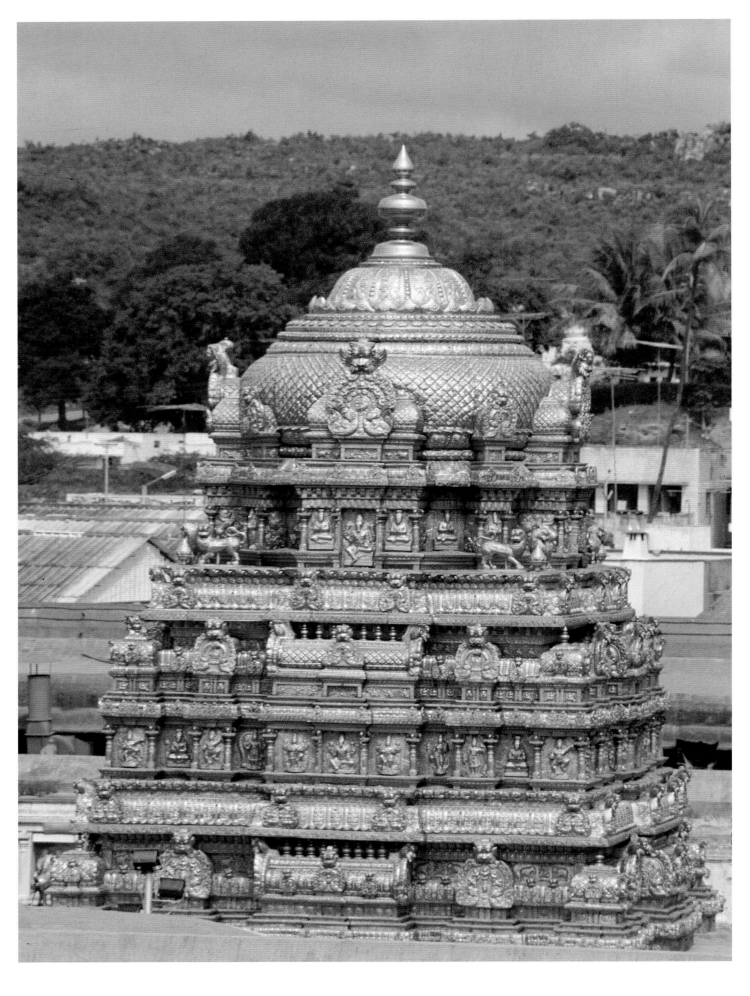

PRECEDING PAGES: *The magnificent Charminar built in 1591, by King Muhammad Quli Qutb Shah,*
*towers over the old city of Hyderabad, the Capital of Andhra Pradesh, as its most important landmark.*
ABOVE: *The Tirupati shrine situated on the crest of one of the seven sacred hills is dedicated to Lord Vishnu or Venkateshwara.*
*His two-meter tall black stone bejewelled image stands on a lotus in the inner sanctum. Tirupati is believed to be*
*the richest and the busiest shrine in the world, as more than 25,000 devotees visit its hallowed portals everyday.*

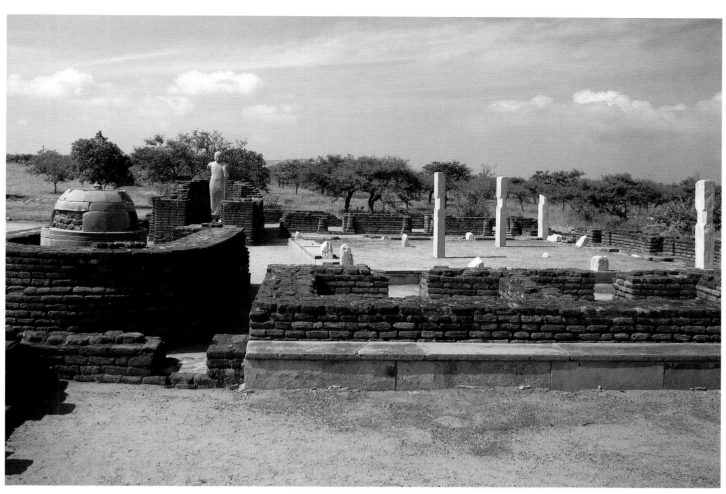

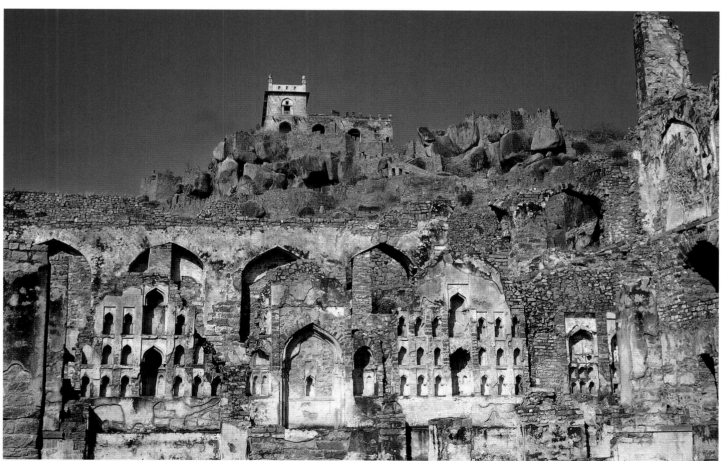

TOP: *A statue of Lord Buddha at Nagarjunakonda, on the banks of Krishna River, was once a flourishing center of Buddhism with many monasteries and stupas. It is one of the greatest archaeological sites in the country.*

ABOVE: *The formidable Golconda Fort situated 11 kilometers from Hyderabad, is at a height of almost 120 meters. The fort and the monuments in and around it still stand testimony to the aura of power and grandeur that surrounded the Qutb Shahi monarchs of the sixteenth century.*

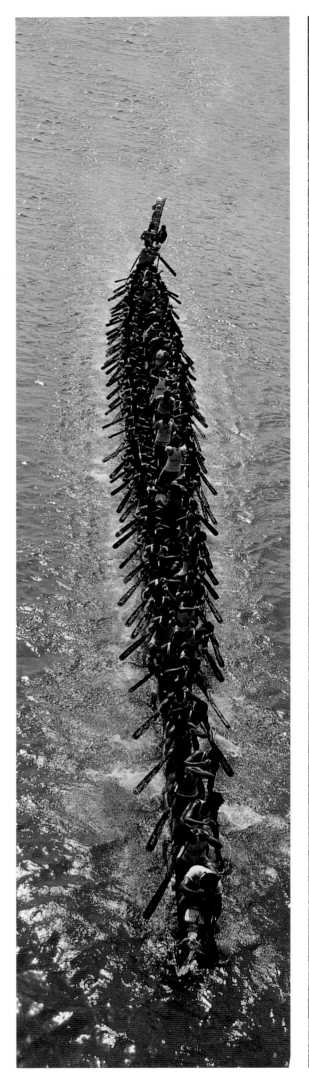

FACING PAGE LEFT: *The speeding snake boats in the backwaters of Kerala during the Onam festival.*
LEFT: *The sprawling tea gardens of Munnar in Kerala. This township stands at a height of 1,800 meters in the High Ranges of Western Ghats, famed for its great natural beauty.*
ABOVE: *The Vadakkunnatha Temple in Kerala of the eleventh century is a triple-shrined temple complex with sanctums for Vadakkunnatha (Kailasanatha), Sankaranarayana and Rama. It is a classic example of the typical Dravida-Kerala temple architecture.*
FOLLOWING PAGE TOP: *In the backwaters of Kerala, a land believed to have emerged from the sea, one can cruise for miles along an intricate network of waterways fringed by palm trees and other lush green tropical foliage.*
FOLLOWING PAGE BELOW: *The enormous Chinese fishing nets on the coast in and around Cochin are part of its cosmopolitan heritage.*

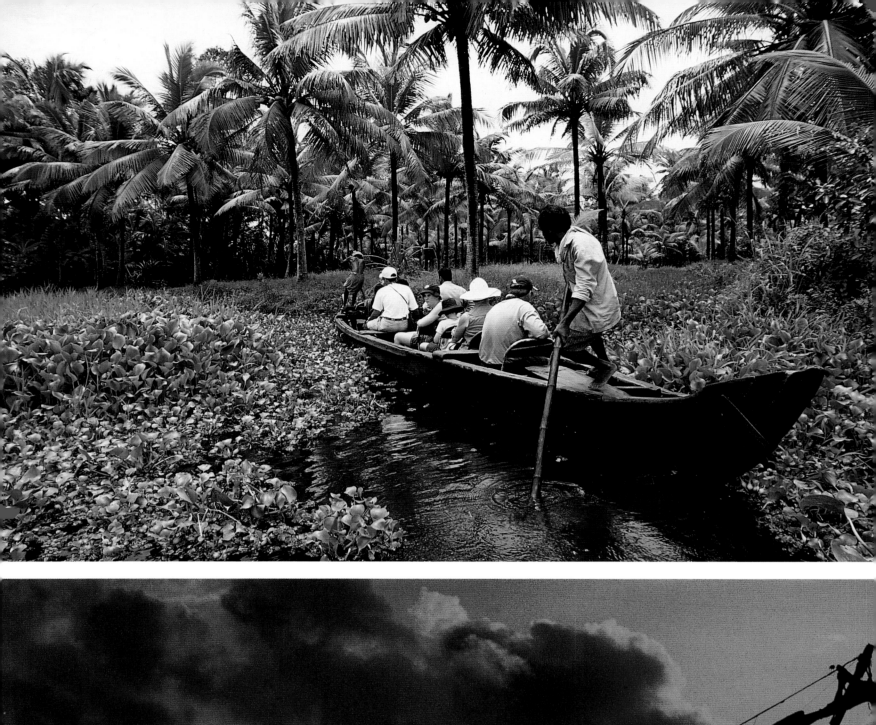

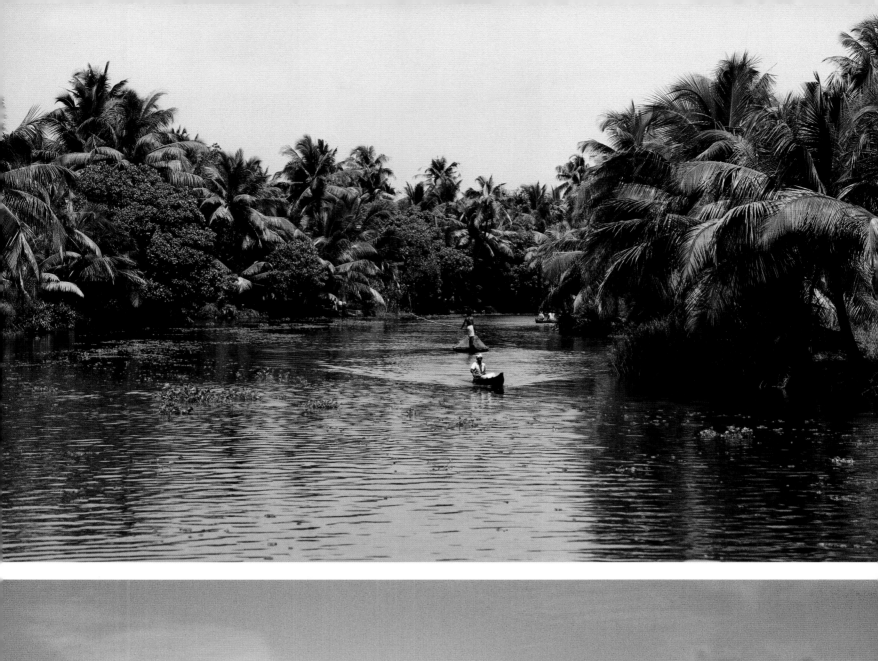
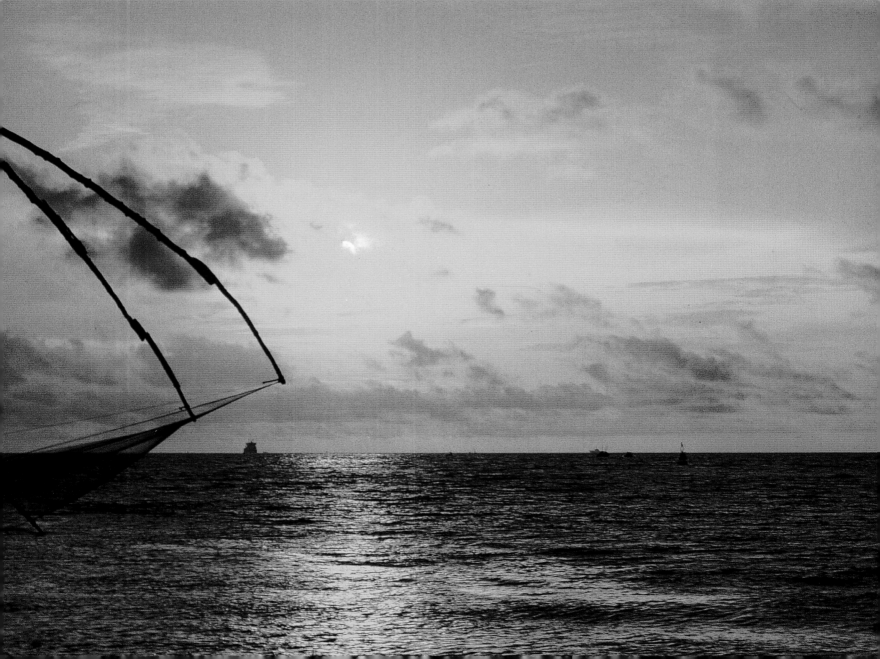

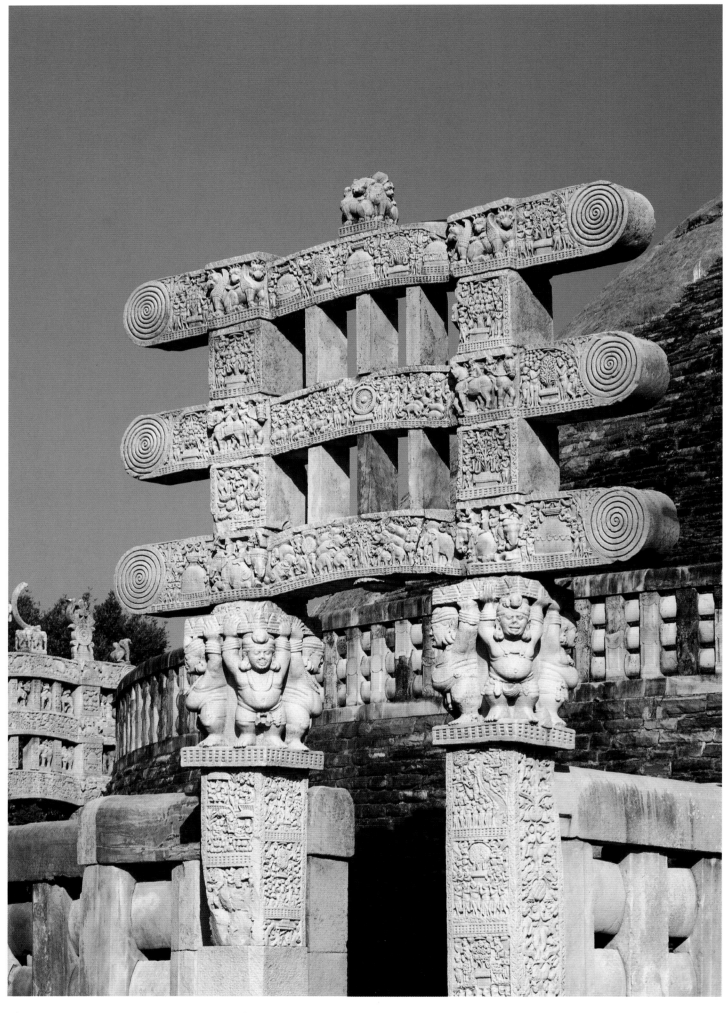

*A gateway of the great stupa at Sanchi in Madhya Pradesh. All the four gateways are superbly carved with Buddhist tales and legends and depict the gradual progression in Buddhist art. Built by mughal emperor Ashoka, the well-preserved stupa is a hemispherical dome, 36.5 meters in diameter and surrounded by a stone railing.*

# Art & Architecture

In the Indian ethos, no distinction is made in either concept or language between the words "arts" and "crafts". The man who works with his hands and creates anew each time he sits at the loom or potter's wheel is viewed as not only using his skills as a craftsman to complete his task, but also, his artistry.

Margi and desi are loosely translated as the "Great Tradition" and the "Little Tradition", with the former indicating that which has been codified and thus, subject to rules of expression, and the latter meaning that which has evolved from the roots, and therefore, is more free in its articulation. One is more universal, one is more local; but in this worldview, all craftsmen are considered to be artists. And, as among all true artists, there is borrowing and intermingling, not just between these traditions, but also from outside influences. Indeed, the genius of the Indian artist lies in his ability to absorb and his talent for innovation, which enable him to re-fashion and adapt a variety of influences to create a uniquely Indian fusion.

The range of arts, crafts and architecture in India is bewilderingly large and varied, with a wide range of textures and traditions with encompassing meanings. The arts of India are a living expression, a part of the daily experience, whether in the garments or jewelry worn by its people, the dishes they use, or their houses and places of worship. Art belongs to home, palace and temple alike. Through the centuries, the Indian aesthetic in everyday life has been guided by the genius and inborn skill of the artist.

Nowhere is this more clearly evident than in textiles, which for centuries have been supremely Indian art, and whose lineage can be traced as far back as the Indus Valley Civilization in the third millennium B.C. Traditionally, the processing of yarn and weaving of textiles was the second largest occupation in India after agriculture, and quite often, the two were intertwined. Across the great textile areas of the country, from the banks of the

*Not gifts of land nor gifts of gold, Nor gifts of cattle nor gifts of food, Are said to be the greatest — Of all gifts greatest is that of the creator's work.*

*- Anon., Sanskrit poem*

Ganges River in the north, to Kanyakumari in the south, from Gujarat in the west, to Bengal in the east, thousands of families spun and wove, dyed, painted, printed and embroidered textiles.

This textile art, nurtured for thousands of years, encompassed a wide variety of types and usages, from the finest cottons, silks and wools for kings and their courts, to cheaper and coarser textures for everyday use by the average person. Textiles served as garments, as painted or printed wall hangings and traveling tents, as bedspreads and canopies, cushions and floor covers, and for headgear and robes. Made to the demands of users in other countries, they formed a staple of trade, and were paid for in precious bullion. Up until to the 18th century, no other country in the world produced such an abundance and range of sheer muslins and rich brocades, warm shawls, luxurious carpets, or elaborately woven silks, like the ikats and patolas of Gujarat. India was the largest exporter of textiles, and its products traveled to eastern and western destinations.

Color permeated fabric, drenching it with myriad social, sacred or ritual meanings. In textiles, the vocabulary of color is extensive: three kinds of red for the three types of love; yellow for spring freshness; indigo for the dark clouds of the monsoon; and white as the color of laughter, which itself was shaded into ivory, sandal or "autumn cloud white". Court patronage increased the range of colors to include "ruby-colored, grass green, sandalwood-colored, grape-colored, pistachio, mango-colored…" and so runs an account of the 300 colors known in the Mughal shawls of the 16th century.

Behind this color palette is the sheer skill inherent in the dyeing process, which in India is as much science as art. The dyer was an artist who achieved color tones with the most basic tools. The dyes were derived from indigo, from madder (an herbaceous plant with yellowish flowers), and flowers from myrobalan trees. The mordants, or fixing agents, came from

the roots and barks of trees, from fruits, and from lichens and shrubs. The cloths were treated and strengthened with mordants, so they would emerge from each wash ever more rich and glowing. Such were the sources of color for textiles.

Other sources of color fed other great arts, such as painting. In the ateliers of the Grand Mughal, Akbar, pigments came from minerals and stones: blue from lapis lazuli, brilliant red from cinnabar, yellow from orpiment, and gold from the softest, most finely beaten gold leaf. Akbar's artists painted on thick, handmade paper, but village artists used materials closer at hand—wood, stone, terra cotta, cloth, palm leaves, and the caked mud of freshly-plastered walls—to create a vibrant explosion of theme and color. In the same spirit, if not style, as the court painters, their rural cousins recorded a living history of joy and sorrow, ritual and festivity.

Court painters followed an earlier tradition of illuminated manuscripts—folios that recorded the deeds of kings or the epics of the gods. In villages, the cycle of seasons, the rites of fertility, and the myths of the people and their deities came to vivid, chromatic life on whatever was the medium of choice or necessity. If the court painters depicted the grand weddings of princes, the wall paintings of the Warli tribals in Maharashtra graphically displayed the elegant whirled formations of their nuptial dances. The work of the court painters was carefully bound or folded in silk so that it could be appreciated by the discerning eye of the connoisseur and be preserved for posterity. Meanwhile, in villages across India, women daubed over their mud walls with fresh coats and painted anew with the change of seasons, as if to celebrate the impermanent nature of life itself, the play of the gods with mankind.

Very often, as continues even today, the artist's work is a devotional outpouring. Across India, artists created for Hindus, Buddhists and Jains alike, painting images to conform along with the canons of iconography. Even when the artists of Tanjore adopted new mediums, such as glass, their plump infant Krishnas, and their Devires resplendent in jewelry and rich silks, reflected these conventions. In the Buddhist tradition, the cave paintings of Ajanta, and the paintings at the monastery of Alchi in Ladakh, are far apart in geography and time, but the same serenity and warm humanism floats

through both, as if carried from one to the other by a divine vector.

This votive spirit is seen also in the sculpture of India, whether in the round or as relief. Stone, metal, wood and ivory were among the materials used, and the scale of the work could vary from the monumental to the delicate. We see here the predominance of the human figure as a representation of the Divine, not just in the form of gods and goddesses, but also, benevolent creatures such as the tree spirits, beautiful young maidens whose touch fructified nature. So much could be written about the tradition of sculpture in India, its weight and antiquity, and the influences that shaped it—but in the end what remains is a series of unforgettable and overwhelming images.

The power, majesty, courage and confidence of the lion are captured in the polished sandstone of The Pillar at Sarnath, now even more significant as the national emblem of India. Shiva as Nataraja, Lord of the Dance, who dances the worlds into both destruction and rebirth, and Shiva as Vrishvahana, with Parvati by his side, is one of the most sublime of the Chola bronzes—two young and beautiful images radiating compassion. The monolithic statue of Gomateshwara at Sravana Belgola, one of the holiest of Jain pilgrimage sites, stands nearly 60–feet high and yet exudes serenity; a figure so stilled in deep meditation that the sculptor has depicted growing vines twined around his legs.

The toranas, or gateways of the Great Stupa at Sanchi, are covered with a multitude of figures and reliefs depicting scenes from the life of the Buddha and from the Jataka tales—an exuberance of life with cities, people, animals, trees and flowers, all executed with a deftness of touch and a passionate joy. In Sanchi, the figure of the Buddha is depicted in symbols; but when Buddha was eventually depicted in human form, both art and emotion reached heights that have the power to move us even today. The pale stone Buddhas of Sarnath are among the most sublime images ever created, their faces calm and gentle, their lips delicately modeled, their eyes half-closed, as if looking inward to a world beyond. These images are like the Buddha's message come to life—that one can transcend all struggles to attain serene inner joy.

But not all artists in India fashioned images in stone or

182

bronze. Terra cotta, baked clay, was a medium from the most ancient times, and the themes were varied. One of the most recurring used in early eras was that of the Mother Goddess, associated with the fertility of the earth and of women, protector of children, and remover of calamities. Terra cotta images portray her with fantastic headdresses, richly bejeweled and girdled, the designs in her ornaments reflecting foliage and flowers as symbols of her bounty.

Clay, the most universal of materials, formed the basis of terra cotta. Because the potter worked with materials close at hand, we find a wide variety of clays in Indian pottery, from the sticky black of Manipur in the northeast to the soft grey of Kutch in Gujarat. The potter's hands worked their magic as he molded, modeled or threw the clay on his wheel, sometimes using more than one technique to crate all manner of objects for daily and ritual use. He made roof tiles, jars for storage, bowls, cook stoves, lamps, votive figures, vessels, toys and cups. In areas like Kutch, he used clay as ornamentation in the home, worked in relief on the walls and embedded with tiny bits of mirror for sparkling reflections of light.

And, of course, he made pots, symbols of the Earth Mother, made from her substance, and denoting a profound relationship with the fertile soil and agriculture. It is little wonder, then, that the potter was called Prajapati, Lord of the Universe, whose implements included not only the wheel, but elements like sun, water, wind and fire, which were all essential to his art and the clay he shaped. Too much or too little of any could ruin his work, and so he respected their power just as he worshipped his wheel.

The potter's art also went beyond the home. Across India, in village and tribal communities, ritual figures made of terra cotta were created to act as guardians. In Tamil Nadu, larger than life horses—made in sections and later assembled—were made for the deity Aiyanar and placed in the fields. It was believed that the deity would visit the villages at night and ride on the horses to drive away evil spirits. In Bengal, the potters of Bankura made ritual figures of animals such as the horse, elephant and tiger, which were offered by the villagers to the forest spirits as a prayer for protection. Some of these figures have become famous, such as the stylized Bankura horse, with its long neck and tall ears, which is now the official logo for Indian handicrafts.

Not far from Bankura is Vishnupur, known for its terra cotta temples built between the late 16th and 18th centuries. The temples are, in fact, made of local red brick, there being no building stone in the area, but their walls are covered with ornate terra cotta plaques and panels depicting tales from the epics and of the Blue God, Krishna. The work here is carved rather than modeled; a sharp knife was used to scoop out the clay. The depictions are rich and detailed, and so closely joined are the panels that they appear as one seamless whole.

The temples are also unique for their hybrid architectural style, using both traditional and indigenous elements. The bamboo roofs of local huts inspire their curved rooftops with drooping cornices and eaves—a coming together of art and architecture.

When we look at buildings in India, large and small, we can see the enormous range and diversity of architectural tradition, and how it varies between regions and periods. This is not surprising, given the differences of topography and climate throughout India, and the number of influences that altered concepts across time. Using available materials, from stone and marble to mud and bamboo, and keeping to the conventions demanded by each form, the unsung artists created a dazzling array of spatial expressions. In fact, the closest word to architect in Sanskrit is sthapati, which means, literally, master of space. It was the role of the sthapati to organize space so that it served various needs; he was indeed its master, whether the space was used for sacred or secular purposes. The process of his creation was Vastu Shilpa—the art, the craft, and the science of design and building.

Rooted in the metaphysics of the sacred mandala (ritualistic art and geometry), vastu was codified, and demanded the well-developed skills of artists who worked with stone and wood. Careful consideration was given to the amount of space, and the needs that governed its use: this was not the principle of vastu alone, but also of many artists in village and hamlet who crafted on a more humble scale with local materials. The combination of necessary application with inborn aesthetic led to a flowering of diverse treatments. From coast to mountain to plain and desert, this is a richness we are now learning to recognize in India as vernacular architecture.

Within the discipline of vastu there are many different expressions. There is religious architecture, embracing forms of all faiths—temple, mosque, stupa, church, gurdwara— a counterpoint, as it were, to the magnificence of the monumental architecture of the palaces, fortresses and mausoleums throughout the country. There is the architecture of planned cities in both historic and modern India, such as the imperial splendor of Akbar's "City of Victory", Fatehpur Sikri; the meticulous layout of 18th century Jaipur; and the bold concepts of 20th–century Chandigarh.

There is the architecture of the home, built to resist heat, dust, rain and snow. Since most parts of the country are warm, home layouts allowed for open spaces so that there was no rigid demarcation between the outside and the inside. That the built form, which serves a utilitarian function need, not be ugly is seen from the number of water storage areas, such as the subterranean vavs, or step wells, of Gujarat, embellished for beauty, and constructed to last hundreds of years. And, of course, there is the colonial architecture present in India, with the most lavish example being the New Delhi of British architect Edwin Lutyens, culminating in the grand spectacle of what was the Viceregal residence, which today is called Rashtrapati Bhawan, and is the official home of the President of India.

Along with these variations, there are those manifestations that defy categories. How to describe the waterfront of the Ganges River at Varanasi, with its temples and bathing ghats? Viewed from a boat, the panorama is an accretion of disparate building styles, yet is somehow a harmonious whole, a backdrop for the teeming life along the riverfront— the hundreds of thousands of pilgrims who come to this holiest of cities.

In the city of Jaisalmer, the mansions of merchants are a deserved tourist attraction for their elaborate carved stonework, but the design elements that drew the community together should not be overlooked, such as the narrow lanes leading to chowks, or pub- lic areas where people could meet. There is also the Jantar Mantar in Jaipur—another is in Delhi—built in the 18th century by the Jaipur king as an observatory to study the move- ments of the sun and the stars. The masonry instruments are themselves architectural forms of bold and sweeping original- ity, a combination of science and art.

The single most famous build- ing in India, perhaps, is the Taj Mahal, described as "a teardrop on the cheek of time"—ethereal words for an ethereal monument. It is one of the most precious legacies of the Mughal dynasty; its precursor is Humayun's Tomb in Delhi. At the Taj Mahal, for the first time, we see the double dome of Persian influence, where the inner dome allows for scale as the outer soars into the sky. In architecture, as in so much else, the Mughals achieved a synthesis of Islamic style and Indian workmanship that astounded the rest of the world.

However, long before the Mughals, Indians had constructed architectural marvels of ingenious design. Consider Ajanta, a repository of art and architecture, along with nearby Ellora the most famous of the Buddhist cave structures. Here, no less than 27 caves were hollowed out from the rock to form a monastery, with some excavations going as deep as 100 feet. It was long in completion, from around the second century B.C. to the 7th century A.D., being the ascribed dates of the earliest and latest caves. Apart from its architectural significance, Ajanta is ornamented with a wealth of sculpture and painting, a glorious monument to ancient India.

The Indian artistic genius lay in such an organic view of all forms. Art, craft, and architecture are all merged into a seamless whole, which is far greater than the sum of its parts. The built form of the temple was merely a shell without the images of the gods, painted or chiseled, which resonated with life and faith. Each object had a meaning; each new permutation was like a fresh creation filled with a lively spontaneity. Variations were not a cause for alarm; they were the artist's breath, spurring him to greater flights of the imagination.

*Asha Rani Mathur*

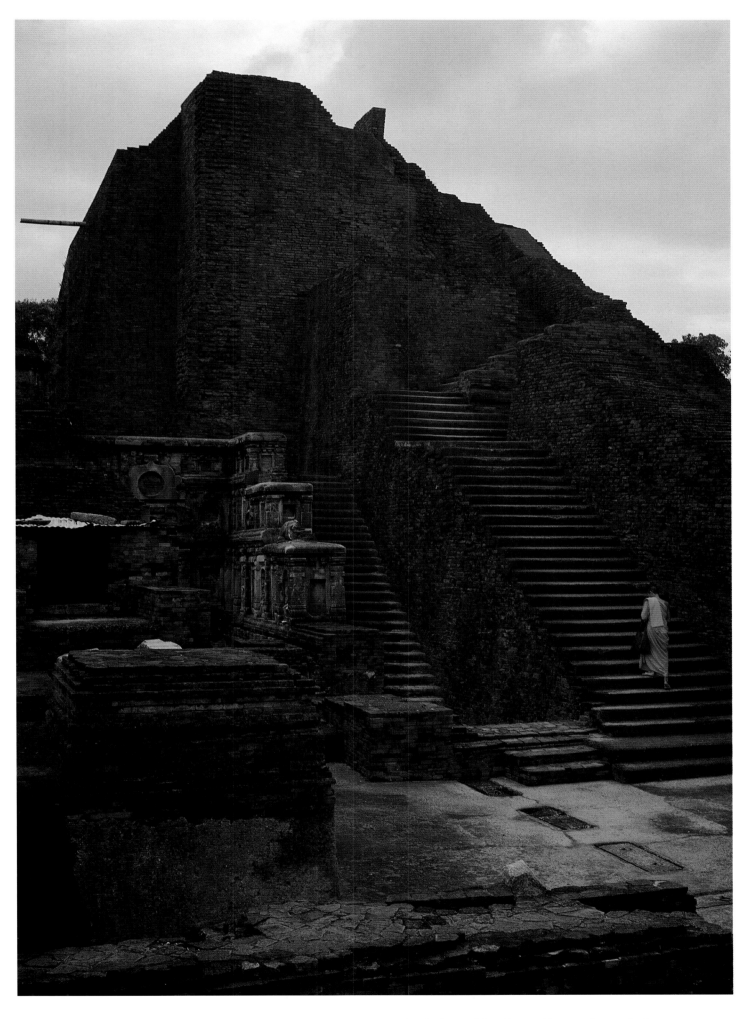

*About 80 kilometers from Patna in the state of Bihar, lie the ruins of Nalanda, a celebrated seat of learning during the Gupta period in the seventh century. Among the thousands who studied the Mahayana doctrine of Buddhism here, was the famous Chinese traveller Hieun Tsang. Monks still come to this place to seek the ultimate truth in an atmosphere of quiet serenity.*

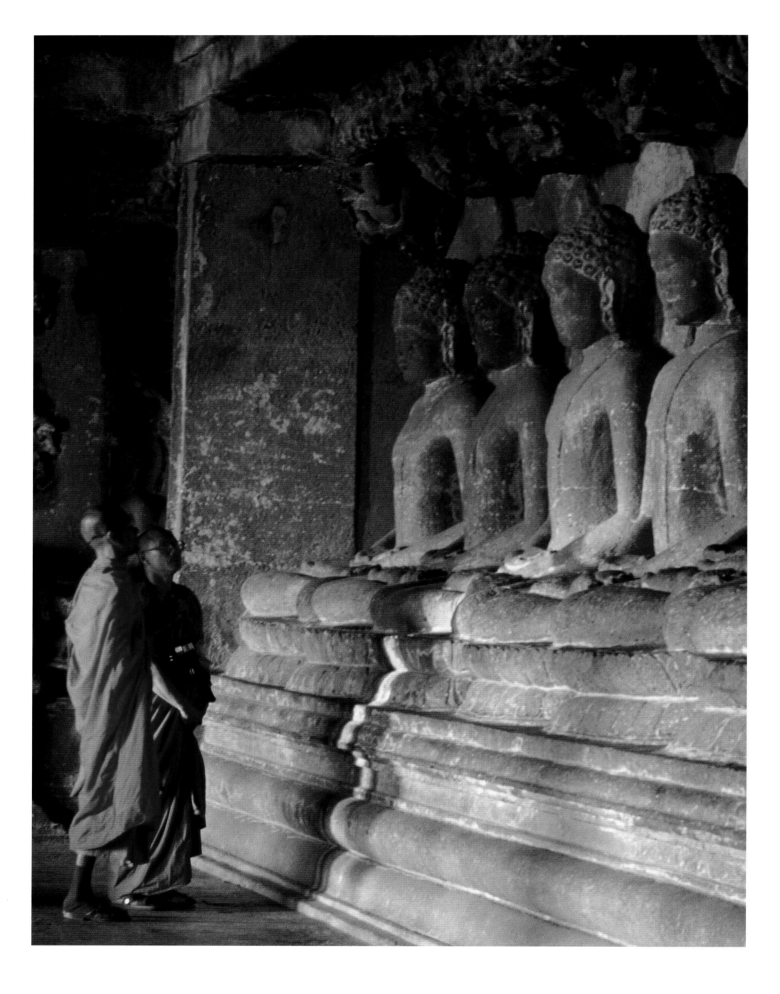

ABOVE: *Monks visiting the sixth-century Ellora cave, are seen paying homage to the images of Lord Buddha in a meditative stance.*
FACING PAGE TOP: *Nearly 110 kilometers from Aurangabad in Maharashtra are situated the 30 rock cut caves of Ajanta with their repository of exceptional Buddhist sculptural art. The cave number 26 depicts Buddha's parinirvana or his passing away.*
FACING PAGE BELOW: *Buddha lay on a bed placed between two Sala trees and with his eyes closed, addressed his followers for the last time. The Ajanta caves are strung out along the sheer rock face of a cliff. All those who come here, marvel at the devotion and persistent hard work that went into creating these extraordinary works of art*
FOLLOWING PAGES: *A sixth-century painting in a Ajanta cave depicts a court scene.*

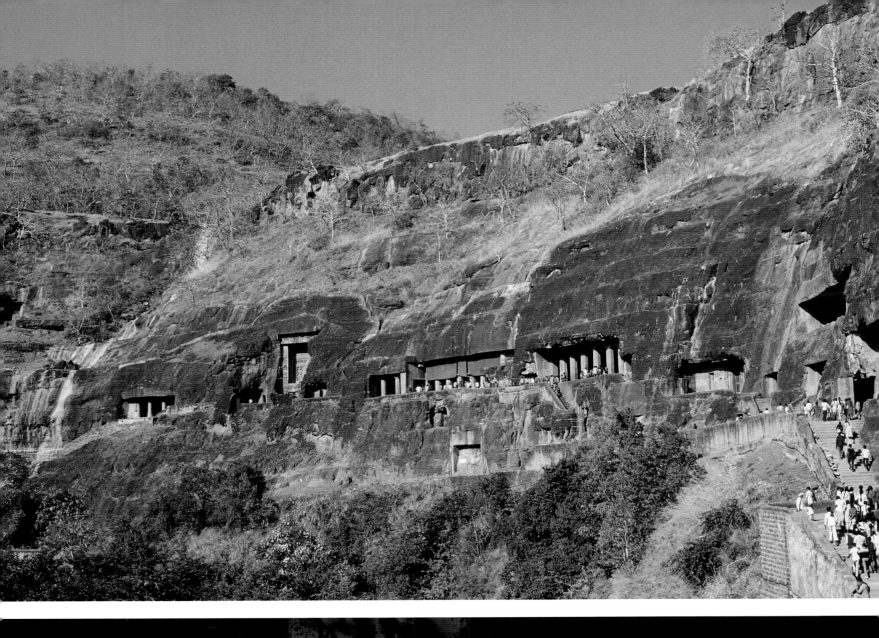

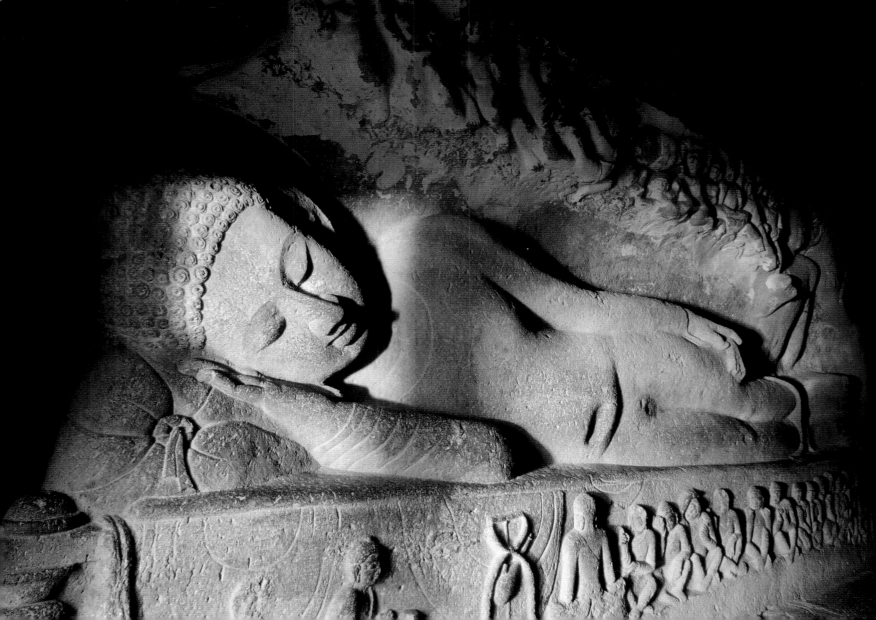

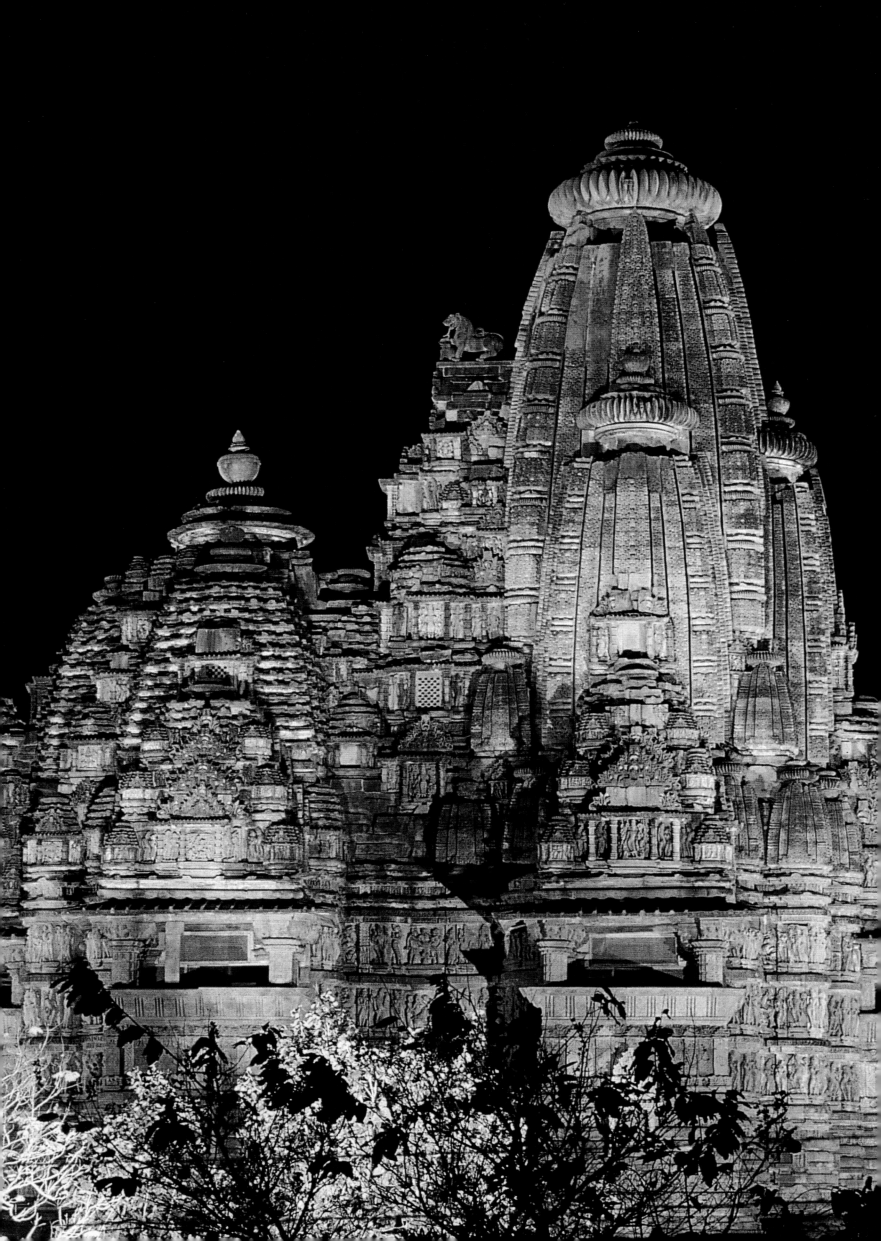

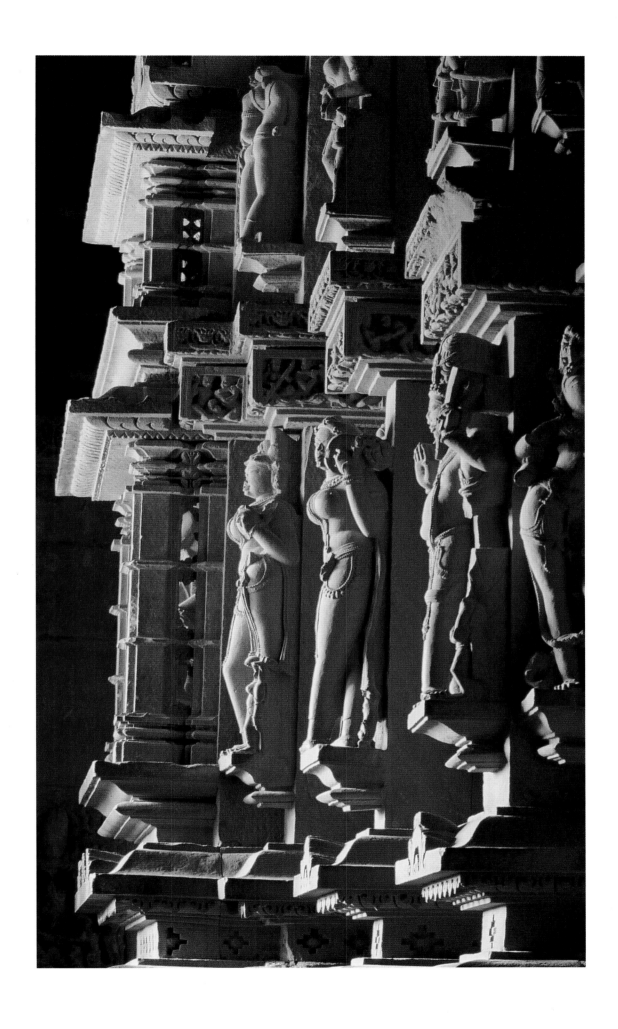

FACING PAGE: *The Vishvanath temple built in AD 1002 is one of the finest temples of Khajuraho. Standing on a platform, which it shares with a shrine dedicated to Shiva's mount, the bull Nandi. The temple shows a marked maturity in terms of plan and design in Khajuraho temple architecture.*
ABOVE: *The light and shadow create a dramatic effect on the beautifully carved figures in the interior of the Lakshmana temple.*

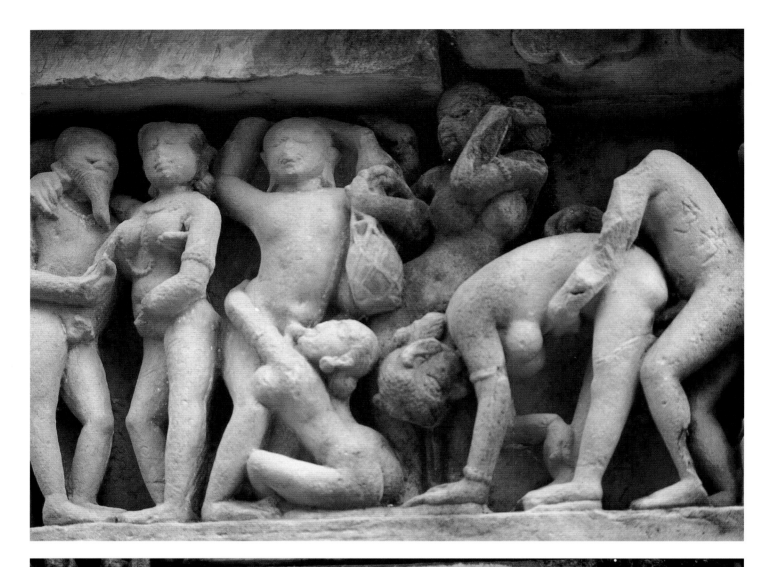

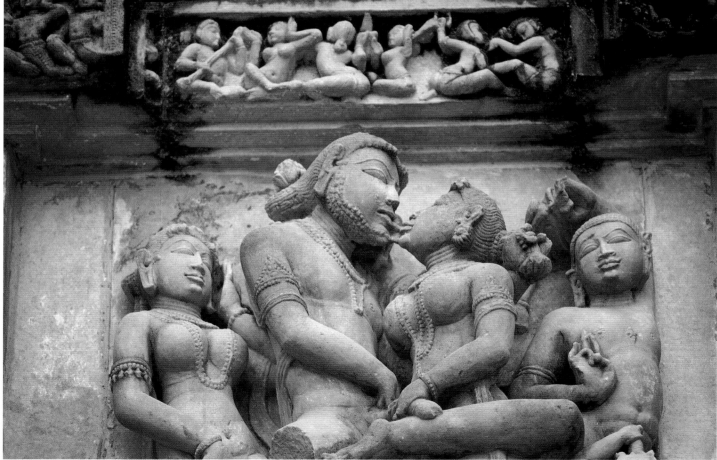

*The very finely carved panels of sculptures from the Parswanatha Temple in Khajuraho.*

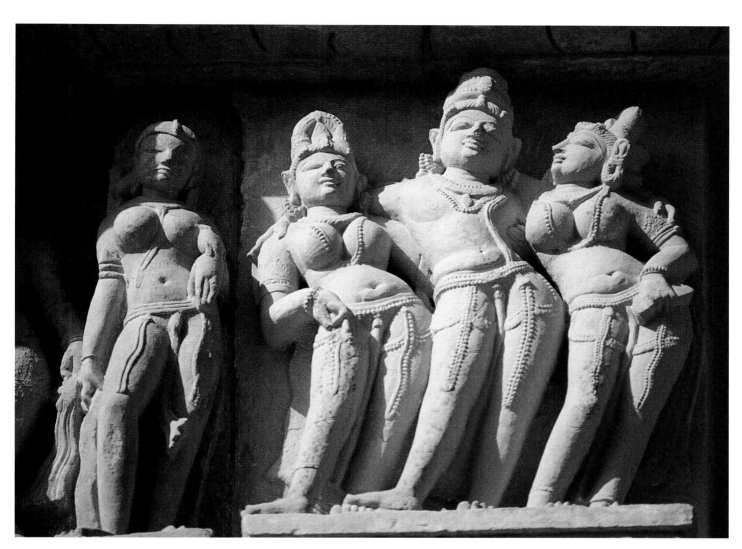

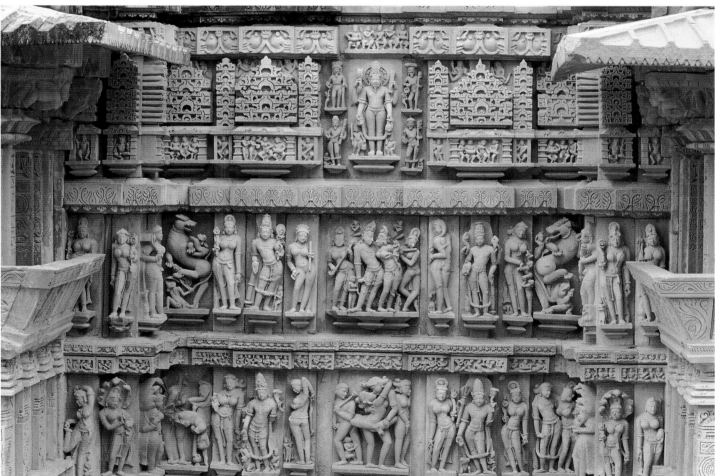

*Erotic sculptures from Lakshmana temple at Khajuraho.*

194

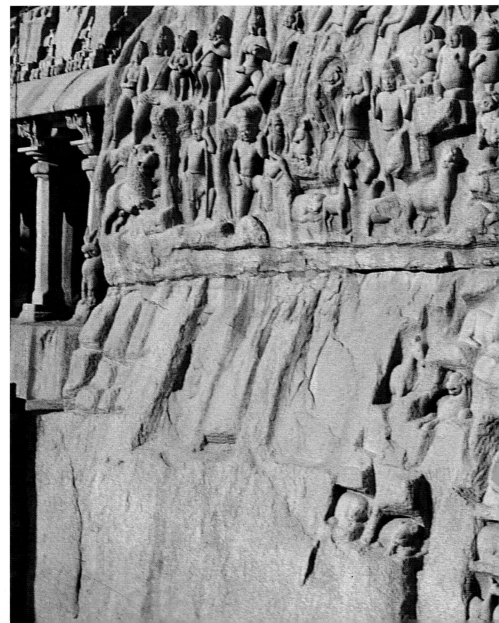

ABOVE: *The Sun temple at Konark in Orissa
is famous for its exquisite sculptures,
some of them erotic in content.*
FACING PAGE TOP: *350-years-old wood carving in
Meenakahi Amman Temple Chariot in Madurai.*
FACING PAGE BELOW: *A masterpiece of Indian art can
be seen at Mahabalipuram in the form of the world's
largest bas-relief. On a huge outcrop of fissured rock,
artists sculpted a beautiful composition of human,
celestial beings and animals depicting 'Arjuna's
penance', or the descent of the Ganga'.*

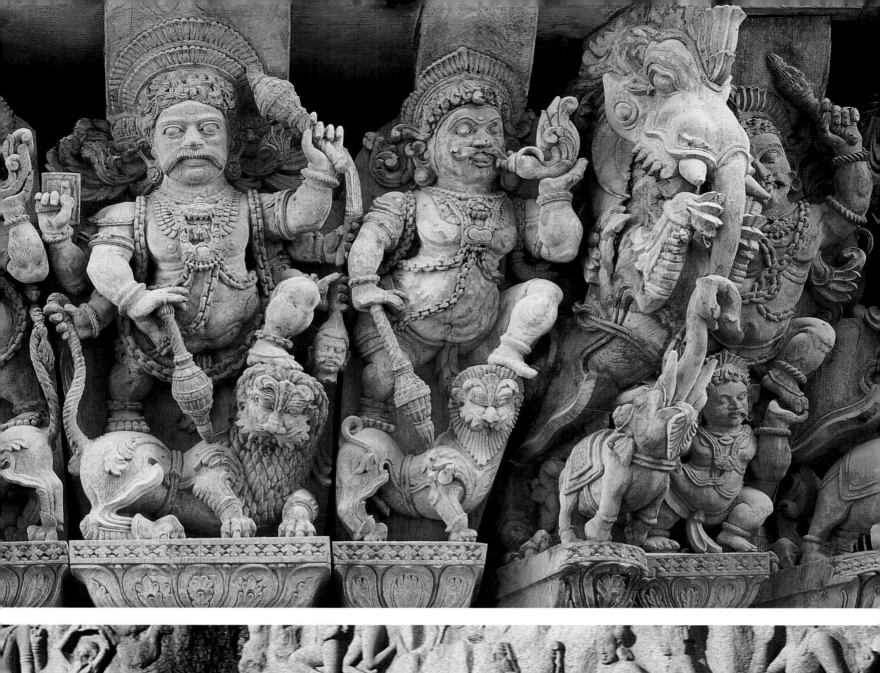

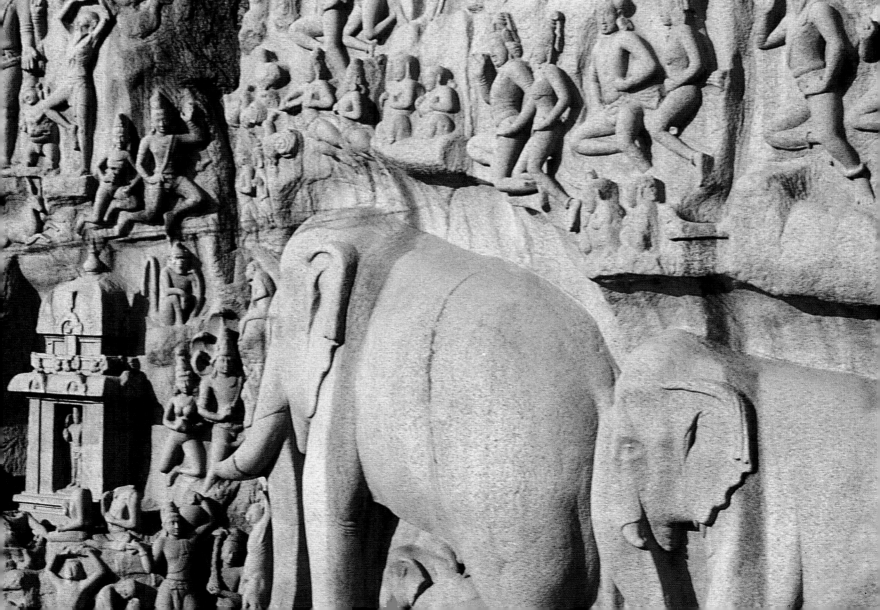

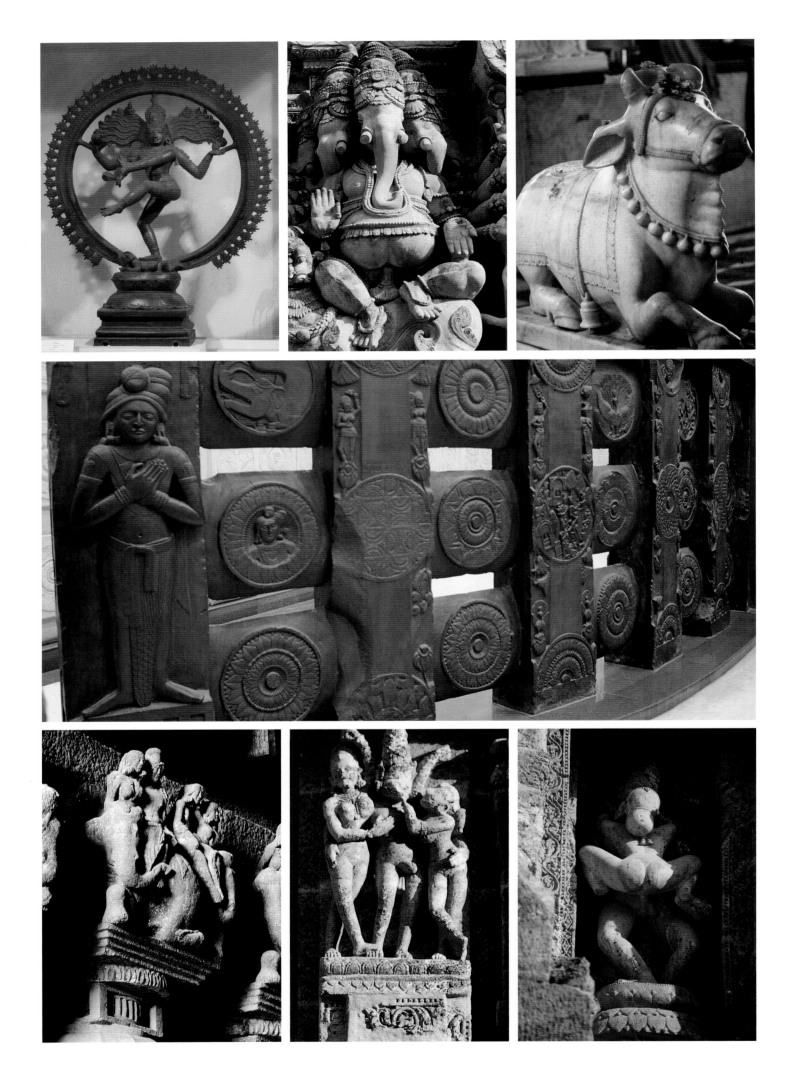

*Indian art was born out of deep religious feeling. From ancient times sculpture and painting have been used to embellish and adorn our religious shrines.*

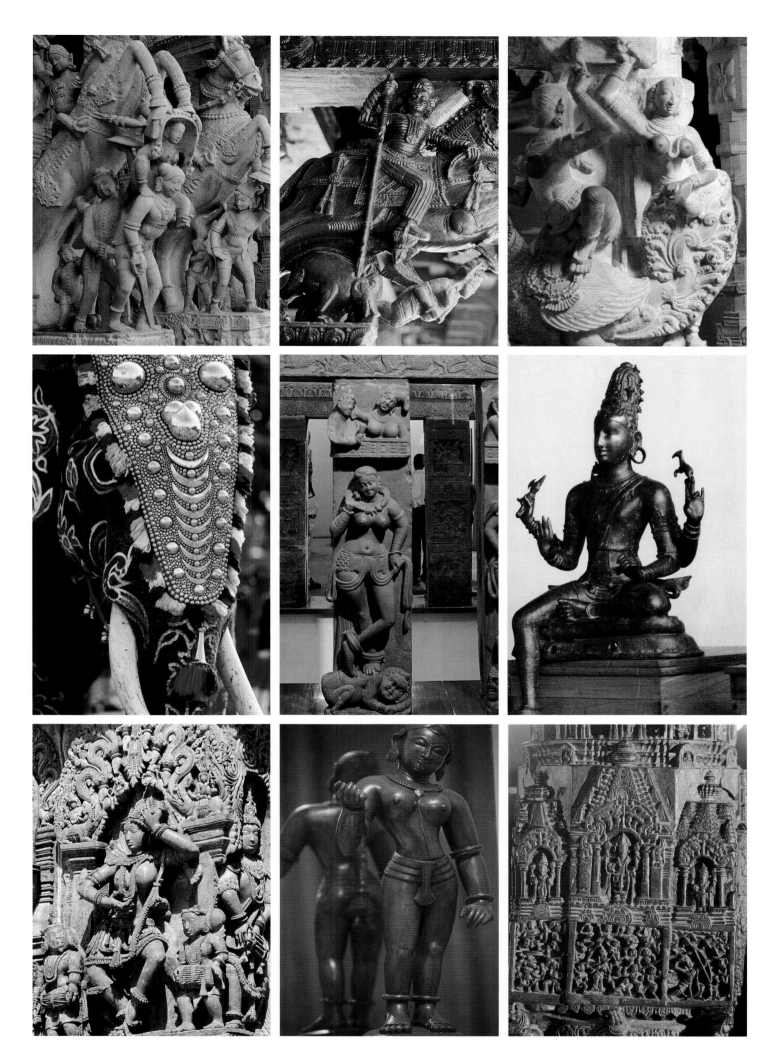

The origins of Indian art can be traced back to the beginning of civilization, and thereafter,
given the foreign influences it developed along both the traditional and indegenous path.

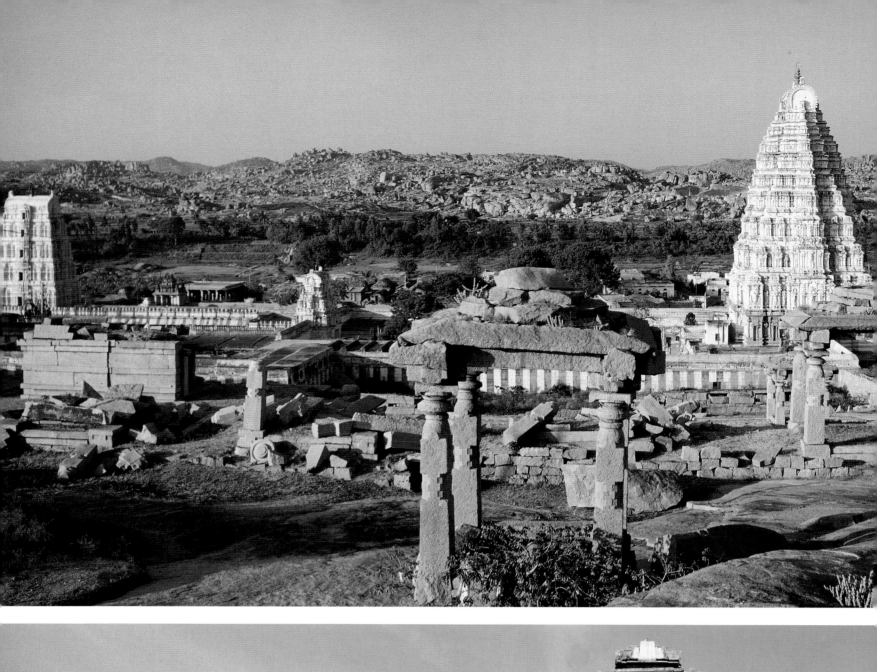
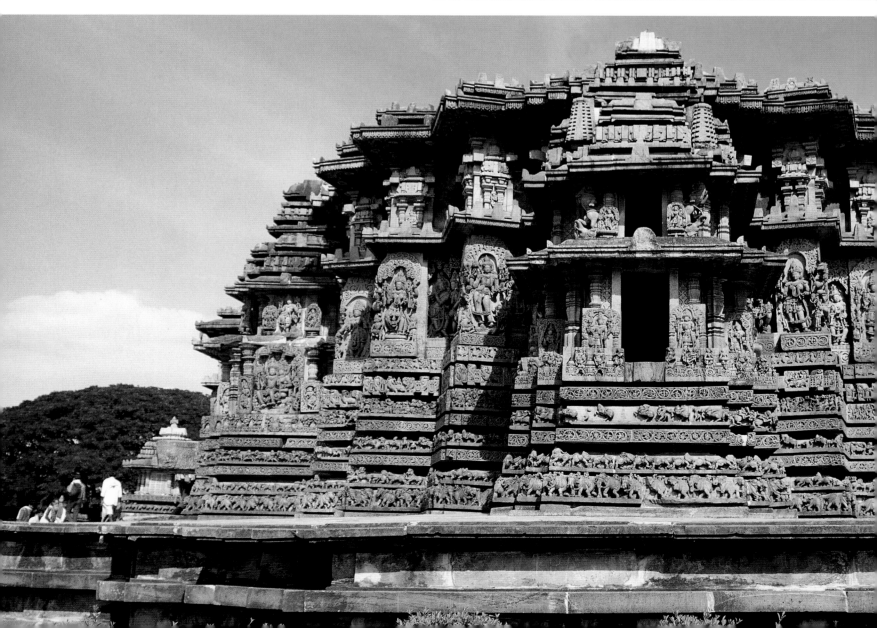

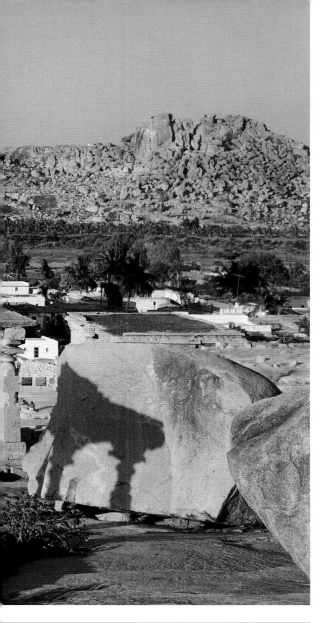

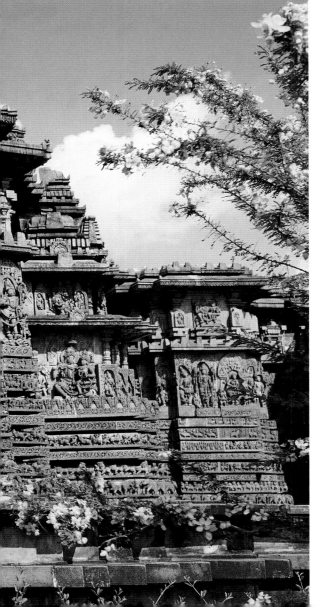

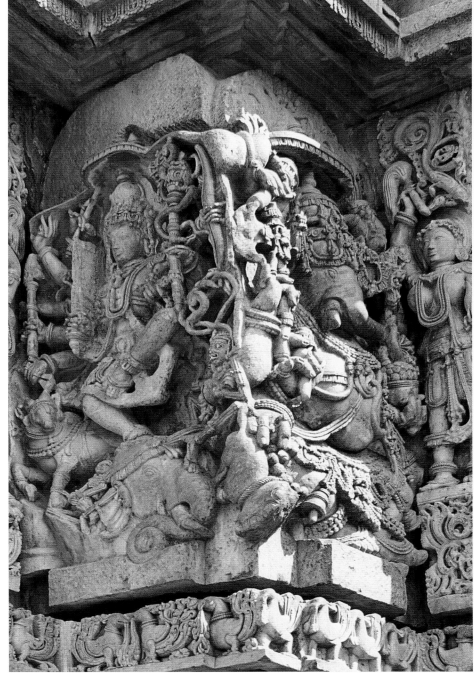

FACING PAGE TOP: *The ruined capital of the great sixteenth-century Vijaynagar kingdom can be seen at Hampi in Karnataka. Palaces, temples, baths, stateless and other structures are scattered across a dramatic landscape beside the Tungabhadra river. The sacred Virupaksha temple, built in medieval Deccan style and dedicated to Lord Shiva and his consort is still used as a place of worship.*

FACING PAGE BELOW: *The famous twelfth-century Hoysalessara temple in Halebid is 180 kilometers from Bangalore. The temple marks the pinnacle of Hoysala artistic creation with its wall friezes, statues and carved panels. The structure consists of two identical temples functioning as a single shrine.*

ABOVE: *Details from Halebid Temple.*

FOLLOWING PAGES: *From every conceivable angle, the Taj is perfectly proportioned and harmoniously balanced.*

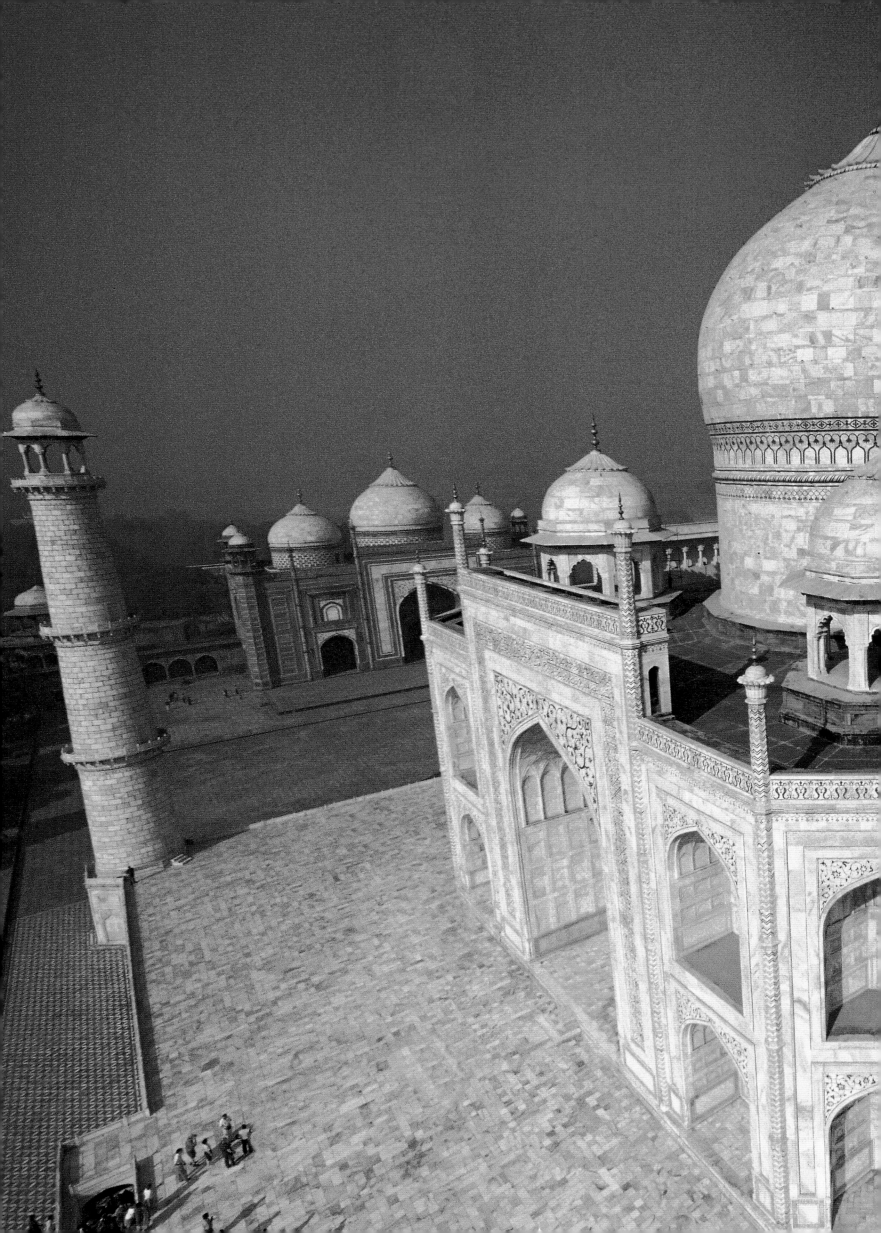

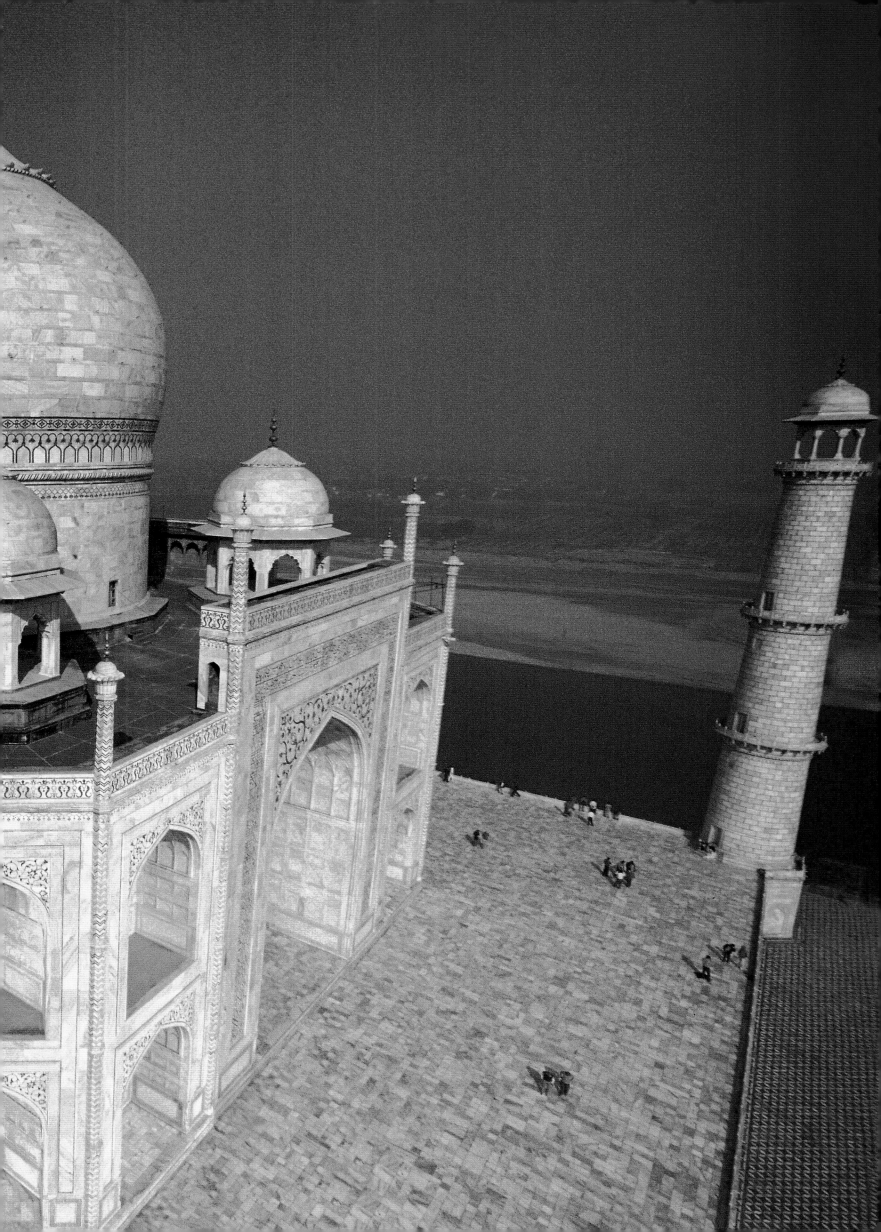

ABOVE: *A Mughal miniature painting of mid-seventeenth century shows a meeting of Sufi saints.*
FACING PAGE: *Emperor Akbar is out on a hunting spree in this Mughal miniature dated AD 1595.*
FOLLOWING PAGES: *Illustration of Krishna and Satyabhama in the Palace at Dwarka,   Harivasma*
*Purana Kangra, Pahari, AD 1810-15.(Photos courtesy: National Museum)*

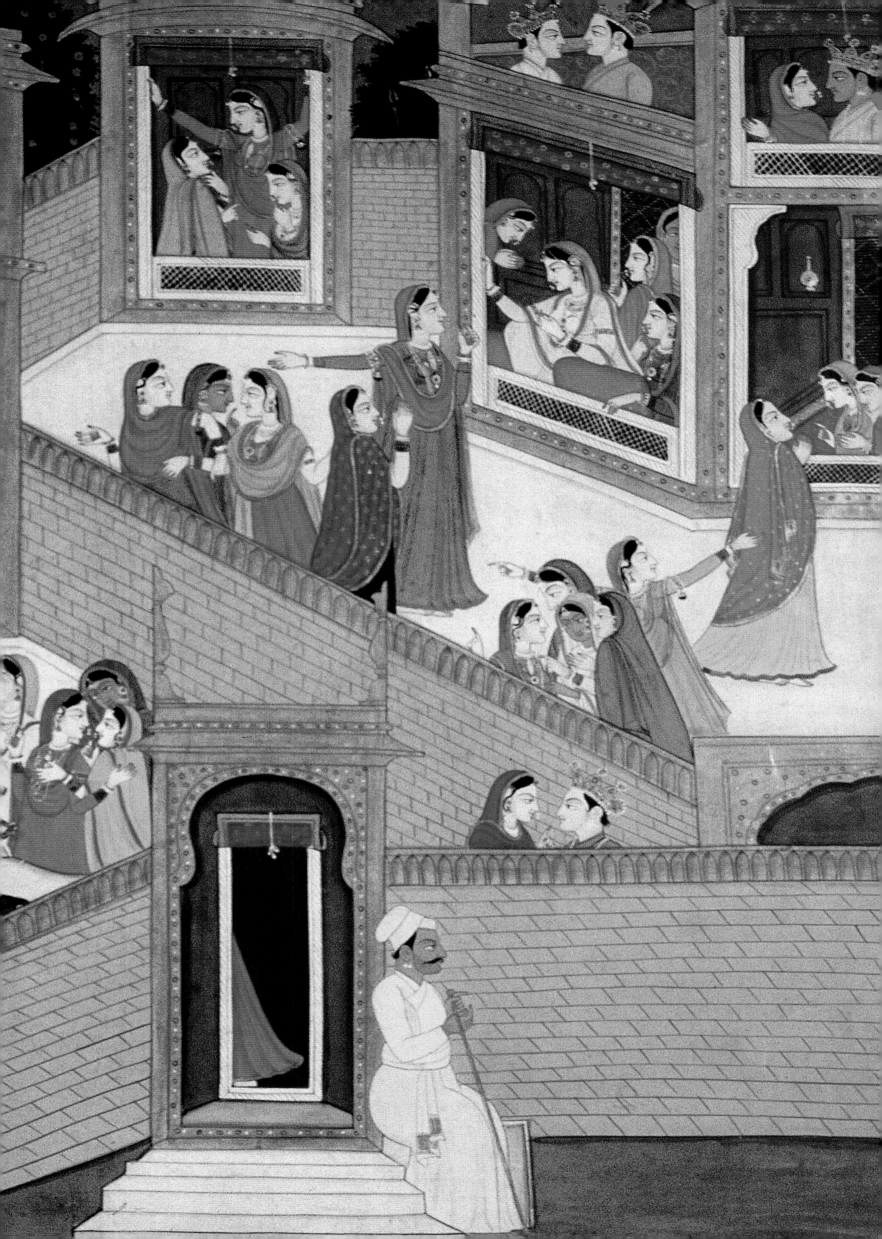

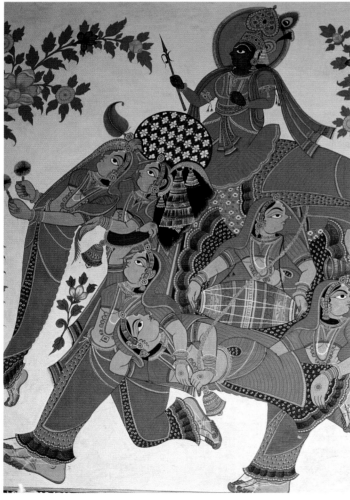

TOP LEFT: *Silk-weaving from Varanasi.* TOP RIGHT: *Weaving from northeast.*
ABOVE RIGHT: *A wall painting from the Craft Museum, New Delhi.*
ABOVE LEFT: *Brightly hued appliqué work from Orissa.*

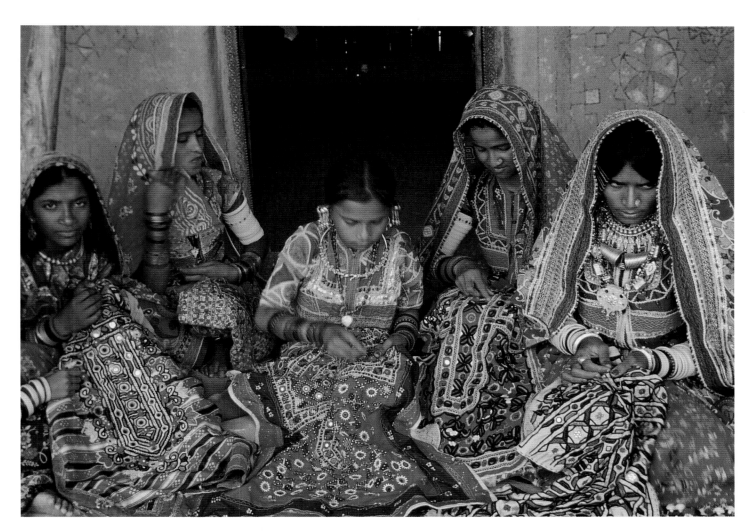

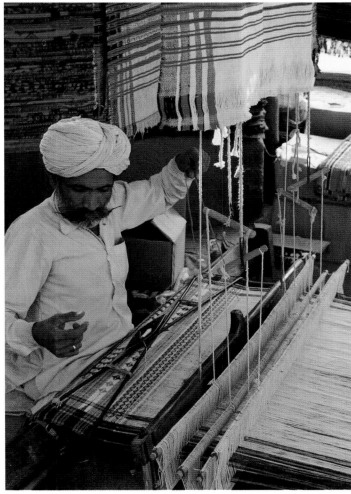

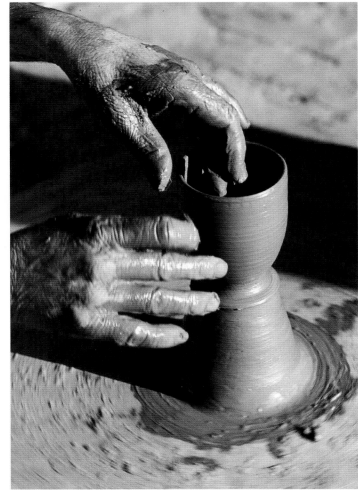

TOP: *Colorful Kutch embroidery.*
ABOVE LEFT: *Pattu-weaving from Rajasthan.*
ABOVE RIGHT: *A potter from Khurja in Uttar Pradesh.*

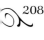

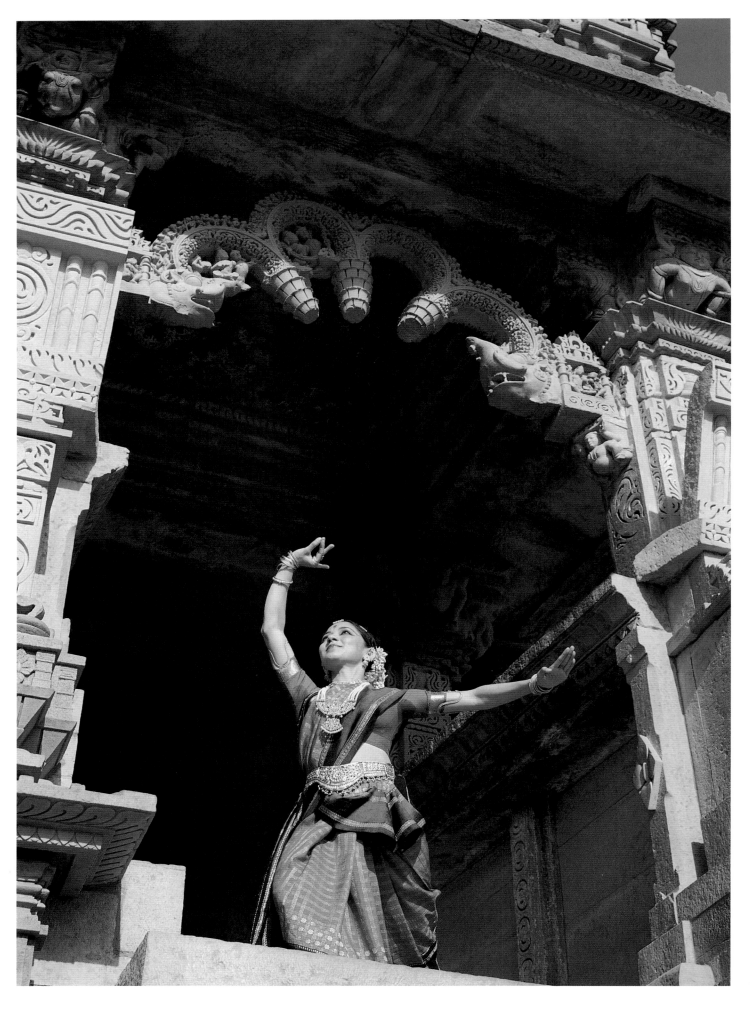

*Bharatanatyam, which is perhaps among the oldest of the contemporary classical dance forms of India, was earlier performed in the temples of south India. A Bharatanatyam dancer has to be extremely creative, sensitive and skilful, while expressing through her eyes, face and hands to convey the true meaning and also hold the attention of the audience. Leela Sampson, an accomplished dancer, performing Bharatanatyam at the Khajuraho Dance Festival.*

# Music & Dance

As in any culture, music and dance, like all forms of art, reflect a way of being and of looking at life. India's staggering diversity of ethnic groups, regional cultures and religions has resulted in dance and music of incomparable richness, the linking thread of Indian identity derived from a shared worldview, whose integrated approach draws its fierce intensity from an awareness of past experience—a steadfast faith in abiding propensity—called vasana, in Sanskrit.

The central pillars of Indian culture are represented by two words: Samskara, what is chosen, shaped and chiseled to perfection; and Sanskriti, the already achieved and shaped culture. Both words underscore a philosophy in India whereby the past, present and future are linked in an endless wheel of timelessness. Ananda Coomaraswamy, the legendary art critic, spoke of the "wonderful spectacle of the still surviving consciousness of the ancient world" in Indian art. Indeed, India's music and dance cannot be understood without first appreciating the basic premise of the worldview on which these arts rest, and which has shaped their identity.

India's high philosophy in its otherworldly concerns is not so much a denial of life, as it is believed, but more a transcendence from mundane life to a level of bliss and inner equanimity, where the polarities and contradictions of pain and pleasure or good and bad, cease to matter. All art forms are disciplines providing different pathways for the practitioner, aiming at that state of being that is not experienced in empirical life. Through finite symbols of sound (in music) and movement (in dance), the Indian singer and dancer seeks to experience that higher consciousness—self-realization or Brahman—if only fleetingly, unlike the Yogi who eternally lives in a state of bliss.

Evoked through the art, the aesthetic joy communicated and felt by the empathetic audience is rasa, an experience so akin to that highest state of spiritual realization, that it has been called Brahma-sahodara (brother of Brahman). The word "rasa" means essence or flavor, and as Dr. Kapila Vatsyayan wrote in her book, Indian Classical Dance in Literature and the Arts,

"The Hindu mind views the creative process as a means of suggesting or recreating a vision, however fleetingly, of divine truth." The respect for past experience and wisdom does not suggest a linear continuity of stagnant art, for growth and refinement involving both intellect and talent are part of a constant revitalizing process incorporating contemporary sensibilities. The continuity lies in the recognizable core identity of an art form.

The other significant aspect of this worldview is its holistic nature, integrating into one organic totality: matter and spirit, the divine and the secular, Man and Nature, the Seen and the Unseen, the Manifest and the Un-manifest. Pinpointing this interconnectedness is the Rig Vedic Sukta, which describes how, in this order of creation, "Everything is attuned to everything/Each part inheres the whole/And the whole embraces the parts/All are connected in a very subtle way/All are a part, nothing is apart." The oft-quoted episode from the Vishnudharmottara Purana of the sage Markandeya, advising King Vraja to learn icon making and music before venturing into dance, illustrates best this mutual interdependence in the arts. A discerning French visitor to India commenting on this "mutual dialectical exaltation between matter and mind," said, "Here the body is lived intellectually, and the spirit physically."

Considered one of the premier means of evoking this sense of spiritual well being through aesthetic joy, or rasa, is classical music as disciplined sound. The Rig Veda describes the beginning of the creative process as emerging out of the "ocean of nothingness" and mentions "Primordial Sound" in space as the starting point. Vocal music is regarded as the highest of all arts, always aspiring to a condition of music. The word Sangita now applied to music has a broader connotation in the Sastras, referring to music, dance and drama as Natya, or total theater.

With this approach of art as a vehicle for attaining self-realization or "Ultimate Truth", art becomes more of an experience, pursued through an individual's art journey. There is no place here for team or group effort; it is the solo form that represents the most intense manifestation of India's classical music and dance.

Only in India does music associate with the concept of Anhad-Naad, or sound without vibration. It is almost a mystical experience, and only such an approach could have resulted in a colorful and passionate concept like the raga.

Within the raga discipline of a set of notes in the ascending or descending scale, there is total freedom for aesthetic creativity to improvise and build a melodic landscape, unique when rendered, and never to be replicated. A raga or melodic mode is made up of swaras. The swara, unlike the mechanical note of Western music on a range of frequencies of a calibrated musical scale, derives its authority, not from a written score (though there are structured lyrics in different ragas, particularly in Carnatic music), but from the singer's creative urges honed by years of sadhana – representing a whole journey of living with the music, its conviction not dependent on either blinding virtuosity and technique, or a dulcet voice.

Significantly, the etymology of the word swara—swa means "self" and ra means "to shine"—shows that, within the prescribed theory, it is the signature of the individual singer and the inner self (not to be mistaken for the egoistic self), in the music of Kumar Gandharva, Fayyaz Khan, Bade Ghulam Ali Khan, Bhimsen Joshi, Chembai Vaidyanatha Bhagavatar, Madurai Mani or Semmangudi Srinivasa Iyer, that one cherishes. Raga becomes the musical clothing for a host of inner emotions, and the same raga rendered on different occasions may reflect entirely changed moods. It is this deep involvement with the spirit of man, which the late Raghava Menon, in his book about Indian music, summed up in his statement that ragas are not made, but are discovered "through supremely delicate awareness." Therefore, it is not surprising that saints have been some of the great founders of Indian music.

Raga remains a mere idea until brought to life by the musician. To imbibe the basic knowledge of the spirit of raga music, which is not bound by a score, the guru or the teacher in an oral tradition is of supreme importance, for only through transmission to succeeding generations, and through the performance of countless musicians, does the raga acquire a strong identity in cultural memory. Transmission through the guru imparts legitimacy, bestowing a stylistic identity.

Unlike Western music and the microtonal interval, Indian music has no fixed scale; the quartertone, called "sruti," provides an anchoring point. Also, without the grace of the gamak as embellishment, any rendition would seem bare. Ragas are associated with certain hours of the day and also, with seasons, when they may be appropriately sung, particularly in Hindustani music. Ragas have been given anthropomorphic characters such as Raga Bhairav, which is meant to reflect the ascetic Siva. Ragas, and Megha and Malhar, are all associated with the monsoons.

India has two distinct genres of music, the Carnatic in the south, and the Hindustani music of the north. Language and socio-political climate have played a large part in defining the consciousness of these two different traditions. The Kudumiyamalai inscriptions in southern India pertain to grama ragas mentioned in the Brihaddesi of Matanga Muni, from the ninth century A.D. Until the seventh century A.D., it appears there was a shared concept of music in the country. By the time the Sangita Ratnakara of Sarangadeva, a Kashmiri who lived and worked in the south (1210-1247 A.D.), was written (this work still forms the first source book for Carnatic music), cultural differences of the north and south were beginning to establish themselves.

Venkatamakhi is the chief architect of present day Carnatic music. Great vaggeyekarars—composers of both lyrics and musical scores—like Shyama Sastri (1763-1827), Tyagaraja (1767-1847) and Muttuswamy Dikshitar (1775-1835), have left behind a rich legacy of Keertanams (lyrics with a typical Pallavi, Anupallavi, Charanam structure) in different ragas, and they still form the main repertoire of Carnatic music.

While the alap part is improvised, the structured compositions do not allow the massive improvisational play as in Hindustani music, where only a two-line bandish is the given, with the musician in a Khayal-rendering, making an interplay of time with musical phrasings, meter, changing emphasis, and so on; the raga delineation taking place within a rhythmic mold, with accelerando, or gradually increasing speed, as a feature of the rendition. Conversely, in Carnatic music, Kalapramanam insists on the set tempo being maintained. Acceleration can be achieved through an exact doubling or quadrupling of time. No "in-betweens" are allowed.

In northern India, with a large section of court patronage being from non-Hindu rulers, virtuosity and abstract elements of the raga in Carnatic music assumed greater

importance than any devotional text. Although in the final analysis the goal in both systems is spiritual, the sahitya element, given so much prominence in Carnatic music, is a fringe concern in Hindustani music. Bhajan, as a genre, is common to both systems, and is sung as the less heavy part of a concert after the Khayal and Keertanams of Hindustani and Carnatic music, respectively. The thumri in Hindustani music and the Padam in Carnatic music, both extolling love themes, have formed the textual format for interpretative items in Kathak and Bharatanatyam.

Away from heavy textual content, the highly abstract and secular nature of Hindustani music can be gauged from the fact that the meditative form of Dhrupad music has been largely the preserve of singers hailing from the Islamic community. Nadaswaram players, drummers and vocalists from non- Hindu religions, have been known to Carnatic music, too, though to a lesser degree.

Classical dance is based on the same philosophy. The dancer's persona is not crucial to the art, for as the Rig Veda says, nobody can know the dancer from the dance. Embodying this basic premise is the profound representation of Shiva as Nataraja, a metaphor for cosmic activity, symbolizing the primeval rhythms of the universe. Connecting earth with sky, Nataraja dances, his theatre being the entire cosmos, the rhythms of his dance setting in motion the cycle of creation and dissolution. Nataraja's locks standing out at right angles to the head suggest fast movement, but in the supremely balanced figure and the tranquil face, there is an unmistakable stillness. "Our Lord is the Dancer, who, like the heat latent in firewood, diffuses His Power in mind and matter and makes them dance in their turn," says the Tiruvatavurar Puranam.

Discovery of the atom in constant movement, as an integral part of a ceaseless flow of energy, reinforced scientifically a highly imaginative artistic concept symbolizing a profound philosophy. The male torso, suggestive of a dance pose, and the dancing female bronze with one foot raised, from the Harappa and Mohenjodaro civilizations respectively, prove the antiquity of dance in India, its importance substantiated by the innumerable sculptured figures on early stupa and temple walls in Sanchi, Mathura, Amaravati and Nagarjunakonda. There would seem to have been a shared dance tradition throughout the country until approximately the eighth century A.D.

It is from the 10th century onward that the Sanskrit culture was superimposed by strong regional cultures, with language playing a dominant role. Expressions multiplied, although the ideas were the same.

Ultimately, poets and reformers like Kalidas, Upendra bhanj, Tulsidas, Kambar, Tirumoolar, Kshtragya, Surdas, Sankar Dev, Jayadeva, and a host of others, while enriching literature, also unified India under one philosophy. Just looking at the dance figures sculpted in the Rajarani or Parasurameswara temples in Bhubaneswar and comparing them with those in the Tanjavur Brihadeeswara temple, or in the numerous temples at places like Kumbhakonam, is enough to show how different the body technique is clearly manifested in Odissi and Bharatanatyam. From the thirteenth century onwards, dance manuals proliferated in all the regions. Also, The Bhakti movement spread to all parts of the country, and injected a strong Vaishnavite thematic element to the dances. And in literature, Jayadeva's Gita Govindam, particularly influenced almost all dance forms.

The main pillars of art patronage, the temple and the court, were emasculated during British rule. The devadasi, or temple dancer, not only lost her support base, but also earned societal censure, the institution of the temple dancer being finally abolished by law. The devadasi in the south and the Tawaif in the north, were special categories of women, empowered as entertainers living outside the conventional institution of marriage and domesticity. Highly skilled in music and dance, it is this community that gave India some of its greatest artists: Bade Ghulam Ali Khan, Begum Akhtar, Rasoolan Bai, Siddheswari Bai, Sardari Begum, Madurai Mani, Balasaraswati, and M.S. Subbalakshmi. But derogatorily referred to as the "nautch", Indian dance in the 19th century reached a low point, until saviors like E. Krishna Iyer, Rukmini Devi, Vallathol, Uday Shankar and Ram Gopal, with the strong support of liberal poets such as Rabindranath Tagore, rose over the horizon to give a new lease on life to dance.

Dance became a part of the self-discovery of the Indian, inspired by the struggle for freedom. It was between the 1930s and the 1960s, when classical dances were revitalized and attained their present form, with some even being re-christened, such as Bharatanatyam, for the original Dasi Attam or Sadir.

The classical dances of the present are really neoclassical

As in any culture, music and dance, like all forms of art, reflect a way of being and of looking at life. India's staggering diversity of ethnic groups, regional cultures and religions has resulted in dance and music of incomparable richness, the linking thread of Indian identity derived from a shared worldview, whose integrated approach draws its fierce intensity from an awareness of past experience—a steadfast faith in abiding propensity—called vasana, in Sanskrit.

The central pillars of Indian culture are represented by two words: Samskara, what is chosen, shaped and chiseled to perfection; and Sanskriti, the already achieved and shaped culture. Both words underscore a philosophy in India whereby the past, present and future are linked in an endless wheel of timelessness. Ananda Coomaraswamy, the legendary art critic, spoke of the "wonderful spectacle of the still surviving consciousness of the ancient world" in Indian art. Indeed, India's music and dance cannot be understood without first appreciating the basic premise of the worldview on which these arts rest, and which has shaped their identity.

India's high philosophy in its otherworldly concerns is not so much a denial of life, as it is believed, but more a transcendence from mundane life to a level of bliss and inner equanimity, where the polarities and contradictions of pain and pleasure or good and bad, cease to matter. All art forms are disciplines providing different pathways for the practitioner, aiming at that state of being that is not experienced in empirical life. Through finite symbols of sound (in music) and movement (in dance), the Indian singer and dancer seeks to experience that higher consciousness—self-realization or Brahman—if only fleetingly, unlike the Yogi who eternally lives in a state of bliss.

Evoked through the art, the aesthetic joy communicated and felt by the empathetic audience is rasa, an experience so akin to that highest state of spiritual realization, that it has been called Brahma-sahodara (brother of Brahman). The word "rasa" means essence or flavor, and as Dr. Kapila Vatsyayan wrote in her book, Indian Classical Dance in Literature and the Arts, "The Hindu mind views the creative process as a means of suggesting or recreating a vision, however fleetingly, of divine truth." The respect for past experience and wisdom does not suggest a linear continuity of stagnant art, for growth and refinement involving both

intellect and talent are part of a constant revitalizing process incorporating contemporary sensibilities. The continuity lies in the recognizable core identity of an art form.

The other significant aspect of this worldview is its holistic nature, integrating into one organic totality: matter and spirit, the divine and the secular, Man and Nature, the Seen and the Unseen, the Manifest and the Un-manifest. Pinpointing this interconnectedness is the Rig Vedic Sukta, which describes how, in this order of creation, "Everything is attuned to everything/Each part inheres the whole/And the whole embraces the parts/All are connected in a very subtle way/All are a part, nothing is apart." The oft-quoted episode from the Vishnudharmottara Purana of the sage Markandeya, advising King Vraja to learn icon making and music before venturing into dance, illustrates best this mutual interdependence in the arts. A discerning French visitor to India commenting on this "mutual dialectical exaltation between matter and mind," said, "Here the body is lived intellectually, and the spirit physically."

Considered one of the premier means of evoking this sense of spiritual well being through aesthetic joy, or rasa, is classical music as disciplined sound. The Rig Veda describes the beginning of the creative process as emerging out of the "ocean of nothingness" and mentions "Primordial Sound" in space as the starting point. Vocal music is regarded as the highest of all arts, always aspiring to a condition of music. The word Sangita now applied to music has a broader connotation in the Sastras, referring to music, dance and drama as Natya, or total theater.

With this approach of art as a vehicle for attaining self-realization or "Ultimate Truth", art becomes more of an experience, pursued through an individual's art journey. There is no place here for team or group effort; it is the solo form that represents the most intense manifestation of India's classical music and dance. Only in India does music associate with the concept of Anhad-Naad, or sound without vibration. It is almost a mystical experience, and only such an approach could have resulted in a colorful and passionate concept like the raga.

Within the raga discipline of a set of notes in the ascending or descending scale, there is total freedom for aesthetic creativity to improvise and build a melodic landscape, unique when rendered, and never to be

replicated. A raga or melodic mode is made up of swaras. The swara, unlike the mechanical note of Western music on a range of frequencies of a calibrated musical scale, derives its authority, not from a written score (though there are structured lyrics in different ragas, particularly in Carnatic music), but from the singer's creative urges honed by years of sadhana – representing a whole journey of living with the music, its conviction not dependent on either blinding virtuosity and technique, or a dulcet voice.

Significantly, the etymology of the word swara—swa means "self" and ra means "to shine"—shows that, within the prescribed theory, it is the signature of the individual singer and the inner self (not to be mistaken for the egoistic self), in the music of Kumar Gandharva, Fayyaz Khan, Bade Ghulam Ali Khan, Bhimsen Joshi, Chembai Vaidyanatha Bhagavatar, Madurai Mani or Semmangudi Srinivasa Iyer, that one cherishes. Raga becomes the musical clothing for a host of inner emotions, and the same raga rendered on different occasions may reflect entirely changed moods. It is this deep involvement with the spirit of man, which the late Raghava Menon, in his book about Indian music, summed up in his statement that ragas are not made, but are discovered "through supremely delicate awareness." Therefore, it is not surprising that saints have been some of the great founders of Indian music.

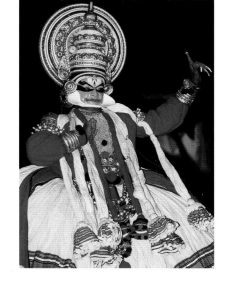

Raga remains a mere idea until brought to life by the musician. To imbibe the basic knowledge of the spirit of raga music, which is not bound by a score, the guru or the teacher in an oral tradition is of supreme importance, for only through transmission to succeeding generations, and through the performance of countless musicians, does the raga acquire a strong identity in cultural memory. Transmission through the guru imparts legitimacy, bestowing a stylistic identity.

Unlike Western music and the microtonal interval, Indian music has no fixed scale; the quartertone, called "sruti," provides an anchoring point. Also, without the grace of the gamak as embellishment, any rendition would seem bare. Ragas are associated with certain hours of the day and also, with seasons, when they may be appropriately sung, particularly in Hindustani music. Ragas have been given anthropomorphic characters such as Raga Bhairav, which is meant to reflect the ascetic Siva. Ragas, and Megha and Malhar, are all associated with the monsoons.

India has two distinct genres of music, the Carnatic in the south, and the Hindustani music of the north. Language and socio-political climate have played a large part in defining the consciousness of these two different traditions. The Kudumiyamalai inscriptions in southern India pertain to grama ragas mentioned in the Brihaddesi of Matanga Muni, from the ninth century A.D. Until the seventh century A.D., it appears there was a shared concept of music in the country. By the time the Sangita Ratnakara of Sarangadeva, a Kashmiri who lived and worked in the south (1210-1247 A.D.), was written (this work still forms the first source book for Carnatic music), cultural differences of the north and south were beginning to establish themselves.

Venkatamakhi is the chief architect of present day Carnatic music. Great vaggeyekarars—composers of both lyrics and musical scores—like Shyama Sastri (1763-1827), Tyagaraja (1767-1847) and Muttuswamy Dikshitar (1775-1835), have left behind a rich legacy of Keertanams (lyrics with a typical Pallavi, Anupallavi, Charanam structure) in different ragas, and they still form the main repertoire of Carnatic music.

While the alap part is improvised, the structured compositions do not allow the massive improvisational play as in Hindustani music, where only a two-line

*Leela Venkataraman*

*Kathakali, the intense dance drama from Kerala, in southern India, is traditionally the domain of male dancers who wear very colorful and elaborate costumes with a mask-like make-up. Years of regular training and practice with emphasis on communicating through facial expressions, stylized gestures and body movements are needed to become a proficient dancer.*

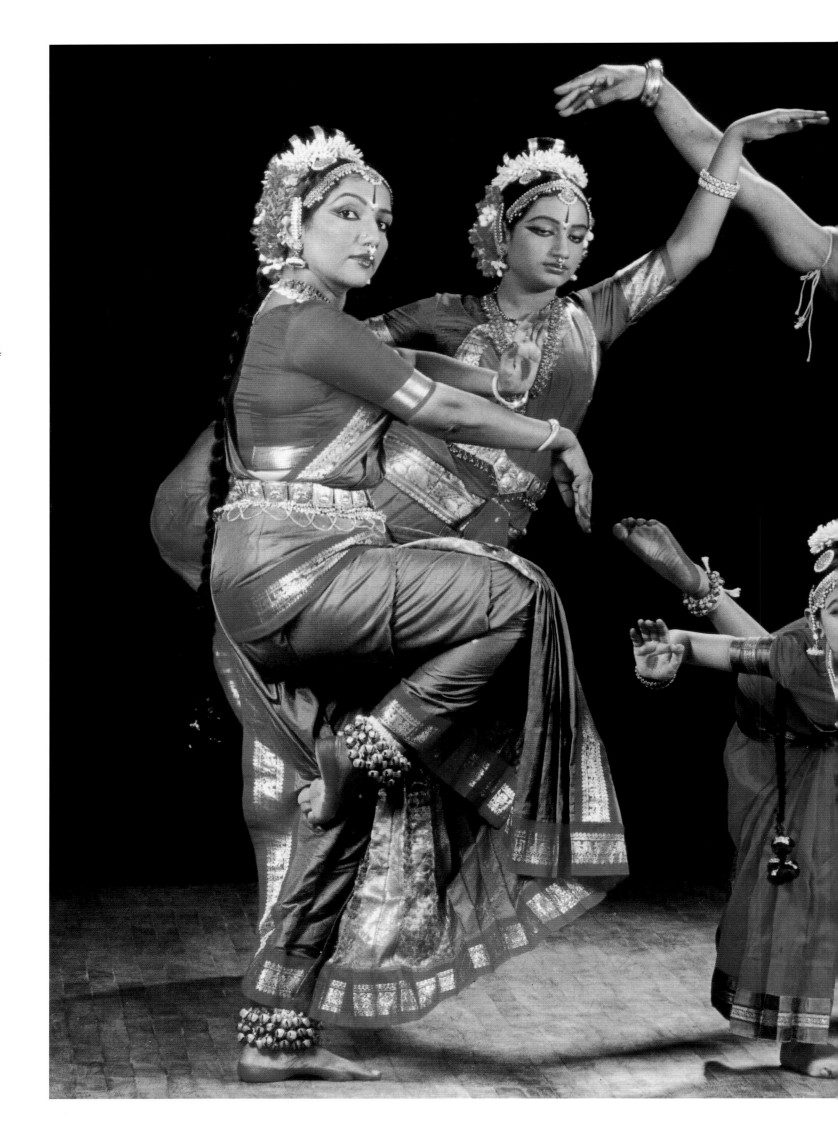

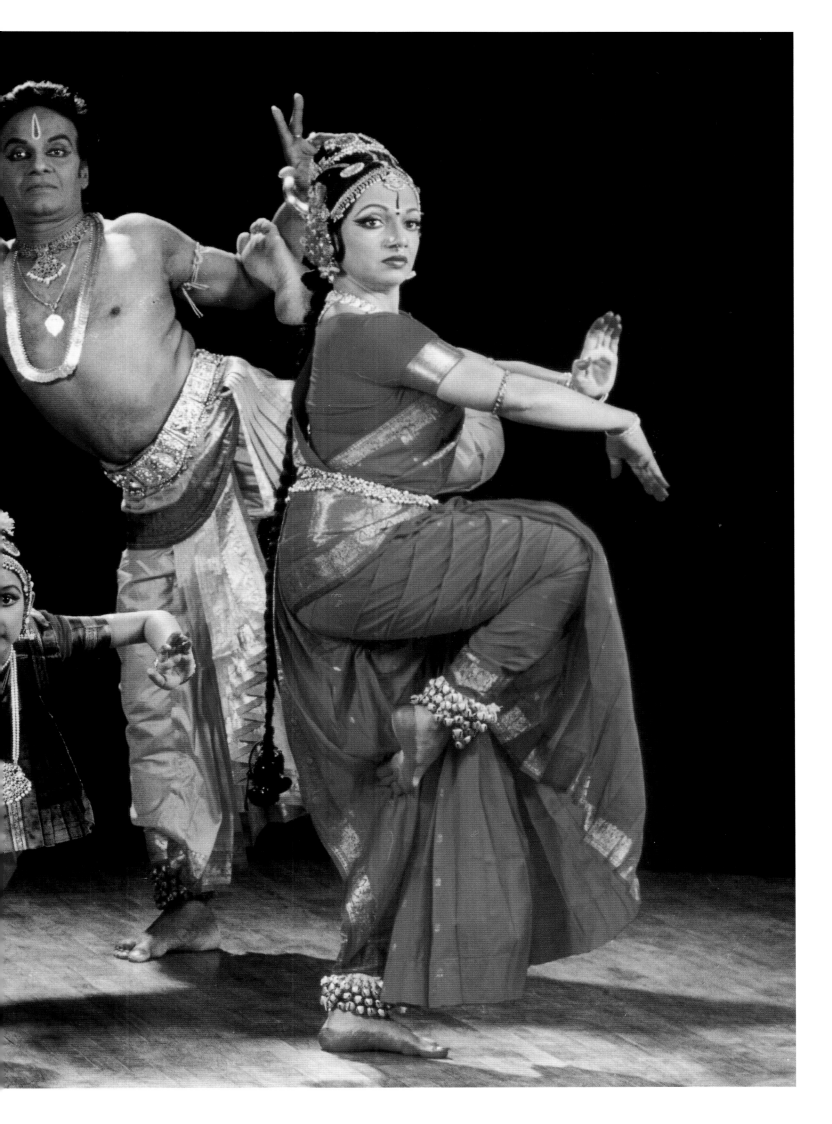

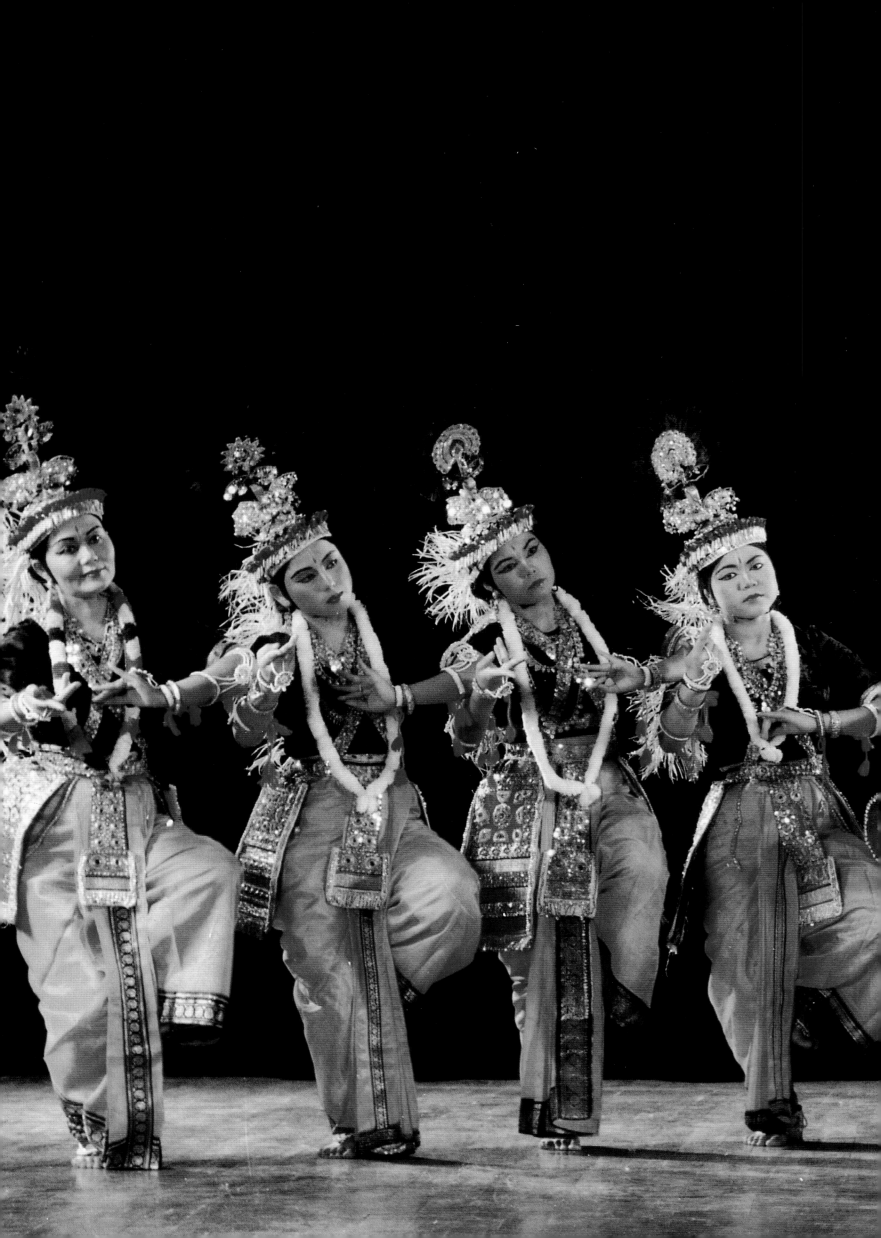

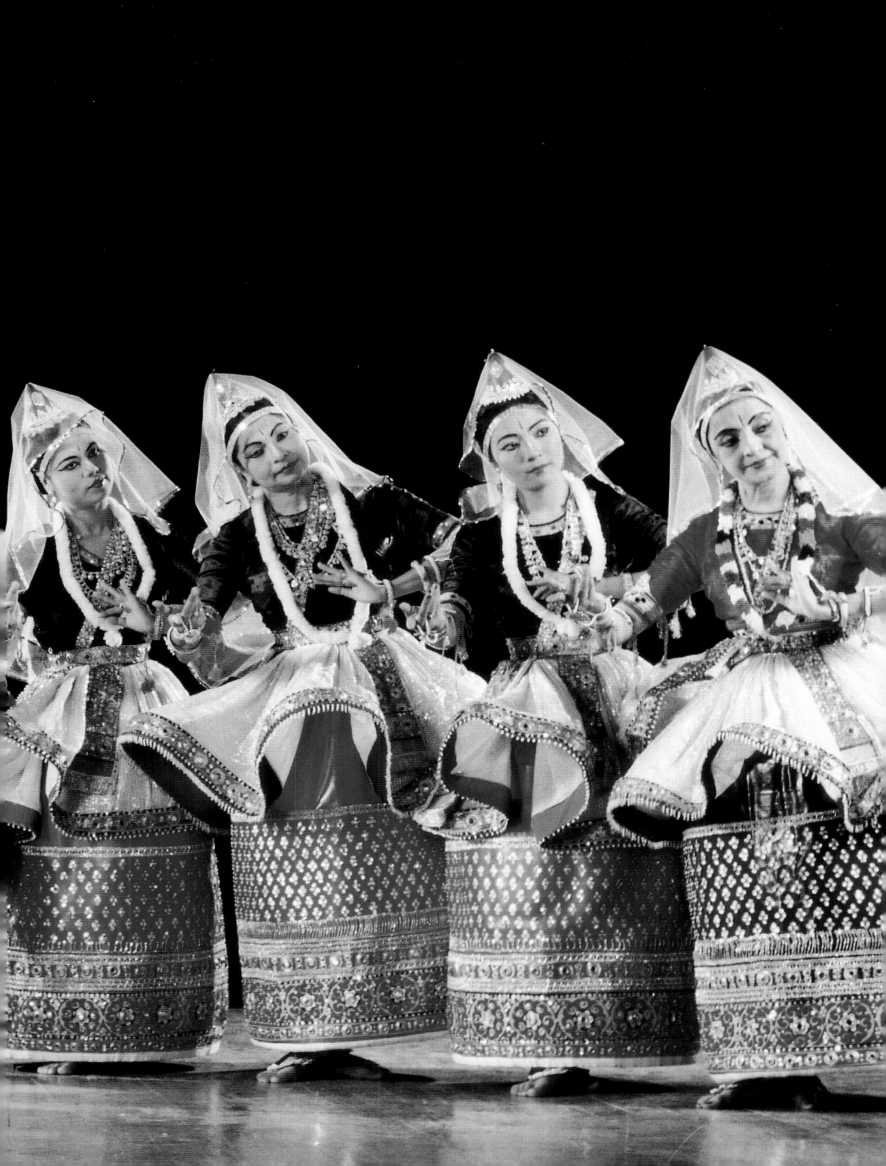

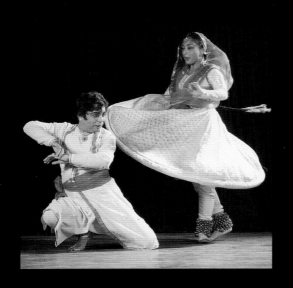

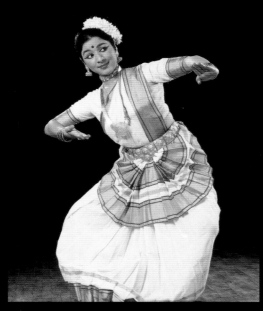

PRECEDING PAGES (214-215): *The Reddy family are well-known exponents of the Kuchipudi style of dance.*
PRECEDING PAGES (216-217): *The Manipuri Nartanalaya troupe performs a scene from 'Maha Rasa' in elaborate costumes. These cultural festivals are closely interlinked with their religion.*
TOP: *The King of Kathak', Birju Maharaj performing a dance sequence with leading dancer Saswati Sen.*
FACING PAGE: *as in Bhara the Sun Temple of Konarak and the philosophy of Lord Jagannath of Puri are reflected in this dance form. Every Odissi dancer's aim is to successfully blend the erotic with the sublime, as depicted in the twelfth- century love poem, 'Gita Govinda', by Jayadeva. Kavita Dwivedi a famous Odissi dancer strikes a typical graceful stance.*
ABOVE: *Vijayalakshmi, demonstrating a pure dance movement of Mohiniattam. Earlier known as the 'Kerala' version of Bharatanatyam or 'a gentler form of Kathakali', Mohiniattam has earned its own place in the performing arts of Kerala.*
*(Photos courtesy: Avinash Pasricha)*

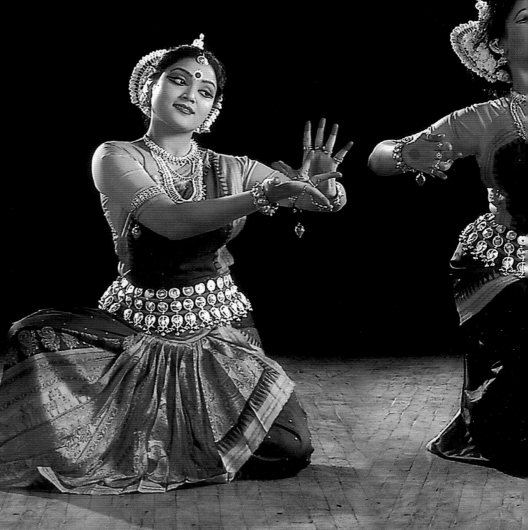

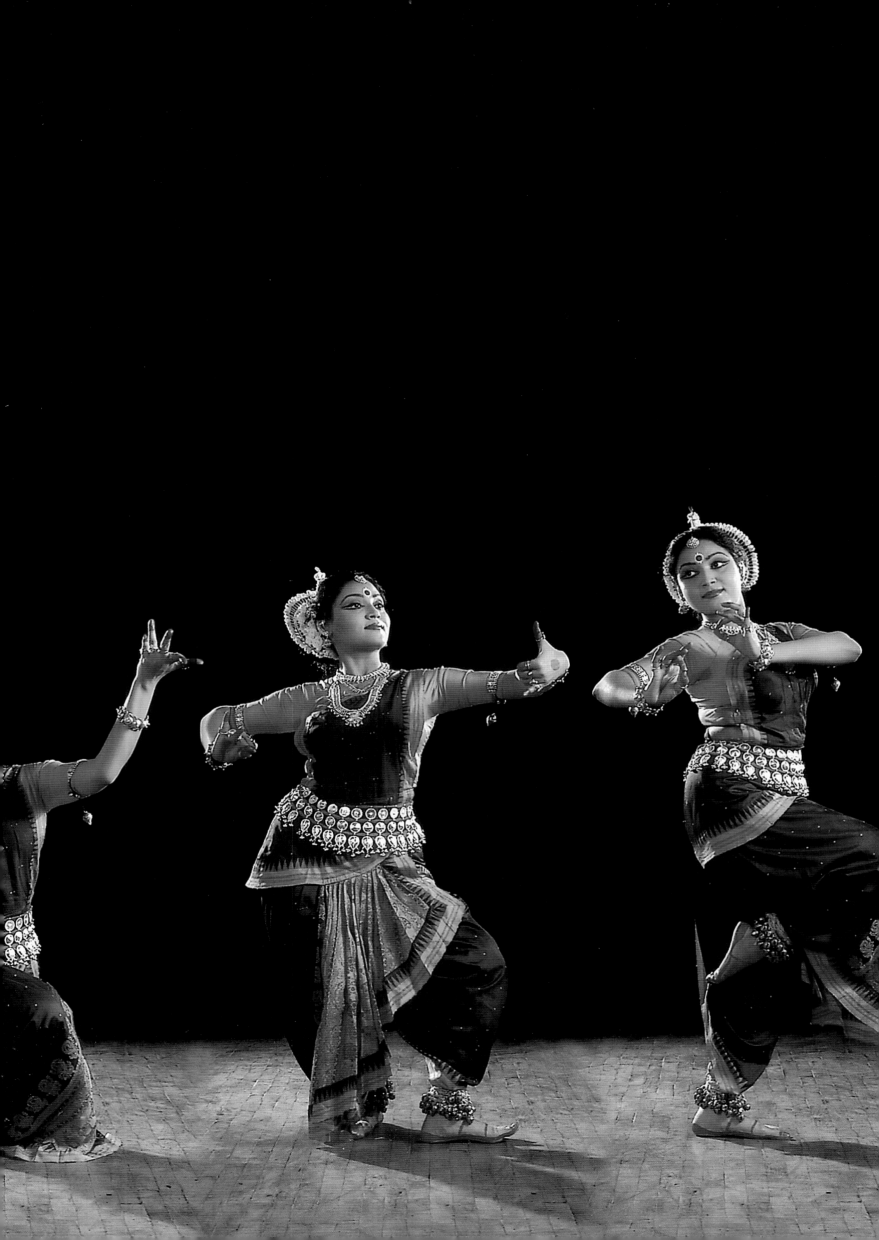

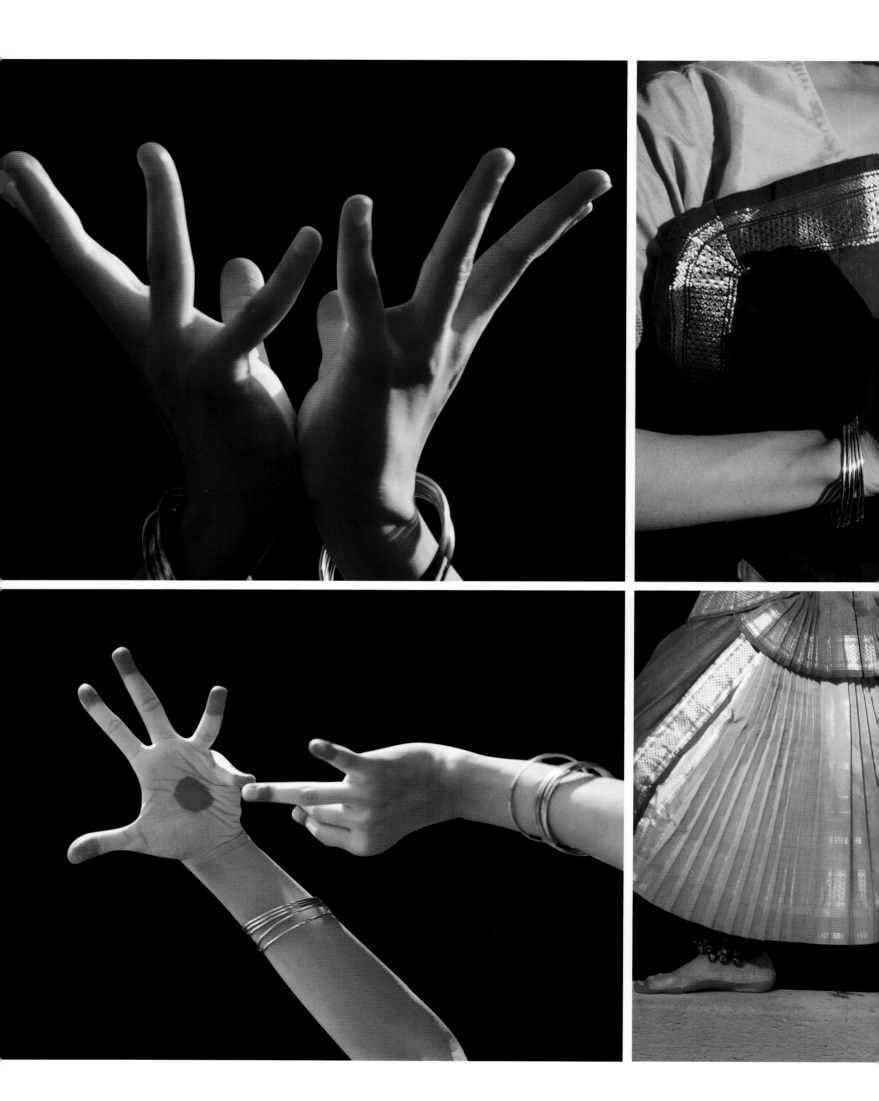

*A dancer expresses through these movements of hands & feet.*

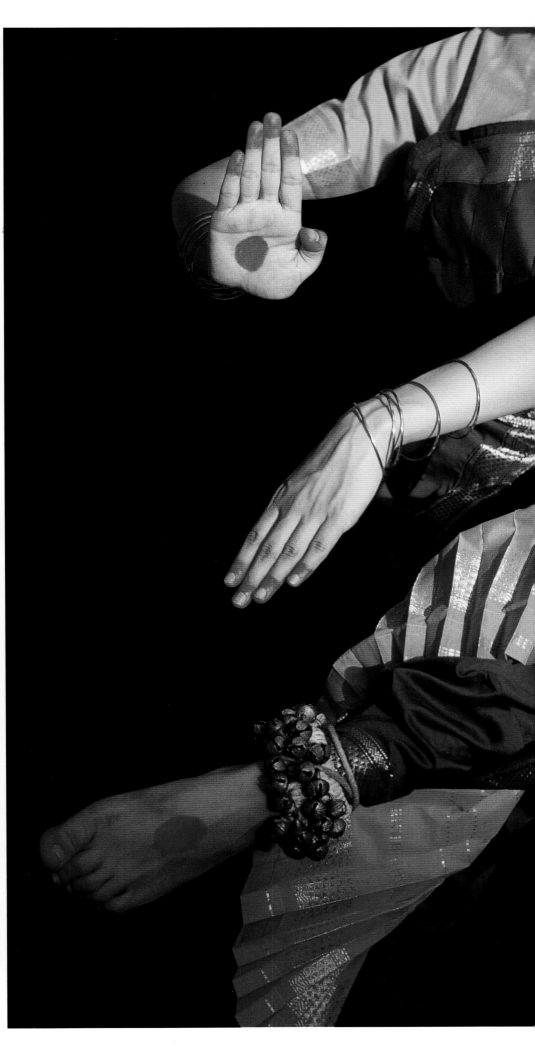
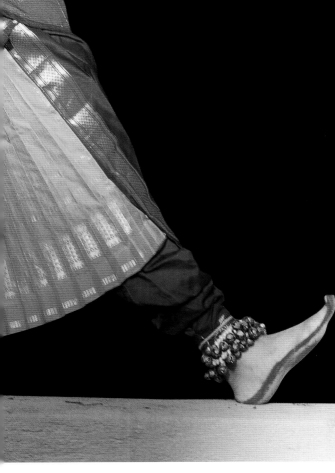
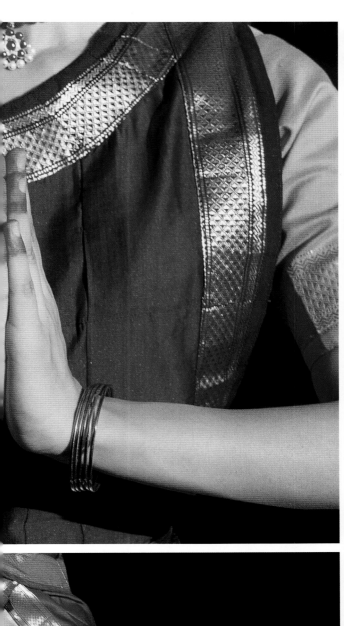

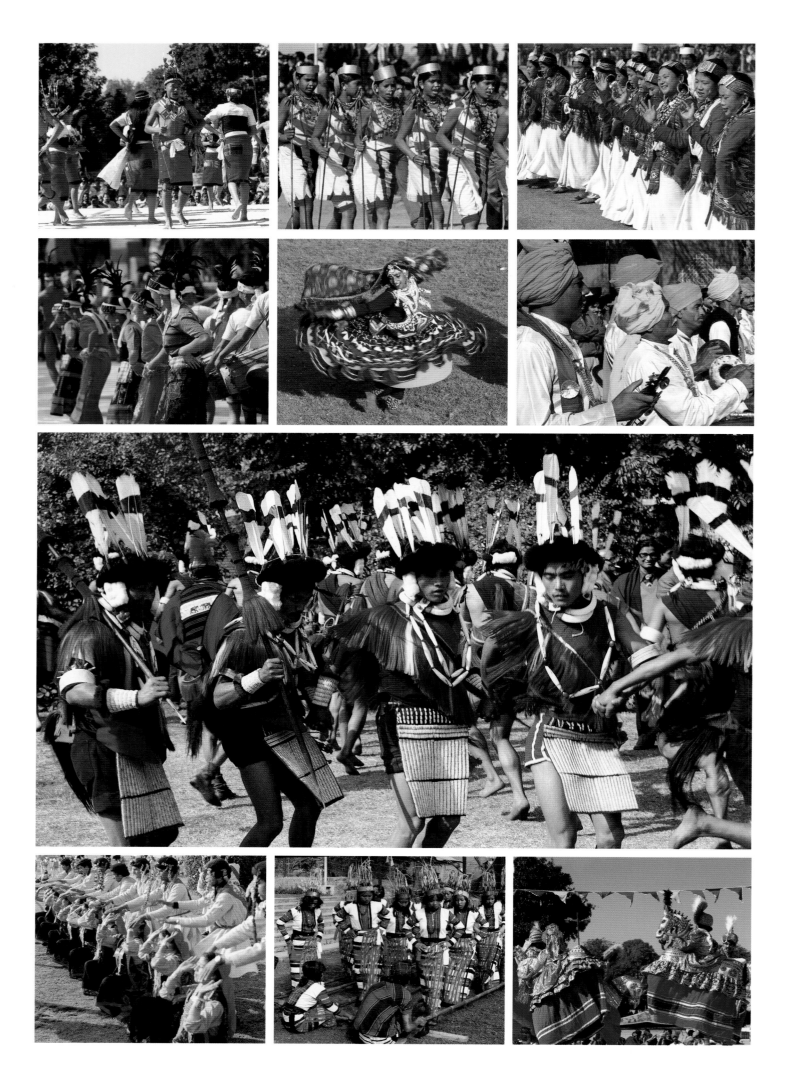

*Every region in the country, the mountain or the plain, the desert or the valley, the coastal area or the island, has its own distinct music and dance tradition.*

*The dance form could be tribal, folk, community or traditional; these colorful and joyous outpourings of expression, varying in language, style and costume, form a very important part of the daily lives of these people.*

*Exceptionally gifted and celebrated Carnatic singer, M. S. Subbulakshmi, at a concert.*
*(Photo courtesy: Avinash Pasricha)*

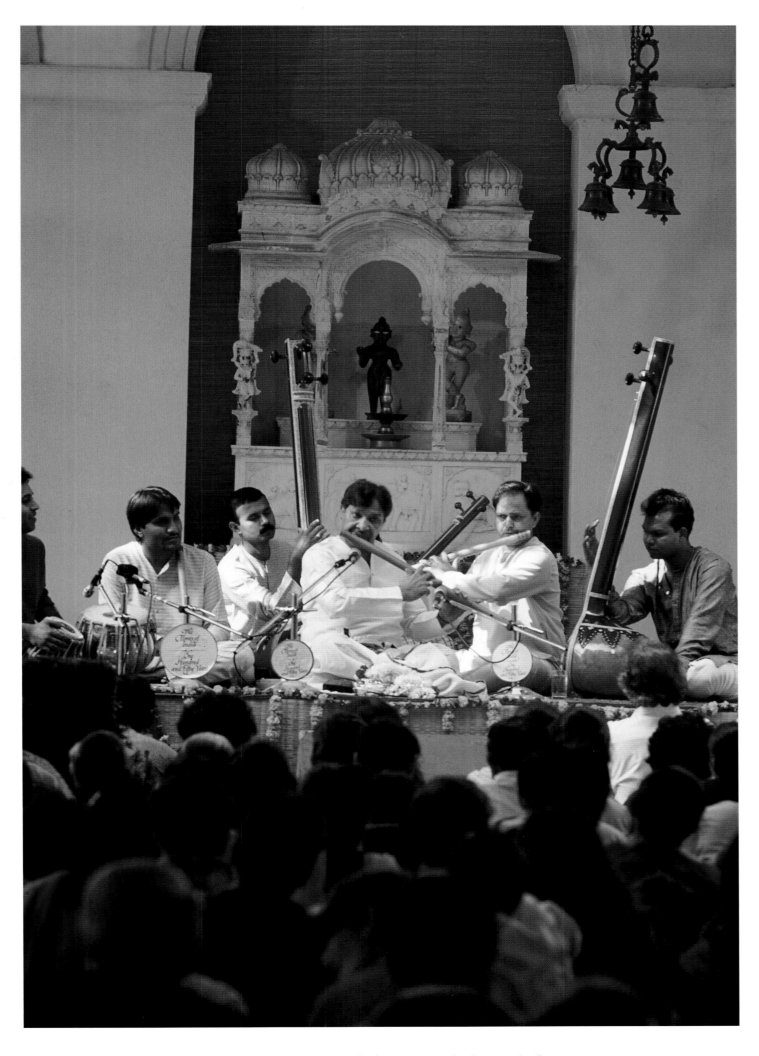

*When the legendary Hari Prasad Chaurasia moves his fingers on his flute.*
*the result is sheer magic. (Photo courtesy: Avinash Pasricha)*

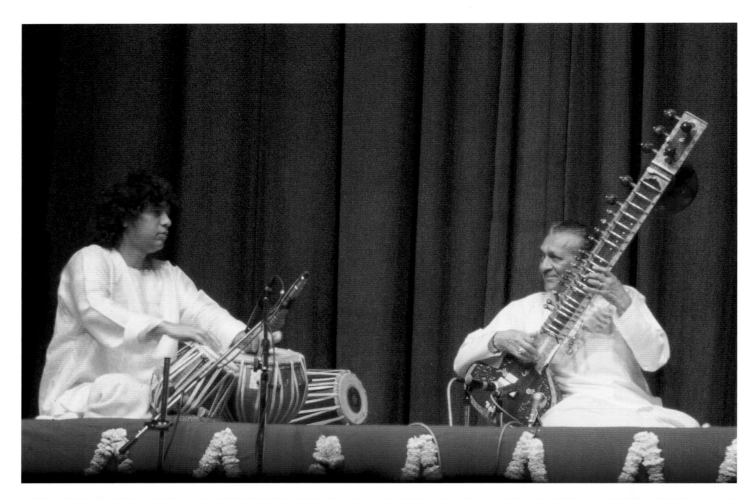

TOP: *Illustrious sitar player Pandit Ravi Shankar and noted tabla player Ustad Zakir Hussain enthrall the audience with their jugalbandi. Anoushka, Pandit Ravi Shankar's daughter also joins in the concert.*
ABOVE LEFT: *People are left spellbound when Ustad Amjad Ali Khan, a highly acclaimed sarod player gives a performance.*
ABOVE RIGHT: *Eminent santoor player Pandit Shiv kumar Sharma. (Photos courtesy: Avinash Pasricha)*

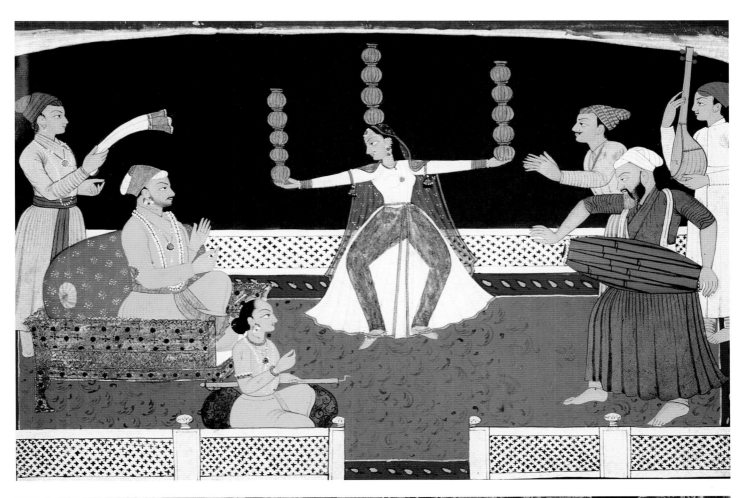

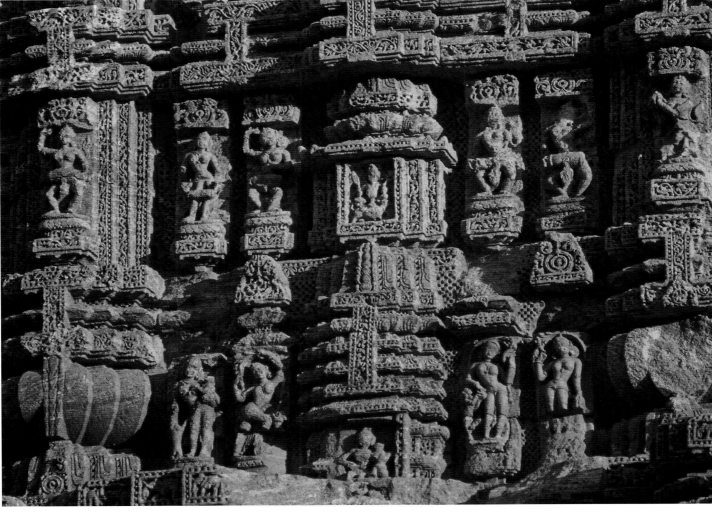

TOP: *Royal patronage of the fine arts by the rulers sustained the excellence of performing artistes.*
*(Photo courtesy : National Museum)*
ABOVE: *Sumptuous sculptures showing the dance forms at Konarak Temple, Orissa.*

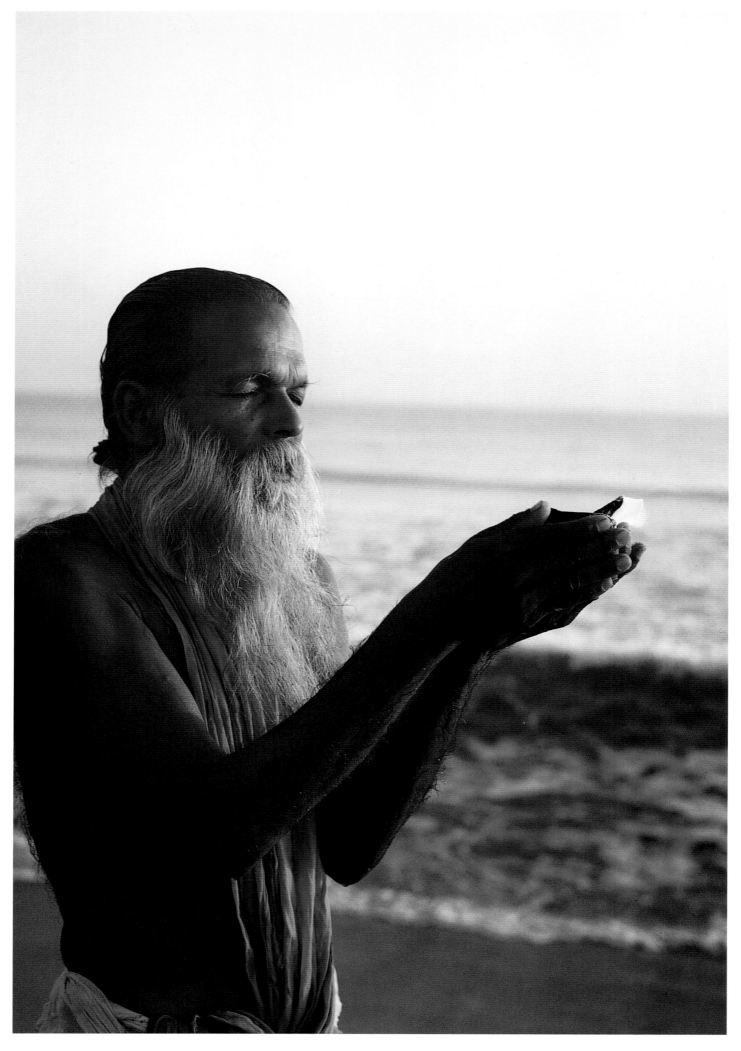

*An early morning Surya Namaskar, salutation to the Sun God.*

# Spiritual India

Now that India has entered the 21st century, what can she wish for her future? That she succeeds in her liberalization? That she overcomes the hurdles of globalization, which has destroyed the soul of so many Third World countries? Or should she wish to avoid the pitfalls of Westernization and its alien concepts, which could ultimately destroy all that is holy and ancient in India?

And if these wishes were granted to India, then, at last, in spite of her huge problems, would she become a superpower in the Third Millennium? Would the West finally take notice of her, as it did China 40 years ago?

What can India bring to the world as a superpower? Democracy is certainly one thing. She has maintained democracy throughout 57 years of strife, fighting separatism all over the nation. Democracy is evident in her people, who are confident enough to elect their leaders, and also, remove them from office when they do not perform. India has managed to remain a democracy in spite of bureaucracy and widespread corruption.

What else does India possess that would be of interest to the West? It is a bastion of pro-Western, open-minded, English speaking, and highly cultured people. No Western nation could wish for a greater friend than India, whose elite dream of sending their sons and daughters to study at Harvard University, and who always perceives its own ethos through a Western prism.

But there is something else—something infinitely more important—that India can bring to the West: her spirituality. India is a vast and ancient land, which has managed to keep within itself by the stubbornness of its people, who were battered by numerous invasions, and also, by the silent tapasayas of yogis hidden in her Himalayan caves or dark and foreboding temples, seeking the immaculate truth, the ultimate knowledge—the secret of India's destiny.

At a time when the world has perhaps never felt so miserable, where mankind is erring on the road to evolution, at a time when man has forgotten the "why" and "how" of his existence, and when many religions not only have failed, but have sometimes turned against their fellow men, India holds the key to man's future.

Indian spirituality has influenced all other religions, even those that have "invaded" the country. Christians in India, for instance, are unique. Not only did the first Christian community in the world establish itself in India–the Syrian Christians of Kerala in the first century A.D.–but before the arrival of the Jesuits with Vasco de Gama in the 16th century, they developed an extraordinary religious pluralism, adopting some of the local customs, while retaining their faith in Christ, and accepting the existence of other religious practices.

It should also be said that Christians are among some of the most educated Indians today, and even though they constitute less than three percent of the population, they wield enormous influence in India, primarily through education. Many of India's top schools and colleges are missionary. Christian hospitals and nursing homes are also highly regarded for the quality of care they provide. Finally, Indian Christians are often gentle, soft-spoken, friendly and God-fearing people.

More than anything, Christianity is alive and well in India. Few Indian Christians realize that Christianity in the West is on the ebb. Church attendance is often dangerously low in European countries; and there are very few boys and girls in the western world today, who dream of becoming priests and nuns. Many parishes, in the French countryside, for example, have no ministers, whereas until the 1960s, even the smallest of hamlets had a church priest. Compare this to India, which has such a small percentage of Christians, but yet there are 14,000 priests and 60,000 nuns throughout the country. In addition, more than six million children in India are taught in Catholic schools.

But do Christians in India today realize that as they hold high the flame of Christ in the world, they are doing so because of the innate spirituality with which most Indians are gifted, be they Hindu, Sikh, Christian, Muslim or Jain?

There is also Islam in India. We find Sufism, of course, which adopted some of the beauty of Hindu India: Mughal architecture, which retained the perfect symmetry of Muslim linear design, while achieving infinite humanity; and Hindustani music, which is enchanting to the ear. However, above all else, Islam in India borrowed the shakti concept of Hinduism—the feminine power of god.

Look at the Islamic countries surrounding India today. Some of them are now governed by women, or have been in the past. Is this not ample proof that deep inside the Bangladeshi or the Pakistani, or the Sri Lankan for that matter, are still worshippers of the eternal shakti principle? For without her, you do not manifest. And is it not also proof enough that deep at heart, they are all still Indians?

As the Indian political and spiritual leader Sri Aurobindo reminds the people of India, "Mohammad's mission was necessary, else we might have ended by thinking, in the exaggeration of our efforts at self-purification, that earth was meant only for the monk and the city created as a vestibule for the desert…When all is said, Love and Force together can save the world eventually, but not Love only or Force only. Therefore, Christ had to look forward to a second advent and Mohammad's religion, where it is not stagnant, and looks forward through the Imams to a Mahdi."

More than anything else, India possesses a knowledge deep within its recesses that was also visible once in other civilizations, but today now seems extinct. And what exactly is this knowledge? Take Pranayama, for instance, the most precise, mathematical, powerful and breathing discipline imaginable. Its effects and results have been observed and categorized by Indian yogis for millennia. This extraordinary knowledge can produce wonderful results in both the well being of the body and the tranquility of the mind. Pushed to its extreme, it lends a disciple deep spiritual experiences and a true inner perception of the world.

And what of Hata Yoga, a 5,000-year-old technique, which has inspired yoga-centered exercises and techniques that are practiced around the world today? When practiced properly, Hata Yoga can bring health, strength and endurance to the body, and is the innate secret of Indian yogis' incredible longevity. Like Pranayama, its exercises, results and particularities are so well categorized that it offers a solution for each problem of the human body, and an application for each part of the human anatomy.

Pranayama is propagated throughout the world today by His Holiness Sri Sri Ravi Shankar, the founder of the Art of Living Foundation, and a key founder of the International Association for Human Values, which is headquartered in Geneva. Honored the world over by various governments, His Holiness has been instrumental in helping people lead happier, healthier and stress-free lives. He is reviving human values all over the globe, and his Foundation has undertaken tremendous social work at all levels: human, spiritual, social, ecological, and medical. In a world marred and troubled by conflict, he has carried the eternal message of love and service, addressing diverse audiences, such as the United Nations, the World Economic Forum, and various parliaments, academic and social institutions.

Yet, beyond all these visible, tangible achievements, he is a guru whose touch is personal. As he says, "We are here to develop the individual, not a movement." He lights the flame of love in one heart, and this one heart transforms another ten, which, in turn, touch another hundred. Across all continents, over two decades, he has been a role model, inspiring people from all walks of life, giving an opportunity for leadership and service to every single person connected to him. His wisdom, love, compassion and playfulness have given a whole new dimension to spirituality.

Born on May 13, 1956, in Papanasam, Tamil Nadu, it was apparent from an early age that His Holiness was destined to lead a spiritual life. Even as a child, he was often found rapt in meditation. At the age of four, he could recite the Bhagavad Gita. As a young boy he would often tell his friends, "People all over the world are waiting for me." By 17, he completed his education in both Vedic literature and modern science, and soon after, he began his travels around the world, teaching people the art to living life simply, joyfully and effectively.

In 1982, he emerged from a ten-day period of silence with the Sudarshan Kriya, a powerful, yet simple, breathing technique that eliminates stress, and energizes a person both physically and emotionally. Beyond any barriers of nationality, class or religion, this technique is taught around the world in more than 140 countries as part of the Art of Living workshop.

Hundreds of thousands of people and communities across the globe have experienced physical, mental, emotional and spiritual transformation because of His Holiness, and the various programs offered by the Foundation.

Meditation, queen of all the yogic sciences, cannot be forgotten here, for without it, any yogic discipline is impossible. Meditation carries us within ourselves, to the discovery of our true soul and nature. There are hundreds of different meditation techniques, which have been devised by Indian sages since the dawn of Bharat. Each one has its own characteristics; each one gives particular results, which have been experienced by countless aspirants since the dawn of Vedic times.

Apart from Sri Sri Ravi Shankar, are these yogic sciences in danger of extinction, to vanish forever from the consciousness of planet earth? Not at all, for India is full of ashrams, yogis and masters, who are still keeping alive all of these wonderful sciences. From the tip of Cape Comorin to Kashmir, you cannot go anywhere in India without finding some spiritual place, some sadhu practicing a particular tapasaya, or some course in meditation being offered. You have only to step out of the big cities, with their five-star hotels, mad traffic, and hurried businessmen with ties and briefcases, and enter into the countryside, and you step again into India's immortal dharma, where you can feel the line of continuity of 7,000 years of sages.

This is the wonder that is India.

What do you think might happen if these ancient arts still alive in India today were officially recognized by the Indian Government, and by Indians themselves, and put to best use in daily life? What do you think would happen, for instance, if Pranayama were systematically taught to athletes from the very start of their training? It might produce supermen—Indian athletes very difficult to defeat because of the concentration they learned through this marvelous technique.

What would happen, if Indian businessmen also practiced Pranayama? It could enhance their capacity to work and endow them with enthusiasm for their task. And what if school children in India were taught the combined techniques of Pranayama, Hata Yoga, meditation and Ayurveda at a very early age? It would, perhaps produce, the next human species of our era—a race, which would be spiritualized in both mind and body.

Unfortunately, for the moment, not only does the Indian government not recognize the wonder that was India, but also, it constantly denigrates these great techniques, which are part of its heritage. The Christian and Muslim minorities reject them outright as part of the Hindu culture. Modern Indians—businessmen, intellectuals, or bureaucrats—also show disdain for these golden treasures of India.

Fortunately, for the planetary evolution, India's yogis, gurus and teachers are not only actively practicing in India, but also traveling around the world to spread this wonderful knowledge. Some are certainly genuine teachers, some are semi-fakes, and others are complete fakes. But it does not matter, ultimately, because almost all of them carry abroad the message of yoga and the desire to propagate India's eternal dharma around the world. Thanks to them, slowly but surely, there are increasing numbers of people in the West, who are interested in Indian sciences, and who practice Pranayama, Hata Yoga or meditation.

It even may be that India will have to realize its "wonder" when the West points its finger at it, as is what happened in a lesser way in Japan with its martial art techniques, Zen Buddhism, rock gardens and Bonzai art, when America took hold of them. Let us hope, though, that in some way, the true India will emerge soon.

The key to India's oneness is its diversity, and the unifying element found in its ancient Hindu culture—the "Indu" culture—which has immensely influenced all Indians, whether they are Hindu, Christian or Muslim. India's dharma is not Hinduism; it is the knowledge preserved through the ages of a higher plane above surface life, of states of being which superimpose our ordinary mind and lead like a pyramid, towards the highest reality—Sat-Chit, Truth-Existence.

In the words of Sri Aurobindo, "A wider spiritual culture must recognize that the Spirit is not only the highest and inmost thing, but all is manifestation and creation of the Spirit. Its aim must be not only to rise to inaccessible heights a few elect, but to draw all man and all life and the whole human being upward, to spiritual life and in the end to deify human nature." However, breathing space must be given to the vast

mosaic that is India. Let Indian Muslims rule their own communities, but encourage them to recognize India's sovereignty and keep within the framework of the Constitution. Let Christians worship in peace in their cathedrals, while discouraging their conversion of more Hindus.

Once again let us listen to the wisdom of Sri Aurobindo:

"India, shut into a separate existence by the Himalayas and the ocean, has always been the home of a peculiar people with characteristics of its own, with its own distinct civilization, way of life, way of the spirit, a separate culture, arts, building of society. It has absorbed all that has entered into it, put upon all, the Indian stamp, welded the most diverse elements into its fundamental unity. But it has also been throughout, a congeries of diverse people, lands, kingdoms and in earlier times republics also, diverse races, sub-nations, with a marked character of their own, developing different brands or forms of civilization and culture..."

"India's history has been marked by a tendency, a constant effort to unite all this diversity of elements into a single political whole under a central imperial rule, so that India might politically as well as culturally be one..."

"The ancient diversities of the country carried in them great advantages as well as drawbacks. By these differences, the country was made the home of many living and pulsating centers of life, culture, a richly and brilliantly colored diversity in unity; all was not drawn up into a few provincial capitals, or an imperial metropolis, other towns and regions remaining subordinated and indistinct or even culturally asleep. The whole nation lived with a full life in its many parts and this increased enormously the creative energy of the whole. There is no possibility any longer that this diversity will endanger or diminish the unity of India. Those vast spaces, which kept her people from closeness, and a full interplay, have been abolished in their separating effect by the march of science and the swiftness of the means of communication.

"The idea of a federation, and complete machinery for its perfect working, has been discovered and will be at full work. Above all, the spirit of patriotic unity has been too firmly entrenched in the people to be easily effaced or diminished and it would be more endangered by refusing to allow the natural play of life of the sub-nations than by satisfying their natural aspirations...

"India's national life will then be founded on her natural strength and the principle of unity in diversity, which has always been normal to her and its fulfillment the fundamental course of her being and its very nature the many in one would place her on the sure foundation of her swabhava and swadharma...a union of states and regional people would again be the form of a united India." (India's Rebirth, pp. 240-241).

For the India of tomorrow, the spiritual leader of the world, as Sri Aurobindo exhorts Mother India, Durga, "is not a piece of earth; she is a Power, a Godhead, for all nations have such a Devi supporting this separate existence and keeping it in being... Mother Durga! Rider on the lion, giver of all strength, we are seated in thy temple. Listen, O Mother, descend upon earth, make thyself manifest in this land of India..." (*India's Rebirth*, p. 235).

The spirit of India has always been permeated with deep-rooted spirituality, that infinite reservoir of wisdom that transcends the material world. And the message of its seers must be shared and spread across the continents. For that is the essence of India— the richness of its inimitable spirit.

 *François Gautier*

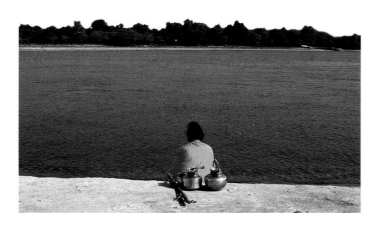

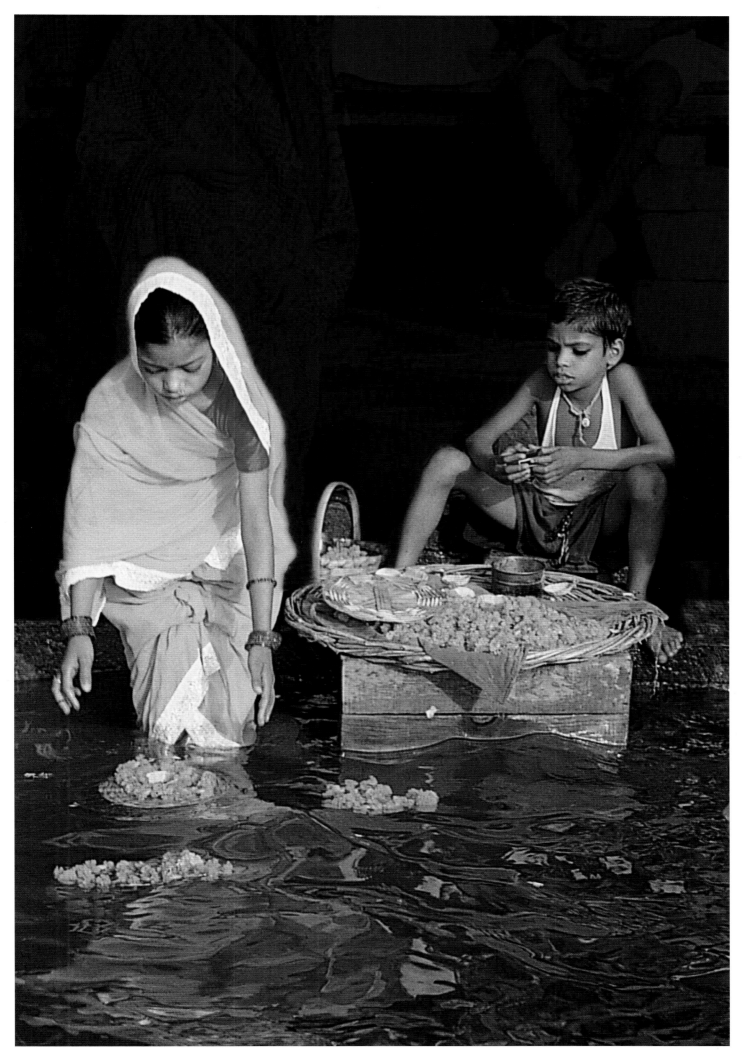

*A young bride offers flowers to the holy Ganga at the Varanasi ghats.*

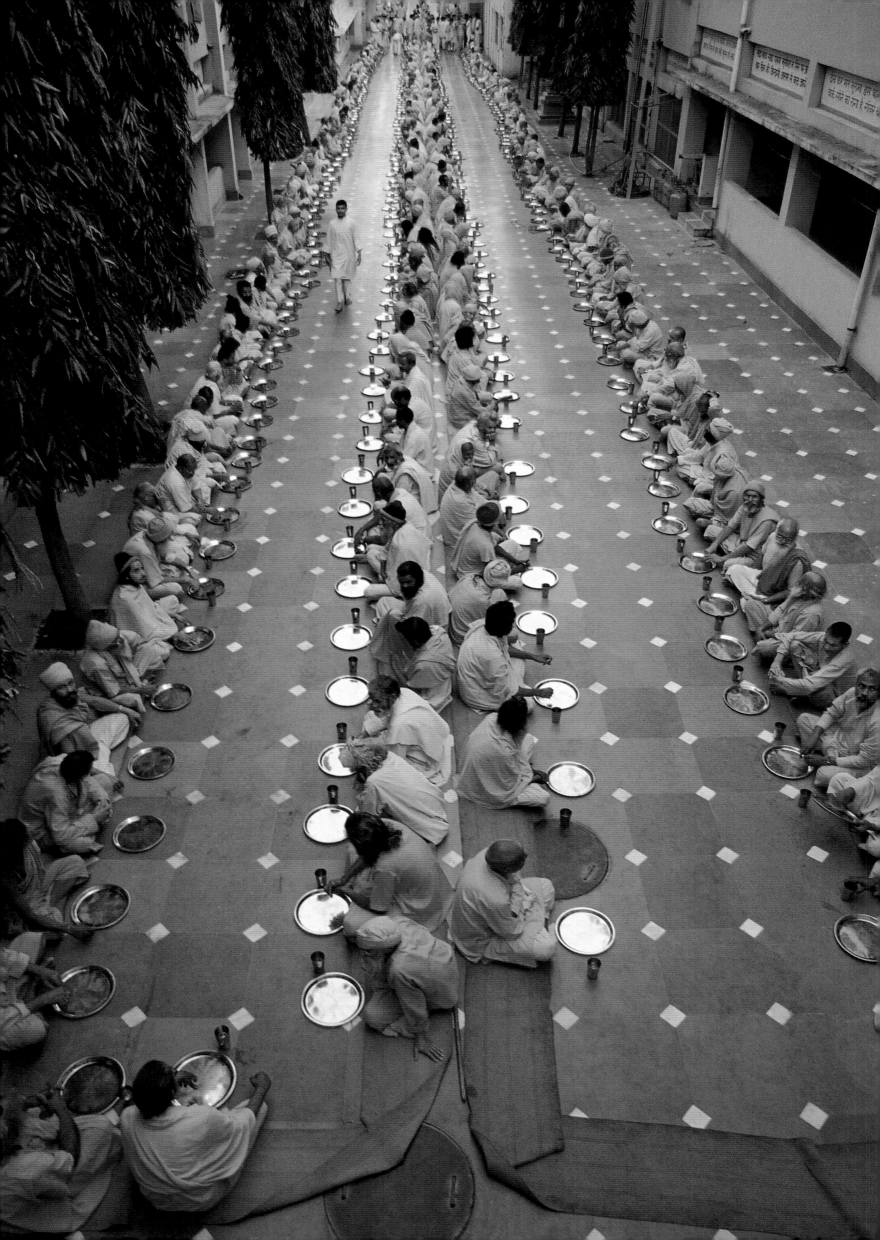

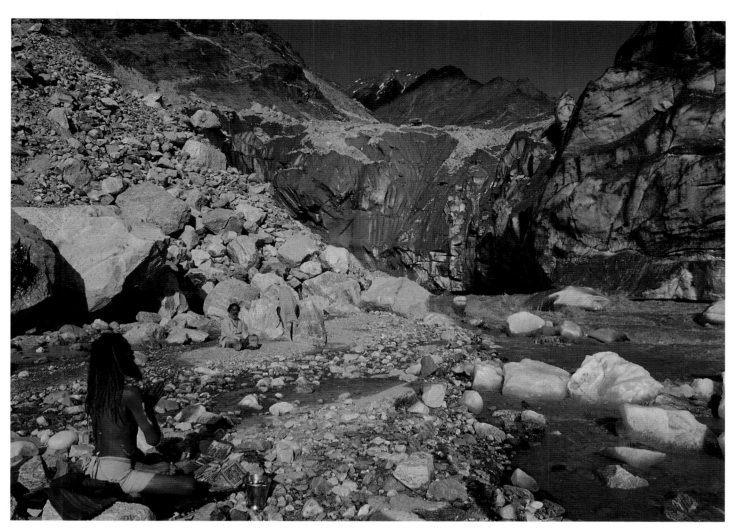

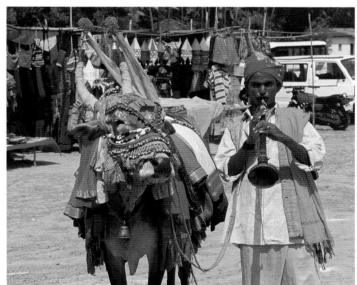

FACING PAGE: *An evening meal for the large number of sadhus
and saints at Gita Kutir in Haridwar, Uttranchal.*
TOP: *An ascetic in a moment of repose in the upper
reaches of the Ganga beyond Gangotri in Uttranchal.*
LEFT: *A roadside shop selling prints depicting
Hindu gods and goddesses outside a temple in Goa.*
ABOVE: *A wandering mendicant with a decorated
cow venerated by the Hindus.*
FOLLOWING PAGES: *His Holiness Sri Sri Ravi Shankar
meditating during an evening discourse.*

238

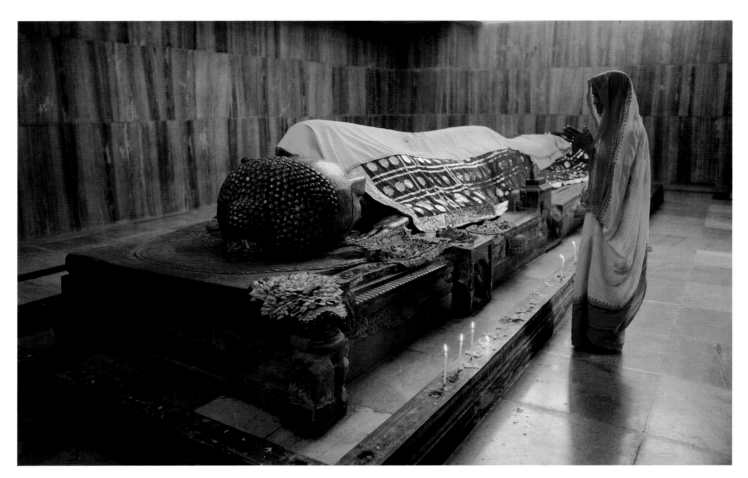

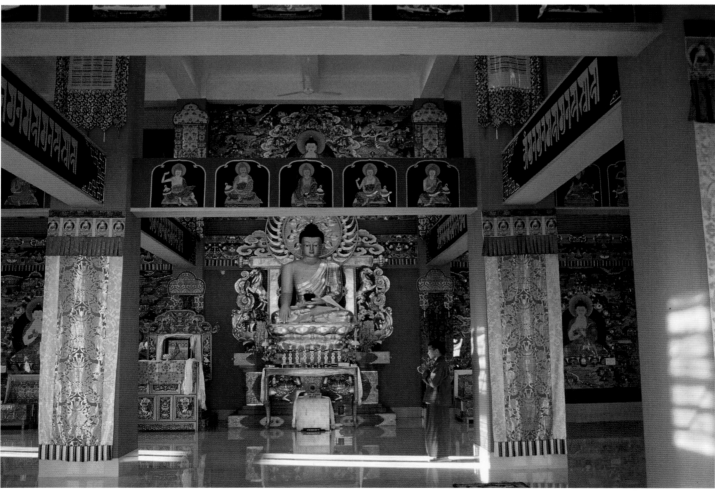

TOP: *A contemporary image of the Parinirvana, the Great Cessation of Being, at Kushinagara, where the Buddha passed away.*
ABOVE: *An extremely beautiful Tibetan Temple in Clement Town in Dehradun, Uttranchal.*
FACING PAGE: *After Buddha attained Enlightenment, he spent the next 40 years of his life, travelling in the Gangetic plains, preaching the Law and making converts to the Sangha. The picture shows the preaching Buddha (Ajanta Caves, sixth century AD).*

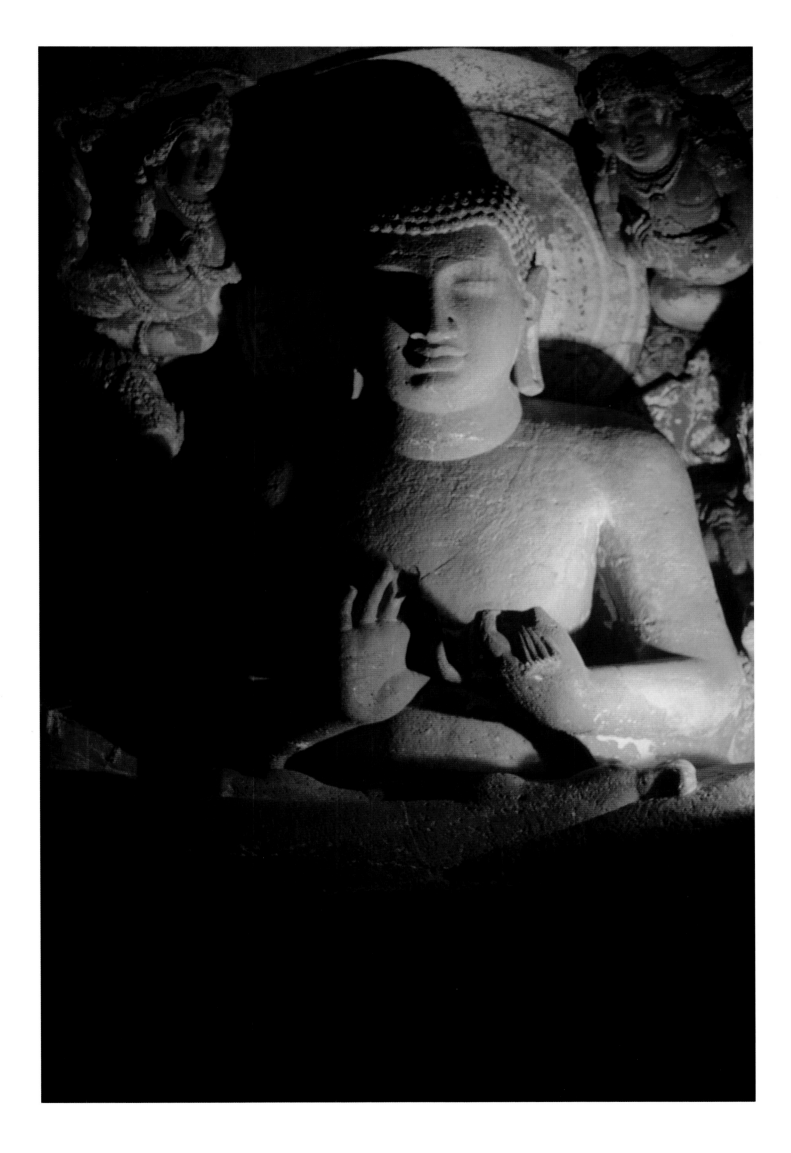

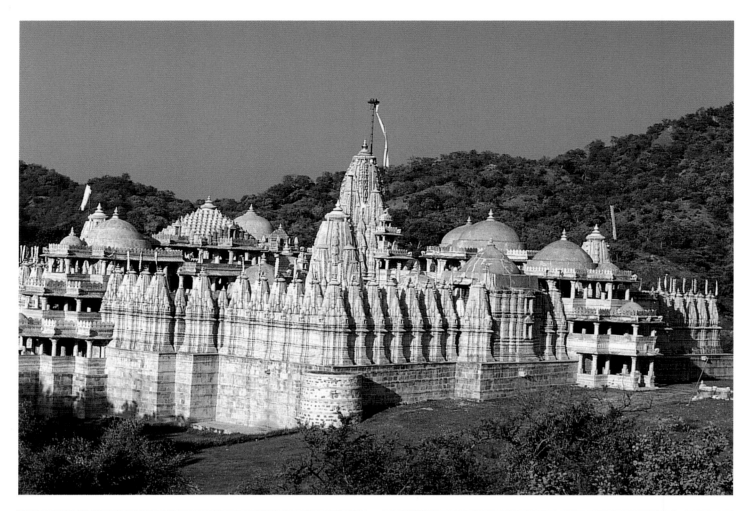

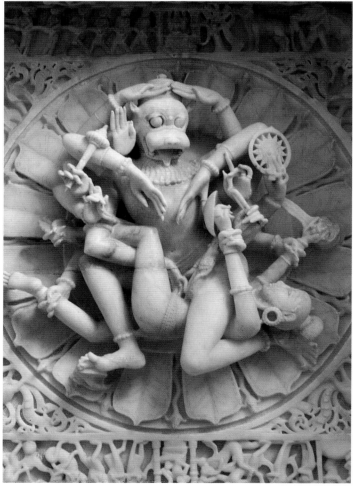

*The sublimely beautiful Adinatha Jain Temple in the secluded wooded valley of Ranakpur near Udaipur.*
*Intricate carving, splendid relief work and motifs are engraved on the ceilings of the Ranakpur Temple, which*
*is made from marble. A plaque in the temple depicting the twenty-third Jain Tirthankara Parshva.*
FACING PAGE: *Images of Tirthankaras inside a beautiful Jain temple in Chandni Chowk, Old Delhi.*

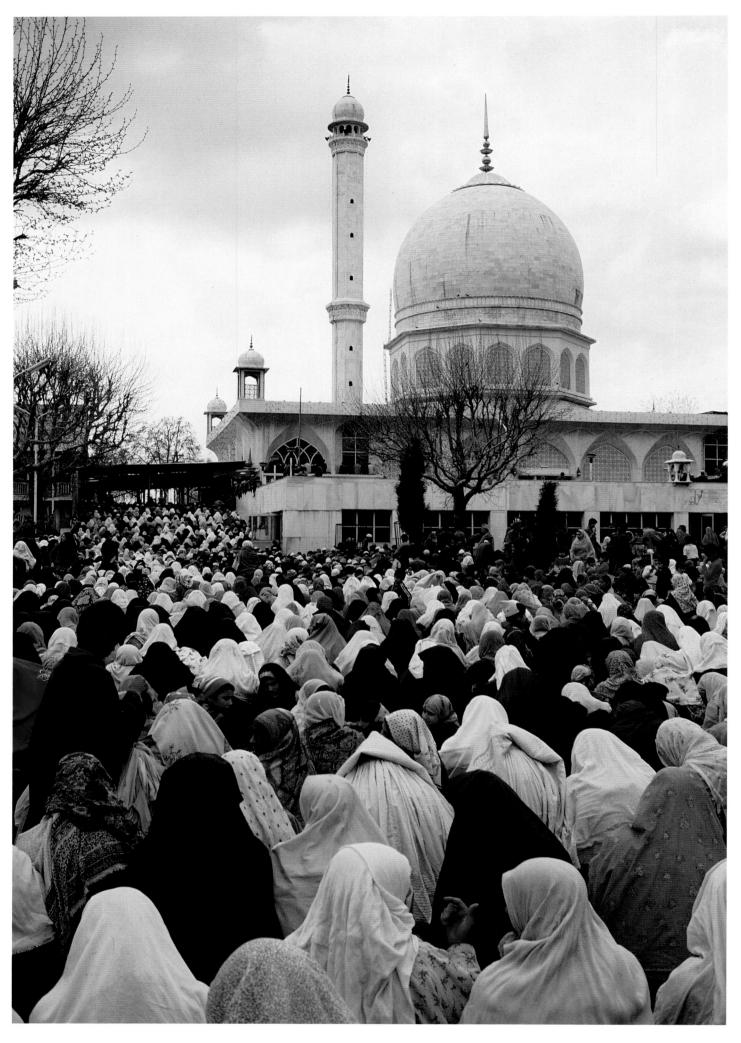

*Women offering prayers at the Hazratbal Mosque in Srinagar, Kashmir. This mosque with a dazzling white dome, contains an extremely sacred relic, a hair of the Prophet Mohammed.*

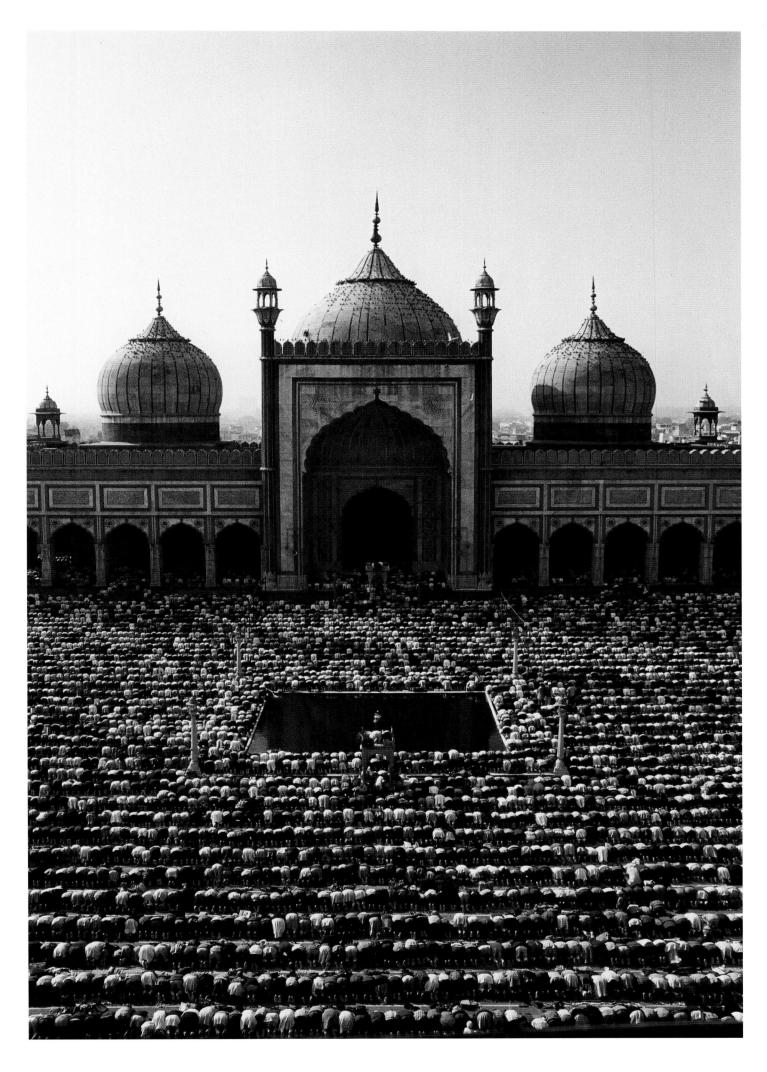

*A view of the Id prayers at Jama Masjid in the walled city of Old Delhi, the largest mosque in the country.*

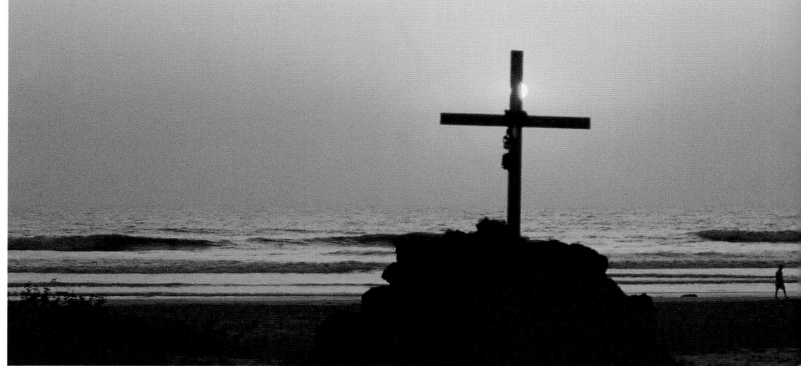

*Sunset on a beach in Goa.*
FACING PAGE AND TOP: *Interiors of St. Thomas Church in Kolkata.*

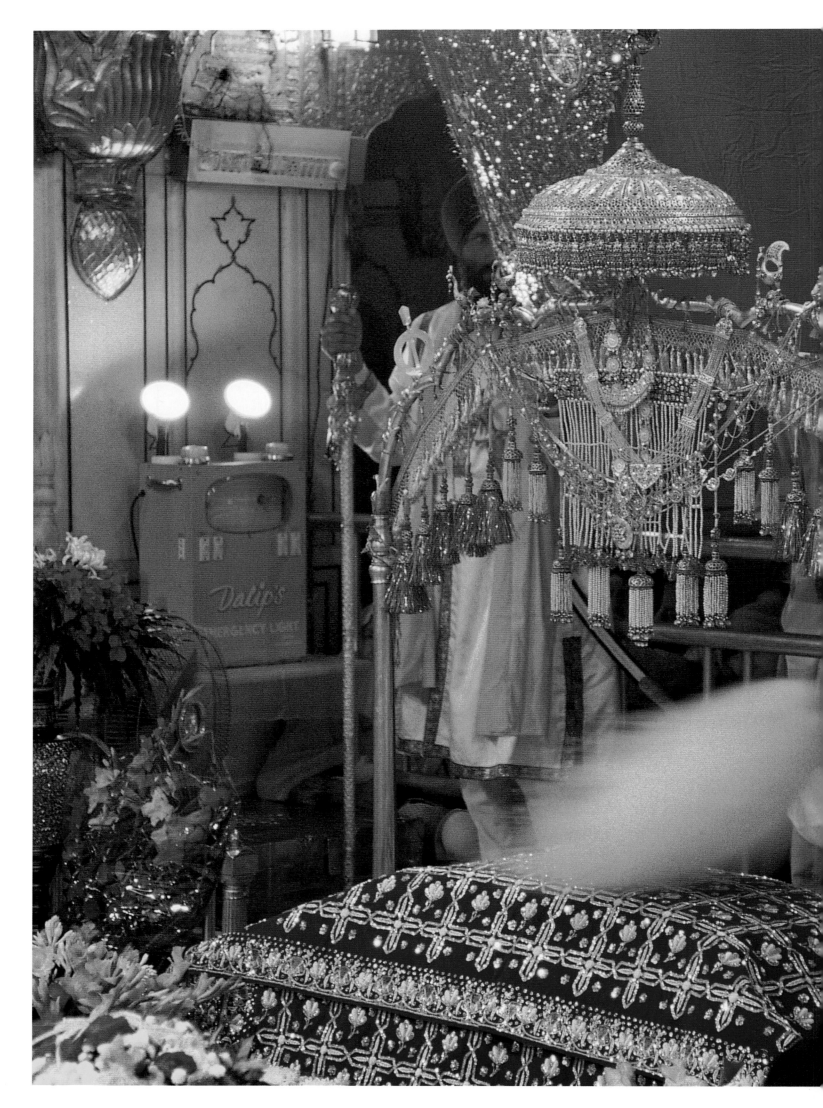

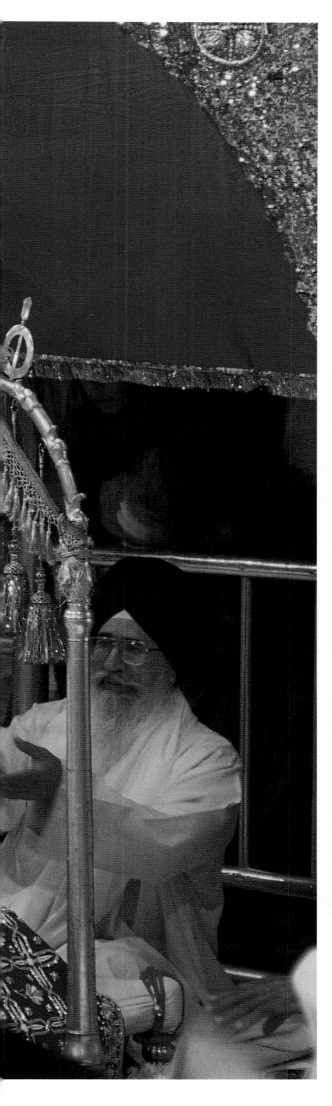

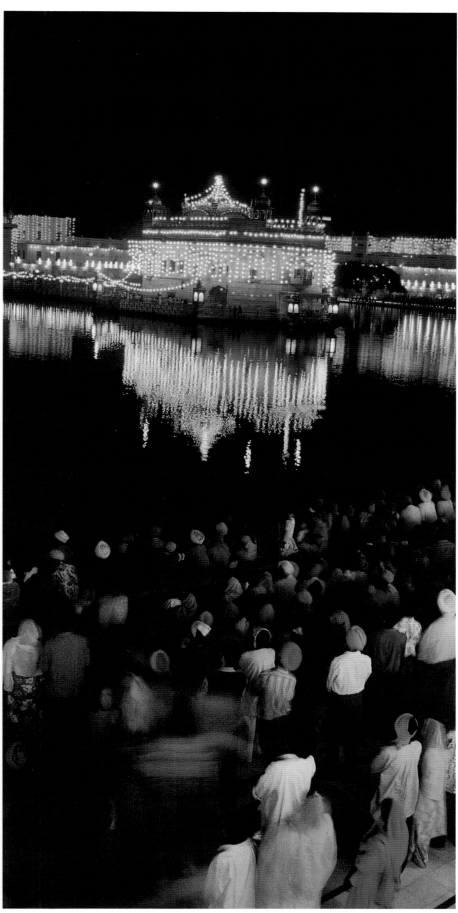

FACING PAGE AND ABOVE: *There is an atmosphere of peace and calm as devotees pay their respects to the Guru Granth Sahib and Hazur Ragis sing the Shabad Kirtan in the sanctum of the Golden Temple in Amritsar, Punjab. The brightly illuminated Golden Temple and its shimmering reflection in the Pool of Nectar during the Guruparb, Guru's commemoration.*